Gardens in Time

For Nathalie

"I wish that I could infuse the whole universe with my taste for gardens. It is inconceivable to me that anyone evil could have one: no bad man could be associated with anything of the sort. But whilst by the same token I esteem the wild seeker after herbs, the joyous, skipping conqueror of butterflies, the methodical examiner of seashells, the somber lover of minerals, the icy geographer, the mad trio of Poet, Musician, and Painter, the distracted author, the abstracted thinker, or the discreet chemist, there is no virtue I will not attribute to a man who simply loves to garden and to talk of gardening. In his absorption with this, the only passion that increases with age, each day the gardener sloughs off more of those other passions which threaten to disturb the tranquillity of the human soul and the calm regulation of society."

—Prince Charles-Joseph de Ligne
Coup d'œil sur Belœil, 1781

Gardens in Time

PHOTOGRAPHS BY

ALAIN LE TOQUIN

TEXT BY

JACQUES BOSSER

ABRAMS, NEW YORK

Introduction

Although the first mentions of gardens date from more than four thousand years ago, it is really only with the gardens of Pompeii, whose outlines were, paradoxically, preserved by the lava flow of A.D. 79, that we have our earliest physical record of garden design. Apart from a few vague or poetic descriptions, we know very little of the immense Chinese parks that drew the admiration of literati more than three thousand years ago, or of the marvelous hanging gardens of Babylon, or of Cyrus's "paradise" at Pasargadae, which so fascinated travelers in antiquity.

The reason is obvious, and mundane. Although it takes many years for a park or garden to attain the desired shape, a few seasons of neglect, a violent storm, a series of excessively hot summers, or an economic crisis can quickly ruin all the work that has been put into it. Often, too, changes in taste, fashion, or ownership have led to alterations in a garden's layout and the plants within it. The history of gardens, therefore, exists chiefly in archives, travelers' descriptions, poems, letters, treatises, paintings, manuscript illuminations, plans, gardeners' accounts, and, for little more than a century, from the records and interpretations made by photographers. The gardens themselves elude us. Thus the art of the garden is ephemeral.

The aim of this book—to retrace in pictures two thousand years of the history of this fragile art—was therefore an improbable one. It depended inevitably on choices that were dictated by the gardens' state of preservation and stylistic importance, but also governed by our taste. The eighty-four gardens on five continents that we have chosen include some of the most famous in the world, such as those of Versailles and the Taj Mahal, and others that are virtually unknown, such as those of Bruges or Tacaruna. They may be immense, sumptuous parks such as Stourhead, or a simple façade of plants covering an office block in Barcelona. While all the main types are classified and described, we have also taken care to show—and this is one of the original features of this book—how most have had, and continue to have, a permanent influence over time. The history of the art of the garden consists also of derivations.

Between the garden of the Alhambra and that of the Villa Île-de-France at Villefranche-sur-Mer, between the Myoshinji in Kyoto and the Japanese garden at the Huntington Botanical Gardens in California, several centuries passed; yet each shows, to an equal degree, the same passion for an affectionate vision of nature. Transcending the periods in which they worked, the tastes of gardeners and landscape gardeners can sometimes echo each other. Thus Achille Duchêne, in France, revived classicism at the end of the nineteenth century, while at Great Dixter, Charles Lloyd began the history of the ecological garden, which links us to the original, mythical Eden.

Although for a long time the creation of gardens was the preserve of a small number of specialists—landscape designers, architects, and gardeners, sometimes helped by painters and sculptors—from the twentieth century onward artists, designers, botanists, contractors, and engineers became increasingly involved. Today, each can draw inspiration from gardens the world over. Eclecticism is triumphant, experimentation is in the ascendant, and standing out amid this polymorphous, abundant output are some outstanding successes—such as the creations of Fernando Caruncho, Gilles Clément, and Jacques Wirtz—which will no doubt act as new models.

This book does not attempt the impossible task of painting a complete portrait of an art that is so ancient, rich, and varied. It simply offers a glance at the garden, today and through history: a marvelous projection of the culture of an age onto nature. This is truly a great art form.

—Alain Le Toquin, Jacques Bosser

Gardens of the East

CONTENTS

Gardens of the West

Contemporary Gardens

Gardens of the East

Gardens of Persia

The West has long dreamed about Persian gardens. The first to describe them was Xenophon in the fourth century B.C.; at the same time, he invented the word "paradise"—the Greek word *paradeisos,* from the Persian *pairidaeza,* meaning "enclosed space." However, earthenware cylinders and bas-reliefs of far earlier date bear witness to the existence of these enclosures from 1100 B.C. The Bible itself mentions one at the time of the Creation: "And the Lord God planted a garden in Eden, in the east; and there he put the man whom he had formed." (Genesis 2:8)

The Median and Achaemenid "paradises" were certainly not the delightful gardens that have been imagined, but rather vast reserves enclosed by walls, planted with trees, and irrigated by canals and pools. They were sometimes stocked with exotic animals, and the ruler would visit to hunt these. Divided into four equal rectangles—a reminder of the power of the emperor, "master of the four corners of the world"—they sometimes contained pavilions for resting, surrounded by plantations of fruit or other trees, arranged along the lines formed by cooling, mirrorlike pools. These were therefore both reserves of food and places of amusement, in the middle of regions whose climates were harsh. This paradise was a domesticated natural environment, protected and developed for the exclusive benefit of the ruler or his satraps, which would make it the ancestor of the Western eighteenth-century park rather than a garden. The artistic "gratuitousness" of gardens would arrive only much later, but this archaic Persian model nevertheless inspired the Mughals, the Muslims, and ultimately, the West.

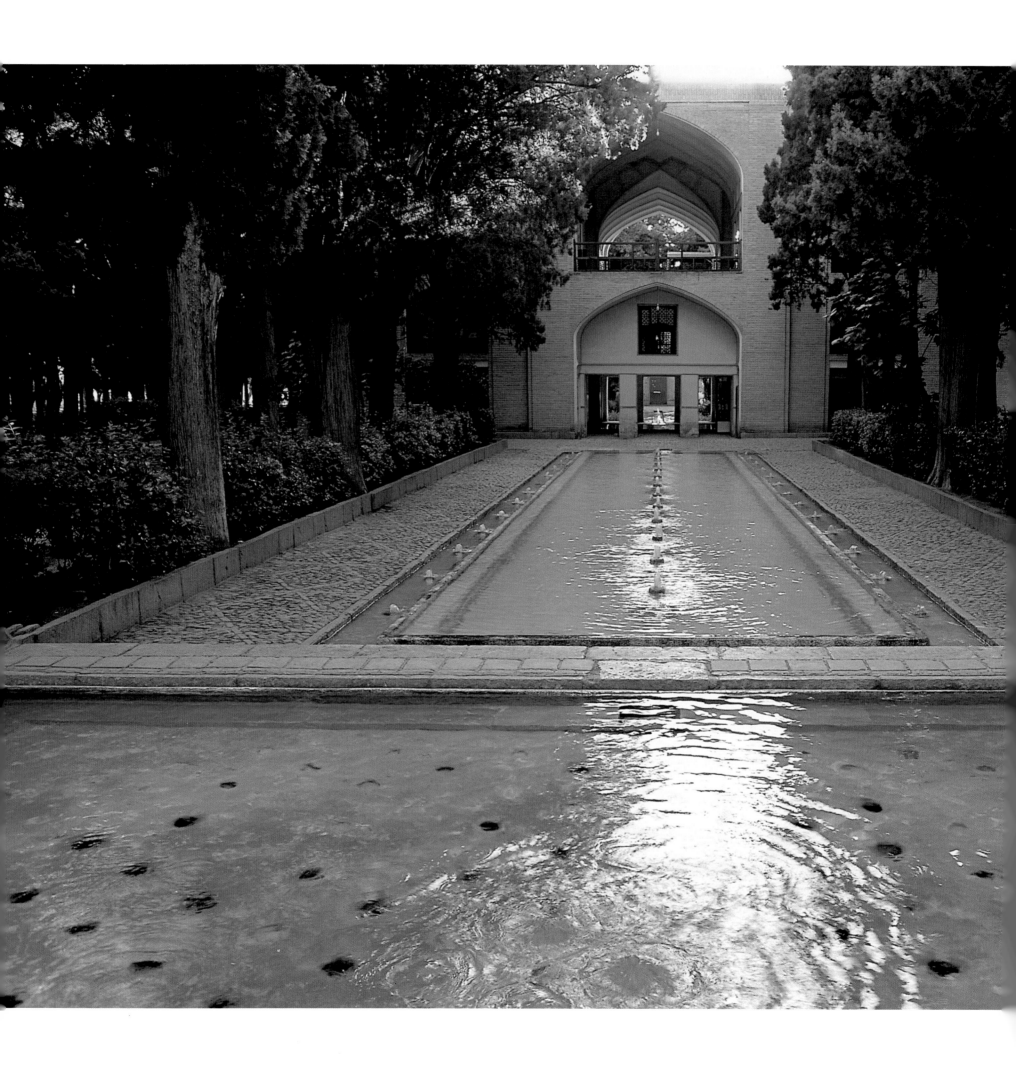

Bagh-e-Fin

Magic of the *Chahar Bagh*

KASHAN, IRAN
Sixteenth century

*The two canals in
the four-section
plan of the* chahar
bagh *intersect at the
garden's center, inside
a monumental* suffeh,
or pleasure pavilion.

Bagh-e-Fin is considered to be one of the finest of
Iran's historic gardens. Its location was formerly
secluded, but today it is in the suburbs of Kashan,
a large city 160 miles (260 km) south of Tehran. Its
high earthen walls protect it from urban develop-
ment, just as they sheltered it from the desert wind
when it was laid out at the end of the sixteenth
century by Shah Abbas, a Safavid ruler, on what was
probably the site of a former Sassanid "paradise."
A place where contemporary poets hold festivities
and receptions, it has always been well preserved,
although its buildings have been modified many
times.

Its layout is based on the *chahar bagh*, the geo-
metric, four-section plan of Mongolian origin. Within
its high walls, it has six large, rectangular sections
demarcated by a grand canal, a canal parallel to it,
and one at right angles, the whole being bordered by
a canal around the perimeter. Pools have been dug
where these canals intersect: a large square pool,
a second square pool inside the central pavilion at
the main intersection of the axes, a third that lies
lengthwise, and five smaller square or rectangular

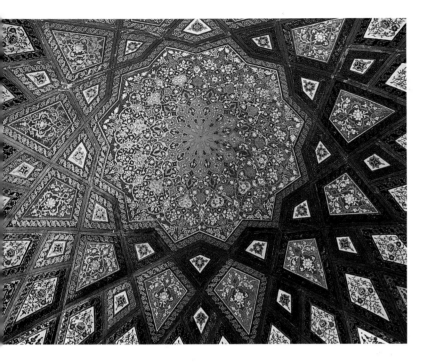

Left: A ceiling decorated with mosaics

Right: The false arcade of the garden's perimeter wall

pools. This watery web, heightened by turquoise tiling, creates a rhythm that is not only visual but also auditory, thanks to the flow of the water and myriad jets, fed by springs in the nearby mountains. Water is brought via underground aqueducts, part of a system called *qanat*, which has existed from time immemorial and was originally designed to reduce evaporation.

Eucalyptus and fig trees have been allowed to grow tall, but it is rare to see flowers. Nevertheless, at dusk, when the light is captured by turquoise trickles, an infinite magic pervades the place. ⚜

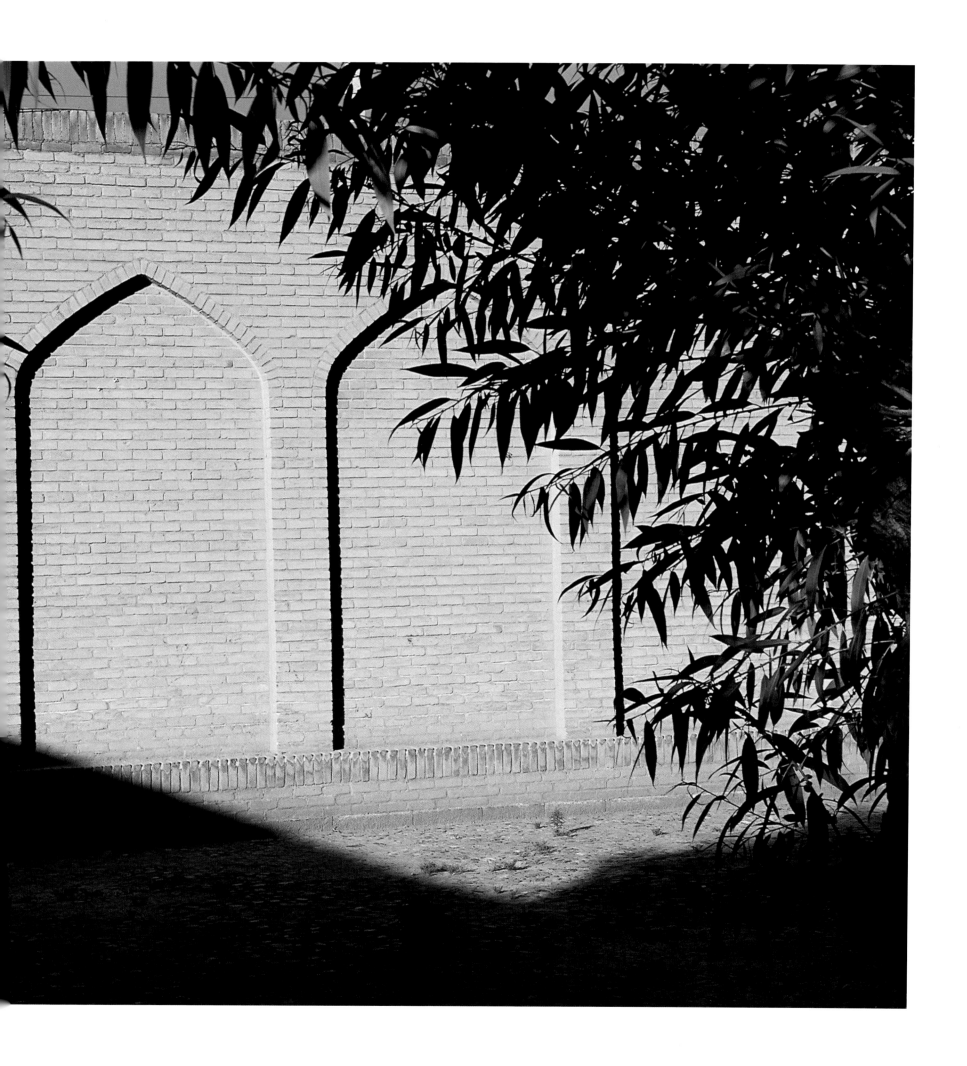

Bagh-e-Shazdeh

A Dream of Paradise

MAHAN, IRAN
1878

At another time, in a different place, this would have been described as a "folly." For it was in the middle of the desert that Bagh-e-Shazdeh was laid out, in 1878, by Naser al-Douleh, governor of the nearby city of Kerman, five hundred miles (800 km) south of Tehran. This summer residence, a solitary enclave of luxury in the depths of the desert, is even more surprising when seen from the air: a dark green rectangle etched into the surface of an

empty, dull-colored vastness. In fact, the miracle of this desert garden is easily explained. There is water in the nearby mountains, and it can be fed directly to the residence via underground channels. Simple gravity made possible not only irrigation but also many water jets, which continually diffused a cooling mist under the trees. From time to time, a sluice gate was lowered and the garden was flooded to regenerate its soil.

The pavilion has an inimitable elegance in its classical Iranian style that is almost modern in its simplicity. The estate was abandoned after the death of its creator, and lay neglected for a long time. Efforts are now being made to bring it back to life. For Iranians it is the symbol of the Qajar dynasty (1794–1925), but for many visitors it illustrates, more than anything else, a dream of paradise. ⚜

A governor's summer residence, Bagh-e-Shazdeh is literally an oasis in the desert at the foot of arid mountains which can be seen in the distance—like the original Eden.

The Islamic Garden

From about the seventh to the thirteenth century, the art of the garden in the Mediterranean region seems to have been dominated by the Islamic model. In fact, this must be placed within a broader historical context, supported by the many archaeological discoveries that have been made. Ancient Egypt, for example, had a garden tradition, as attested by many paintings and bas-reliefs. Byzantium brilliantly adopted the traditions of Roman villas. And how could one ignore Persia, and the east beyond, in the vast diversity of Asia? Nevertheless, the dominant Islamic tradition of the Umayyad, Fatimid, Ayyubid, and Mamluk dynasties succeeded in formalizing a model that was to fascinate and partly influence Europe right up until the great leap forward of the Renaissance.

Islam is a religion born in the desert—a vastness with no shade, where scents are rare. A garden is created to be a dream that is the opposite of this, with abundant water, cool shade, and protective walls, with the intoxicating perfume of plants and flowers. However, this fragile sensual microcosm demands infinite care, and must be protected from the hot wind as well as from the eyes of outsiders and enemies. The garden is a private paradise, a place for meditation, where we renew contact with the essential world of nature, even if this contact is mediated by sophisticated hydraulic installations, refined design, rare plants, and the cultivated harmonies of music and poetry.

The Islamic garden corresponds to an ideal of introspection and serenity, a foil for the extremes of a period of intense military, political, and social upheaval. It is a place for the powerful to relish, yet it represents the simple, calm pleasure of everyone—from early history up to the present day—who loves to sit on a bench and simply admire the beauty of gardens.

Alhambra and Generalife

NOSTALGIA FOR A VANISHED CIVILIZATION

GRANADA, SPAIN
Twelfth to fourteenth century

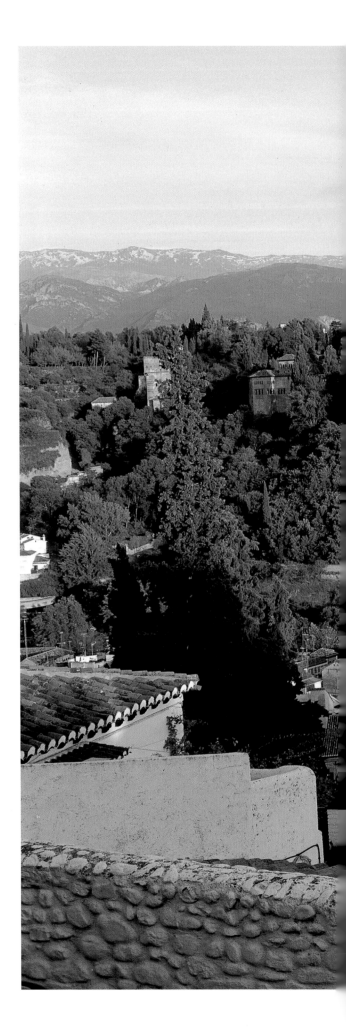

The Alhambra in Granada immediately fascinated its visitors. A royal and military city, this fortified complex combined on a 2,400-by-722-foot (720-x-220-m) platform all the elements that made up the nostalgic myth of a powerful, sophisticated Arab civilization, expelled by the Catholic kings of a still-backward Spain. When Granada was taken in 1492 and Boabdil, the last Muslim ruler, surrendered, the seat of the Nasrid dynasty was more or less respected, apart from the customary executions and looting. A little later, Charles V, a lover of gardens, was so charmed by the remains of the beauties that must have seemed infinitely exotic that he had a strange imperial palace built there that showed a surprising sensitivity to the setting. Gradually, however, the "red castle" was forgotten, and the Arab presence was buried away in the unconscious mind; it was not until the nineteenth century, with its great travelers and archaeologists, that anyone

thought to preserve this masterpiece of architecture and garden design.

The centuries have erased the marks of power, war, and the downfall of a powerful kingdom, leaving only this complex of intensely poetic, imposing buildings, whose harmonious proportions elevate the delicate interior decoration to an incredible level of splendor. Between the palace's towers, halls, and rooms run gardens that are among the most emblematic of any Islamic model in existence.

These strange places, often of modest dimensions, like outdoor rooms, enchanted the French writers Chateaubriand, Alexandre Dumas, Théophile Gautier, Victor Hugo, and Maurice Barrès, the

Granada was a very old Iberian city, which then became Roman, before being taken by Syrian soldiers in 745 and finally becoming an independent kingdom in 1013. The Alhambra, the "red castle," was a citadel that was converted to a royal residence in the thirteenth century.

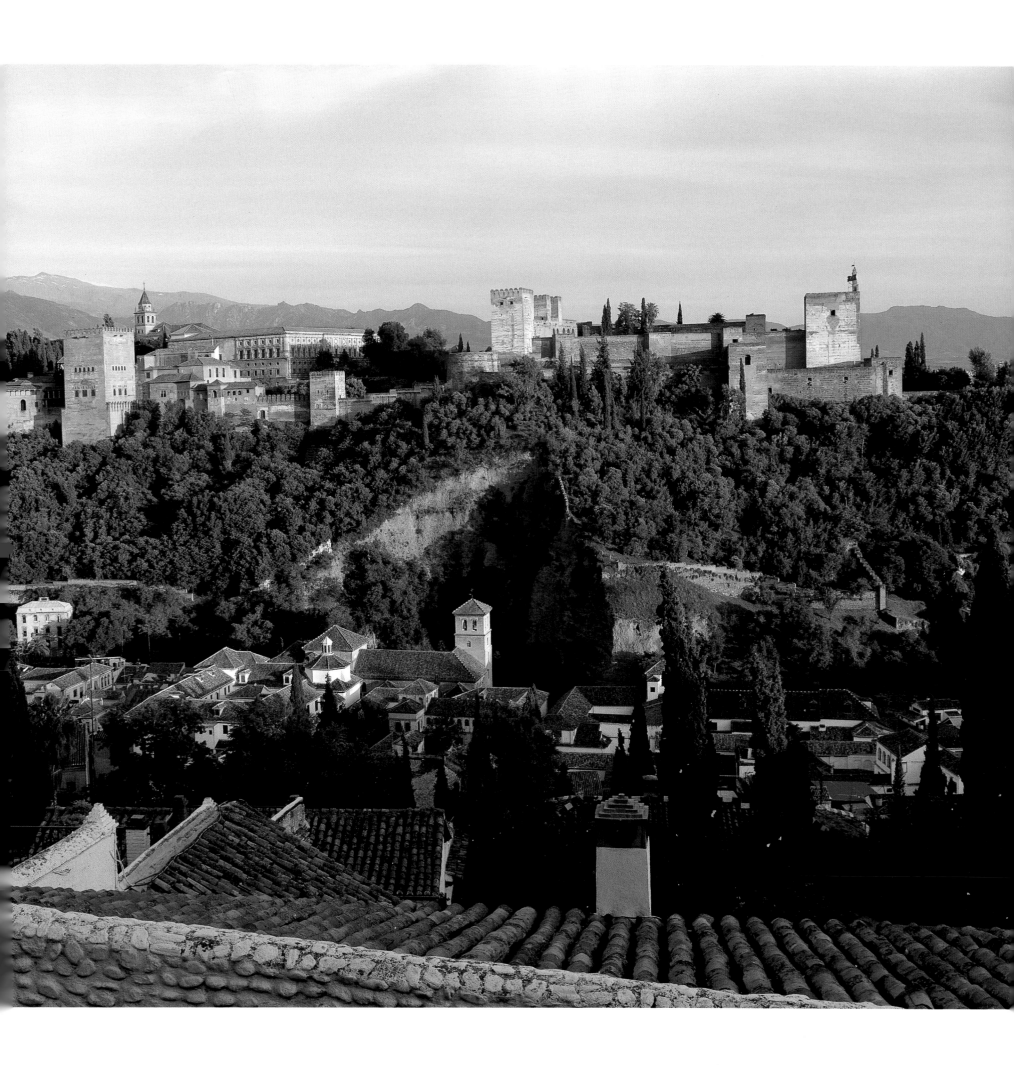

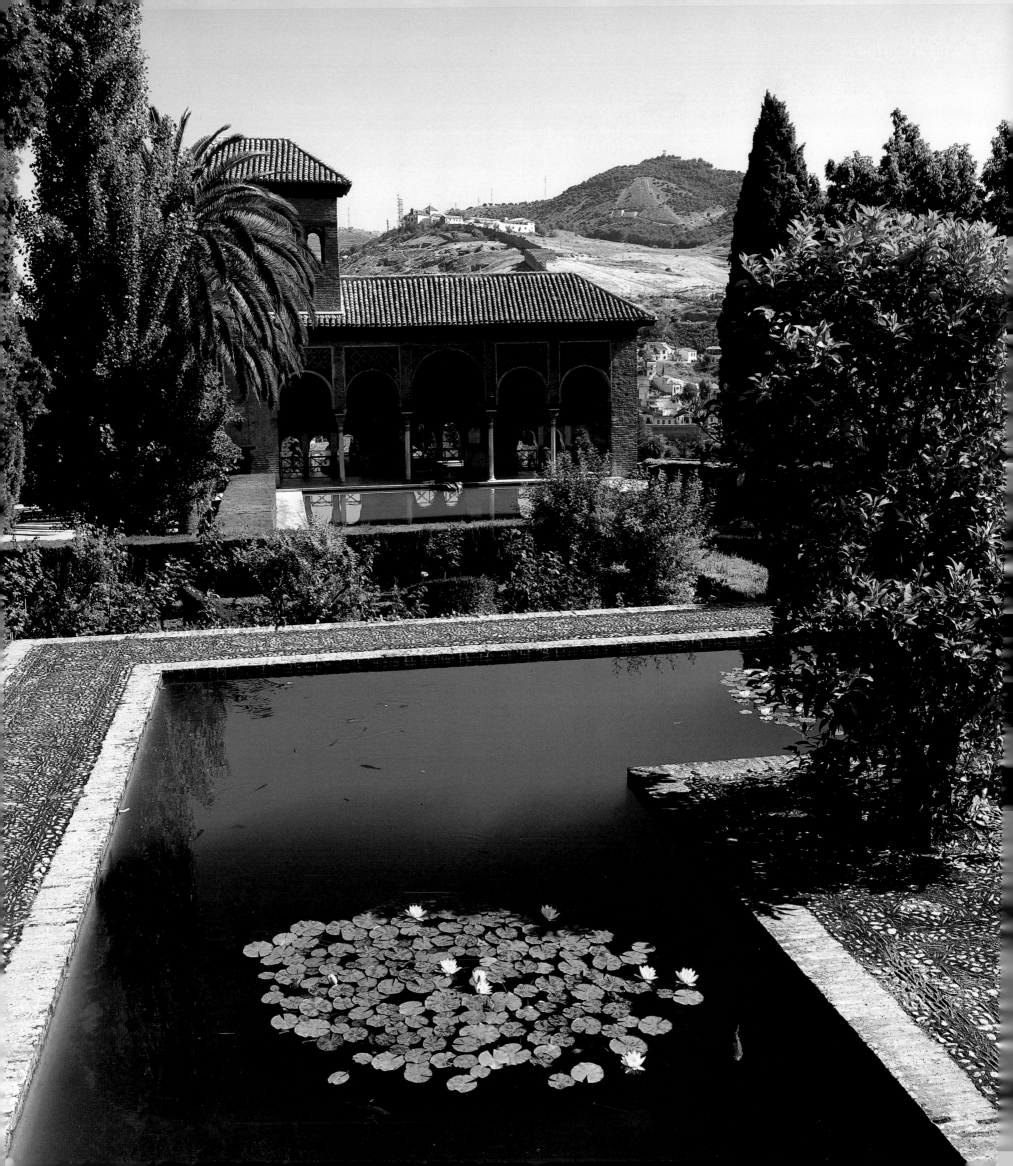

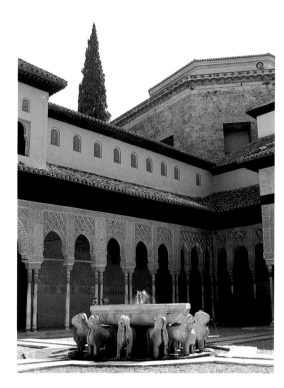

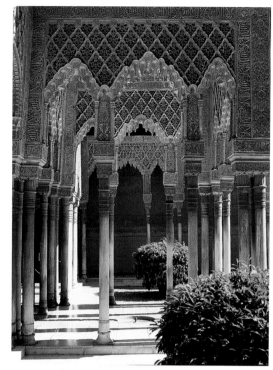

English writer Swinburne, and the American writer Washington Irving. Their structure and poetry are founded on the use and mastery of water. Indeed, the very existence of the Alhambra and the Generalife, the small summer palace immediately next to it, was totally dependent on a complex, protected water supply system that dated from the eleventh century. Water was drawn from the Darro River and carried by channels to underground reservoirs, from where it was raised by means of norias. The network was complemented by many gutters, channels, basins, fountains, and more reservoirs. This sophisticated water management system allowed the creation of little gardens, especially the great garden courtyards that are a distinctive feature of the Alhambra.

The Myrtle Courtyard is a minimalist garden design in which all the elements of creation are juxtaposed in a masterly fashion: the immense sky bordered by high walls, water in the mirrorlike basin,

and earth, in the form of the marble paving and plants (today replaced by a hedge). One can imagine fire being brought there at night in the shape of torches and lanterns. Contemporary designers, who can sometimes only achieve an awkward symbolism of elements such as these, have rarely attained such a luminous simplicity, which still moves us eight hundred years after it was created.

The Acequia patio, the Generalife's Grand Canal, has virtually the same four-section plan but is gentler in character, for which it is no doubt more appreciated by the millions of tourists who flock to the heights above Granada. It is also a garden courtyard, but the narrowness of the central canal leaves space for more plants than in the Myrtle Courtyard. The plants and flowers are carefully chosen for their scents, which fill the enclosed space at nightfall. Small fountains produce what looks like a liquid hedge around the edges of the basin; these, however,

date from the nineteenth century. Although they create enchanting movement and a refreshing tinkle, they shatter the image of the sky, which should be visible in the mirror-like surface of the canal.

The gardens of the Alhambra, which have inspired so many gardeners, princes, writers, and poets, are ghostly memories haunting the heights above the city, but the shadow of their beauty still evokes nostalgia for a vanished civilization. ❧

Opposite: The Ladies' Patio,
or Lindajara courtyard,
adjoins the rampart.

Above left: The fountain of the
Lion Courtyard has recently been
restored to its original shape.

Above right: One of the entrances
to the Lion Courtyard, with its
astonishing vaults and arches with
stucco muqarnas of rare complexity

Above left: The walls of the Alhambra contained numerous tanks and basins from which water flowed to courtyards and gardens via canals and gutters cut into the walls themselves.

Opposite: The Sultana's Patio is an enclave of shade and coolness.

Right: The "Grand Canal" of the Generalife, the royal summer residence. Before the fountains were installed in the nineteenth century, the curbstones functioned as a walkway.

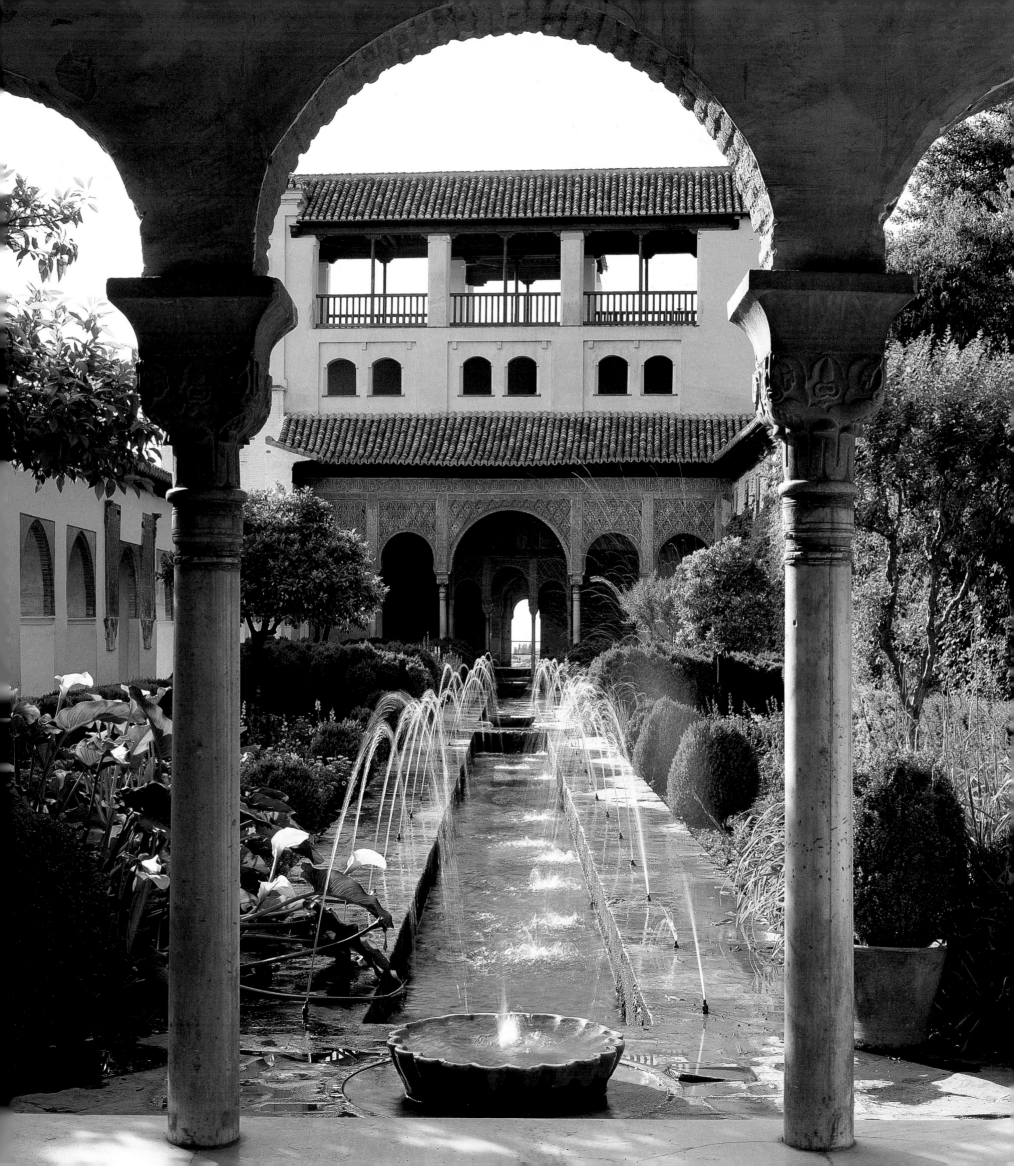

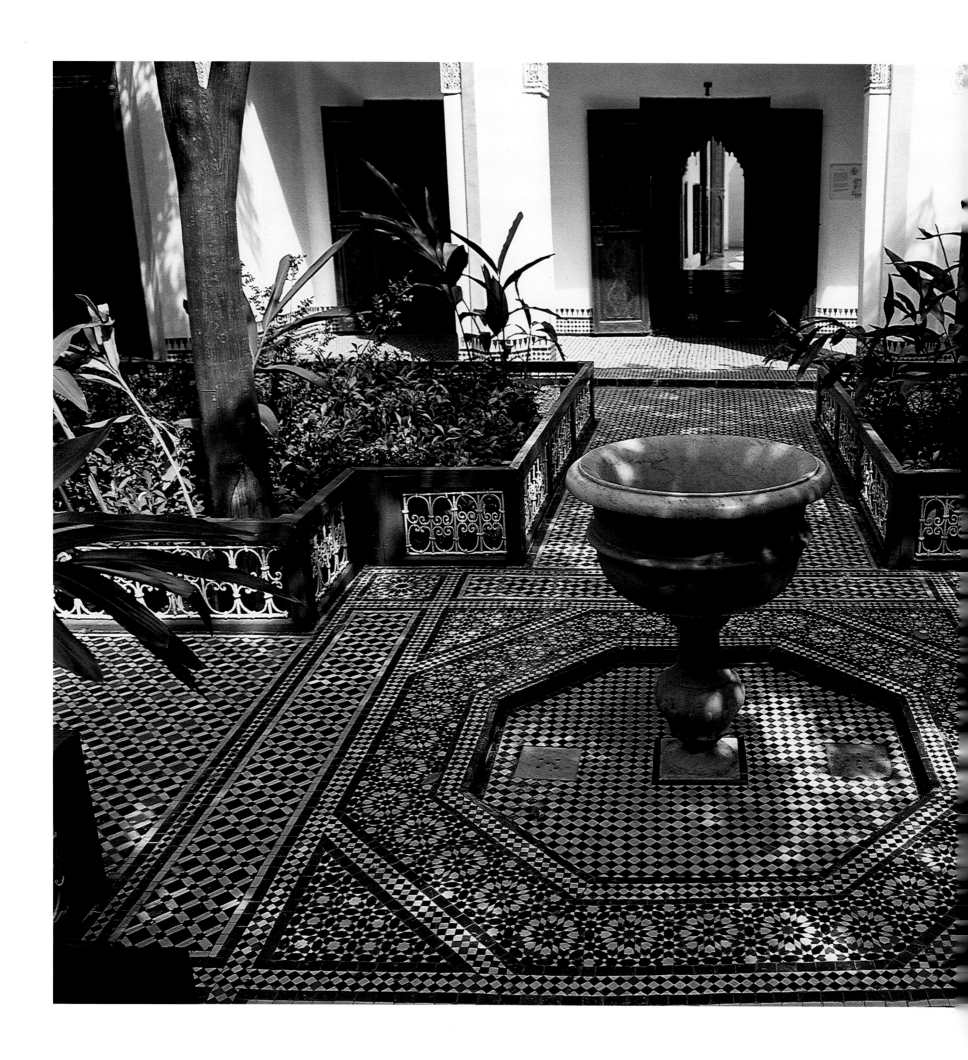

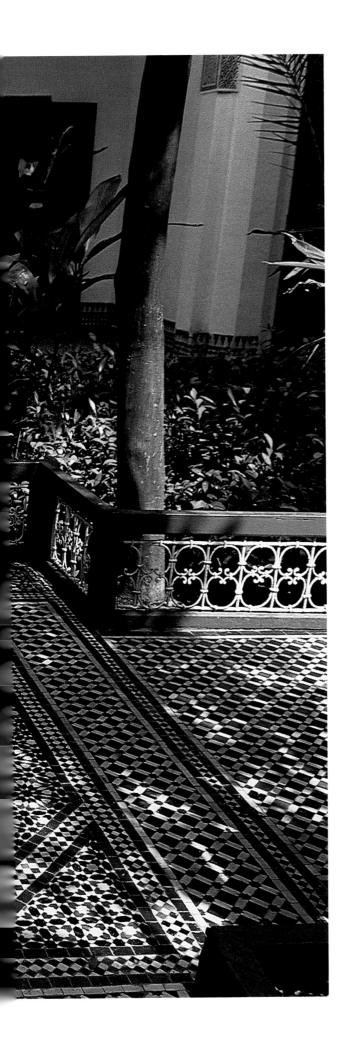

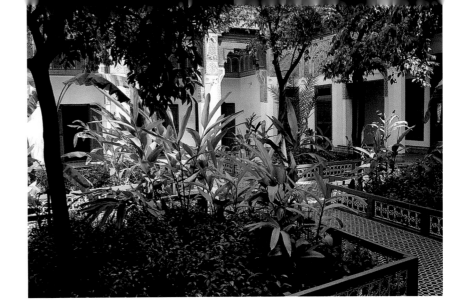

El Bahia Palace
A LABYRINTH OF PATIOS, COURTYARDS, AND GARDENS

MARRAKECH, MOROCCO
Nineteenth to twentieth century
Designer: El Mekki

El Bahia Palace was built relatively recently, commissioned from the Moroccan architect El Mekki by the grand vizier Sidi Moussa and his son Ba Ahmed, who succeeded him in his post. Hundreds of the kingdom's best artists and craftsmen worked from 1894 to 1900 to construct—by incorporating several ancient riads and erecting a few new buildings—a labyrinth of rooms, halls, patios, courtyards, and gardens, of which a part is always reserved for the royal family. During the French protectorate (1912–46), Marshal Lyautey made it his residence and had the Petit Riad furnished in very modern taste. Situated in a marvelous position, the palace is one of the most luxurious residences in Marrakech, traditional in style but bearing the marks of the time when it was built, and clearly constrained by the single-floor plan imposed by the man who commissioned it. The idiom of the gardens is traditional,

overlaid with the decorative touches of the time, and tends to favor the interplay of different materials, textures, shapes, and colors produced by tiling, mosaics, paving, paths, curb stones, and the edging of pools. As is appropriate in a noble garden, the visitor's foot never touches the bare earth, but only marble or tiling. Water flows, trickles, gushes, rises, and falls, with a gentle tinkling sound. The flowering shrubs and the flowers grow thickly, overflowing from their containers, creating a dark, perfumed, stifling atmosphere. Bahia still bears its name proudly. ✛

Left and above: One of the many shady courtyards of El Bahia, the palatial residence of a grand vizier, with vast gardens whose plans are traditional but bear the marks of the approaching twentieth century.

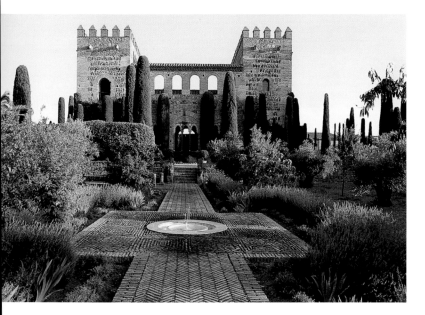

Left: An elegant
defensive structure, of
unknown date, towers
over the gardens of the
former taifa kings.

Right: The great pool
is slightly raised above
ground level in the
tradition of Spanish-
Moorish gardens.

The Galiana Palace

THE SILKY MURMUR OF WATER

TOLEDO, SPAIN
Eleventh to thirteenth century

On the banks of the Tagus River and on the edge of the Alficén, the fortified Arab city separated from the medina of Toledo by ancient defensive walls, stretch the gardens of the Galiana Palace, the remains of one of the most mythical Andalusian garden complexes, together with the Albufera Gardens at Seville. History relates that about 1060 the taifa king Al-Ma'mun had a pavilion surrounded by sumptuous gardens built for the festivities celebrating the circumcision of his nephew. The dying embers of this dynasty, which was to be ousted by the Castilians in 1083, are the subject of several contemporary accounts, including one by a Toledo writer, Ibn Yabir. He describes a multitude of halls whose walls were hung with tapestries of brocade edged with gold; a perfume room, where people would come in the evening to breathe in the scents of the flowers and aromatic plants in the gardens below and admire the reflections of the setting sun in the Tagus River; and a silver fountain in the shape of a tree, from whose branches perfumed water gushed with a silky murmur.

The omnipresent water was drawn from the river and carried to the terraces by a gigantic noria driven by a camel. It flowed along channels, poured into basins, rose in graceful jets, or gushed from the maws of marble lions. "The perfumed flowers drank the

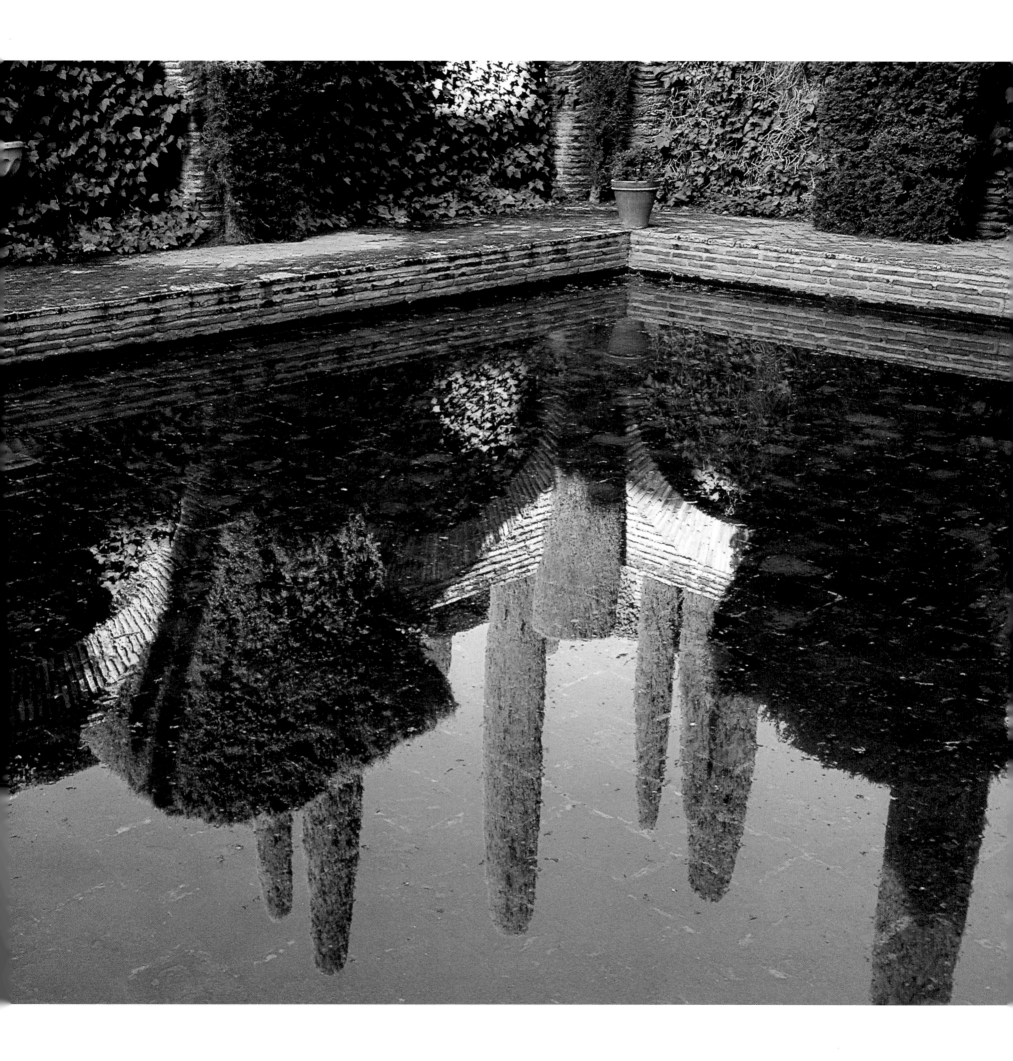

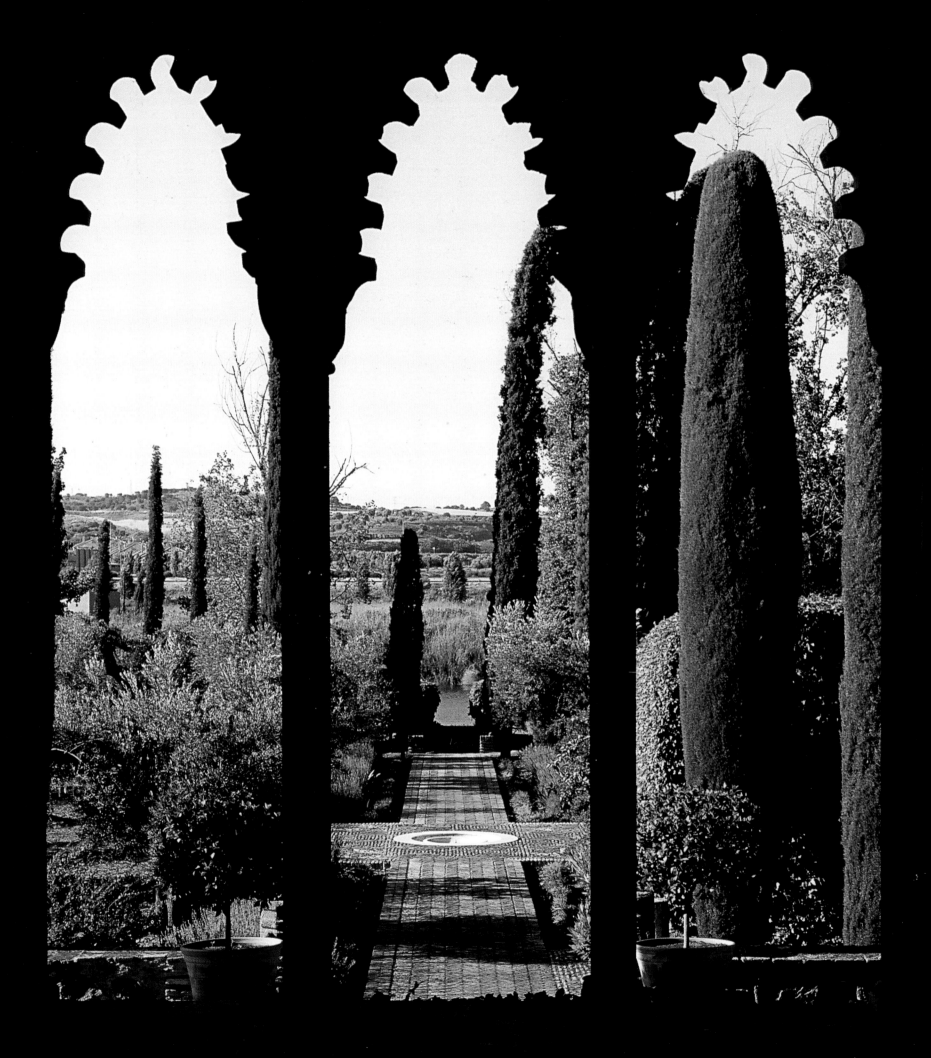

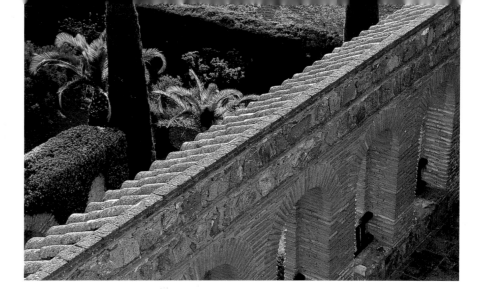

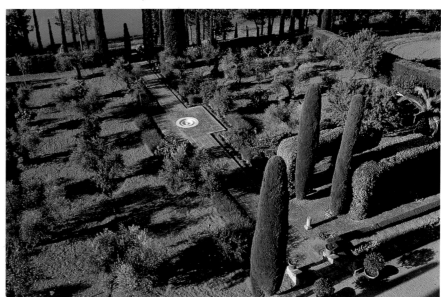

Opposite: The gardens extend as far as the Tagus River, and from the loggia of the "castle" there is a view over a miraculously reserved countryside.

Right: Galiana gradually returns to its original classical plan, consisting of orthogonal compartments.

river's waters . . . in the morning, the garden was studded with dewdrops." In the middle of a pool stood a pavilion with a glass dome inlaid with gold, from which fell a curtain of water that protected Al-Ma'mun from unwelcome visitors. The garden was also a place where agronomical experiments for the acclimatization of plants were carried out, as well as experiments in astronomy.

Time passed and, in the fourteenth century, King Alphonse XI gave Galiana to the Guzmán family, in whose possession it remained until the twentieth century. Eugenia María de Montijo de Guzmán, countess of Teba and future empress of France, often spent time there before she was married. Today the complex is a listed monument; it has been restored so enthusiastically that the visitor soon loses any sense of its style. What remains—towered over by a very old pavilion that looks like a stage fortress—are the terraces, the plants, the majestic cypress trees, the king's vegetable garden, and a network of channels, pools, and fountains that evokes rather than reproduces the sophisticated charm of the gardens dating from the final years of a dynasty that had made luxury into a way of life, while all around it those who would reconquer the peninsula were arming themselves for war. ✣

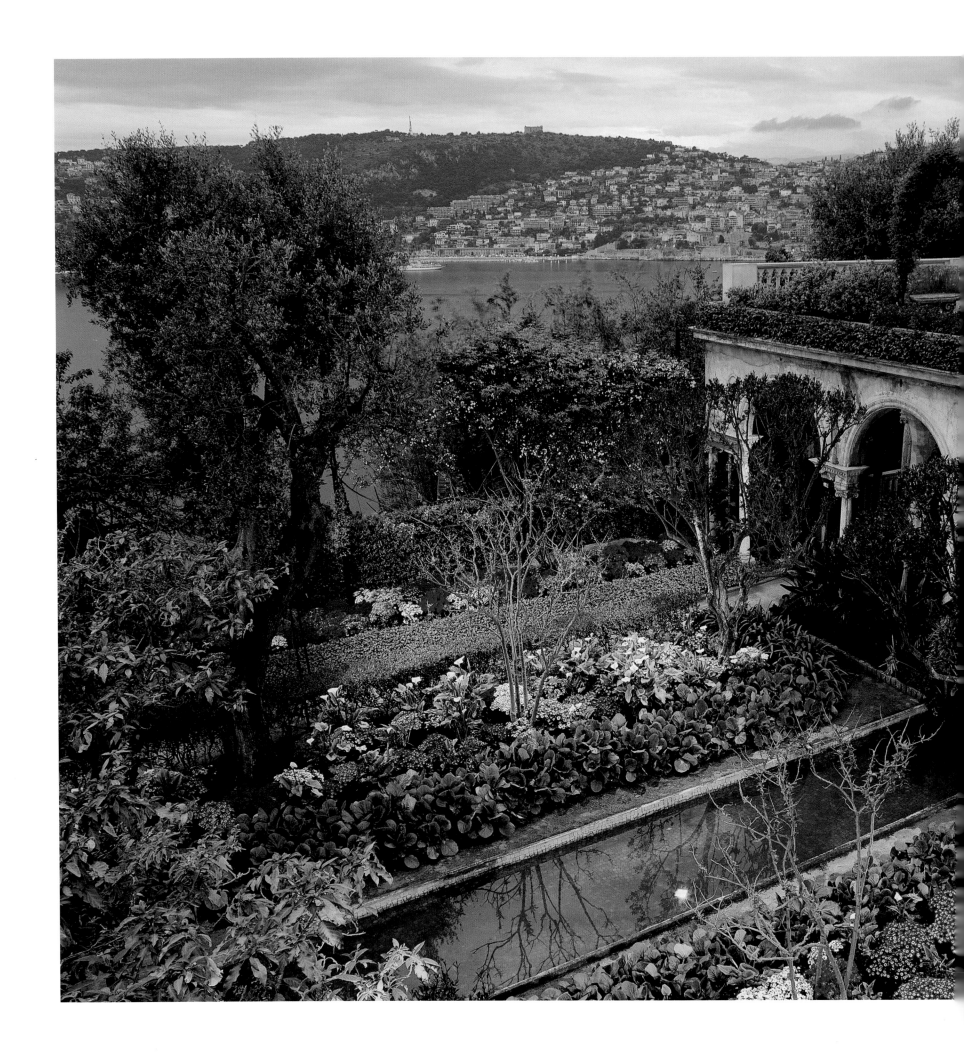

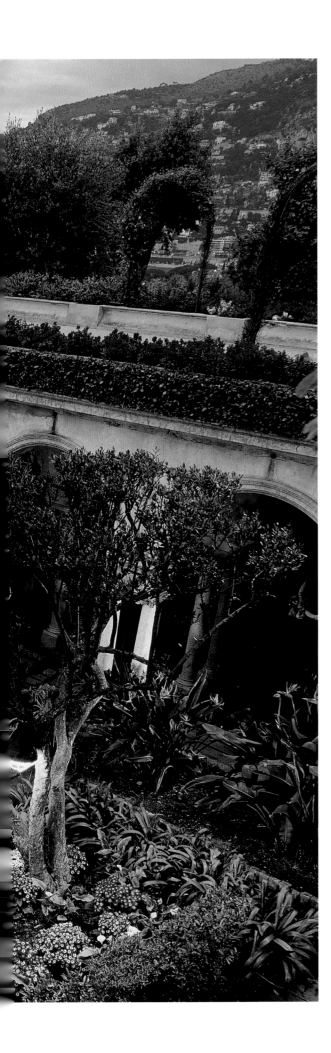

Above the roadstead of Villefranche, this small garden in the Spanish-Moorish style brings together in a limited space the features of the great gardens of Granada and Seville.

Villa Île-de-France

A BALCONY OVER THE SEA

SAINT-JEAN-CAP-FERRAT, FRANCE
Twentieth century
Designer: Louis Marchand

For more than a century, from 1820 until the 1930s, the Côte d'Azur was a hothouse of experimentation in the gardener's art. Wealthy Englishmen—such as Lord Brougham in Cannes (around 1820), Lawrence Johnston at Serre de la Madone, Menton (1905), the great gardener Harold Peto, and French enthusiasts such as Ferdinand Bac at Villa Croisset and Baroness Béatrice Ephrussi de Rothschild at Saint-Jean-Cap-Ferrat—vied with each other in their imagination, boldness, and eclecticism. For them, a garden was often an illustration of a page of the history of gardens.

The baroness, a great traveler, decided in 1905 to have a villa built on the isthmus of Cap-Ferrat. She may have acquired her taste for gardens from the grounds of Ferrières, the palace where she spent her childhood, which was designed by Joseph Paxton, who was responsible also for Crystal Palace in London. Be that as it may, she undertook vast digging and shoring up operations to prepare the ground for an Italianate villa designed by Aaron Messiah, and its majestic formal garden, in the Italian style, designed by the great landscape architect Achille Duchêne. Alongside there arose, in tiers, a more personal collection: a garden filled with statues and sculptures, an English-style garden, an Asian garden, a Provençal garden, and a Spanish garden. The last of these was inspired by Arab gardens on the Iberian peninsula, and bears witness to their enduring influence. Plants grow in raised beds separated by a reflective canal, and an arcaded loggia completes the illusion of a Generalife on the shore of the bay of Villefranche. ⌗

CHINESE GARDENS

In garden design, as in many other areas throughout history, the West has long had a fascination with China that is mingled with a large measure of ignorance. The Chinese civilization has palaces built as early as about 2100 B.C., and it can be assumed that, in a country with a largely tropical climate, if there were palaces there were also gardens. The first detailed descriptions date from the Qin dynasty (221–206 B.C.) and, especially, from the Han dynasty (206 B.C.–A.D. 220), one of whose emperors possessed a garden that was fifty miles (80 km) long.

The traditional Chinese garden aimed to be a fragment or a reconstruction of nature. Structures were introduced with great precision, to enhance the beauty or picturesqueness of the place. Water and some higher ground (often transformed by means of immense works) were essential elements, and referred back to shamanic and symbolic origins (yin and yang). To this natural setting—which was often filled with flowers—would be added lakes, pools, false rivers, pavilions, bridges linking islands and islets, and tombs. Thus this garden, where the emperor or noble lived, surrounded by his wives and court, was an artificially natural world, entirely closed to the outside—a piece of self-sufficient nature in the middle of nature itself. Although the English garden—which the French call the Anglo-Chinese garden—has drawn on the same forms, its philosophy was radically different. In the West, from the seventeenth century onward, and even more after the eighteenth century, Chinese influence spread but went no further than the addition of picturesque pavilions—such as the tea house in the Sanssouci Park in Germany, the pagoda at Chanteloup in France, or even Chinese villages such as Drottningholm in Sweden. Thus the Chinese philosophy of nature was transformed into a decorative object.

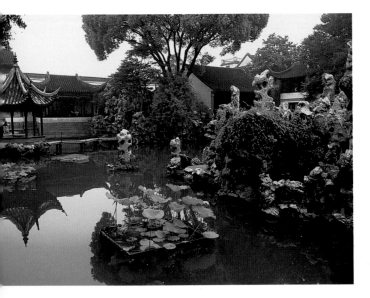 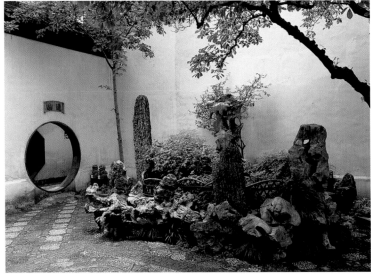

Suzhou

CHANGING THE LANDSCAPE WITH EVERY STEP

CHINA
Eleventh to nineteenth century

Not far from Shanghai, in the Yangtze Delta, Suzhou is a Chinese Venice that has been the pinnacle of the gardener's art in China for more than two thousand years. Wealth generated by silk manufacturing, the presence of an aristocracy, abundant water, locally available Tahiu ornamental stones, and a warm climate go some way toward explaining the local love of gardens. These are not the immense parks of the Han dynasty, but rather town gardens, carefully enclosed by walls built from the eleventh to the nineteenth century under the Song (960–1279), Yuan (1206–1368), Ming (1368–1644), and Qing (1644–1911/12) dynasties. Yet the idea is still to imitate nature or to evoke it through the symbolism attached to each element. A spring-fed lake brings happiness, a peach tree in front of the door evokes immortality, a rock brings to mind a mythical mountain, and so forth.

The gardener's art lies in creating a landscape loaded with meaning, forging harmonious ties between man and nature. Its aim is to achieve the ultimate effect that a short walk in a Chinese garden must produce: to change landscape with every step. Nothing is unimportant; there are no empty areas or lifeless corners. Everything—the choice of plants and their regulated size, the false river whose beginning and end must be invisible, the sublime mountain of rocks whose peak rises twenty feet high—contributes to skillfully created beauty that is imbued with religion. It is impossible to not mention some of these gardens' names: The Villa of the Mountain in Love with Beauty, Humble Administrator's Garden, the Lion Grove, the Surging Wave Pavilion, the Garden for Lingering. ⚜

Opposite: Two views of the Lion Grove, one of Suzhou's oldest gardens (10th–13th century). There are more than 500 statues on the shores of the little lake.

Above: Windows with fretwork in carved stone or stucco allowed the garden of the Surging Wave Pavilion to be admired, the view framed the same as it was originally.

Following pages: The winding gallery walkway of the Surging Wave Pavilion garden.

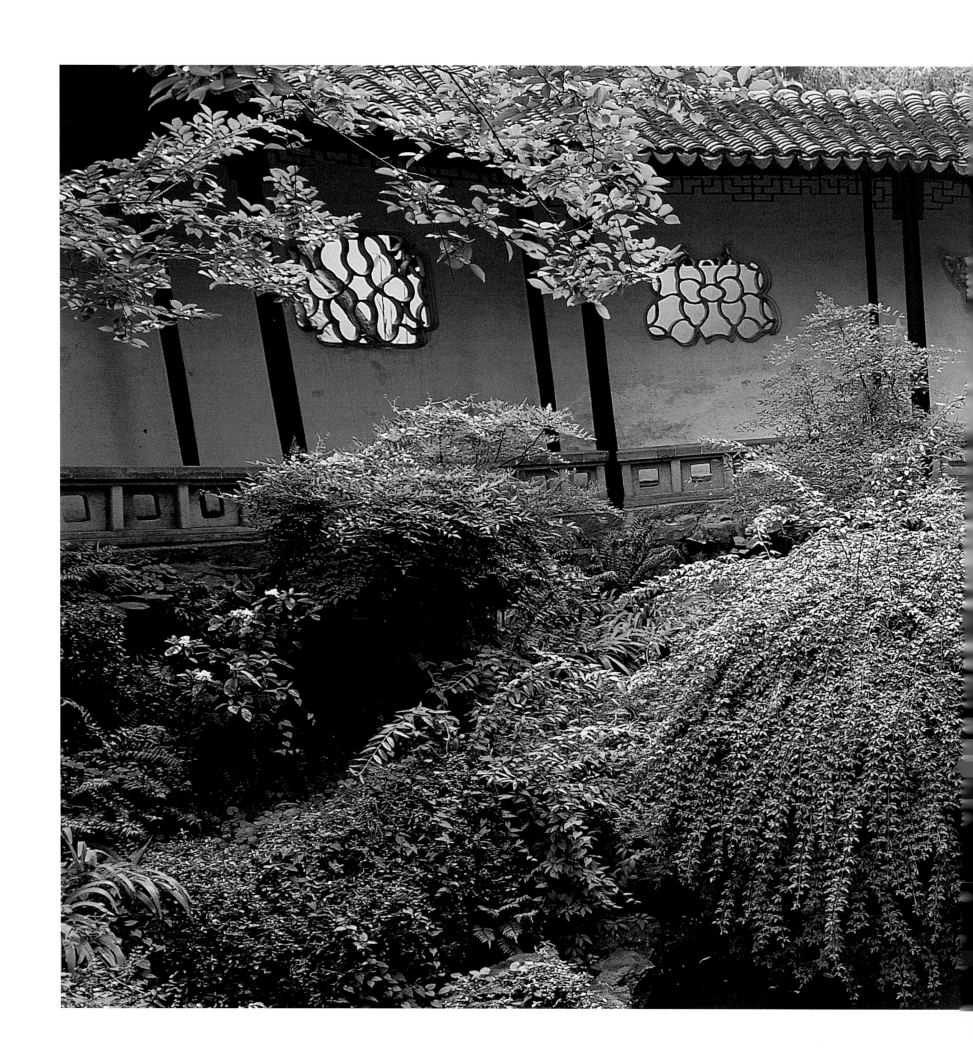

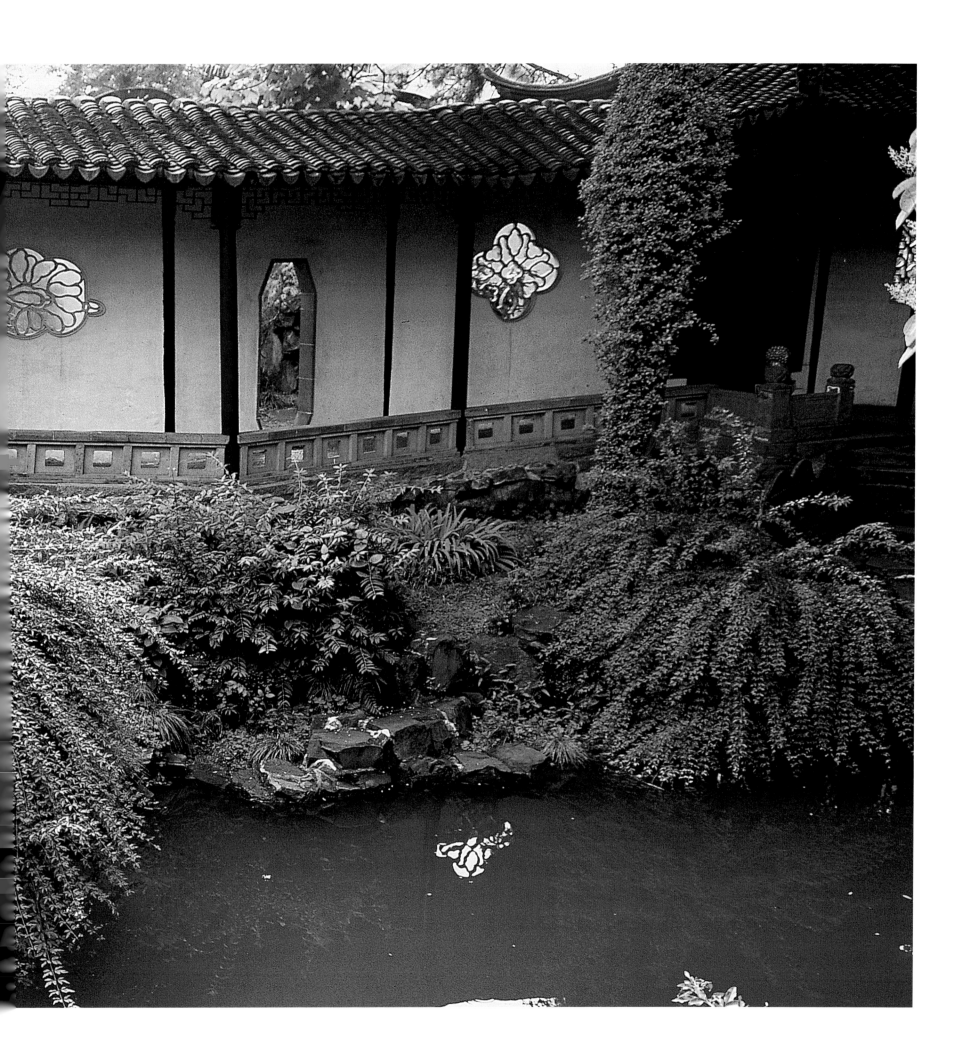

Sanssouci Park

CHINA IN BERLIN

POTSDAM, GERMANY
1755
Architect: Johann Gottfried Büring

The royal estate at Potsdam was one of the most extraordinary testing grounds for the gardener's art of the eighteenth and nineteenth centuries. The celebrated Sanssouci palace, built by Frederick II of Prussia (1712–1786) and situated at the top of an astonishing staircase of terraces planted with vines, used to overlook a vast Baroque garden that was transformed into an English-style park in the nineteenth century by Peter Joseph Lenne. Although Lenne dotted his plan with picturesque but functional buildings, he nevertheless preserved some of the follies of the old garden, including this delightful tea house built by the king's architect, Johann Gottfried Büring, in 1755. Büring had drawn inspiration from the Chinese pavilion, or Trefoil Pavilion, designed in 1737 by Emmanuel Héré for the gardens of the palace at Lunéville, one of the first Chinese-style buildings to appear in Europe.

This circular pavilion with celadon walls and a blue undulating roof is guarded by a dozen statues of finely gilded imaginary Chinese figures, which gleam in the sunlight. It fulfilled its function delightfully, and the king would come and take tea in the central hall, which was decorated with a collection of porcelain, or in one of the three small rooms with loggias whose columns are shaped like palm trees. Perched at the top of the roof, a mandarin ponders under a parasol. ✥

Right: The façade of the tea house, one of the first Chinese-style buildings in Europe.

Top: One of the imaginary "Chinese" figures that encircle the pavilion.

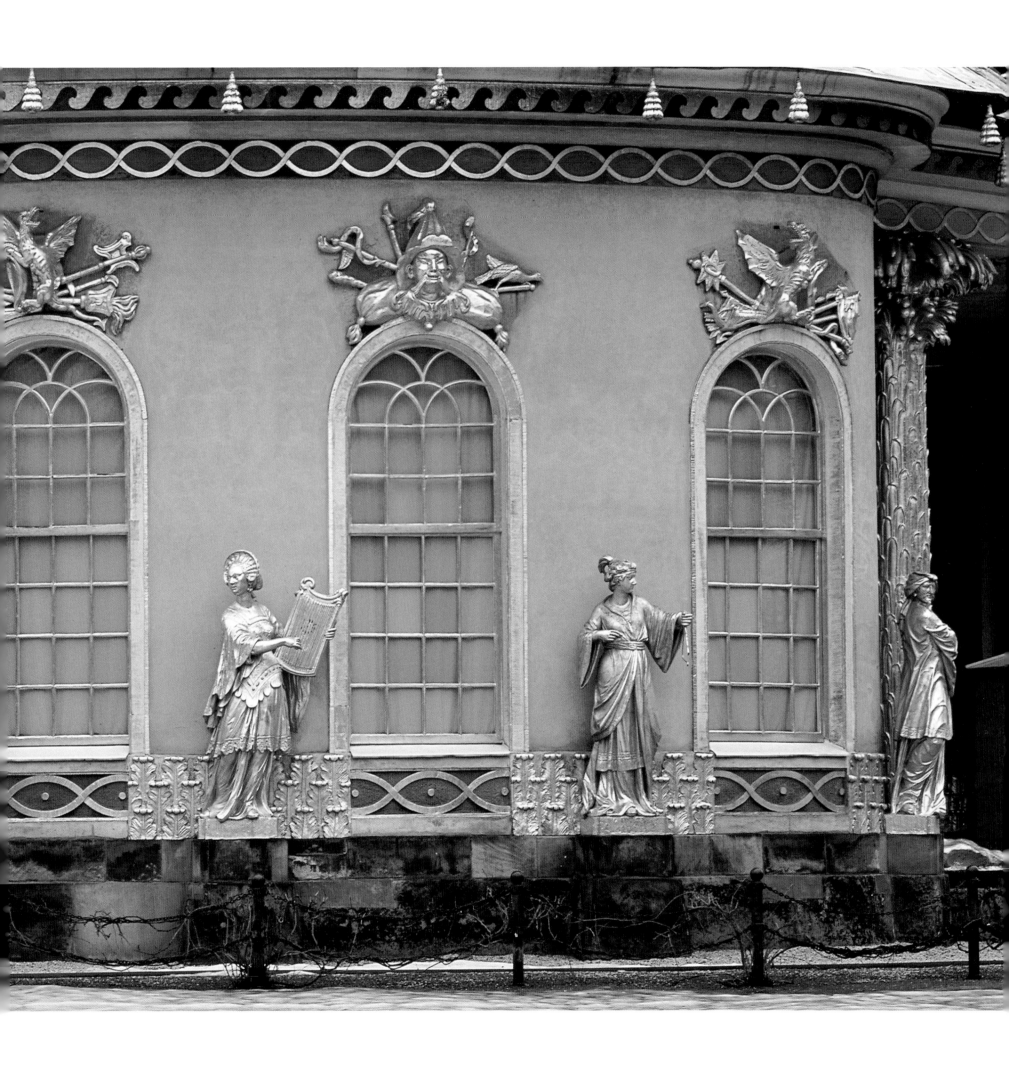

Oranienbaum

A Pagoda in Saxony-Anhalt

GERMANY
1795
Designer: Inspired by William Chambers

Not far from Dessau, the town famous for Bauhaus, stretches the immense Gartenreich Dessau-Wörlitz. Set in the lush but monotonous countryside of Saxony-Anhalt, through which the Elbe River meanders, this eighteenth-century complex of palaces, villas, parks, and gardens is an enclave of refinement. A couple miles from Wörlitz, a strange piece of architecture soars skyward. The Chinese pagoda of Oranienbaum bears direct witness to the

influence of William Chambers, an English architect who had traveled through China, taking notes on the country's gardens but without fully understanding their symbolism. His *Designs for Chinese Buildings, Furniture, Dresses, Machines, and Utensils,* published in English and French in 1757, met with great success and earned him the commission to design the giant pagoda in Kew Gardens, London.

The park at Oranienbaum was laid out around the palace at the end of the seventeenth century, in the Dutch Baroque style. Prince Franz von Anhalt-Dessau, a lover of nature and the picturesque, decided in 1795 to convert a delightful island garden to the Chinese style. He had built a five-story tower observatory, shaped like a fantastic pagoda and decorated with Chinese wallpaper, porcelain, and furniture, as well as several small Chinese bridges linking the island to the shore and a tea house.

Chinese influence, which had arrived via London, was now advancing into central Europe. ⚜

In about 1795, Prince Franz von Anhalt-Dessau laid out a Chinese island in his park at Oranienbaum.

Apremont

CHINA IN BERRY

APREMONT-SUR-ALLIER, FRANCE
Twentieth century
Designer: Gilles and Elvire de Brissac

This little bridge, probably the last chinoiserie to be built for a European garden, was designed in 1986 by the painter and decorative artist Alexandre Serebriakoff.

What is a Chinese bridge doing on the borders of the Berry region of France? Every day some of the many visitors to the flower garden of the garden of the Château d'Apremont wonder about this strange feature, which is a godsend for local wedding photographers. The answer lies in the history of garden design. The present park is actually a recent creation by Gilles de Brissac, who inherited this estate, which was marvelously restored in the 1930s by their grandfather, Eugène Schneider, a famous ironworks owner. Inspired by English gardens of the eighteenth and twentieth centuries (Sissinghurst), the ten-acre park is strewn with elegant follies: a summerhouse, a Turkish pavilion, and the Chinese bridge. This bridge-pagoda, a creation of pure fancy built in 1986, evokes the taste for all things picturesquely Chinese that gripped Europe in the second half of the eighteenth century. It is the work of two great experts on the period—Catherine and Alexandre Serebriakoff, the latter a celebrated watercolorist, painter, designer, and the chief creative force behind the gardens at Groussay. For two centuries bridges have been part of the vocabulary of gardens. They have endured in garden design for good reason, since these lightweight structures, which were ideal for vaulting across a stream or small river, are fairly simple to construct and offer a delightful focal point for the garden. The Chinese bridge is a seductive aesthetic trap. ⚜

Japanese Gardens

There is no fundamental difference between the Chinese and Japanese approaches to gardens, if only because of the enduring artistic influence China had on Japan from the third century onward. However, Japanese gardens have been better preserved, and even today their art permeates Japanese culture to a far greater degree. Although the exemplary creations in Kyoto were destined for emperors and monks, most Japanese people have always had a genuine interest in trees, rocks, water, and flowers, all of which are objects for meditative contemplation. The organizational principles employed often have their origin in Shinto, Taoist, and Buddhist religious beliefs, or call upon very ancient systems of mutual relationships, some of them shamanic, such as *go-gyo*, which sees an evolutionary flow in the universe.

Very early on, scholars or monks designed a number of gardens; their names remain as well known and respected as the finest European landscape architects. From the sixteenth century onward these gardeners broke free of the last of Chinese influence, to attain a concentration of meaning, a striving for design that was to find its apogee in Zen creations.

The Japanese garden can range from luxurious, symbolic refinement to moving, poetic simplicity. It is an integral center of social and religious life: temples, tea houses, villas, palaces, and, from the end of the nineteenth century onward, the city itself, with the vast Edo public gardens being open to all. Even today, as can be seen in the work of great architects such as Tadao Ando or Arata Isozaki, a garden is designed at the same time as the building it surrounds, in a subtle interplay of relationships between interior and exterior, and of bonds between nature and culture.

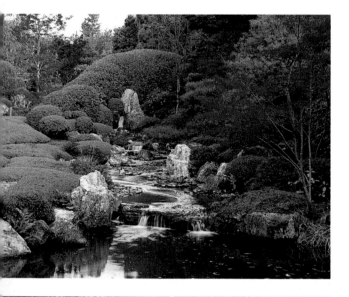

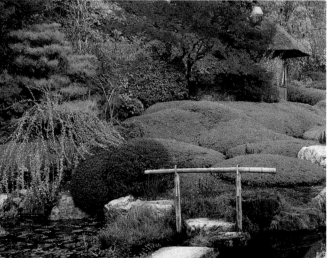

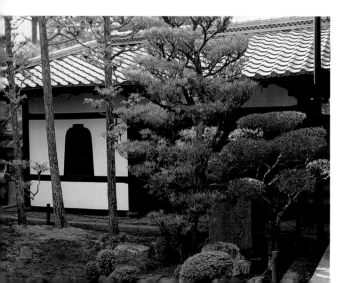

Temple Gardens of Kyoto

A PHILOSOPHY OF NATURE

KYOTO, JAPAN
Thirteenth to fourteenth century

Kyoto was the capital of Japan from 794 to 1868, and for a long time it was a garden city surrounded by mountains. Its economic development during the second half of the twentieth century profoundly altered its appearance, but its gardens have remained protected havens—for their extraordinary beauty, but even more because they symbolize a traditional Japan that is much more strongly present in the Japanese psyche than Westerners realize.

Kyoto once boasted up to 1,650 Buddhist temples and 400 Shinto shrines, which were once surrounded by gardens. Those that survive, including fifteen on UNESCO's list of World Heritage Sites, trace the still-vibrant history of the art of the Japanese garden through the centuries.

The first such work in Japan, created by the monk Gokyogoku Yoshitsune (1169–1206), dates from the beginning of the thirteenth century and is practically a philosophical and moral treatise. It is based on Lao Zi and the division between the

principles of male and female, active and passive, dominant and subordinate. Everything in the garden must contribute to re-creating this complementarity: a rock that is standing must be accompanied by one that lies flat, and a tall, slender tree by a small lantern. In this way, a sort of grammar of the art of the garden is gradually established in which each element has its meaning and its complement. Rocks are arranged into many categories, according to their shape, what they are made of, their origin, and their weight. Trees are classified according to their shape, their changing color with the seasons, and the shadow they cast. These principles are applied to varying degrees, codified into three styles: a perfected style, an intermediate style, and a "rough" style, each requiring plants, flowers, raised ground, and the presence of water in a particular, clearly defined form.

The golden age of the Japanese garden is the Muromachi period (1392–1573), which saw the

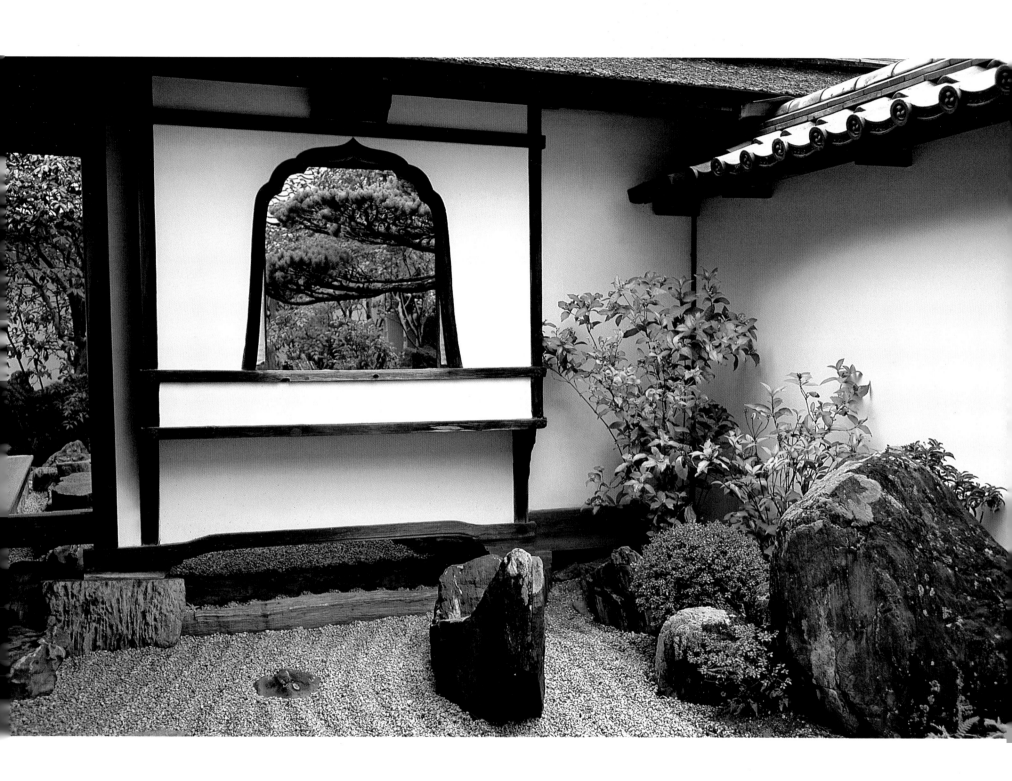

Above: View of the Daisenin (great temple of the hermits), built in 1509. In the foreground is a rock shaped like a boat; the rock on the right represents Mount Hiei.

Opposite, top and middle: Two views of the Myoshinji (14th–16th century). In the center is o-karikomi, *the art of pruning trees and bushes.*

Opposite, bottom: View of the Rinshoin (1624).

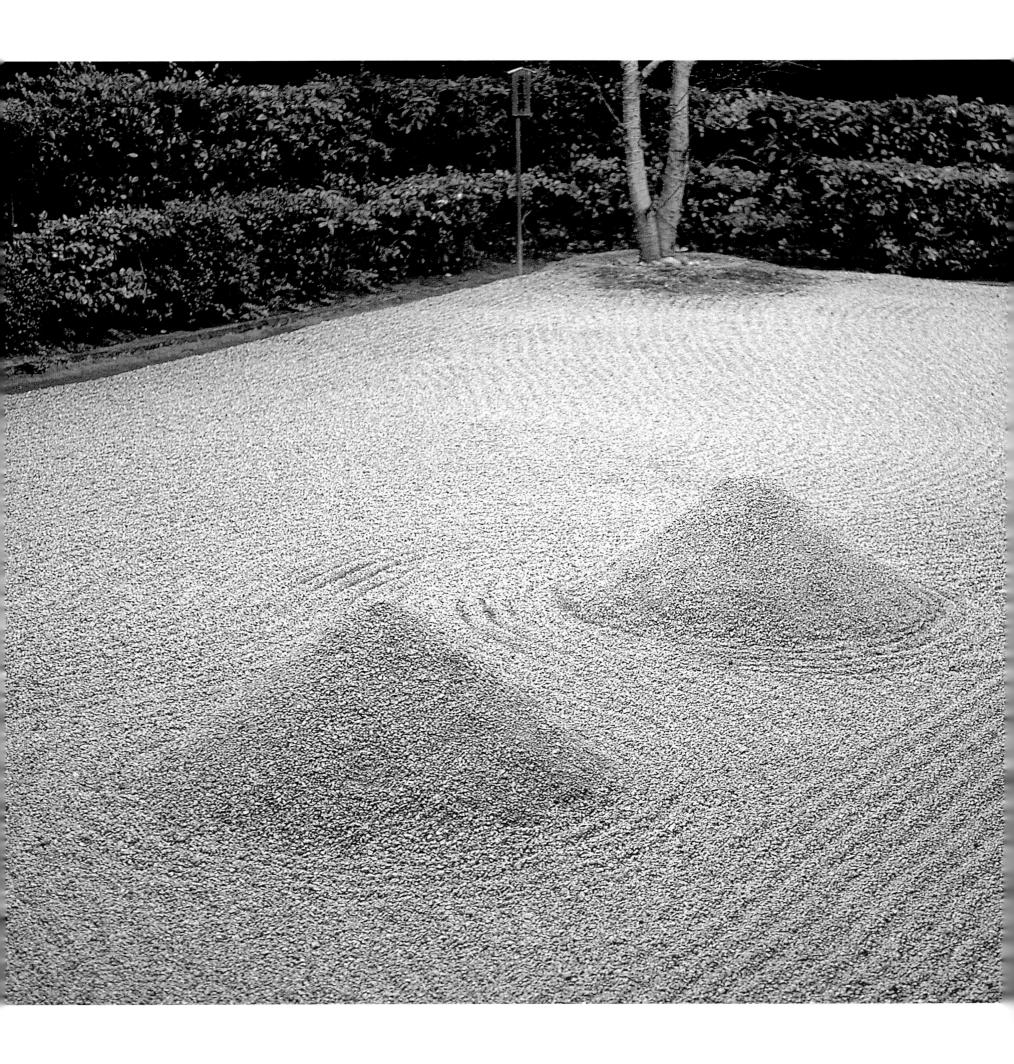

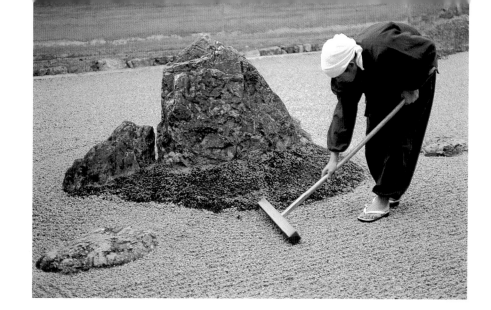

appearance of a new style—*kare-sansui,* the famous "dry garden" that was strongly influenced by Zen Buddhism and its high degree of abstraction. The most remarkable examples are the Ryoanji (1430–1499), Myoshinji (c. 1550), and Daisenin (c. 1509) gardens in Kyoto.

The Ryoanji garden, undoubtedly one of the most famous gardens in the world, is a closed, flat creation apparently consisting of a simple layer of quartz sand, carefully raked, from which emerge fifteen rocks. No matter what angle they are viewed from, it is impossible to see them all at once. Countless interpreters have pored over the meaning of this place, which no written source has been able to illuminate. It has been seen as a depiction of the sea and an archipelago, or of a tigress and her cubs crossing a watercourse, and also as an exercise in numerology, a mandala, an aid to meditation, and so forth. Other gardens also make use of mineral elements, such as the garden of the Silver Pavilion, which contains a conical pile of white sand. The Myoshinji garden was designed by a celebrated painter Kano Motonobu (1476–1559). It is a creation consisting of some large rocks at the center of a dried-up pool, representing the mythical Taoist island of Horai, as well as a cascade of rocks and a stone bridge. These are viewed from a veranda and look like a painting that stands out against the lush background of a little wood of carefully chosen trees. In the Daisenin garden there are little hillocks of gray sand, and twenty rocks that create a mountain landscape, through which "water"—or rather sand—winds its way. Some distance away is the Kinkakuji (c. 1397), a park laid out by a retired shogun that was transformed into a Buddhist temple. This also uses rocks to represent mountains, islands, and boats, but here they are placed in the water of a lake, which mirrors the Golden Pavilion, one of the high points of Japanese culture since the fifteenth century.

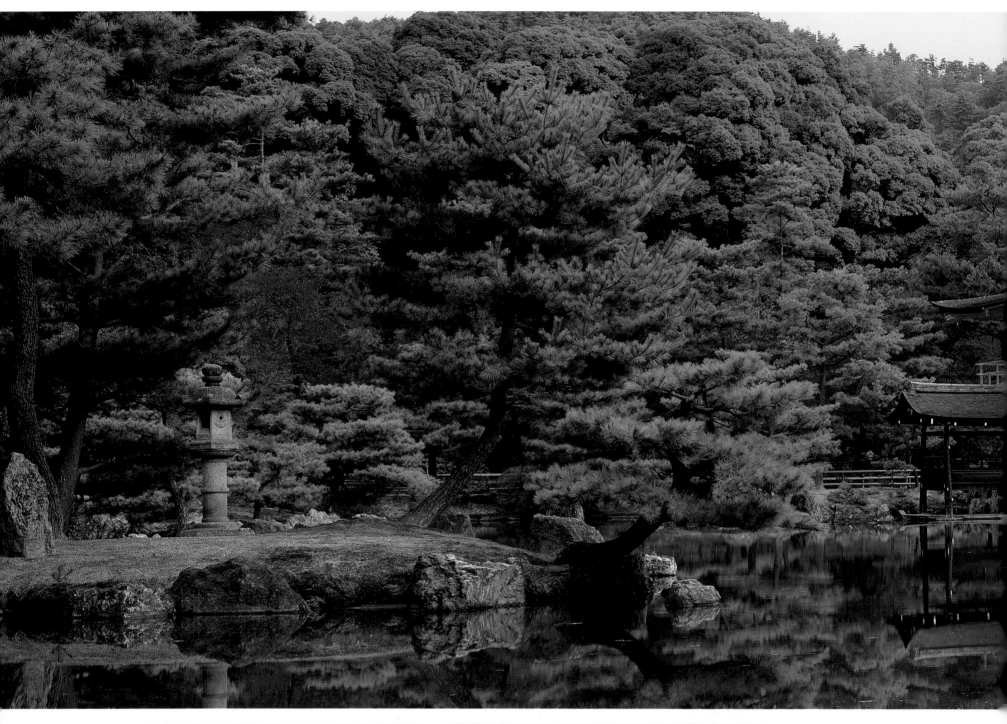

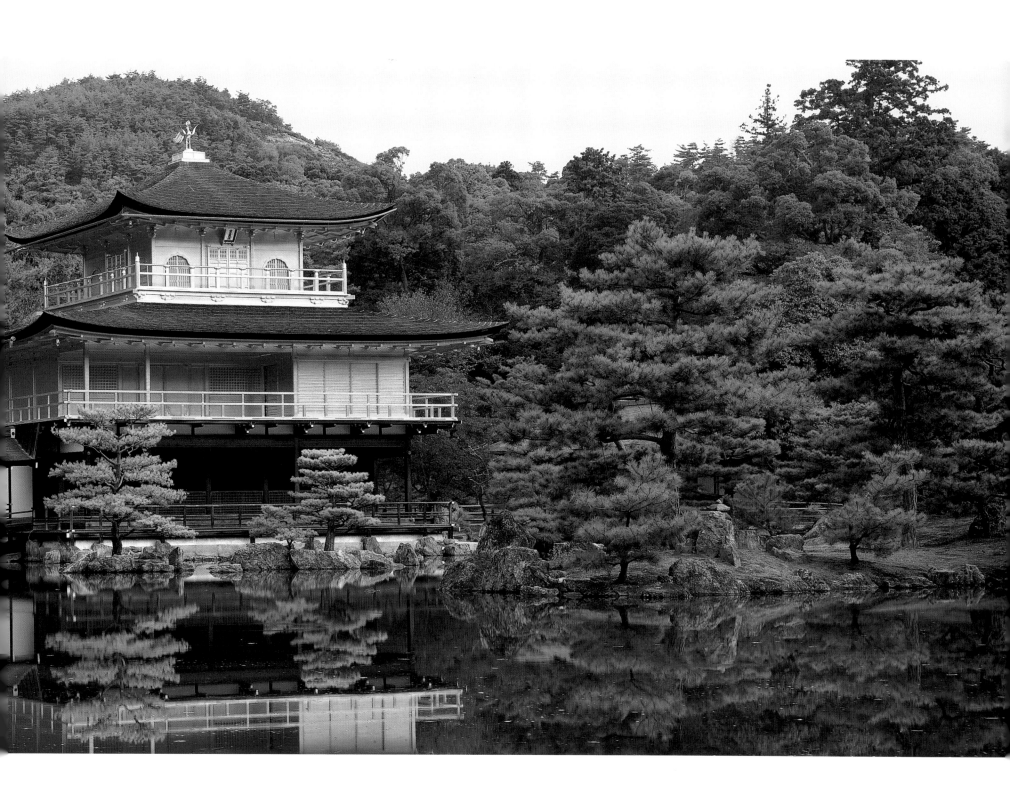

The lake garden of the Golden Pavilion, Kinkakuji, built in 1394 as a residence for a "retired" emperor, and later converted into a Zen temple.

Huntington Botanical Gardens

THE *JAPONISME* GARDENER

SAN MARINO, CALIFORNIA
1911
Designers: Henry Edwards Huntington and William Hertrich

Europe and America had a tremendous curiosity about Japanese culture and design after Japan opened up to the West in 1854, with the Treaty of Kanagawa, signed with the United States. What followed was *japonisme,* a rage for Japanese design that critic Claude Roger-Marx likened to the power of antiquity in the Renaissance.

In 1886, the American academic Edward S. Morse published a collection of descriptions of

Japanese houses and gardens. Interest grew among enthusiasts, thanks to the countless Japanese prints on the market. Likewise, it became fashionable in the United States and Europe to create Japanese gardens.

The botanical gardens at San Marino, California, in the San Gabriel Valley, testify to this craze. Begun in 1904 by the fabulously wealthy Henry Edwards Huntington with the help of a highly talented young gardener, William Hertrich, the garden was to bring together a collection of different styles.

The Japanese Garden (1911) was originally a small gorge, which was skillfully transformed by means of pools, paths, terraces, and even a house that had been shipped over from Japan in prefabricated sections. A century later, this garden has reached maturity, erasing its artificial origins, and has even acquired a Zen component. It bears wit-

ness to the curiosity of an age, but also to the rich possibilities offered by the reconstruction of historic gardens. ⚜

Not far from Los Angeles, this Japanese garden, part of Henry Huntington's garden "collection," bears witness to the love of things Japanese in the United States at the beginning of the twentieth century.

Imperial Gardens

BORROWED LANDSCAPE AND LAKE GARDEN

KYOTO, JAPAN
Fourteenth to nineteenth century

Above: The lake in the Kyoto Gosho, the garden of the Imperial Palace, which was redesigned in 1855.

Opposite: Autumn in the Sento Gosho, the palace of the "retired" emperor (seventeenth century).

Following pages: The small lake in the Sento Gosho, bordered by small beaches for meditating.

In Kyoto, the emperor lived in the Imperial Palace (Kyoto Gosho), a building that has been moved, burned down, and reconstructed exactly as it was several times over the centuries. The present building dates from 1855, as does the design of the park around it. Slightly apart from it stood the Sento Gosho, which was reserved for retired emperors, and the Omiya, the residence of the sovereign's mother. Their gardens were amalgamated during the nineteenth century and today are open to the public, who appreciates them all the more because of their location in the city center. Entirely redesigned, they date essentially from the Edo period (1603–1867), which itself saw the development of several different styles. They contain one of the most important examples of a pool garden, which consists of a walk around a sheet of water. A path is laid out to allow visitors to stroll around the pool, passing a number of very carefully sited viewpoints. This device incorporates the principle of *shakkei*, or the "borrowed landscape," which consists of integrating the natural surroundings into the plan of the garden itself: a view of a mountain, a sheet of water, hilly ground, and so forth. Just as the difference between interior and exterior is subtly softened (though still present) in Japanese architecture, so the division between the garden and wild nature is blurred. Man's creation literally absorbs nature to produce a single system.

At the end of the park, by another pool, an extraordinary mineral surface consisting of thousands of pebbles, all the same size, shines in the moonlight. It is the beach of Odawana Isshaishi, a quiet dry garden where the retired emperor came to contemplate the water.

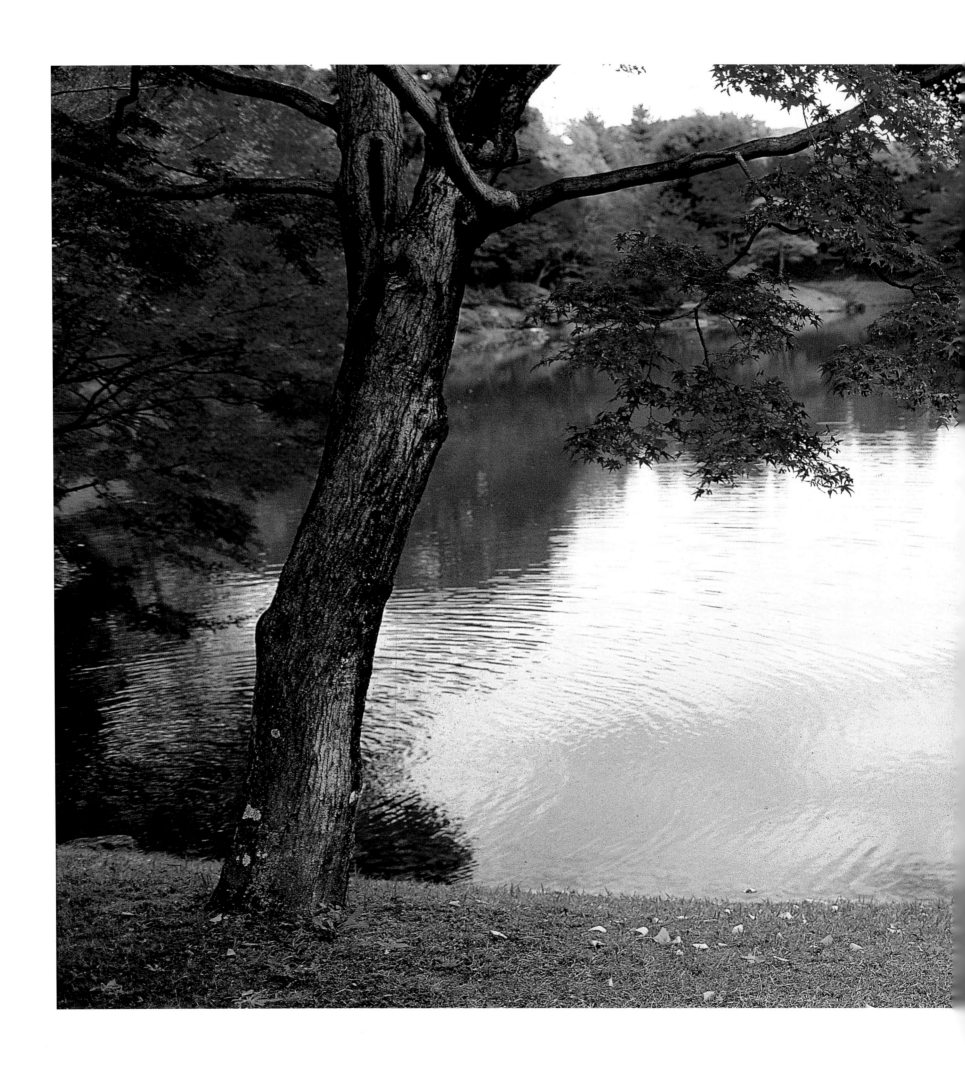

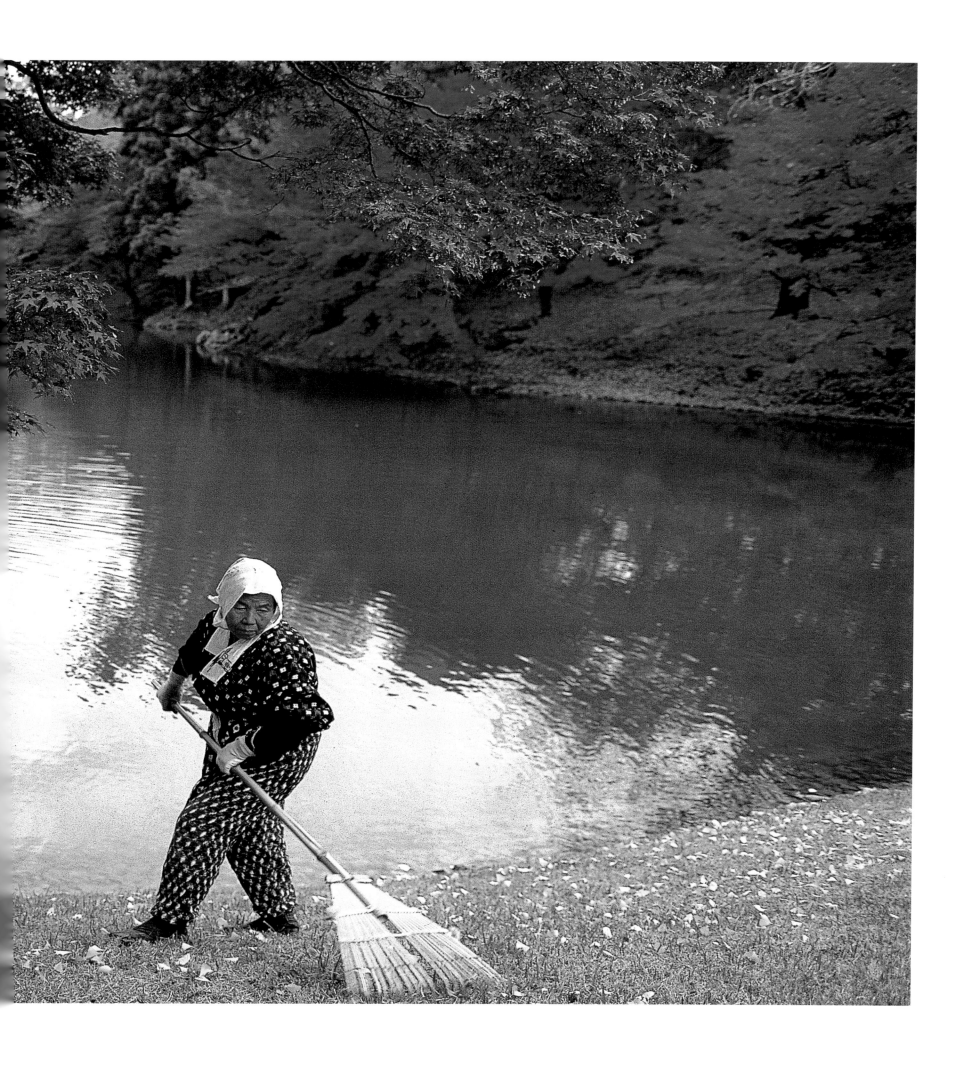

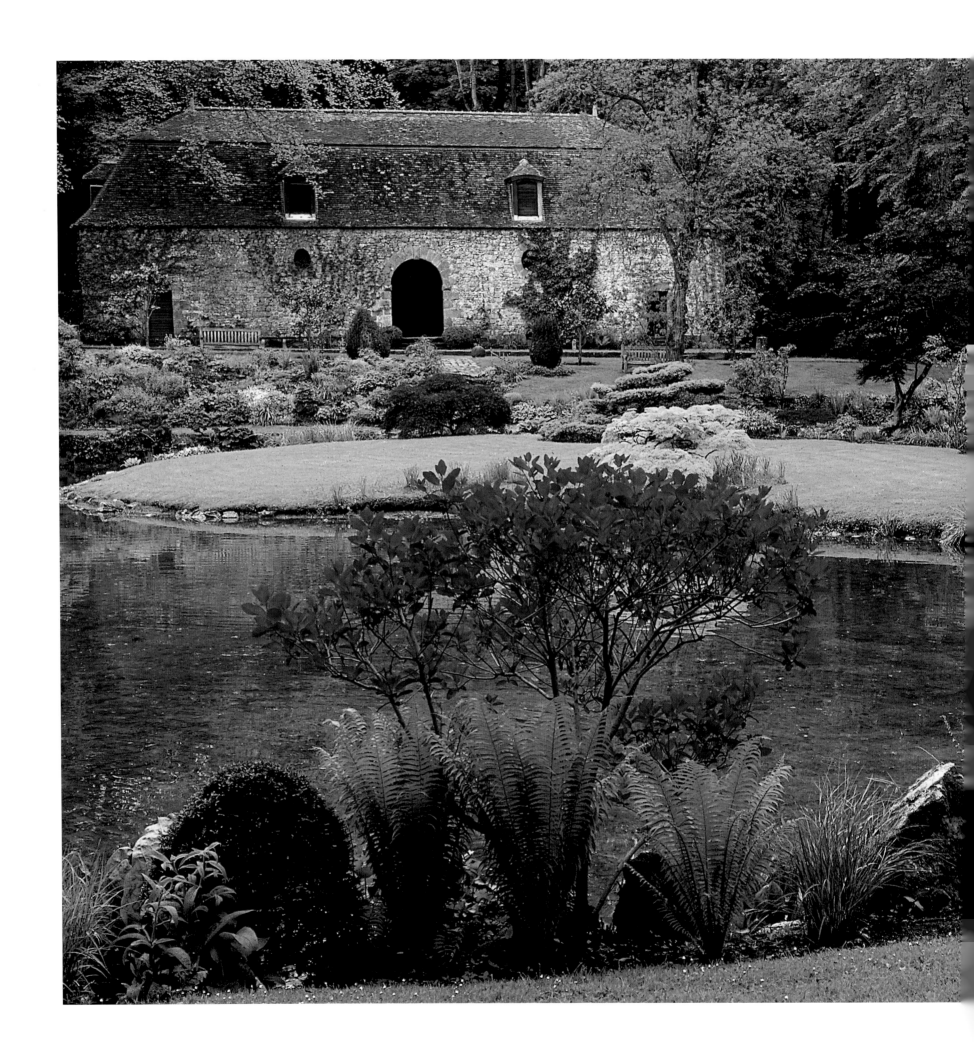

Away from the noble classical vistas of the park, a small Japanese garden was laid out near an old winepress. Although it is not an attempt at a factitious reconstruction, it is nevertheless in the spirit of a Japanese garden.

The Japanese Garden at Courances

DAZZLING COLORS

FRANCE
Twentieth century
Designer: Berthe de Ganay

Ever since the sixteenth century, Courances, not far from Fontainebleau, has alternately been cared for passionately and neglected. Starting in 1872 with the Haber family, and then under the Béhague and Ganay families, this imposing château and its grounds have undergone a veritable renaissance. The first designs for the gardens date from 1558, and contain ponds and canals. It was long thought that André Le Nôtre (1613–1700), the master gardener of Versailles, once worked on the gardens, but this has now been ruled out. It was Henri and Achille Duchêne who, between 1899 and 1914, redesigned the park without rendering it unrecognizable and they gave it the appearance we know today: trimmed hedges arranged to form decorative motifs, rigorous architecture based upon foliage, and a return to the style of the modern formal garden.

Hidden on the edge of this emerald-colored geometry—a hurried visitor might overlook it—is a small poetic enclave with a Japanese garden. It was probably laid out in the years around 1910 by Berthe de Ganay, who used an enclosed basin, not far from an old winepress, as the central element. Had she been inspired by her sister's travels in the Far East, or by Albert Kahn's Japanese garden at Boulogne, or by Alexandre Marcel's at Maulévrier? Or did she simply want a garden that was more intimate than the imposing vistas of the Duchênes? Whatever the case, in a few years she created this sensitively designed place, where all facile picturesqueness is banished. It centers on a collection of plants and trees that cultivates the art of the harmonious contrast of colors and textures in a dazzling spectrum. ⚜

GARDENS OF INDIA

The first known Indian gardens date from the Harappa civilization in the Indus valley, around 2500–2000 B.C. However, there are many accounts dating from not long after this time that mention parks where trees, fountains, and flowers created an atmosphere conducive to relaxation and meditation. Unlike the Persian enclosures of the same period, they were open to all. Trees—which are revered in most Vedic holy texts—were prominent. Queen Maya gave birth to Gautama, the future Buddha, in a park under the shade of a tree. Later, it was under a specimen of *Ficus religiosa* that the young prince was to attain enlightenment. And it was in a park, too—Dshetavana—that he eventually lived: "not too close to the city, and not too far from it . . . easily accessible to those who wanted to come, not too noisy by day, and perfectly quiet by night, far from bother and crowds, a place for retreat and solitary contemplation."

Today we still know the locations of these historical and mythical parks, which were laid out in an informal design. From the twelfth and thirteenth centuries onward, however, with the arrival of the Arabs, the Turks, and then the Mongols, a new formal model of garden came to prevail. Palaces, mosques, mausoleums, and finally Buddhist temples were surrounded by Islamic-style gardens, with a profusion of flowers and flowering shrubs. Lastly, the British arrived. They created English-style parks and gardens while at the same time drawing on traditional forms, such as the famous viceroy's garden in New Delhi, designed by Edwin Lutyens. The art of the Indian garden today bears the marks of these three traditions.

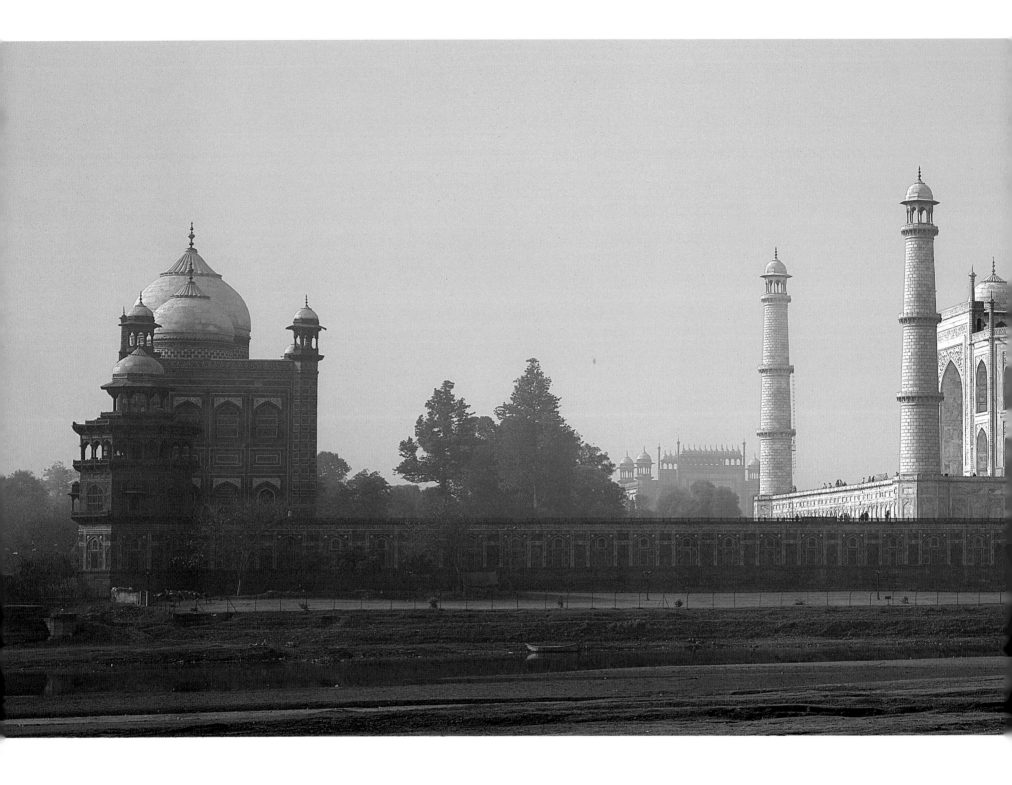

The Taj Mahal

A MAUSOLEUM

AGRA, INDIA
1632–48
Designers: Shah Jahan, Ustad Ahmad

For a long time Agra, 125 miles (200 km) south of New Delhi, was the capital of the Muslim Mughal emperors, who ruled northern India for three centuries. The most famous of these, Shah Jahan, built the Taj Mahal ("crown of the palace") in memory of his wife, Mumtaz Mahal, who died while giving birth to their fourteenth child. Nothing was too beautiful for this mausoleum. Between 1632 and 1648, twenty thousand workers and a thousand elephants

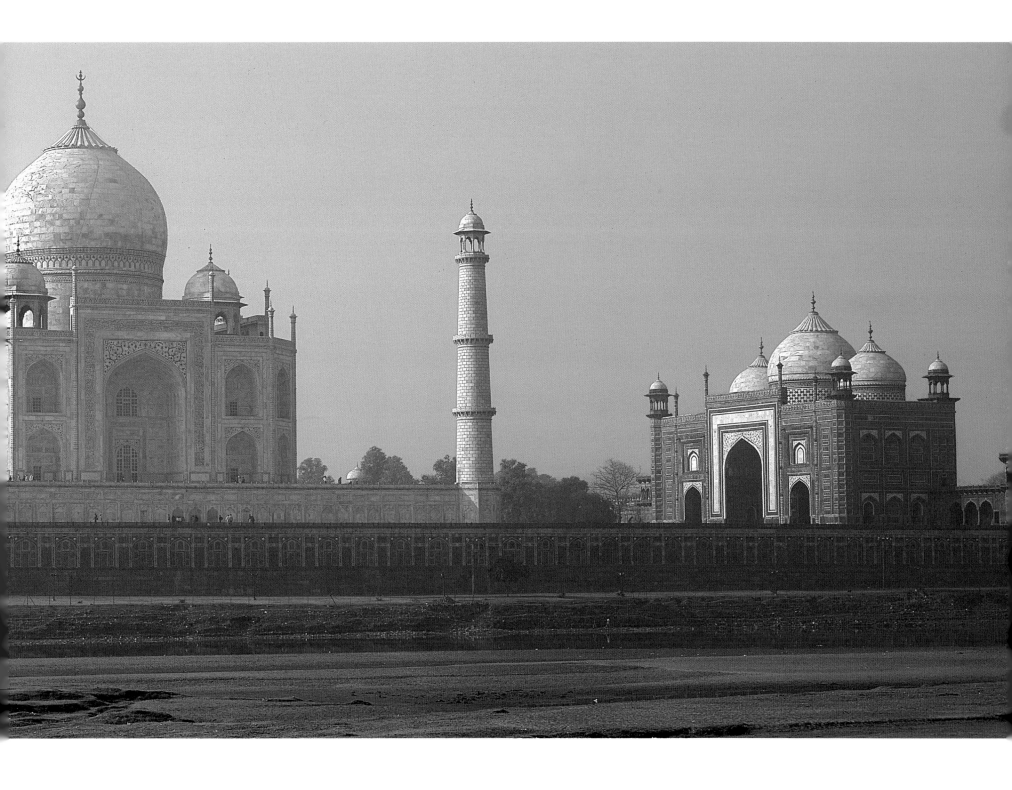

worked tirelessly to build this masterpiece, which has become the most visited monument in India.

For centuries this edifying story has drawn lovers and newlyweds, who have their photograph taken by the great pool with the mausoleum as a backdrop. The truth, however, may be different. It has been claimed that what Shah Jahan built was not a temple dedicated to his wife's memory, but his own future tomb and an allegorical representation of the Day of Resurrection (*Yom al-Din*), when the dead will rise and enter Paradise to appear before Allah. This fascinating theory, by an American historian, Wayne Begley, was published in 1979. According to Begley, the Taj Mahal is a representation of God's throne and Paradise. The theory is based upon the translation of countless inscriptions carved on the walls of the Taj Mahal, including one on the porch leading to the garden, which is a versicle from the

The Taj Mahal at dawn, framed by four 140-foot- (42-m-) high minarets and flanked by a mosque on one side and an identical jawab *(house for guests) on the other.*

Following pages: The central "river," with its white marble fountains and red sandstone curbstones, leads to the great pool in which the Taj Mahal is reflected.

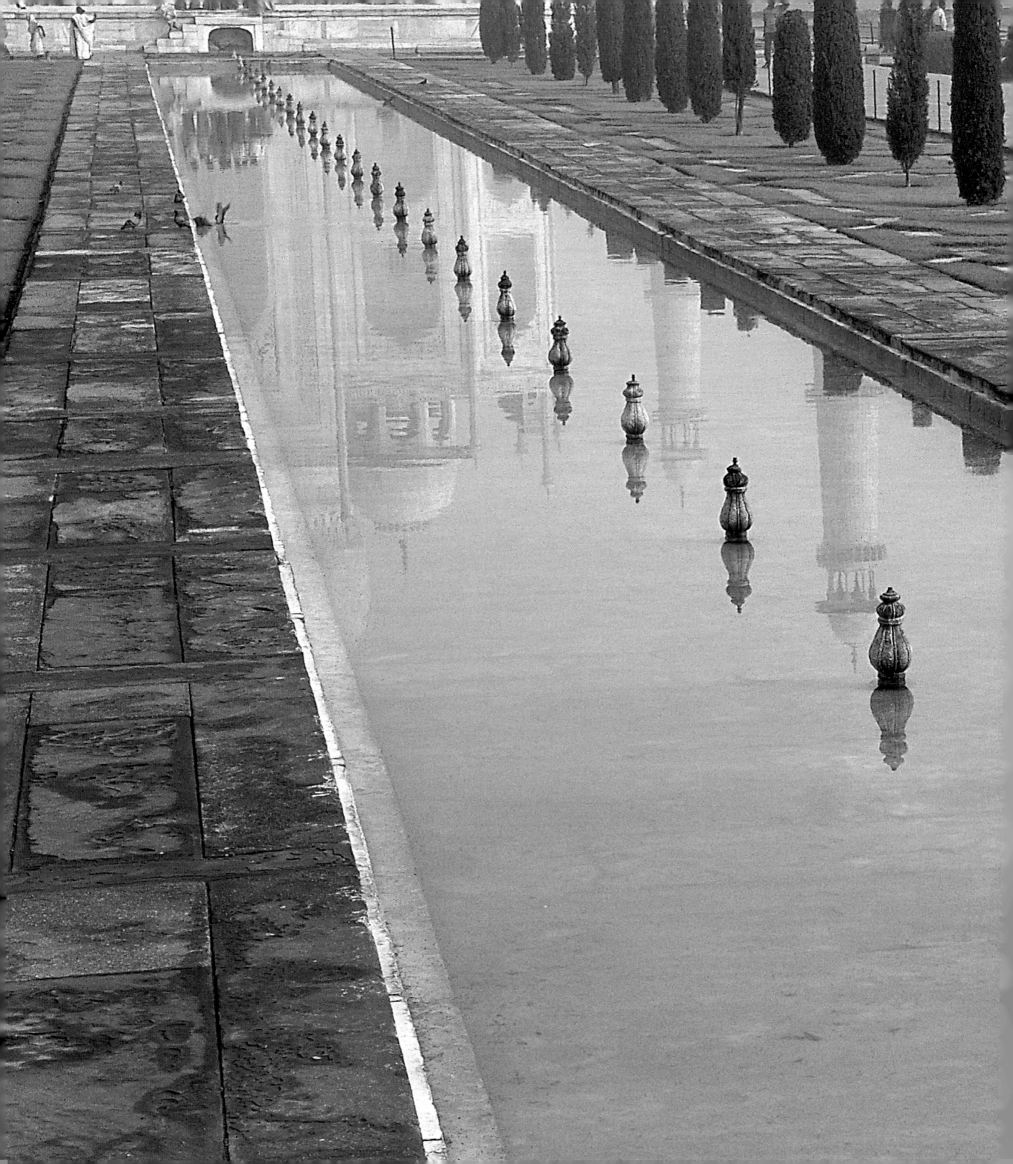

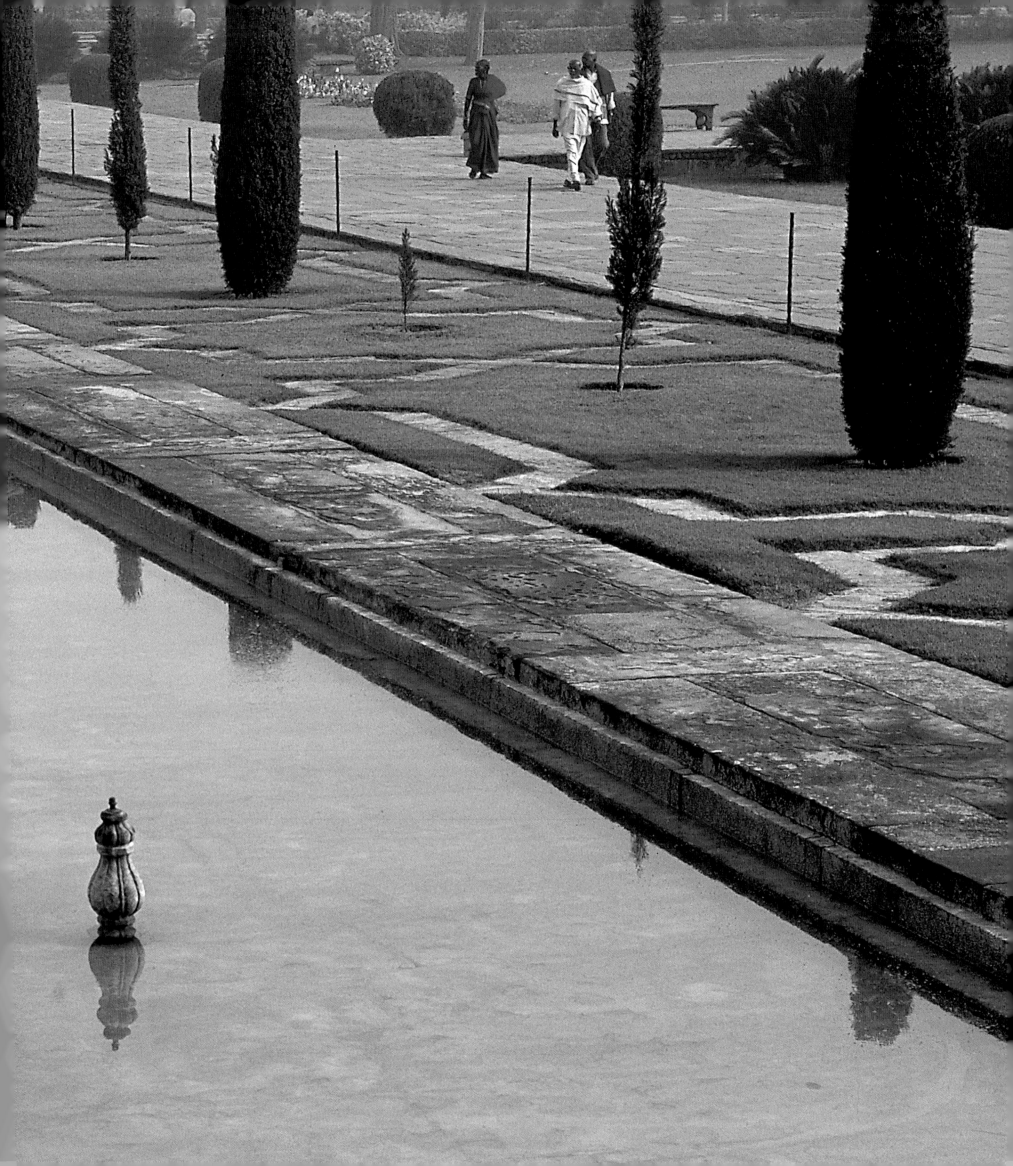

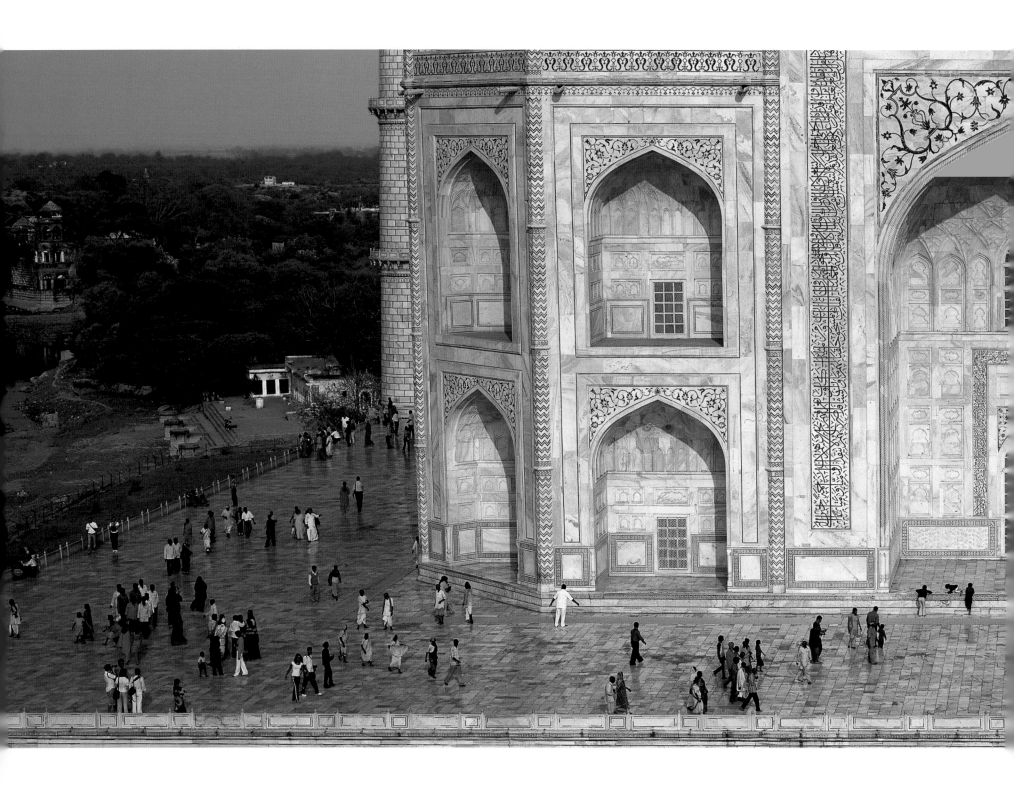

eighty-ninth chapter of the Koran: "You, oh soul at peace . . . enter into my Paradise." Begley also based his argument on the striking similarity between the plan of the "plain of Paradise" described in a book by Ibn Arabi, a famous twelfth-century Sufi master, and that of the Taj Mahal. Its gardens echo the division into four sections, with four rivers "of water, milk, wine, and honey," and once possessed a rich orchard. The mausoleum stands at one end of the

complex, like Allah's throne, and not in the center, as the rules of Mughal funerary architecture dictate. According to this theory therefore, the Taj Mahal and its gardens are an assertion of the presence of religion and the power of the sovereign, not a romantic and grief-stricken memorial to a beloved young woman.

The gardens, where millions of visitors stroll every year—often while breathing polluted air—bear little

relation to those of Shah Jahan, which were filled with flowers and perfume. Lord Curzon, viceroy of India from 1899 to 1905, laid them with lawns, which no doubt made for easier maintenance. But the Taj Mahal remains what is perhaps history's last—surviving—attempt at representing paradise on earth. ✤

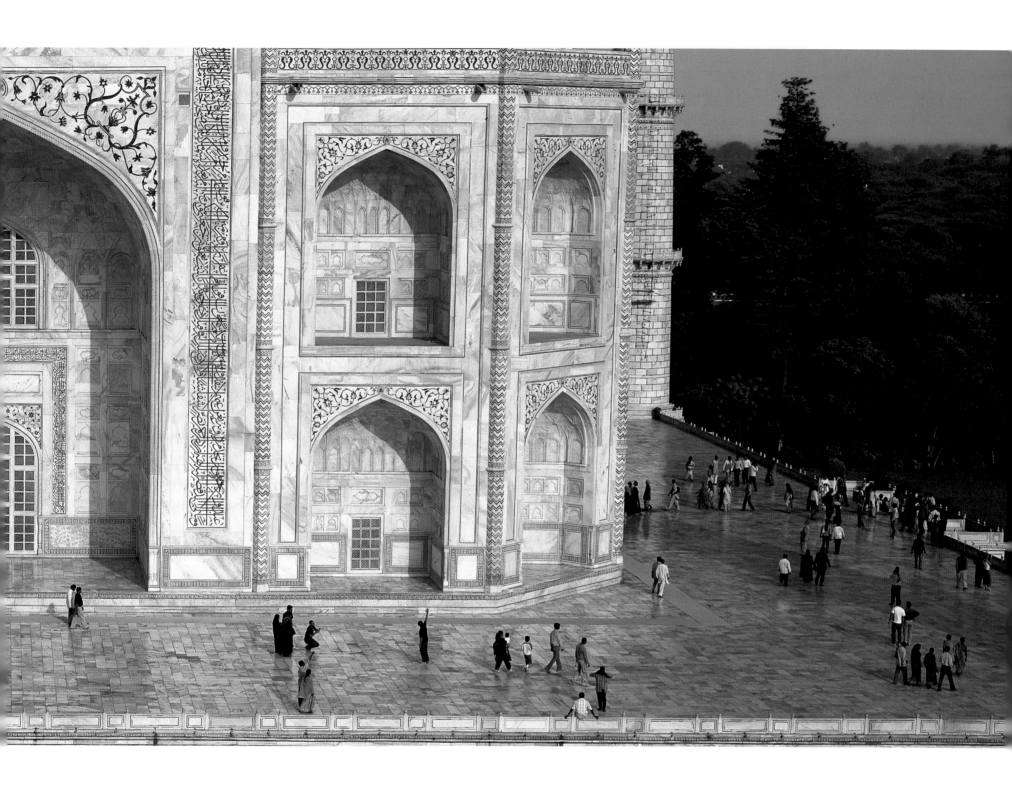

The façade of the Taj Mahal
is made of marble, encrusted
with rare stones engraved with
versicles from the Koran. Twenty
thousand people, including
craftsmen from central Asia
and Europe, worked on the
building's construction.

Fatehpur Sikri

The Abandoned Garden

FATEHPUR SIKRI, INDIA
1569
Designer: Akbar

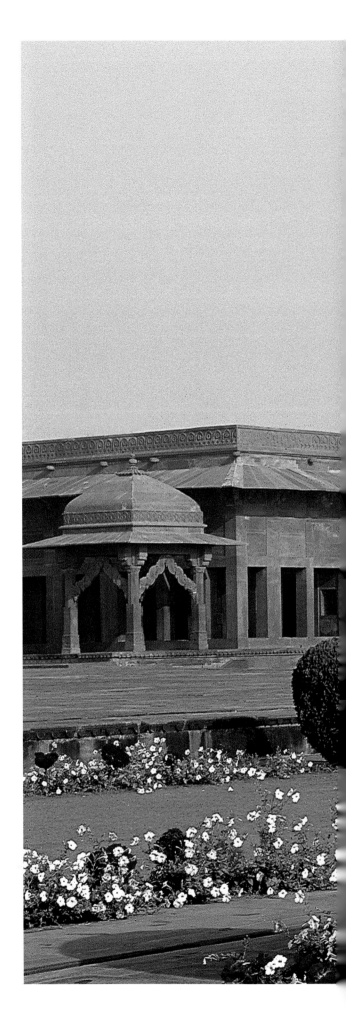

Fatehpur Sikri is one of those mythical abandoned cities in which Asia abounds. In 1569 the Mughal emperor Akbar, a Turkish-speaking Muslim mystic who was brought up in Persia, decided to build his new administrative capital in a wild place where, according to a monk's prophecy, his wife had given him a long-awaited heir. The town was built in a few years, but in 1585 the emperor left it and moved to Lahore. Since it has lain forgotten, it has escaped development and retained the extraordinary appearance of an architectural and town-planning utopia. The city stands on a terrace above a river, and contains many well-preserved palaces and buildings in red sandstone, which mingle Indian, Persian, Turkish, and Arab influences. One such is the strange Ibadat Khana ("house of worship"), which was certainly the first center for ecumenical meetings in the history of the world.

Because Fatehpur Sikri was quickly abandoned, it still contains the first gardens laid out around Mughal palaces, virtually in their original state. The two main ones are of a type that can be seen also in Lahore and Delhi, as well as in other large cities in northern India: the *chahar bagh* garden in the Islamic style, divided by paved paths into six flower beds that were once filled with flowers, and the *zenana* terraced garden—both being enclosed and integrated with the architecture.

In the Mughal design, open space that is protected by walls is an extension of the pavilions around it. The *chahar bagh,* an image of paradise in its strict geometric divisions, was a setting for court life and ceremonies, which took place outside

In the palace of the short-lived capital of Fatehpur Sikri, the royal chahar bagh, *covering 22,000 square feet (2,000 sq. m), and the* zenana, *the women's garden, with an area of some 16,000 square feet (1,500 sq. m), are the oldest surviving Mughal gardens.*

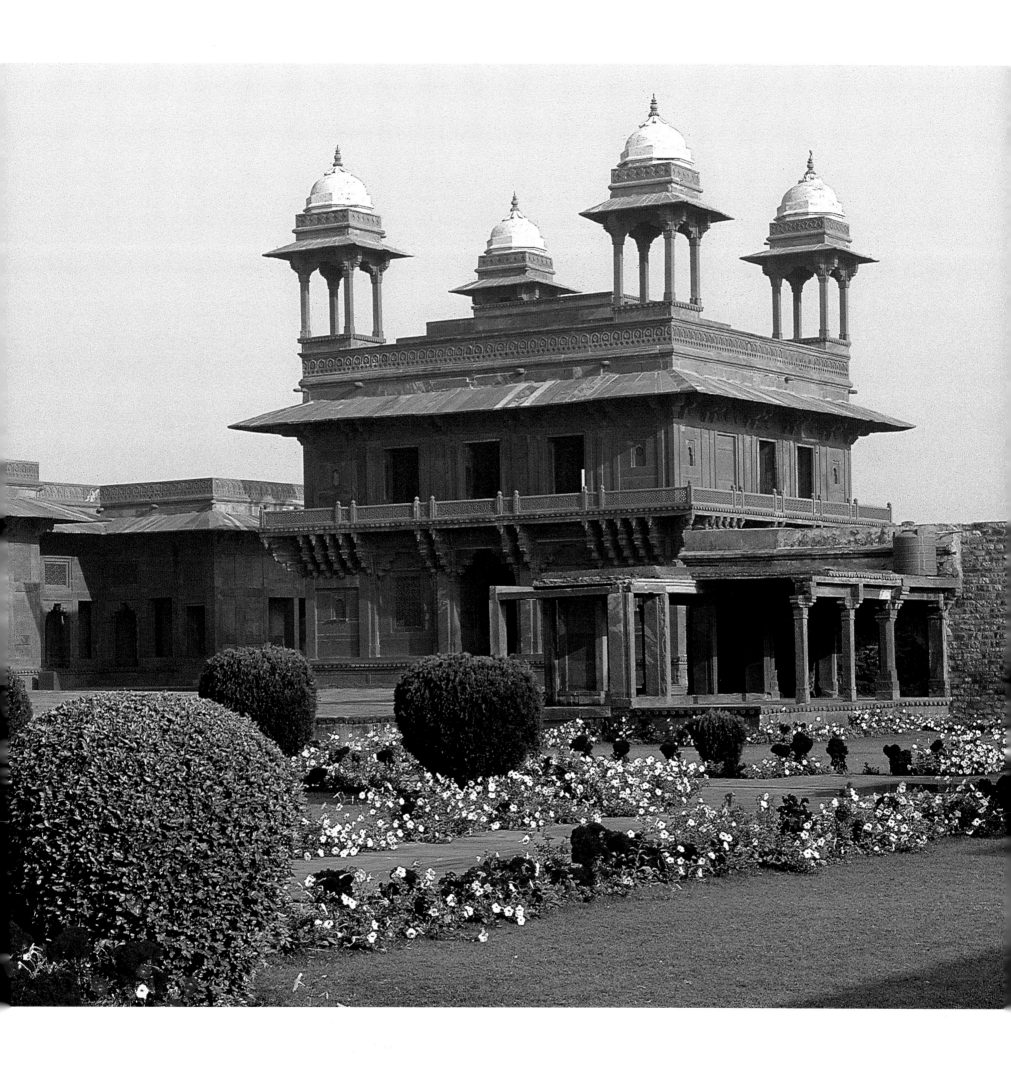

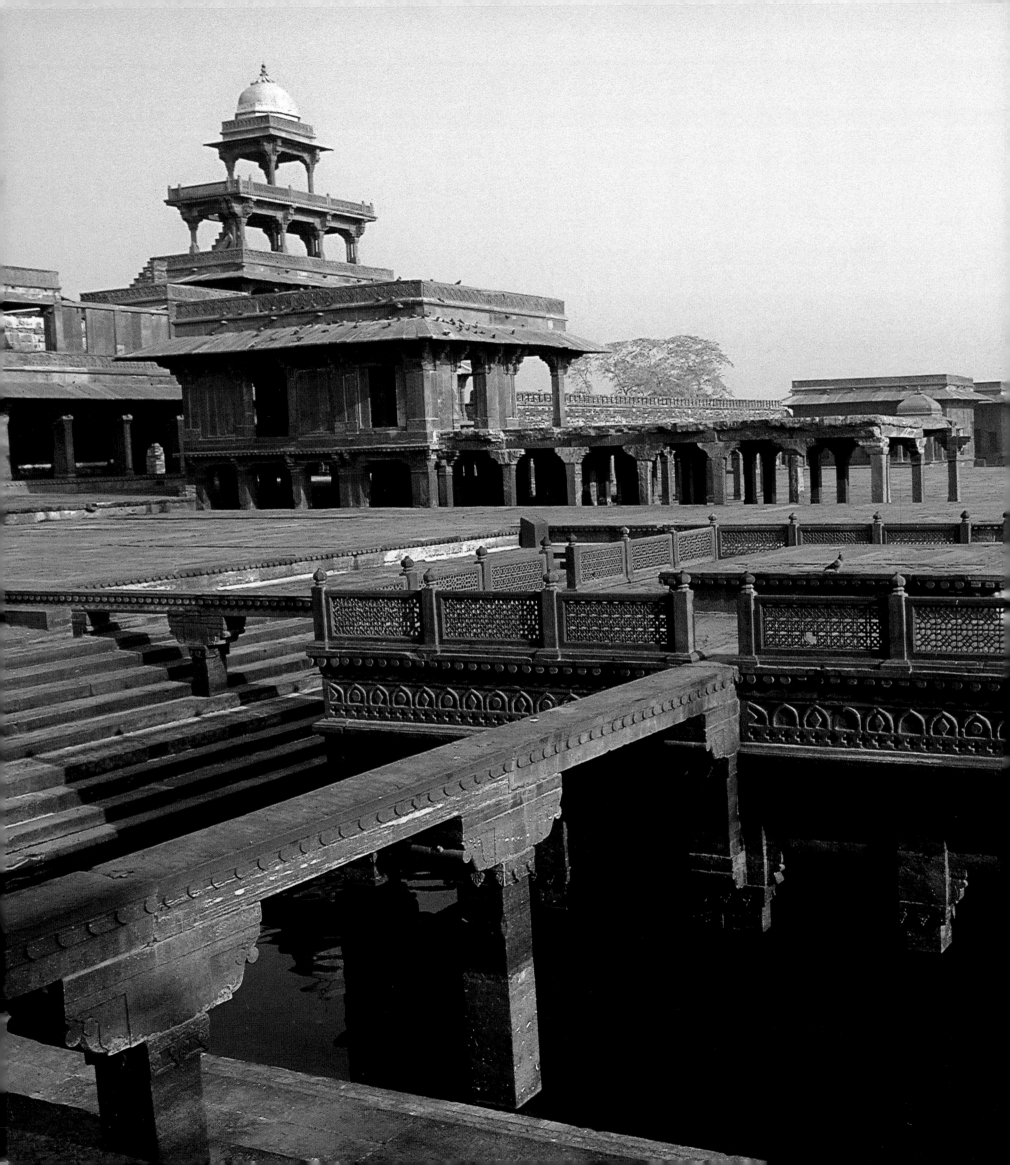

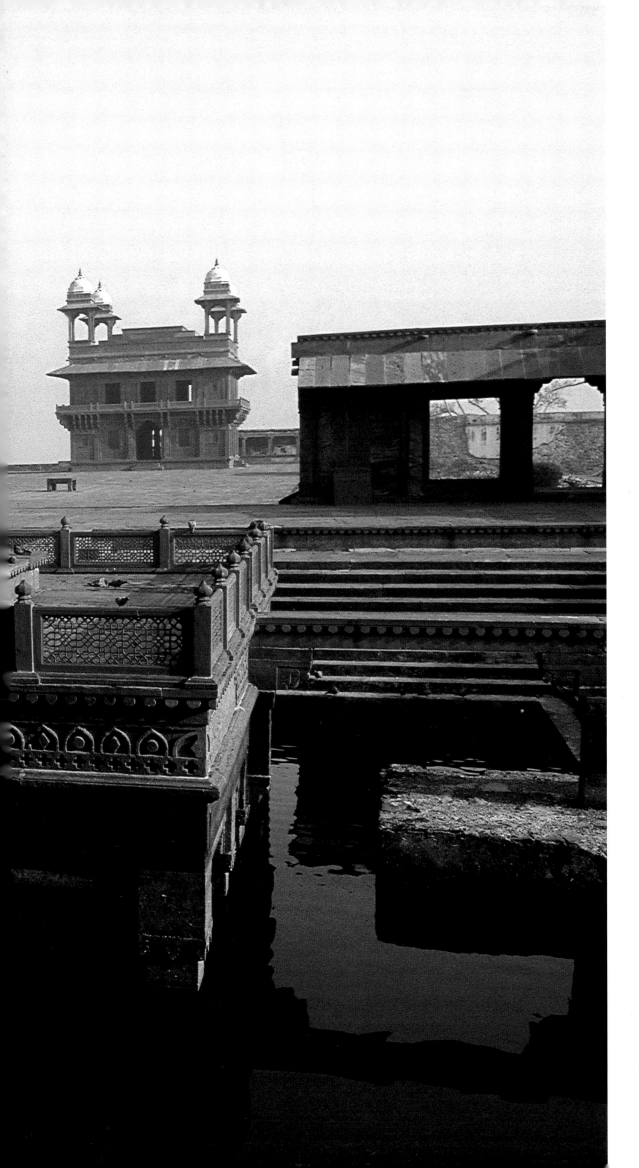

The royal garden is closely integrated with a complex arrangement of pavilions, summerhouses, pergolas, and raised paths.

as well as indoors, depending on the heat of the sun. The *zenana,* on the other hand, which is more pleasant, lively, and lush, was the women's garden, for the use of the harem, and therefore reserved for the ruler's family. Ancient accounts describe how Mughal gardens also came alive in the evening. A multitude of cressets, lanterns, garlands of candles, and small boats laden with candles floating on the pools and canals lit up the night so that all could take advantage of the coolness. This tradition survives in India's public parks today. ❖

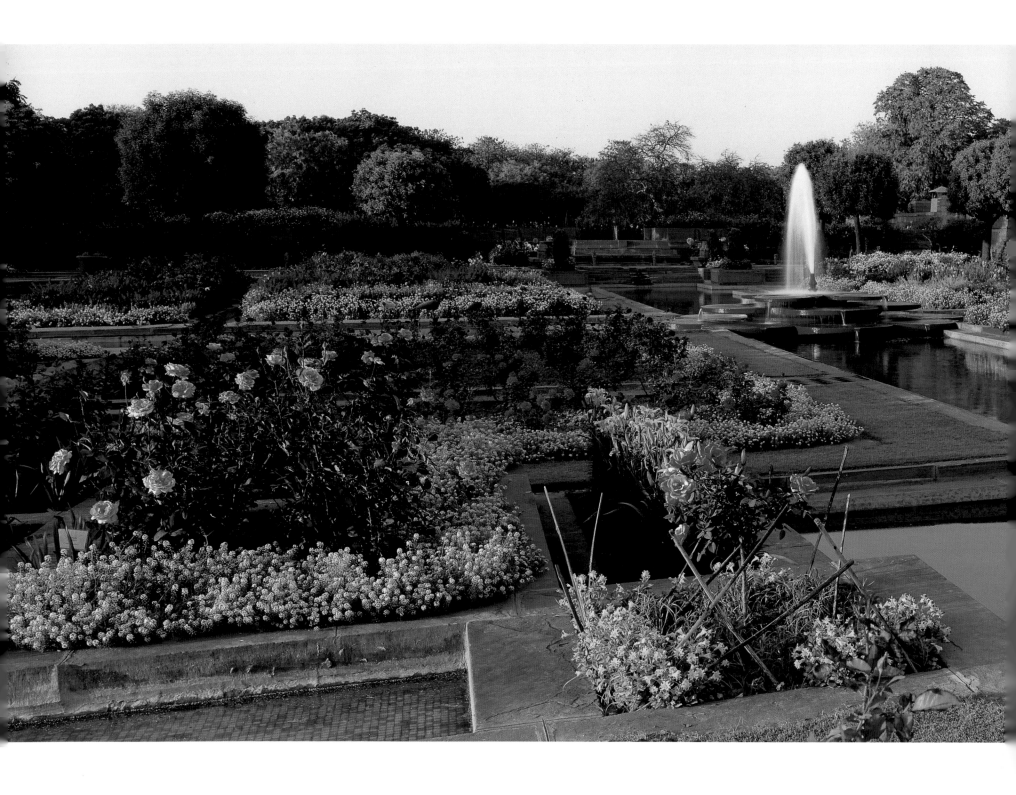

Rashtrapati Bhavan

THE LAST GREAT GARDEN IN THE MUGHAL STYLE

DELHI, INDIA
1917–31
Designer: Edwin Lutyens

In 1912 the British architect Edwin Lutyens was entrusted with the task of creating the new Indian capital. He devoted almost twenty years to this project, visiting the site twice a year at a time before air travel. He exhausted himself in the process, but also produced his masterpiece: the viceroy's residence, a gigantic palace, larger than Versailles, which was intended to assert the power of the British Raj.

Lutyens made clear his lack of interest in Indian

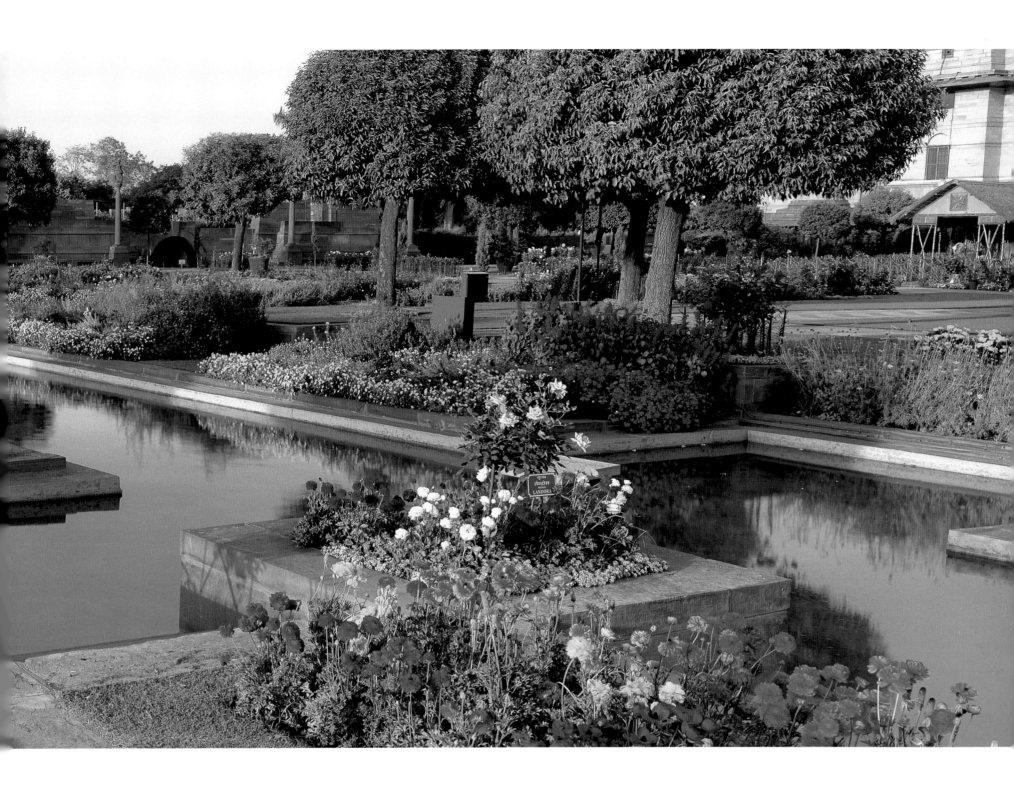

architecture even though, in his own way, he incorporated some typical elements, such as the huge Mughal cornice, the *chajja,* which runs along the building's façades. In 1917, under further pressure to make his project more "Indian," he suggested laying a carpetlike garden covering more than five acres (2 ha) below the windows of the viceroy's apartment (now occupied by India's president), directly inspired by the iconography of Persian carpets. Around a central lawn, where marquees are erected when required, lies an orthogonal network of canals and "rivers of life," more than sixteen feet (5 m) wide, whose intersections are enlivened by fountains shaped like lotus leaves. Two enormous formal pools, fed by other semicircular fountains, are made of red granite, as are the soil, the curbstones, and the lateral pergolas. The whole can feel oppressive: the intense heat, the fountains' musical sound, and the heady scent of thousands of brightly colored flowers. However, despite the fact that it is recent—it was completed only in 1936—this creation inspired by history is the only one that, in its preserved opulence, truly expresses the vanished splendor of the great Mughal gardens. ☙

Edwin Lutyens, the creator of many gardens in England, drew on architecture's classical language, merging it with Mughal and modern sensibilities.

Gardens of the West

GARDENS OF THE ROMAN EMPIRE

Hadrian's Villa 80

Pompeii 84

Although archaeology has yielded hardly any information about Greek gardens, the Roman model is still quite with us. It is present in Latin literature—though few people today read Virgil, Pliny, Horace, and Cicero—but especially in the remains of imperial palaces and the excavations at Herculaneum and Pompeii. There many frescoes have revealed the design of the Roman garden of a few years after the start of the Christian era.

Rome was full of gardens, especially along the Tiber River and on the Pincio Hill. Moreover, rich families had farms in the country (*villae rusticae*), where there was often a holiday villa. This would always have its own garden, starting with the plantings of the house's central atrium. The plan of the ancient Roman garden was not yet very clearly defined. It was dictated by topography, by the garden's effect in combination with the complex of buildings it served, and by the availability of water, rather than by principles of representing or controlling nature. Flowers, fruit trees, and aromatic plants abounded, and pools in the shape of hippodromes kept the air cool, as well as providing a setting for meals, with dishes floating on the water's surface. For a long time the god of gardens was Priapus; gradually he was replaced by Bacchus. These two deities evoked a form of sensual, vitalistic pleasure that was stage-managed by the gardener (*topiarus* in Latin, from the Greek *topia,* whose meaning is close to "landscape"). The Roman garden is neither a place of meditation nor one for religious representation: it is designed to please the senses. In that way, it is modern.

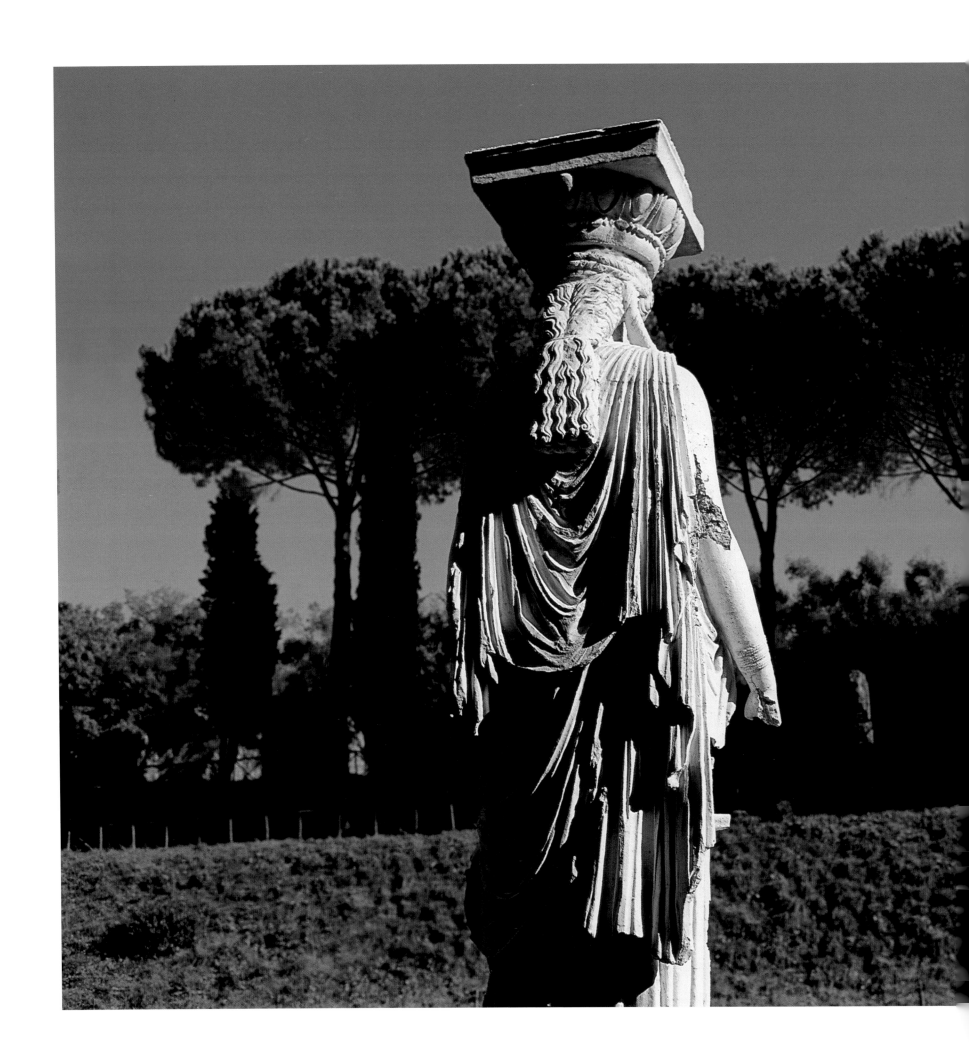

Hadrian's Villa

The Emperor's Retreat

TIVOLI, ITALY
A.D. 125–134

Villa Adriana, at the foot of the Tivoli mountains not far from Rome, was so huge that until the Renaissance its ruins were thought to be those of a town. It survived the death of its builder, and even the end of the Roman Empire, in relatively good condition, but from the sixteenth century onward it was completely stripped by antiquarians seeking statues and architectural elements on behalf of popes, cardinals, and wealthy Roman families. For a few decades, they turned the villa into an "art quarry." A famous reconstruction by Daumet, a pupil at the Villa Medici, gives an idea of the vastness and splendor of what was unquestionably one of the greatest villas in antiquity.

Hadrian (A.D. 76–138) was one of the great Roman emperors. Cultivated, concerned with the law, and an aesthete, he spent two-thirds of his reign traveling the far reaches of his empire. He was a great builder, and erected the villa at Tibur (modern Tivoli) in order to rest and write his travel memoirs.

Its gigantic buildings were arranged around gardens that bordered the palace itself, but also a magnificent complex that included three theaters, a basilica, a library, thermal baths, and more. Although the greater part was open to guests and the vast number of staff, other parts were attached to certain buildings, such as the library terrace, the Piazza d'Oro, or the Academy garden. The complex is on the UNESCO World Heritage List.

Remarkably, these gardens have not yet been studied in depth. So many centuries have passed that all traces of the avenues and plantings have disappeared. All that remains are a few pools, such as the immense *canopus,* which reminded the emperor of the feasts held in his honor in Egypt, and some of the canals that supplied water. The gigantic brick walls (perhaps once decorated with frescoes) and colonnades are complemented by vigorous imported trees, such as planes and palms, as well as by the colorful splendor of flowers, whose seeds and bulbs were brought from all over the empire.

Hadrian's Villa still retains much of its mystery. The preservation carried out since the nineteenth century has created a strange landscape of enormous ruins that always seem in danger of being swallowed up by the over-invasive vegetation. ☙

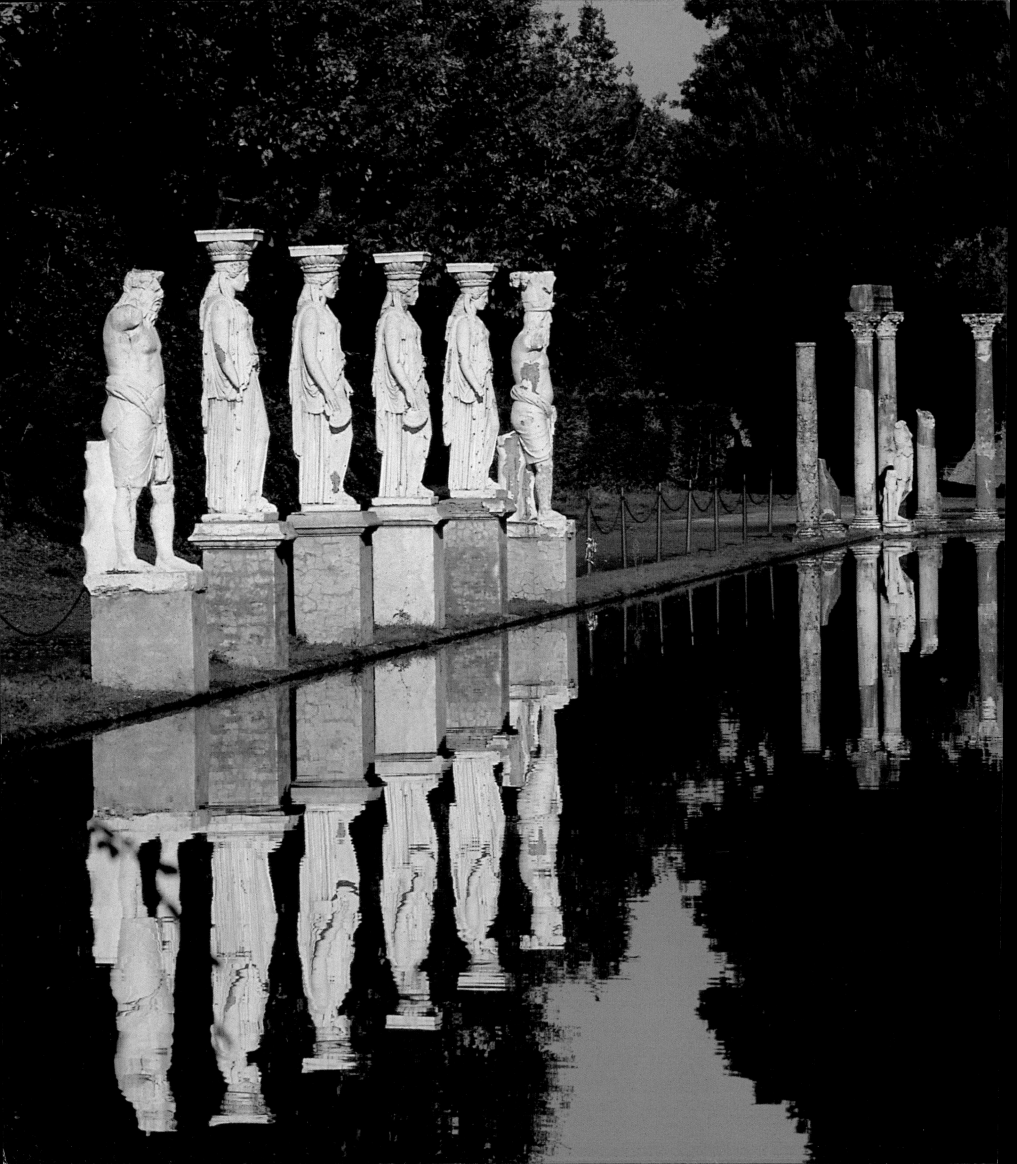

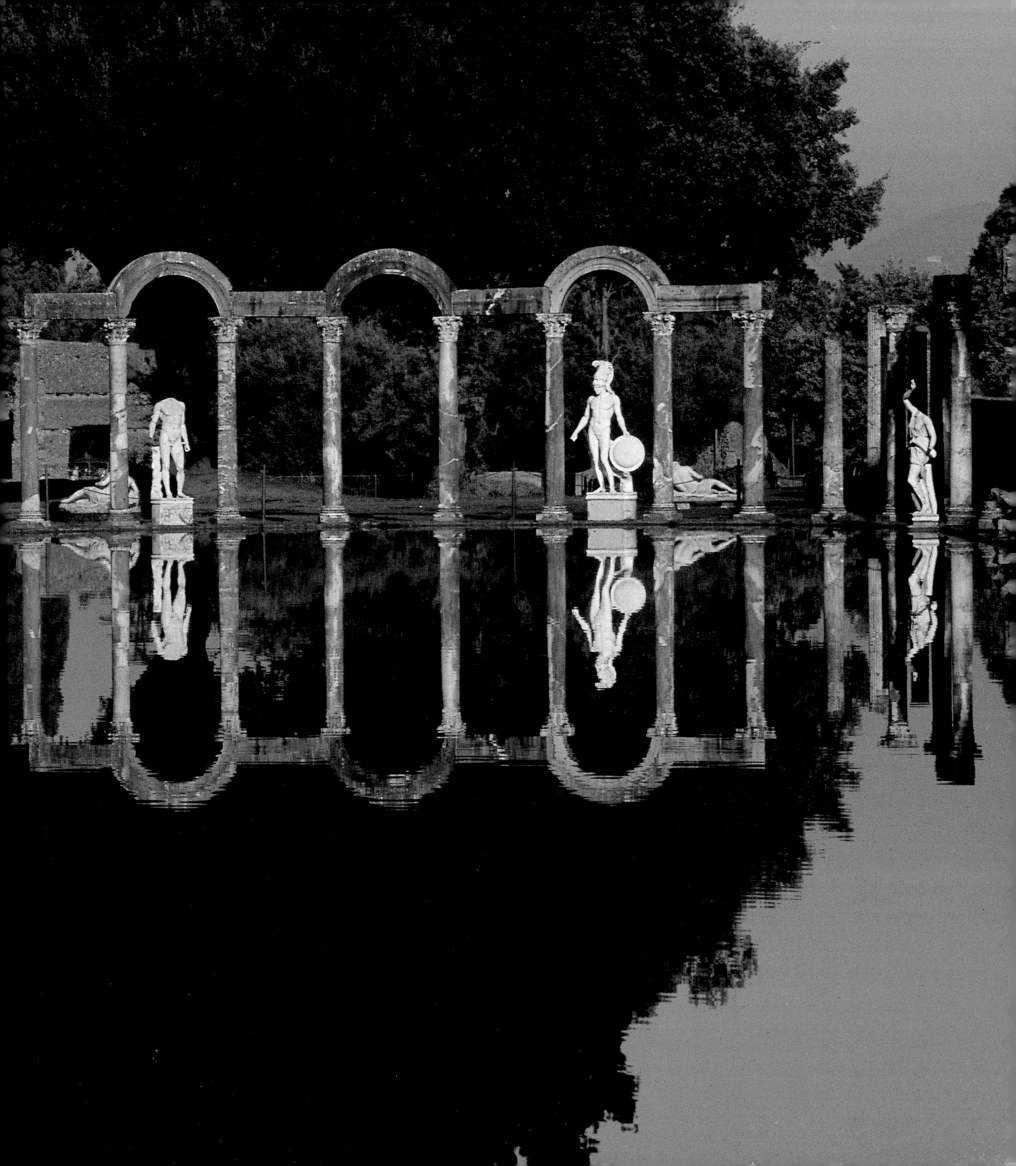

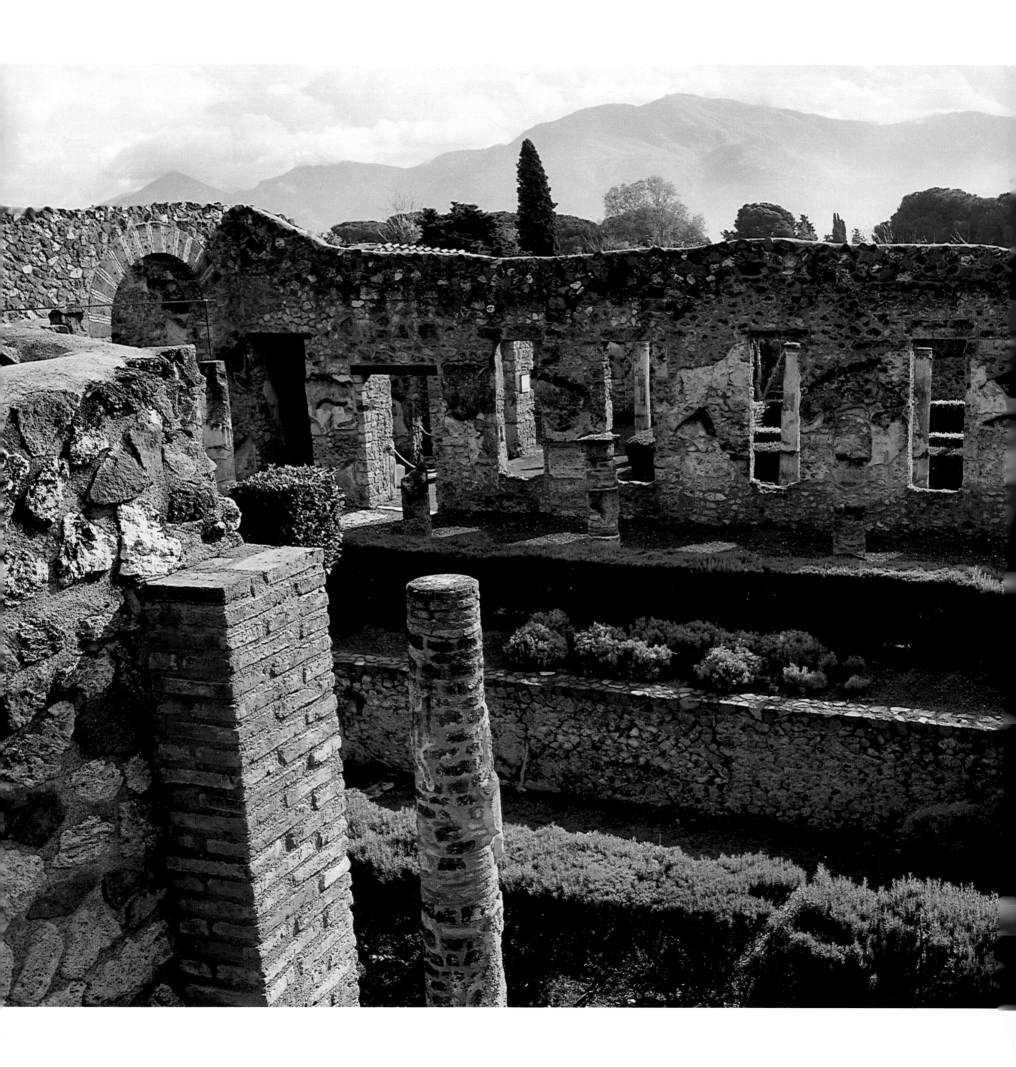

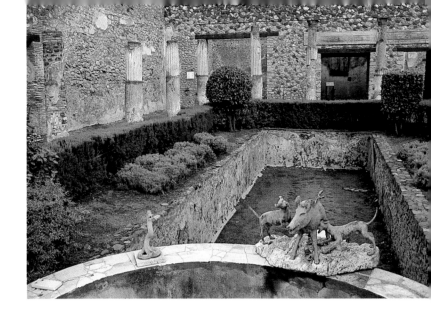

Pompeii

THE PINNACLE OF THE ROMAN GARDEN

ITALY
First century A.D.

Left: The Casa del Citarista, a large villa in which a statue of Apollo playing the cithara was found. A garden has been created there; based on frescoes of the time, it was designed around a central pool.

Above: In the Casa del Citarista, small bronze animals squirted water into a marble basin.

Following pages: The Casa della Venere (Venus's House), a huge, luxurious villa. The frescoes around its atrium depict a garden filled with birds, which are faithfully reproduced from life.

In A.D. 79 an exceptionally violent eruption of Mount Vesuvius engulfed the towns of Pompeii and Herculaneum, luxurious summer resorts on the Bay of Naples, in a cloud of gas and ash. The only positive effect of this frightful catastrophe—which could very possibly be repeated—was to preserve for seventeen centuries the astonishing remains of Roman civilization at its height. Excavations carried out over the last three centuries have given us in-depth visual knowledge of life in these small towns of the Campania region, which were strongly imbued with Hellenism. One of the most striking discoveries has been the profusion of frescoes, many of which deal with natural themes and, especially, with gardens. Their existence is confirmation of the Roman taste for the idyllic myth of *otium,* which today would be translated as "leisure," but which was a state of openness of the mind and the person that could be cultivated only in a natural setting.

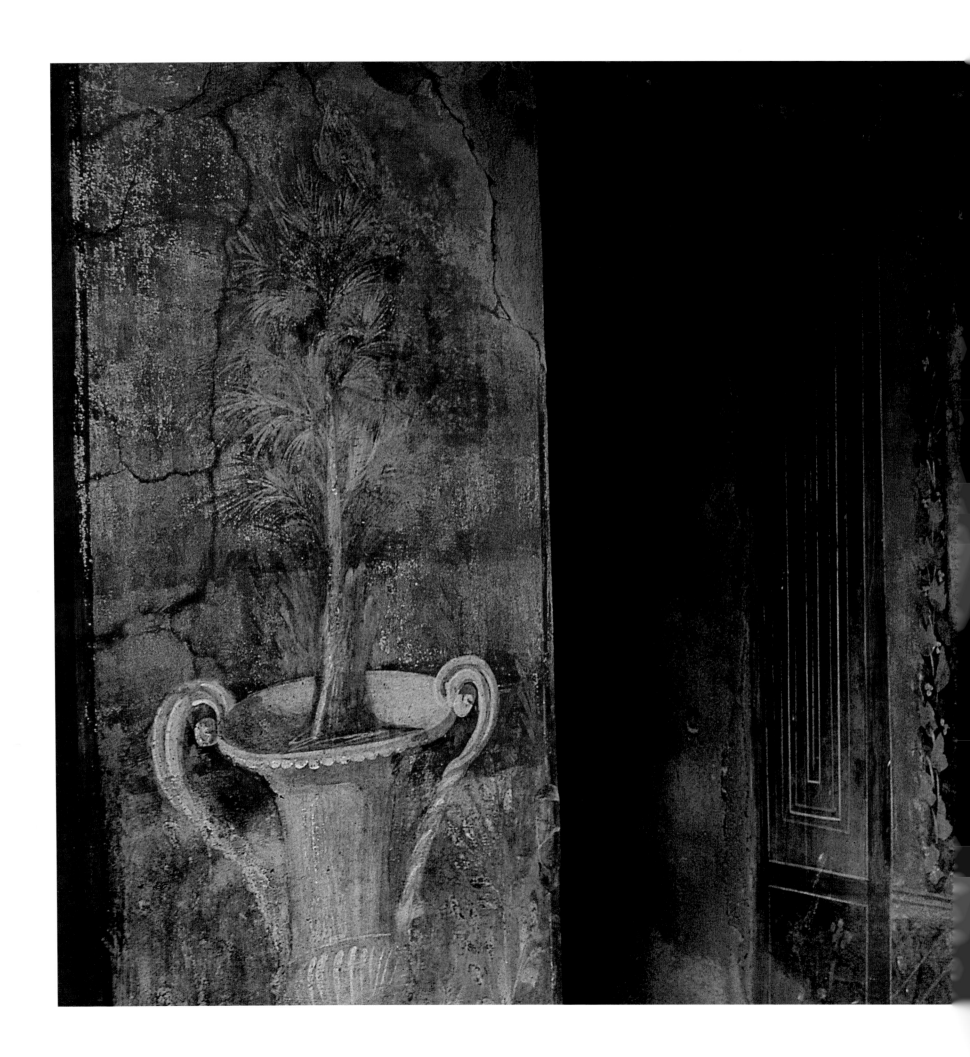

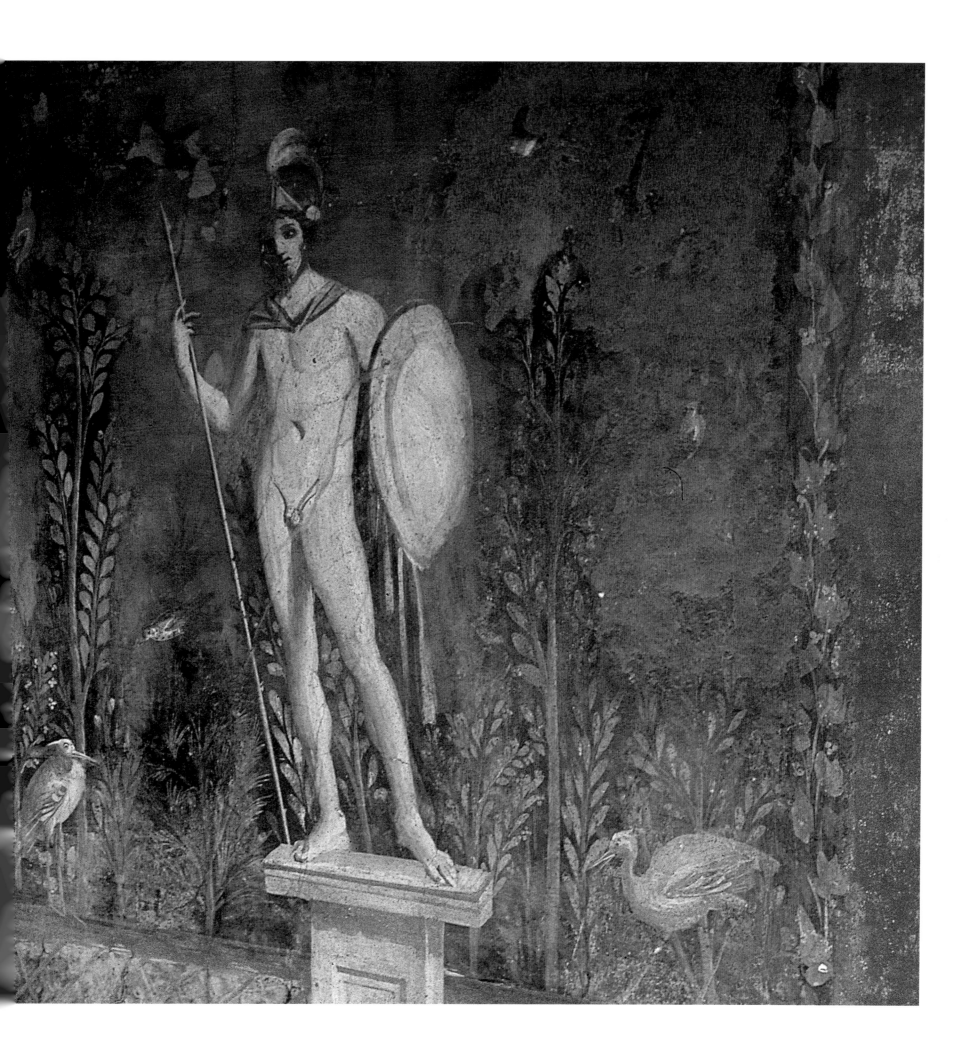

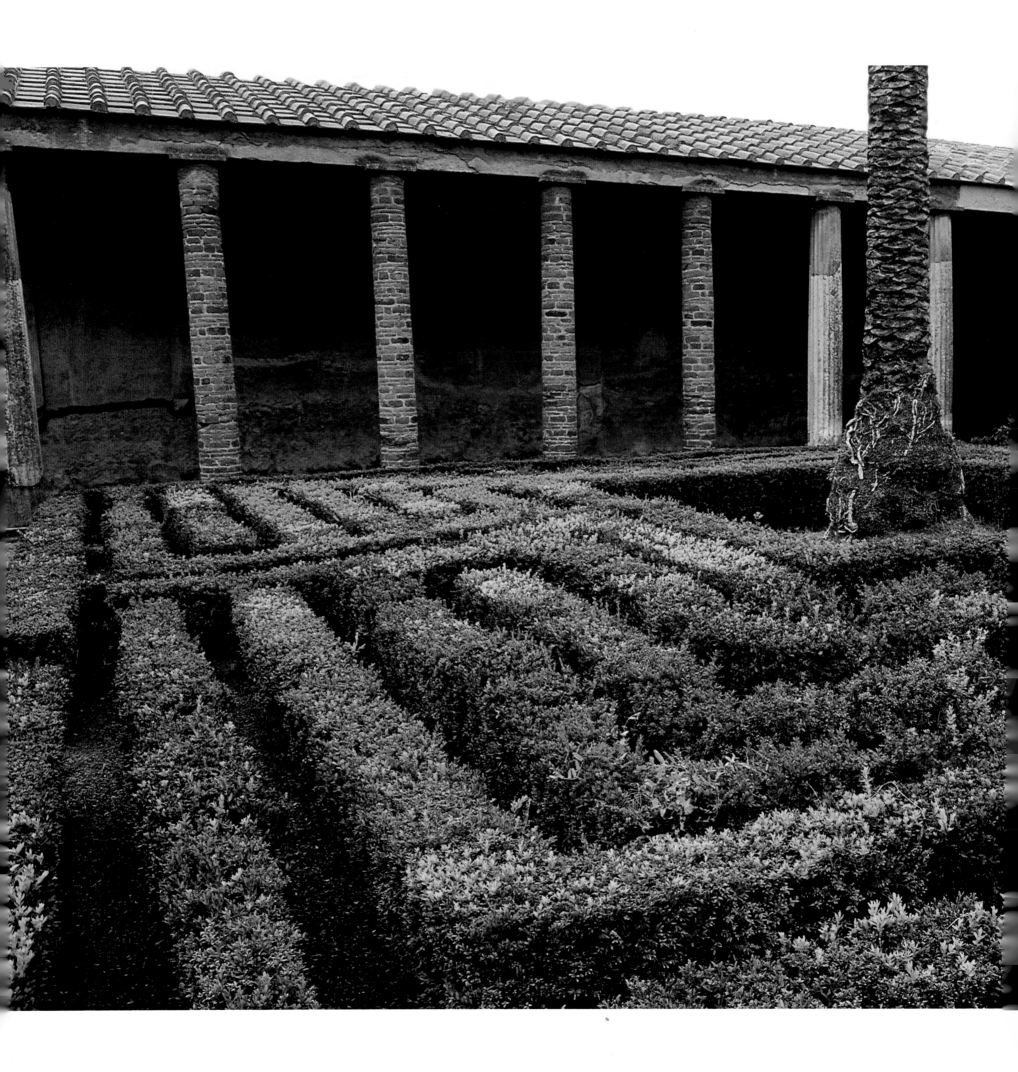

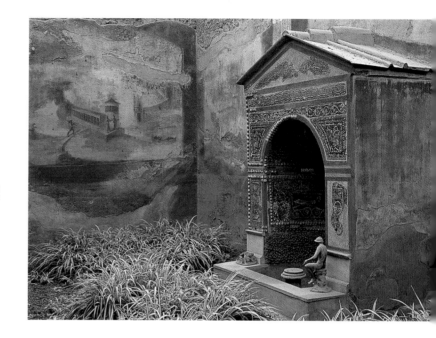

Left: The House of the Labyrinth. Although the labyrinth is recent, it is a reconstruction of the one formerly in this atrium; it is one of the earliest examples of this mythical theme to be found in a European garden.

Right: In the garden of the Casa della Fontana Piccola (House of the Small Fountain) there is a fountain with a charming mosaic made of small pebbles, which depicts a nautical theme.

The gardens of Pompeii take many forms and come in many sizes, ranging from a row of a few lemon trees in pots or flowers planted around a cantharus vase to a luxuriant orchard stretching out behind the house. If the space seemed confined, natural scenes would be painted on the walls to make them blend in with nature. A peristyle, also painted, often provided the link between the interior and exterior of a house. There one could rest in the shade, gazing at the plants and listening to the singing of the birds, who were so ever-present in Pompeian frescoes. The garden was enclosed, for the house was also a sacred space, the seat of the household gods, and as such had to be protected. This enclosure foreshadowed medieval and early Renaissance gardens.

Attempts have made to reconstruct these gardens in situ, but they have been rather hypothetical. We know that many species—such as the plane, palm, laurel, box, and myrtle—were imported from elsewhere in the empire, and cultivated flowers were still a luxury. The gardens of Pompeii retain much of their mystery: a garden is a living creation that can die with those who planted it. ⚜

The Medieval Cloister

The European garden of the Middle Ages is little known yet abundantly illustrated. Thousands of illuminations, miniatures, engravings, paintings, tapestries, and dozens of treatises reveal its many forms and, above all, show what an important role it played in rural as well as urban social life. We know more or less how trees were pruned, how flowerbeds were laid out, and how people visited the garden to listen to music or dine on the grass. But are these sources reliable? Don't artistic style and representational conventions create a false perception of an idyllic garden, a haven of order and beauty, in a rather brutal period of history? Whatever the truth is, for some decades now efforts have been made to restore or create medieval gardens, with mixed results. Examples include the monastery garden of Brother Cadfael (a detective in a series of novels set in the Middle Ages) at Shrewsbury, England; the garden around the Cluny palace in Paris, and that at Villandry in the Loire valley.

It is known that there were three main types of garden, all of them enclosed: the garden proper, the orchard, and the park reserved for hunting. In each case, the medieval gardener sought to meet a practical need. Goods were not easily transported, and food supplies were a constant worry, as there was periodically the threat of famine. The function of a garden was therefore to produce fruit, vegetables, and herbs for cooking and medicine. Only a small part was devoted to the pleasure of residents, who would sit on stone benches or on the grass, around a pool or underneath an arbor. Gradually, though, gardens became larger, often replacing the defensive terraces or filled-in moats of castles. This extension of the garden, this opening up of space, which demanded a new aesthetic, already heralded the arrival of the Renaissance.

Convent of Pedralbes

THE IMAGE OF NATURE

BARCELONA, SPAIN
Fourteenth to fifteenth century

The cloister garden of Pedralbes, enclosed by a triple gallery, bears witness to the wealth of the great Spanish royal conventual foundations. The convent is still occupied by nuns.

On the hills of Barcelona stands one of the most prestigious monastic complexes in Spain. Founded in 1326 by Queen Elisenda de Montcada, wife of James II, the rich royal convent of Santa María de Pedralbes is a vast complex in the Catalan Gothic style, arranged around the cloister garden. The cloister has survived the centuries without suffering damage, for the convent, which was declared a historical monument and turned into a museum in 1991, has always been occupied by the order of the Poor Clares, some of whose members still live there today. Intact, it is astonishing for the elegance of its three superimposed galleries supported by graceful columns.

The garden has retained its medieval character. It is divided classically into four parts, separated by two paths that form a cross, at the center of which is a large pool surrounded by cypress trees. The plants are decorative, but not without some practical use, for this was an herb garden that contained both

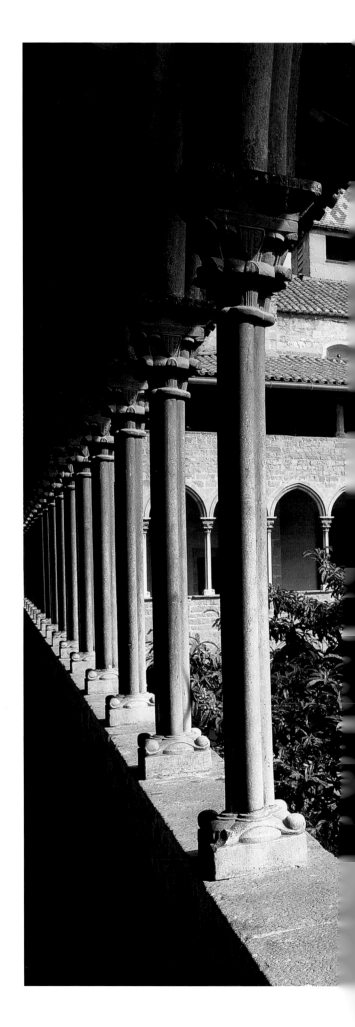

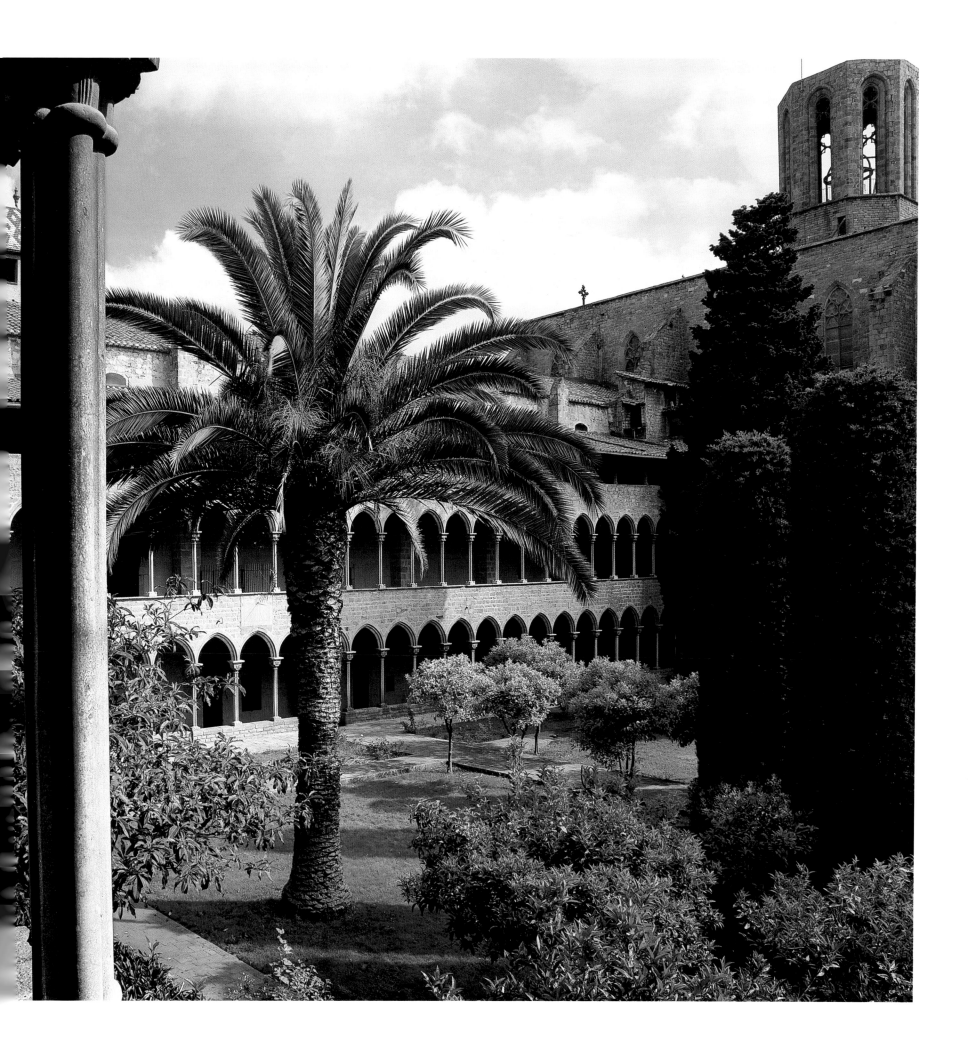

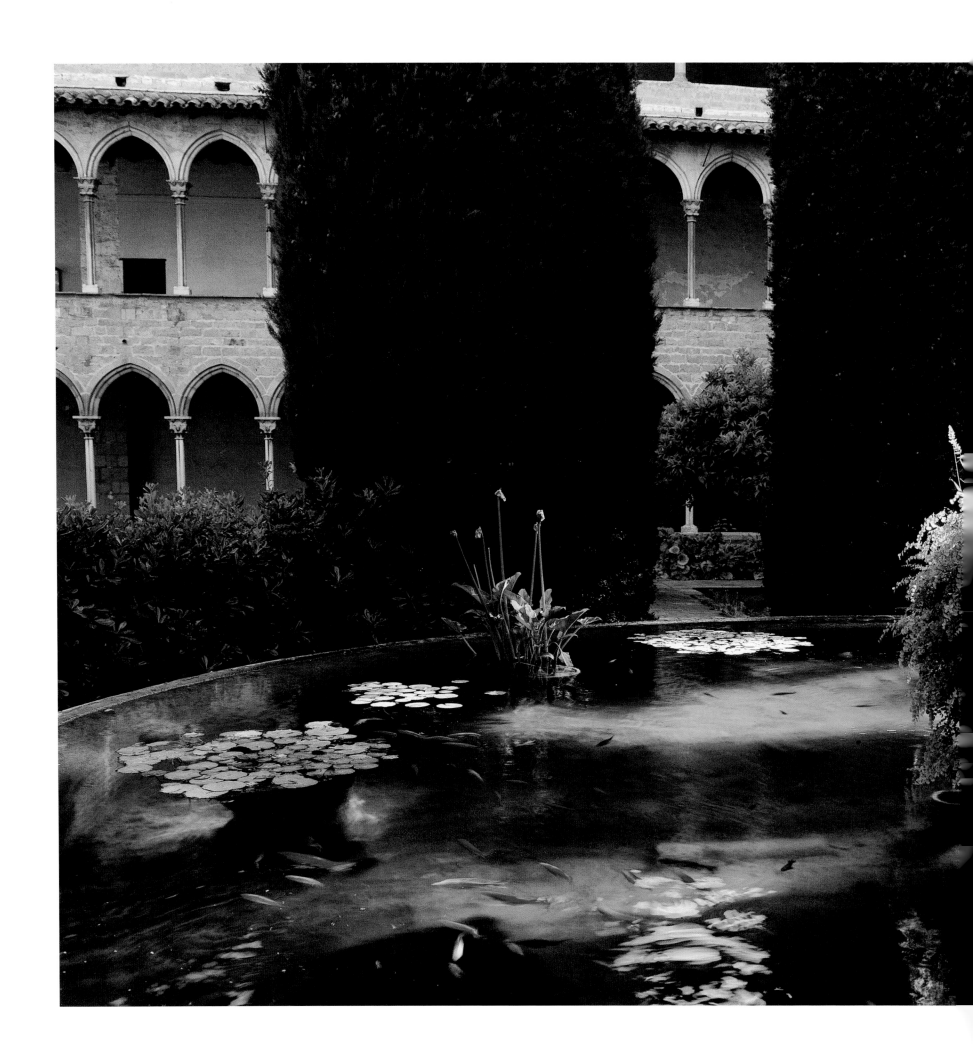

remedies for the infirmary and some plants for the kitchen. Along the paths, orange trees and a huge medlar have been planted, both for their appearance and for their fruit. Irrigation is by the Arab technique, from the central pool.

Above all, however, this garden has a symbolic value. It is the center of the cloister, which is a place for walking, meeting, and meditation, and is often the only contact the nuns have with nature. Bernard of Clairvaux explained that a garden was in the image of the divine plan. Can't we see so clearly how it symbolizes creation through planting or sowing, the development of mankind on earth through germination, and salvation through the harvest? Thus the nuns had before their eyes the miracle of the endless renewal of nature, but in a compact, ordered, peaceful form. Like a stained-glass window, the cloister garden told a story around the water of

the fountain, the source of life, and under the square of the sky, the kingdom of God.

This vast cloister garden, whose sides are 120 feet (40 m) long, has changed little. Only a few ceramic-covered benches were added in the eighteenth century, in a corner. The museum, which for a long time housed the Thyssen-Bornemisza collection, now contains a number of examples of medieval religious art. A few steps from the cloister, which is shrouded in serene silence, the interesting gardens of the royal palace of Pedralbes, laid out at the beginning of the twentieth century and now suffocated by traffic pollution, make a striking contrast. ⚜

The central fountain is part of the metaphor of the garden as well as its source of water.

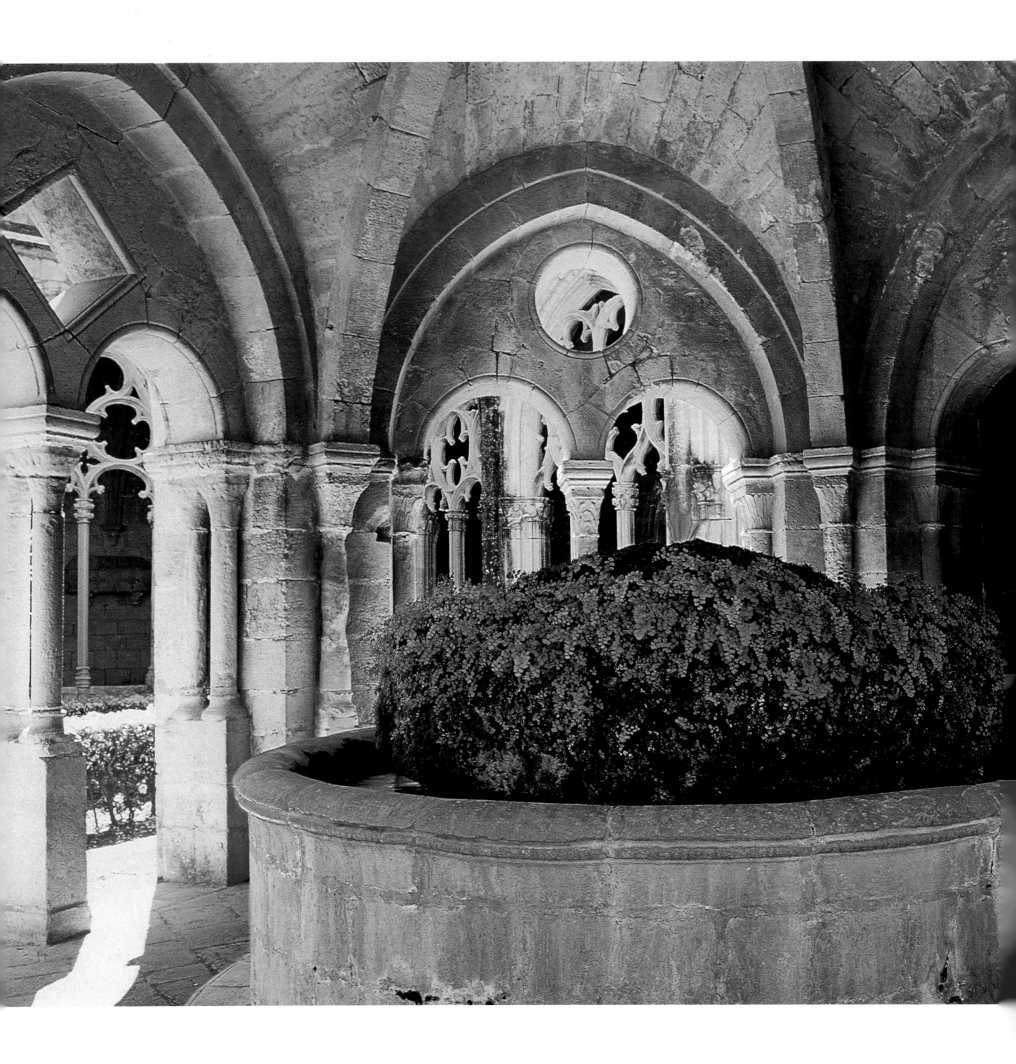

Monastery of Santes Creus

THE GARDEN OF THE RESCUED CLOISTER

SPAIN
Fourteenth century

This Cistercian monastery was founded in a remote valley, not far from Tarragona, in 1158, shortly after Catalonia was reconquered from Moorish rule and at roughly the same time as the monasteries of Santa María de Poblet and Santa María de Guadalupe were founded. The complex, which has lain abandoned since 1835, is relatively well preserved, retaining its unity and the elements, such as its church and cloister, which make it one of the finest examples of Catalan Gothic. According to old accounts, the cloister is in fact that of the vanished monastery of Bonrepòs de Montsant, reassembled at this site in the seventeenth century.

The rectangular garden is divided into four by paths. At the center, a cruciform pool covered with ceramic tiles decorated with geometric motifs is fed by a basin that time has transformed into a moss-covered fountain. To the south stands a small hexagonal stone building that houses another basin, perhaps formerly used for washing, into which water

trickles from an "oozing rock." There has been a modest amount of planting, dating from an attempt at reconstruction that no doubt followed the complex's classification as a national monument in 1921. Here, as elsewhere, the cloister—because it is both shutting off from the outside world and opening up to the natural one—fascinates the visitor in the same way as it must have attracted the monks. It is no coincidence that cloisters have always been endowed with a certain luxury, architecturally speaking. The abstract world of prayer—architecture—brings together in the garden—nature—those "forces that can move and calm the soul," of which Abelard wrote. ✥

Left: In a corner of the garden is the lavatorium, in which the monks washed their hands before going to the refectory for meals.

Above: One of the delicate, leafy capitals of the gallery's small columns.

Abbey of Mont-Saint-Michel

Serene Beauty

FRANCE
Thirteenth to twentieth century

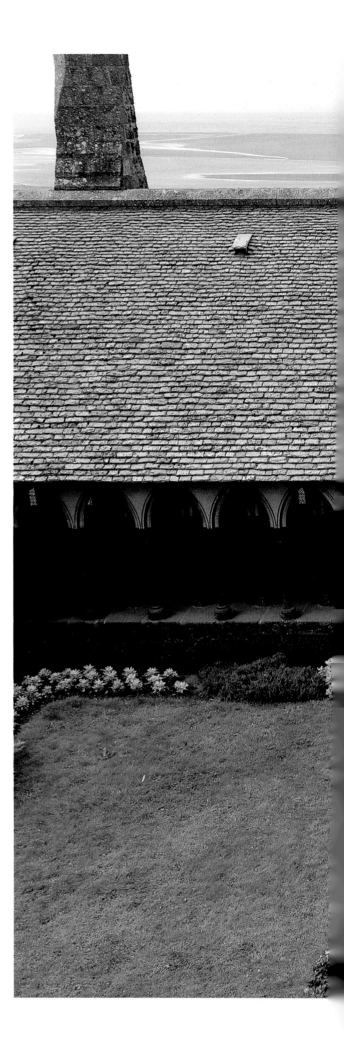

All the rigor of the early Benedictine monasteries can be seen in a succession of horizontal lines—the horizon, the ridge of the roof, the tiles—resting on an arcade of slender quincuncial columns. The garden is modern.

Recently refurbished, the cloister of the abbey of Saint-Michel, with its superb double arcade of delicate offset columns, remains what it has always been: a place of peace. Once it faced only the fury of the ocean; today, it withstands the hundreds of thousands of tourists who every year clamber all over the Mont-Saint-Michel. When a storm was blowing and the equinoctial tide was rising, the Benedictine monks must have felt protected in this small, welcoming cloister that presented a soothing image of nature.

The choice of plants is modern and thoughtful, but the large lawn brings to mind the "green shroud" that one medieval writer poetically suggested should be draped over the garden. Indeed, it was only from the Renaissance that cloister gardens became ornamental, being planted with flowers and aiming for visual effects.

Today, cloistered religious orders have lost their meaning, and this recent arrangement, though pleasing to the eye, contributes to the transformation of this focal point of triumphant Christianity into a museum. Even so, visitors faced with this square of serene beauty lower their voices. ⚜

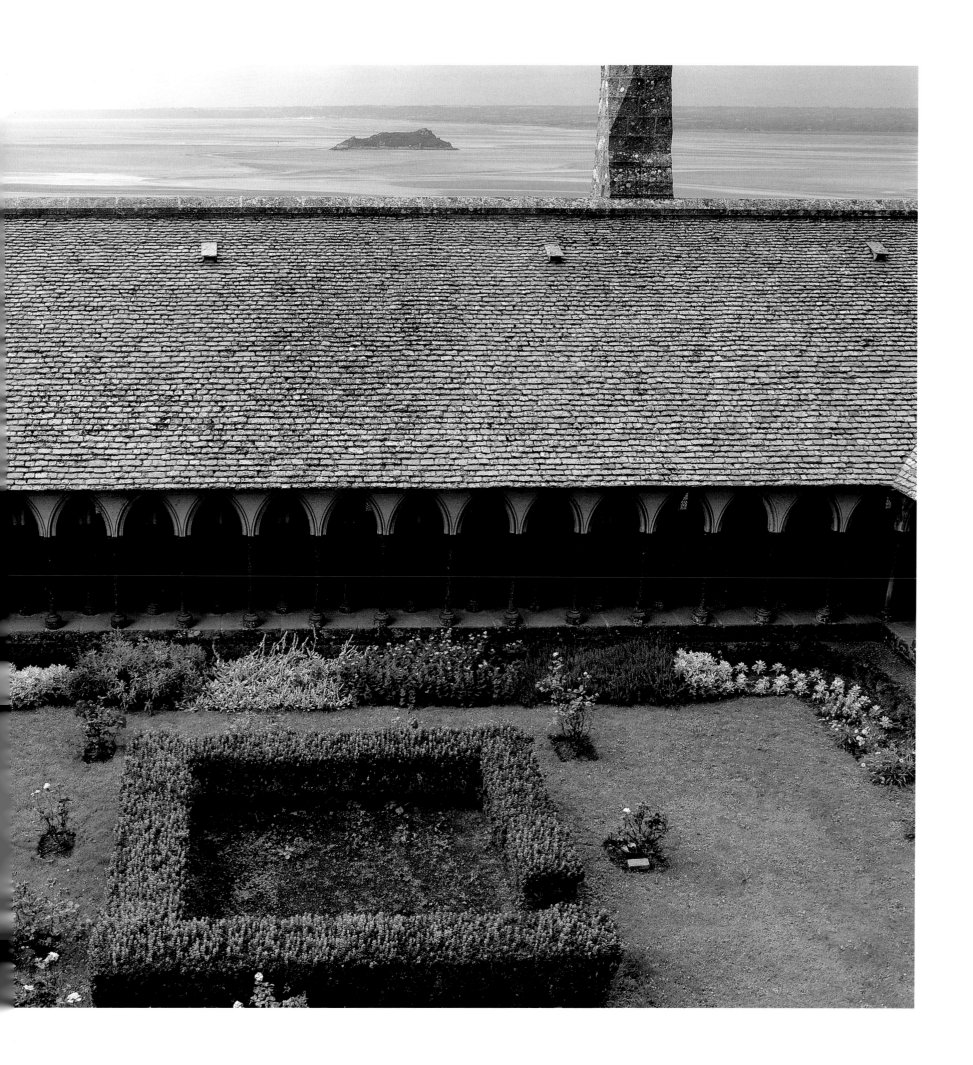

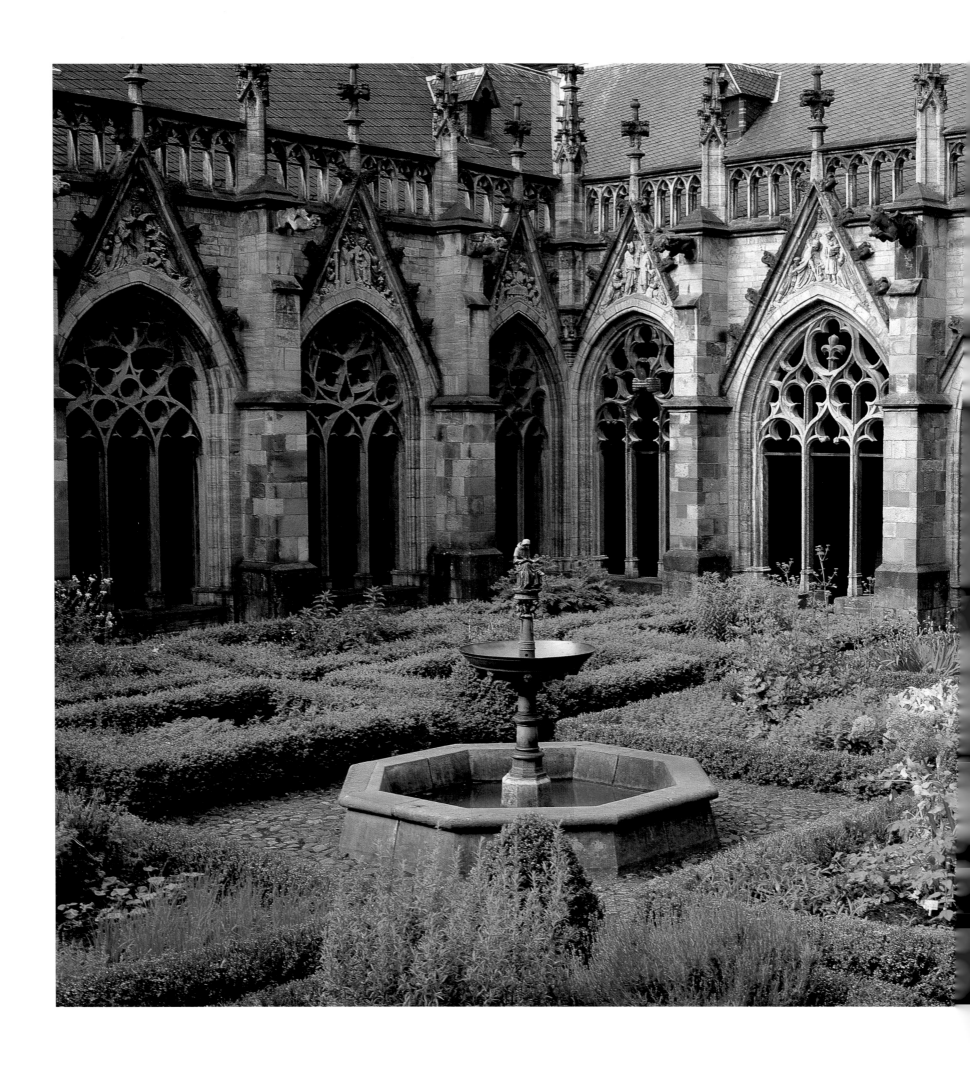

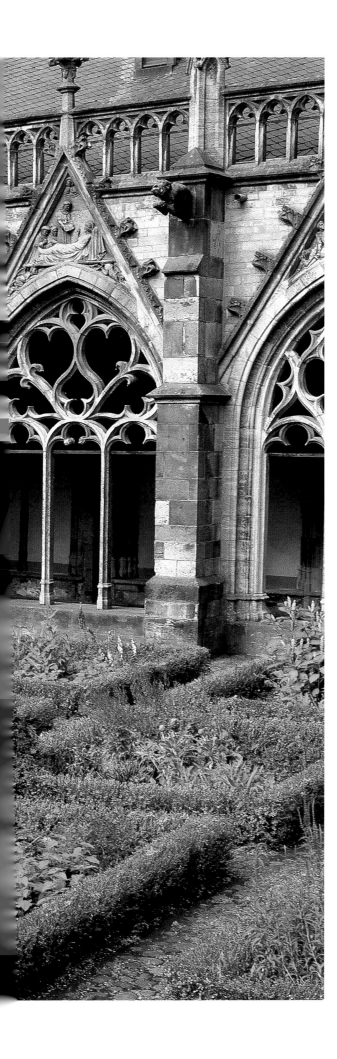

Cloister of Saint Martin's Cathedral

A SCHOLAR'S GARDEN

UTRECHT, THE NETHERLANDS
Fifteenth to twentieth century

In its plan and in the plants it contains, this garden is as faithful a reconstruction as possible of a medieval garden with herbs and simples planted in beds.

The cloister garden of the old cathedral of Saint Martin, Utrecht, lies at the foot of the tallest bell tower in the Netherlands. Thirty years ago it regained what was possibly the appearance it had at the end of the Middle Ages. Its gallery and Gothic arcades are thought to date from the beginning of the fifteenth century, but major renovation work began in 1876. The most noticeable restorations are the gables carved with scenes from the legend of Saint Martin.

The herb garden, restored in 1972, centers on a small fountain (1915) depicting a canon writing above four griffons from which jets of water gush into a basin below. The ground plan comprises twenty-four squares planted with herbs cited in a capitulary that was circulated under Charlemagne around the year 800—*De villis vel curtis imperii*—which attempted to introduce a semblance of order into the agricultural knowledge of the time. There are medicinal plants, condiments, spices, and plants that yield dyes. The University of Utrecht, one of Europe's oldest, was and still is famous for its botanical gardens, which no doubt explains the choice and relevance of these plants. Since most knowledge in the Middle Ages resided in monasteries and universities, it can be imagined that travelers would offer the monastery in their home town the seedlings they brought back from distant lands. This cloister garden—imaginary though it may be—adds charm to the undoubted interest of this scientific reconstruction of our knowledge of nature at a given time. ⚜

The astonishing décor of majolica tiles makes this a luxurious Baroque cloister for the otherwise austere Poor Clares.

The Majolica Cloister

A GARDEN OF LUXURY

CONVENT OF SANTA CHIARA, NAPLES, ITALY
Fifteenth to eighteenth century
Designer: Domenico Antonio Vaccaro

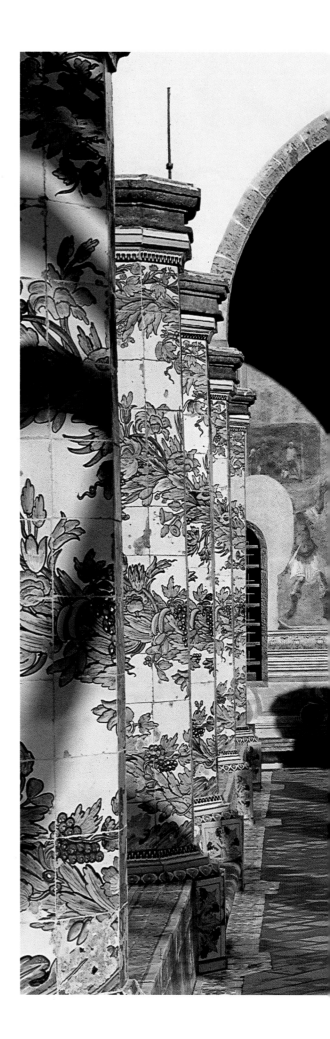

Santa Chiara, one of Naples' biggest religious institutions, consisted of two convents, one occupied by Poor Clares, the other by Minorites. Of a rather severe Gothic style, is was entirely rebuilt and refurbished in the eighteenth century by the painter, sculptor, and architect Domenico Antonio Vaccaro (1678–1745), who gave it a vigorous Baroque treatment as a *giardino rustico* (rustic garden), and devised an extraordinarily effective means of surprising and delighting the visitor—the ultimate goal of the Baroque style. Two perpendicular paths divide the space, bordered by sixty-four octagonal pillars covered in multicolored majolica tiles. Along the galleries are benches, also covered in ceramic tiles. A wooden pergola rested on these pillars, and acted as a support for climbing plants.

The colonnade completely changes the appearance of this space, which is both powerfully structured and transformed into a theatrical set. Creation of the majolica tiles was entrusted to Donato and Giuseppe Massa, who produced their masterpiece: their designs and range of colors were to inspire Neapolitan ceramics until the present day. Starting with three colors—blue, yellow, and green—they created a fantastic décor of harvest scenes, grape-gathering, hunting, seascapes, bananas, figs, and citrus fruit, which blended in a typically Baroque fusion with the fruit on the orange trees in the cloister. ❧

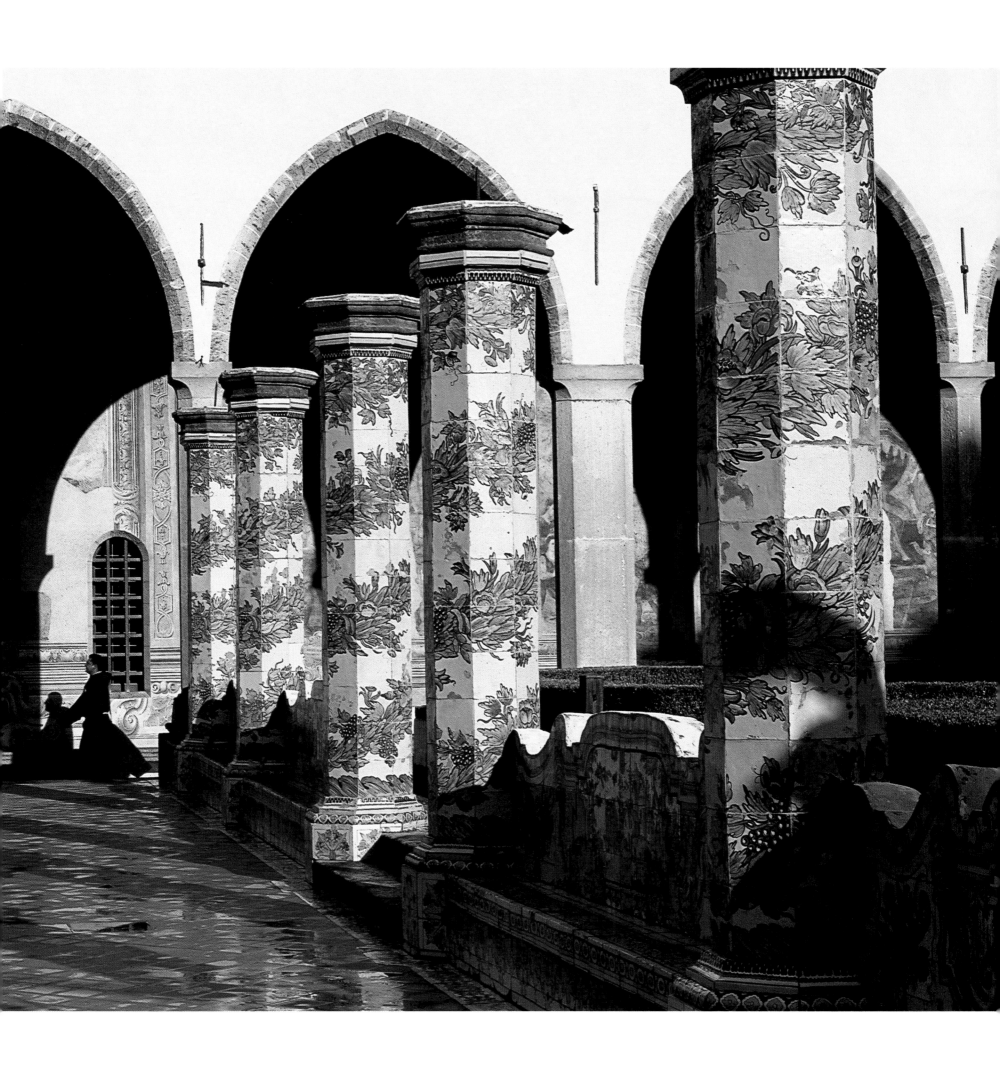

Medieval Garden
Traditions

The medieval garden is in fashion. All over Europe, gardeners and curators are making efforts to reconstruct old gardens or, where this is not possible, to imagine how they might have looked, or an ideal version of them. In most cases all trace of the original plan has disappeared—the exception being a small number of cloisters. Miniatures, tapestries, and the backgrounds of paintings enable us to re-create the spirit of the time, but these sources are often so stylized that they are of little use to the gardener, and we know of no medieval account books for gardens, whereas they are so valuable for the study of gardens from the sixteenth century onward. Many varieties of fruit trees and other plants have disappeared, while others have appeared. How far should we go to re-create the grace of these very old gardens without falling into the trap of a seductive but misleading reconstruction? The gardener's art can draw on very few sources: Charlemagne's *De villis vel curtis imperii*, a few texts by Albertus Magnus and the Franciscan Bartholomeus Anglicus, and descriptions gleaned here and there in *Hortulus* by Walahfried Strabo (ninth century) or *Geoponika* (tenth century), which draws on texts from antiquity. Apart from this historical knowledge, however, we can also try to imagine how medieval people conceived their gardens, based upon the plants—and most importantly the tools—available to them, as well as on what a medieval family expected of a pleasure garden that was also, in large measure, a productive garden. On this basis, after several decades of work, some reconstructions look more convincing than others. These gardens at Maisonnais, France; Winchester, England; and Bruges, Belgium are among the most successful.

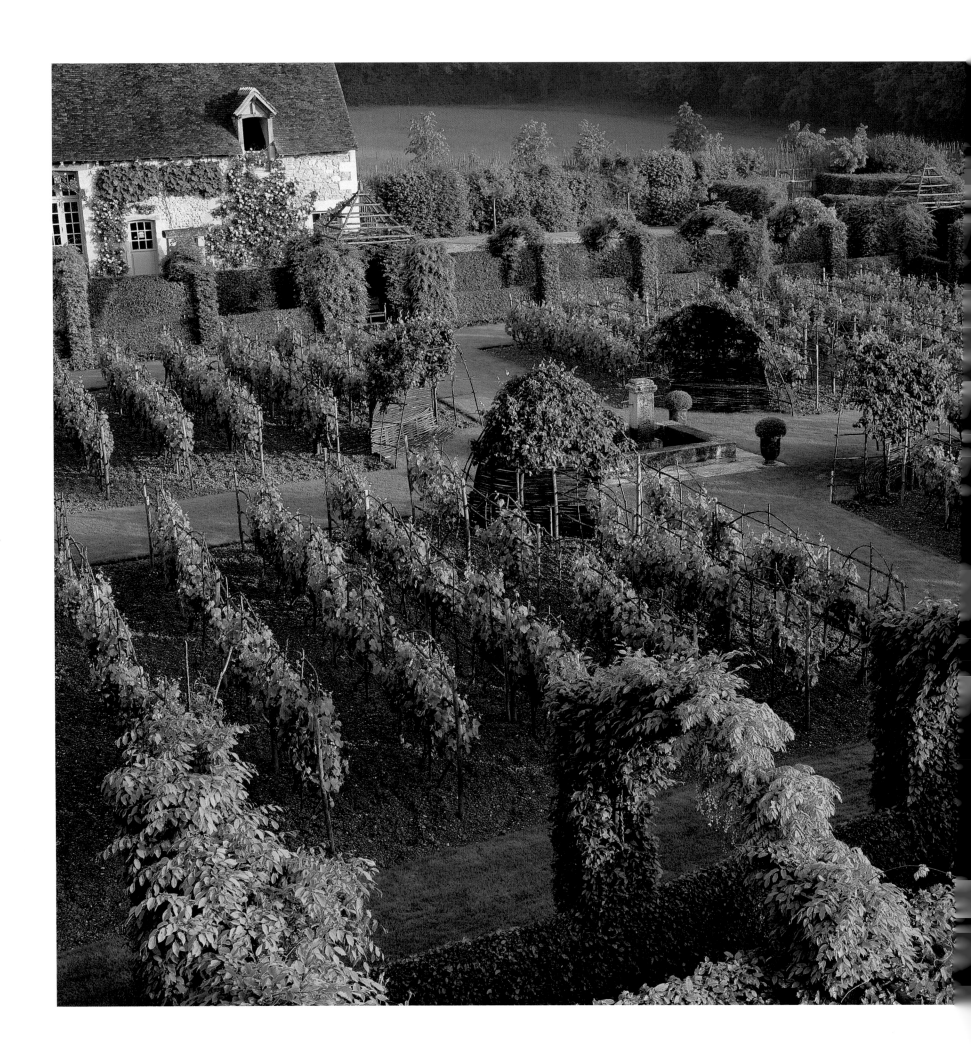

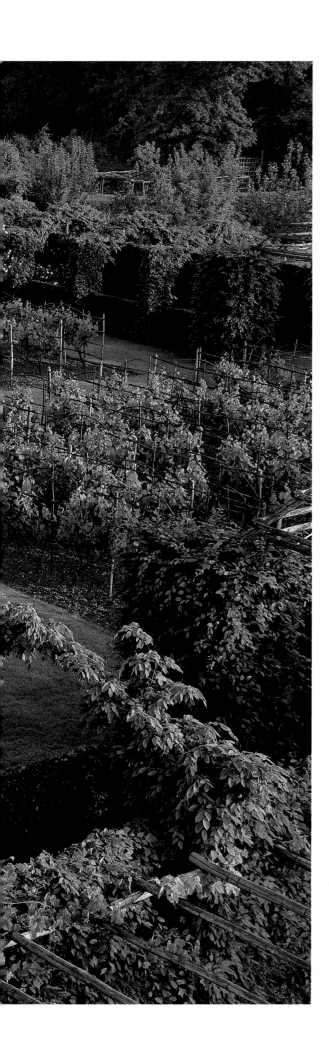

Priory of Notre-Dame d'Orsan

A PASSION FOR RE-CREATING THE PAST

MAISONNAIS, FRANCE
1995
Designers: Sonia Lesot and Patrice Taravella

Schwetzingen, Bomarzo, Sissinghurst: the most beautiful gardens are always born of passion. One such would appear to be the medieval garden of the priory of Notre-Dame d'Orsan, created by Sonia Lesot and Patrice Taravella. This architect couple had been seeking a monastery to restore in Italy when they discovered by chance, in the Cher département of France, the remains of a twelfth-century priory that had been rebuilt in the sixteenth and seventeenth centuries. It had been converted into a farm after the Revolution, and the buildings had remained practically intact; however, nothing remained of any garden that may have existed.

After a year of intensive investigations, the axes of a medieval-style garden emerged. It took only two years to lay out the nine enclosed gardens within the U shape formed by the buildings. These are arranged around a "cloister" of greenery acting as a point of passage between the various gardens, which are reached through eight arbors covered with creepers. There is a garden of medicinal herbs, an apple orchard, a soft-fruit garden, a vegetable garden arranged as a labyrinth, Mary's garden (a rose garden), an aromatic kitchen garden, a square containing different types of grain, an enclosure containing three orchards, and a vast flowering meadow, which acts as a link to the surrounding countryside.

The plants are old varieties, adapted to the climate and clay soil of the Berry region. Lattices of interwoven branches, raised benches, hedges, shelters, wooden benches, and fencing of chestnut wood give the gardens structure. All these elements have been designed and put together on the basis of models found in medieval documents.

As well as simples, flowers, and fruit, Orsan cultivates silence. Faced with this enclosed garden, which offers no vistas, "we stop, we stay silent, and we reflect," Sonia Lesot observes. The masterly success of the priory of Notre-Dame aims only to produce a re-creation, in an honestly informed way. In doing this it may have a better chance of coming close to something authentic. ⚜

This old twelfth-century priory in the Cher département, France, now possesses a garden that is close to the ideal models portrayed in medieval iconography.

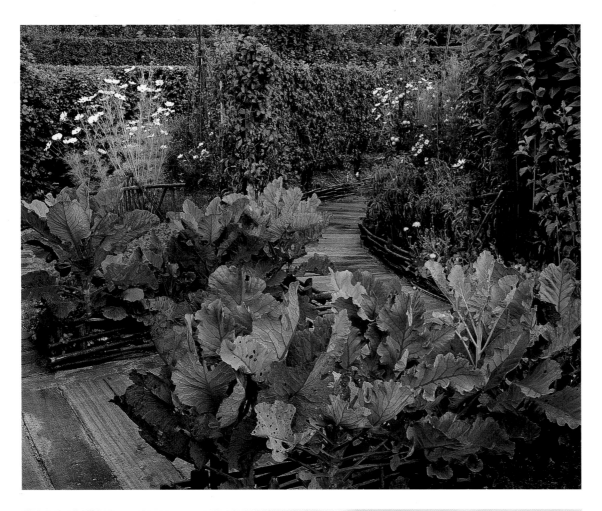

Old plant varieties are grown using traditional techniques: raised beds are protected by lattices of interwoven branches.

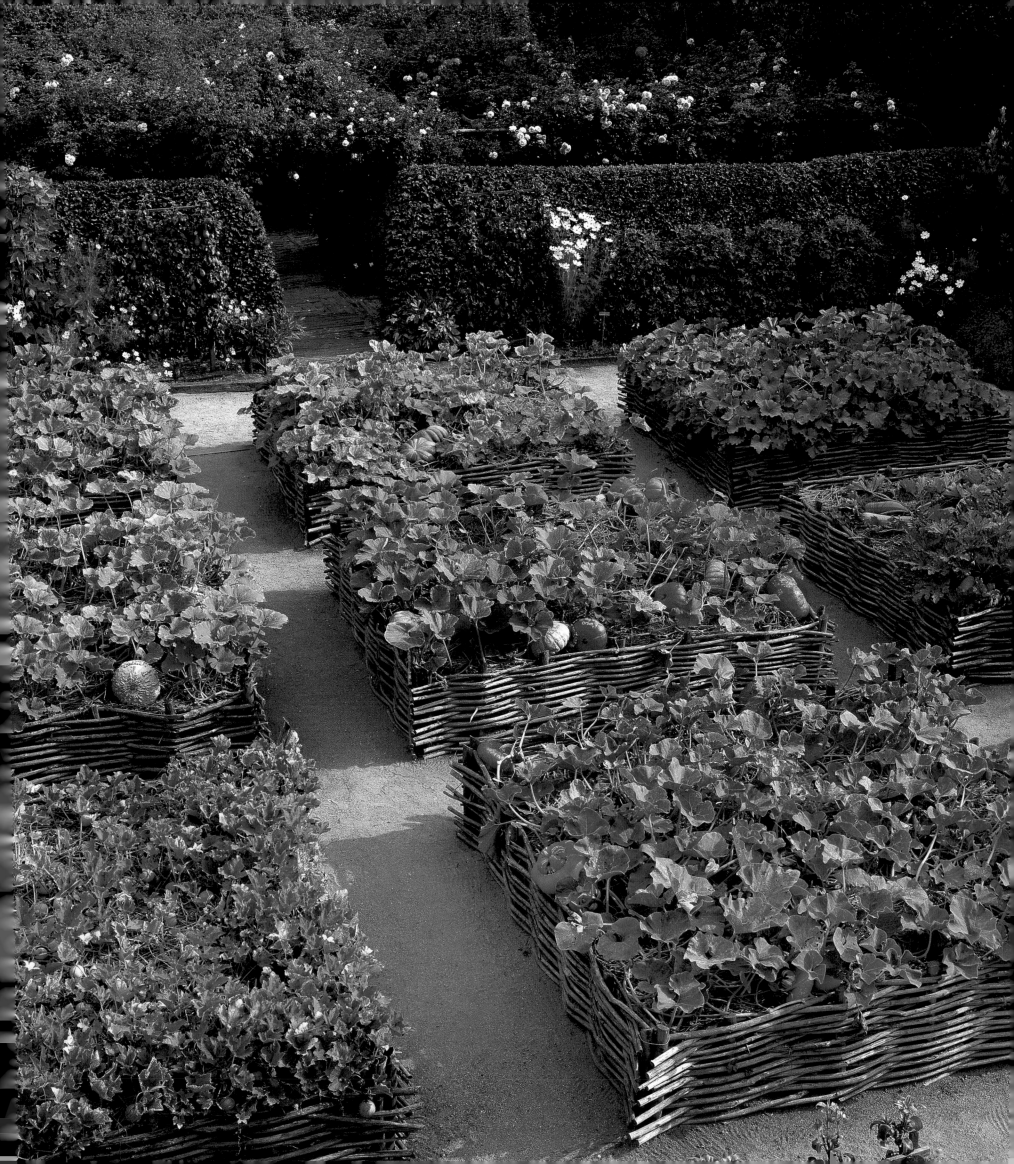

Queen Eleanor's Garden
A Scientific Reconstruction

WINCHESTER, GREAT BRITAIN
Thirteenth century–1986
Designer: Sylvia Landsberg

Were medieval gardens reserved for women? This is certainly the impression created by countless paintings and miniatures in manuscripts, such as that of the *Romance of the Rose,* which show beautiful young women sitting on the grass or under an arbor. Men, in the shape of young noblemen, usually appear only in amorous encounters. These illustrations should be interpreted according to the medieval symbolism of the enclosed garden, which represented the Virgin and young girls.

Along one of the austere façades of the Great Hall of Winchester Castle, which knew its finest hour during the thirteenth century when it was home to King Henry III, a small medieval enclosed garden has been re-created. It was dedicated to Henry's wife, Eleanor of Provence, and to Eleanor of Castile, wife of his son, Edward I.

The reconstruction—carried out by a team of architects, gardeners, blacksmiths, roofers, and an iron founder—drew on Albertus Magnus's texts on gardens (written around 1260) to create an herb garden worthy of the two queens.

Triangular in plan, it consists of a central pool surmounted by leopards' heads and a falcon, copied from an old description; a small canal that supplies water; a summerhouse; a tunnel of greenery; a trained vine; grassy banks; and raised flower beds. The plants are intended to illustrate fidelity and purity, as represented by ivy, holly, irises, peonies, roses, and lilies.

Most of what is known about medieval gardens is concentrated into this one very small reconstruction. ⚜

Left: The tunnel of greenery, 34 feet (10.5 m) long, is formed by chestnut branches mounted on a light metal framework—one concession to the modern world.

Above: The fountain with its bronze falcon and four leopards' heads was inspired by a 13th-century model.

Following pages: The flowers and hedge plants were chosen chiefly with reference to texts by Albertus Magnus.

Bayleaf

The Self-contained Garden

**WEALD AND DOWNLAND OPEN AIR MUSEUM
SINGLETON, SUSSEX, UNITED KINGDOM**
1990

Bayleaf is unquestionably one of the most interesting re-creations of a late medieval European garden. The farm itself was saved from demolition to make way for a reservoir by being dismantled and rebuilt at the Weald and Downland Museum in Singleton, near Chichester. The museum gives a fascinating insight into England's countryside and rural life.

The reconstruction is based on old documents and offers a realistic, plausible image of a wealthy farm at the beginning of the fifteenth century, which cannot have differed greatly from those of the Middle Ages. A small wood or grove shelters the barn, farmhouse, and orchard from damp winds, while the garden itself is sheltered by the handsome farmhouse, which half-timbering renders especially picturesque.

The garden—a kitchen garden—is clearly divided into eight parts, each of which is periodically left to lie fallow. They contain peas, onions, lettuces, leeks, beets, and cabbage, as well as three beds of aromatic plants and "sweet" medicinal herbs. The plants grow on raised banks separated by paved paths: only productive ground is worked, therefore. Of course, only organic methods are used, and after a few years the gardeners have noticed that the plants seemed to do better and better. Medieval treatises on agriculture only rarely mention insect pests or diseases, which suggests that the medieval garden had found its own biological equilibrium. Fertilizer is natural, produced by local livestock or by composting vegetable matter. The plants are protected from wild and domestic animals by fences made of hazel wattle, which is also used to retain the earth banks. Bayleaf is the idyllic picture of a self-contained rural paradise. ⌗

Through its buildings, orchard, thickets, and garden, Bayleaf has produced the most scientific reconstruction possible of a small farm at the end of the Middle Ages.

A Secret Garden

THE PRIVATE COURTYARD

BRUGES, BELGIUM
Twentieth century
Designers: M. Van der Aelst and Mien Ruys

A tiny enclosed space in the heart of the medieval town, this checkerboard garden is sown with medieval flowers: daisies, strawberry plants, pinks, peonies, and lilies.

Bruges was one of Europe's most powerful ports in the Middle Ages, and was famous not only for its canals but also for its gardens. Each large town house and each convent had its own private green space in which the *bouquetiers* (flower beds) contained rare flowers brought back by sailors from their travels. There was even a gardeners' guild, founded in the thirteenth century, which unhesitatingly took Jesus himself as its patron.

The secret charm of the gardens of Bruges is still entirely medieval. The way the town developed explains in part why it was necessary to enclose these spaces, which lay between a street and a canal from which protection was necessary. But from these purely practical constraints was born a very local taste for family intimacy, which is marvelously well conveyed by this garden, hidden in the heart of the city. It can be seen only from the tower of the church of Notre-Dame, for it is enclosed on all sides. This seclusion has allowed it to be converted into

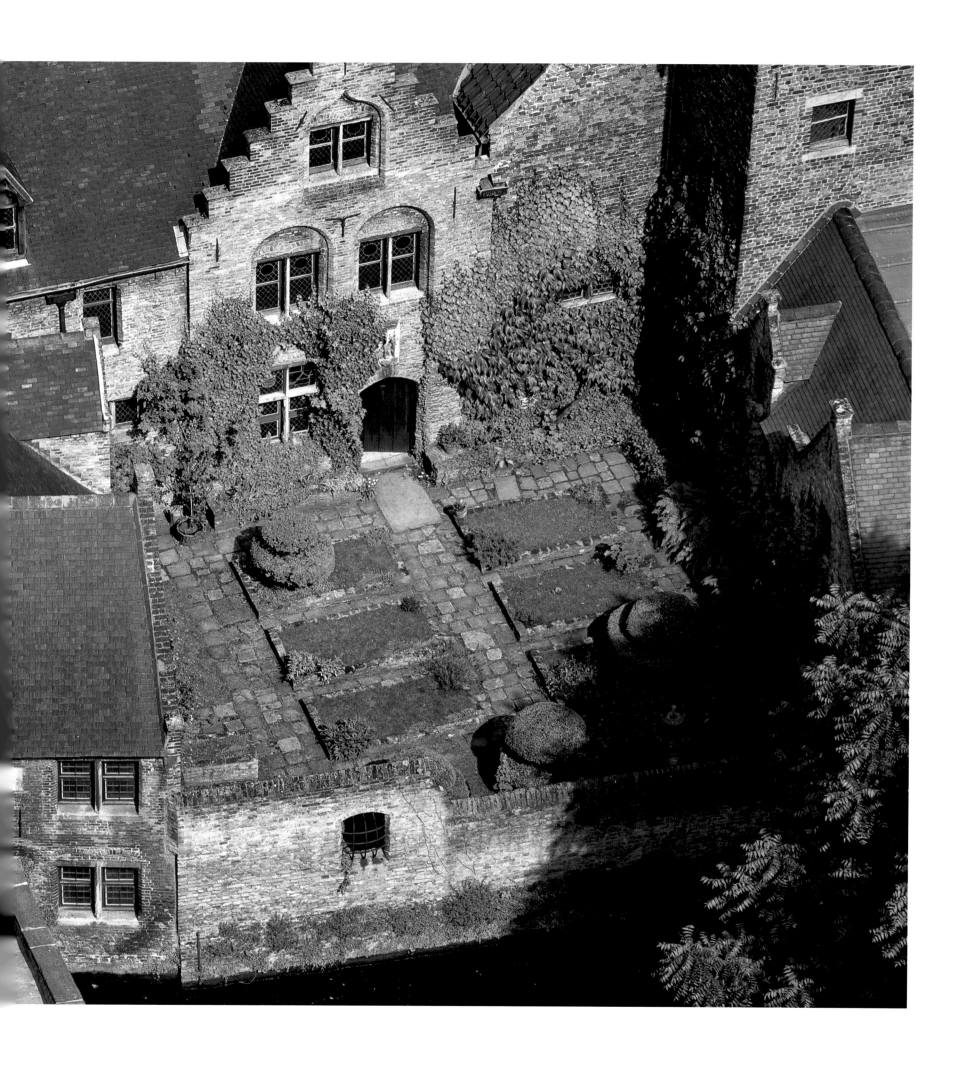

Left: An old variety of climbing rose and box trimmed to a flat shape, as in early Flemish paintings.

Above: In a corner stands a lead fountain from Tuscany.

a sort of outdoor room that is used in summer and that creates a pleasing openness when viewed from the windows of the very old house, which has been restored using early Flemish paintings such as Jan Van Eyck's famous *Portrait of Giovanni Arnolfini and His Wife* (National Gallery, London).

The Middle Ages are evoked simply by the green beds that lie between paved paths, and are raised by a low wall of mossy bricks. Old varieties of flowers (lilies, daisies, pinks, and peonies), a Tuscan fountain made of lead, box trees trimmed flat, and a rose bush re-create an atmosphere of delicate nostalgia for the splendors of the Flemish city that Erasmus called "the Athens of northern Europe." ✤

An Urban Cloister

PRIVATE GARDEN

BRUGES, BELGIUM
1977
Designer: André Van Wassenhove

An asymmetric labyrinth of box, paths and benches of brick, and a pool recreate the atmosphere of the small urban pleasure gardens of the Middle Ages.

Modern gardeners are always interested in the form of medieval gardens. Limited space, walls, orthogonal division of spaces, pruned plants, and the relationship of the garden with the adjacent architecture are all elements in a very modern language, and we might wonder whether some of the creations of Martha Schwartz or Toru Mitani have not been inspired by the spirit of the *hortus conclusus*.

This town garden, which is invisible from the outside (access is only via a long corridor) was designed by the Bruges landscape gardener André Van Wassenhove to complement a fine fifteenth-century house that is set in a particularly dense medieval urban fabric.

The division of the ground into beds has been ingeniously adapted to create a labyrinth—which, however, is not really a labyrinth. This break with the orthogonal structure seems to make the space larger by creating an interplay of complex lines by means of brick or stone paths. The plants and flowers in the garden could have been there at the time the house was built. A pool contains some water plants, a mulberry casts a dark shade in summer, and ivy, wisteria, and some specimens of *Polygonum baldschuanicum* cover the dark brick walls of the adjacent buildings. It is *hortus sereniger*—which brings serenity. ✤

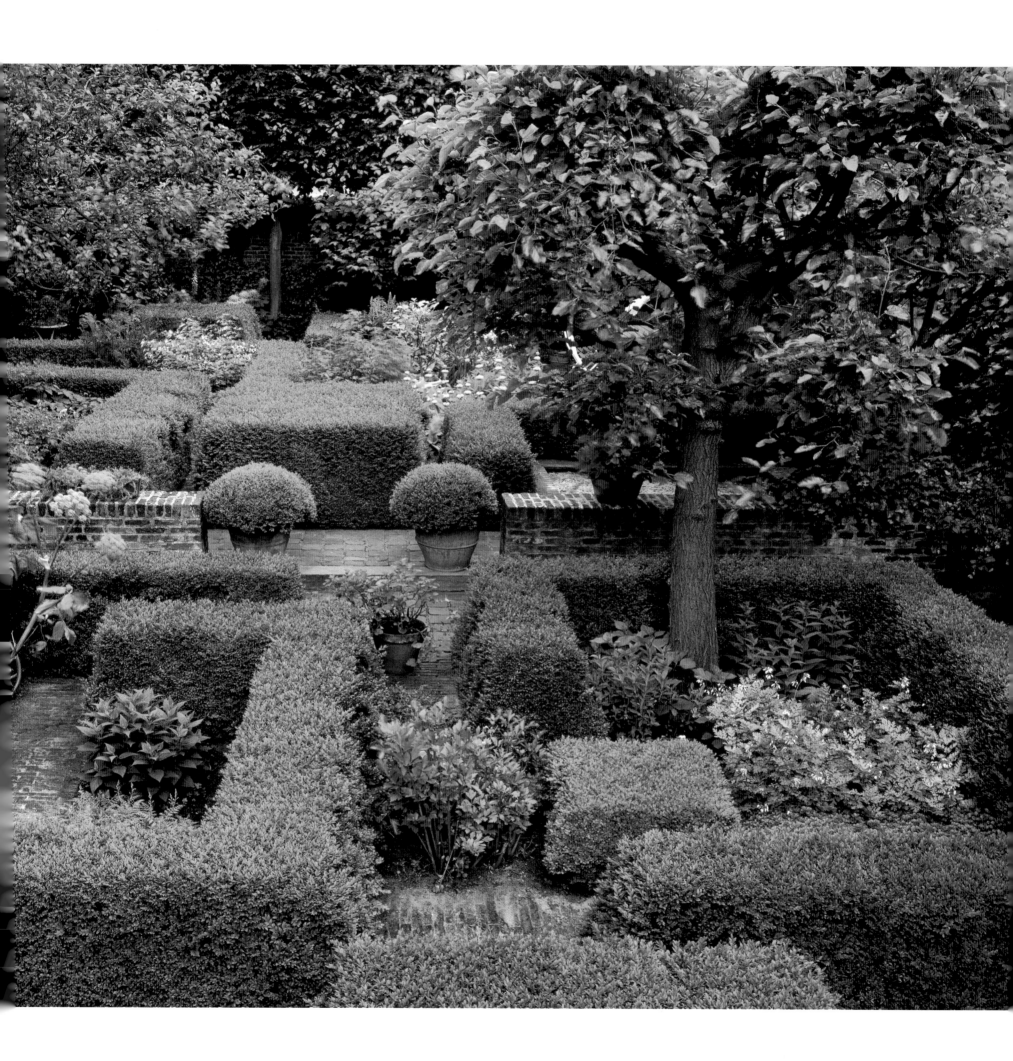

Gardens of the Renaissance

As in all areas of art and scholarship, the Renaissance left a profound mark on the history of gardens. The enclosed medieval garden, intended for ladies or for monks, planted with small flowers and medicinal or symbolic herbs, no longer fitted with the changes under way in society and the new wealth created by the development of trade. Fortresses became villas, and princes left their gloomy urban palaces in search of a more cheerful environment, better suited to enjoyment. A book that appeared in 1499, *Hypnerotomachia Poliphili* (Poliphilo's dream about the strife of love), attributed to the Dominican Francesco Colonna, became the manifesto of the new garden in all respects—structure, horticulture, and arboriculture. It was translated and read avidly throughout Europe.

Designers of Renaissance gardens tore down walls, opened up vistas to wild nature, created subtle visual and functional links with villas, placed antique statues on display, and manipulated water in countless ways. Low hedges planted in patterns formed ever more complex intertwined motifs; flowers took over the beds, which were lowered to ground level; and trees were pruned to exedra shapes to form conversational corners. Nature seemed to become a process of construction, in which each gardener put together the elements according to flexible rules. Mathematics (plans and perspectives) and science (hydrology and agriculture) reigned supreme, and the way they were displayed—for example in Raphael's gardens for the Villa Madama in Rome—dazzled visitors. The Renaissance humanist was visibly glad to prove his new mastery over the world, and his garden was the ultimate expression of a culture of conquest.

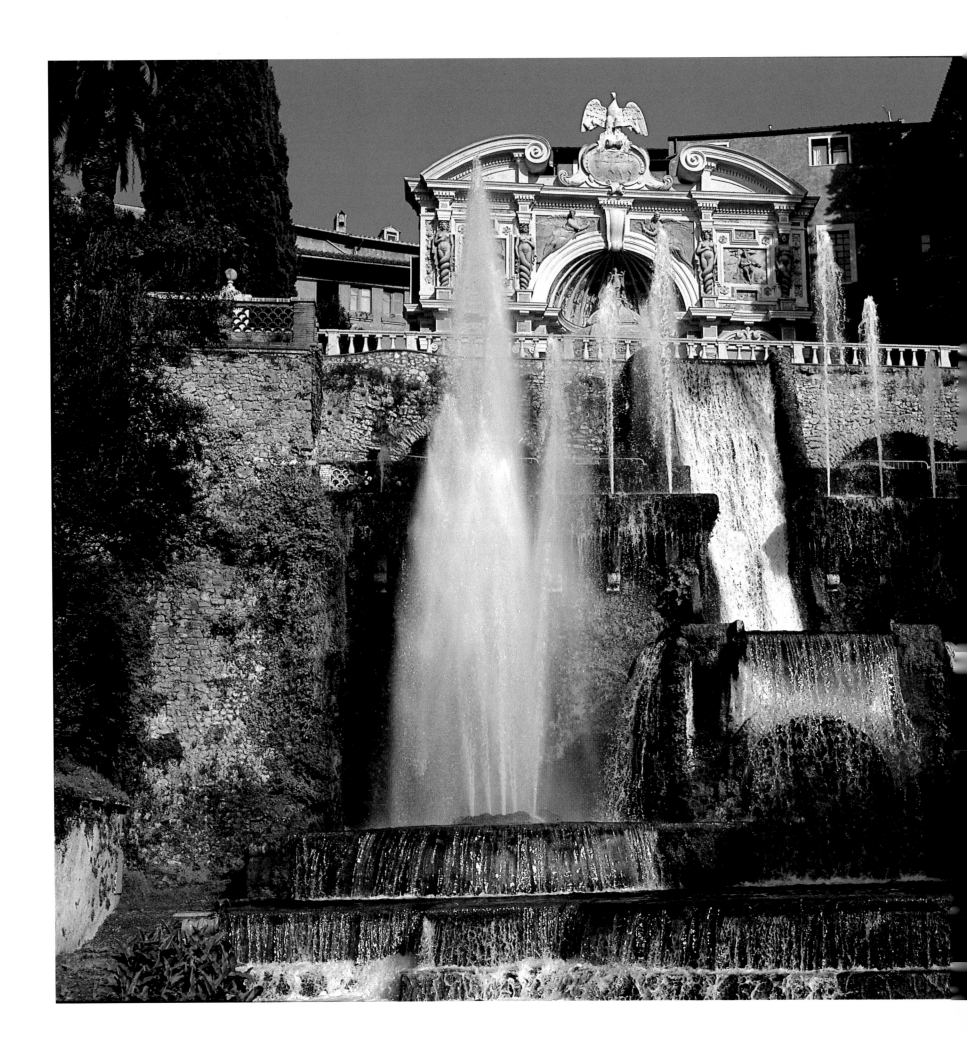

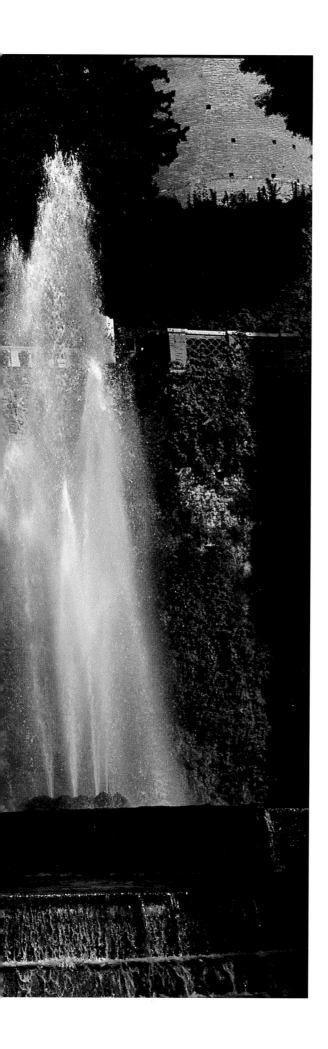

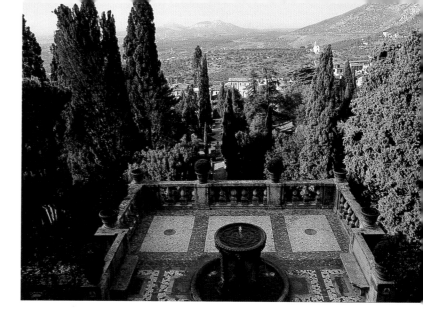

Villa d'Este

The Garden as Epic

TIVOLI, ITALY
1550
Designers: Pirro Ligorio, Giacomo della Porta
and Orazio Olivieri

In 1937 Geoffrey Jellicoe wrote that if we had to draw up a list of the seven wonders of the world of gardens, the Villa d'Este might well take first place. Coming from the pen of one of the great landscape gardeners of the twentieth century, this compliment is by no means insignificant, and his view is shared by the thousands of visitors who each year discover the enchantment of Tivoli, despite its relatively poor state.

Four men were responsible for this masterpiece, which has inspired painters, writers, and composers for more than four centuries: Cardinal Ippolito II d'Este (1509–72), son of Lucrezia Borgia; Pirro Ligorio, an architect of Neapolitan origin who studied the remains of Hadrian's Villa nearby; the Roman architect Giacomo della Porta (born c. 1532), who took over from Ligorio; and Orazio Olivieri, a famous hydraulics engineer who was a discreet but invaluable genius. The villa, this enormous "barracks," as Edith Wharton described it, was never completed but plays a part in the astonishing concave construction Ligorio undertook between a steep hillside and the Aniene River, which feeds a multitude of water jets, fountains, and pools. In erecting this formidable architectonic wall it was necessary to take into account the precipitous terracing; indeed, visitors were invited to start their tour at the lower end, in the *giardino delle semplici,* a simples garden with a highly geometric plan. What we see here is a triumph of the Renaissance movement of Mannerism, which prefigures the Baroque. The effect is studied and cultured, even if this is

A veritable cataract gushes from the upper terrace, where the imposing villa of Cardinal Ippolito II d'Este stands.

Following pages: The Avenue of a Hundred Fountains, at the bottom of the terraces, where water is spewed out of the mouths of as many lion heads or vases.

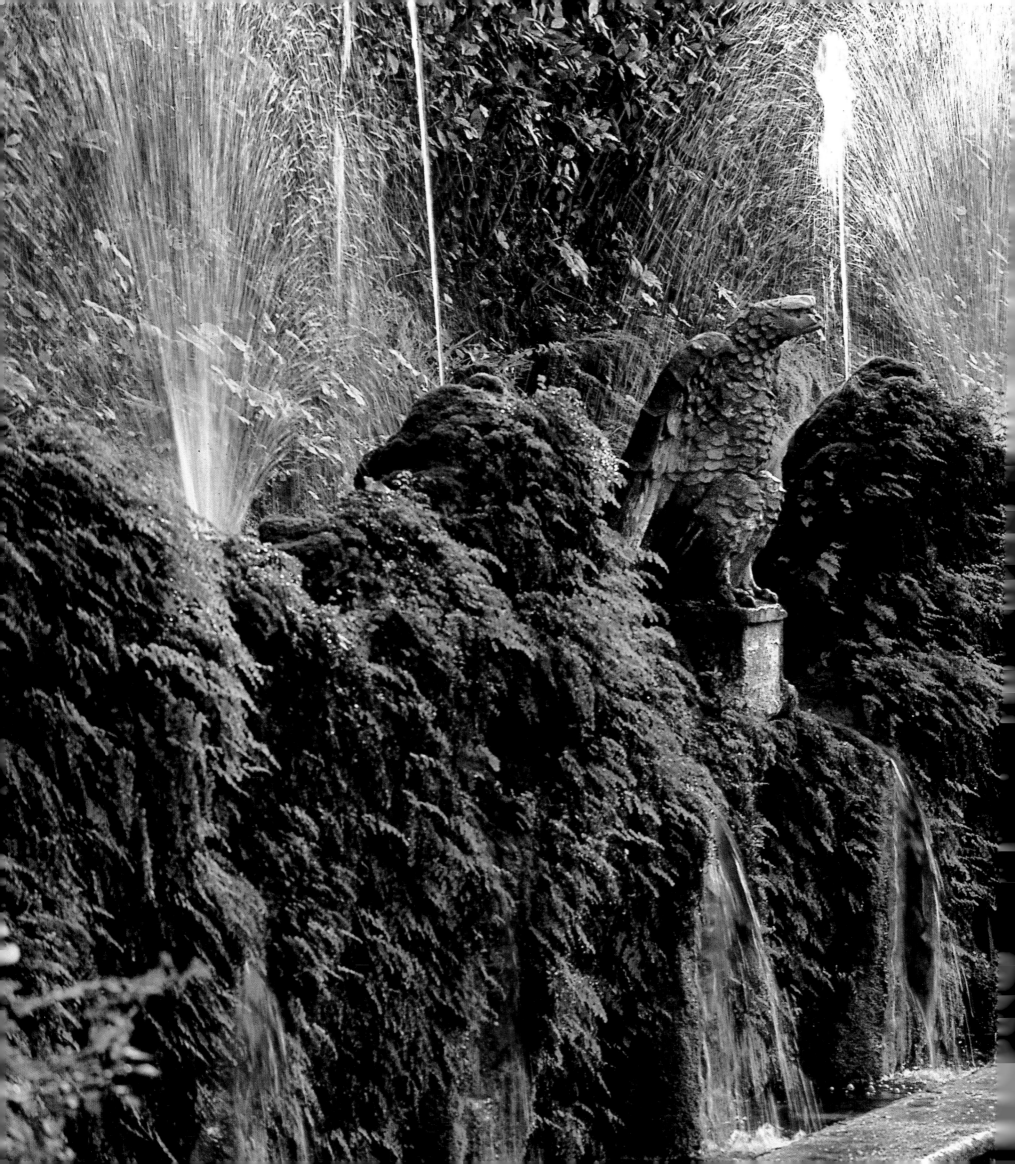

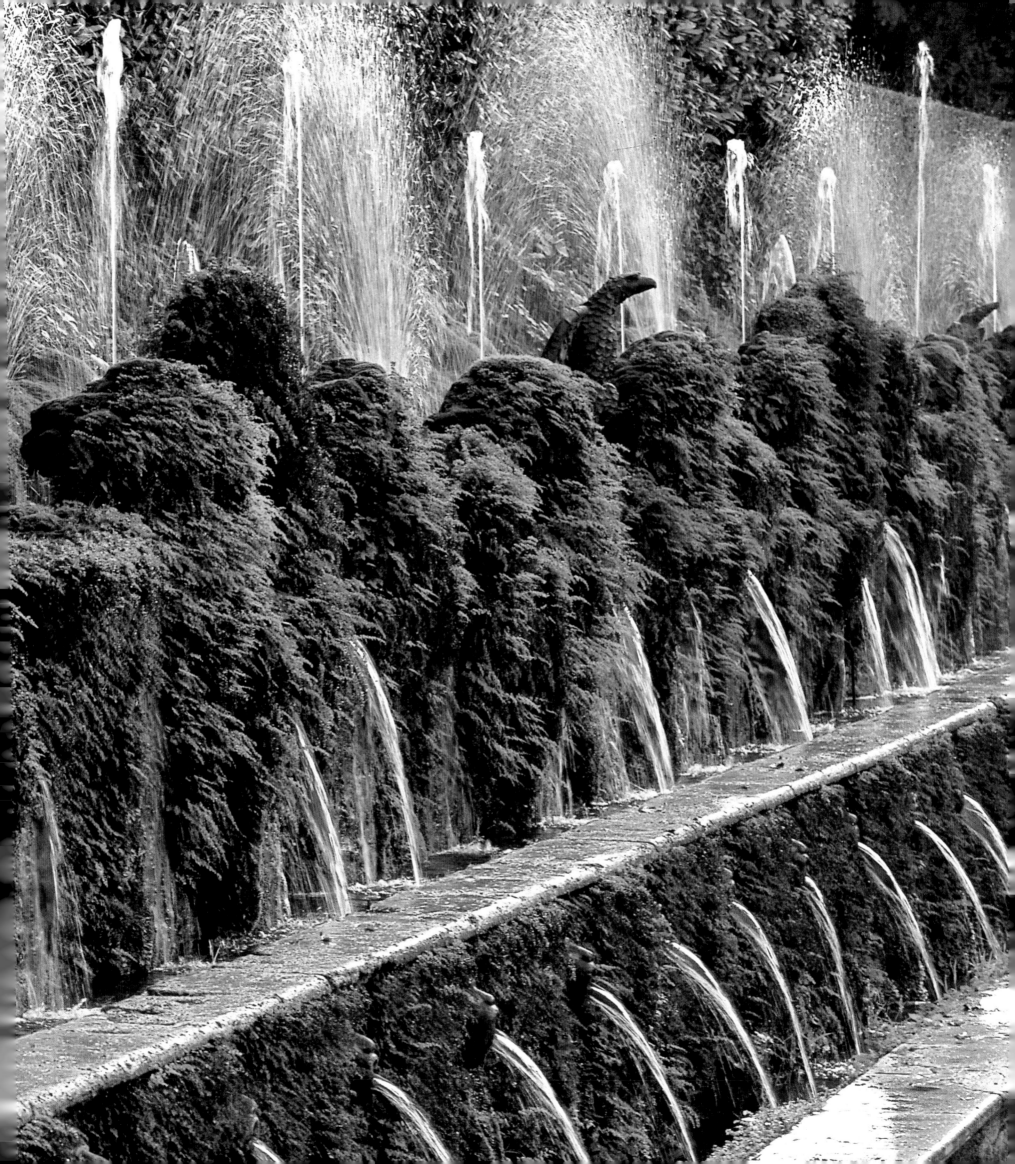

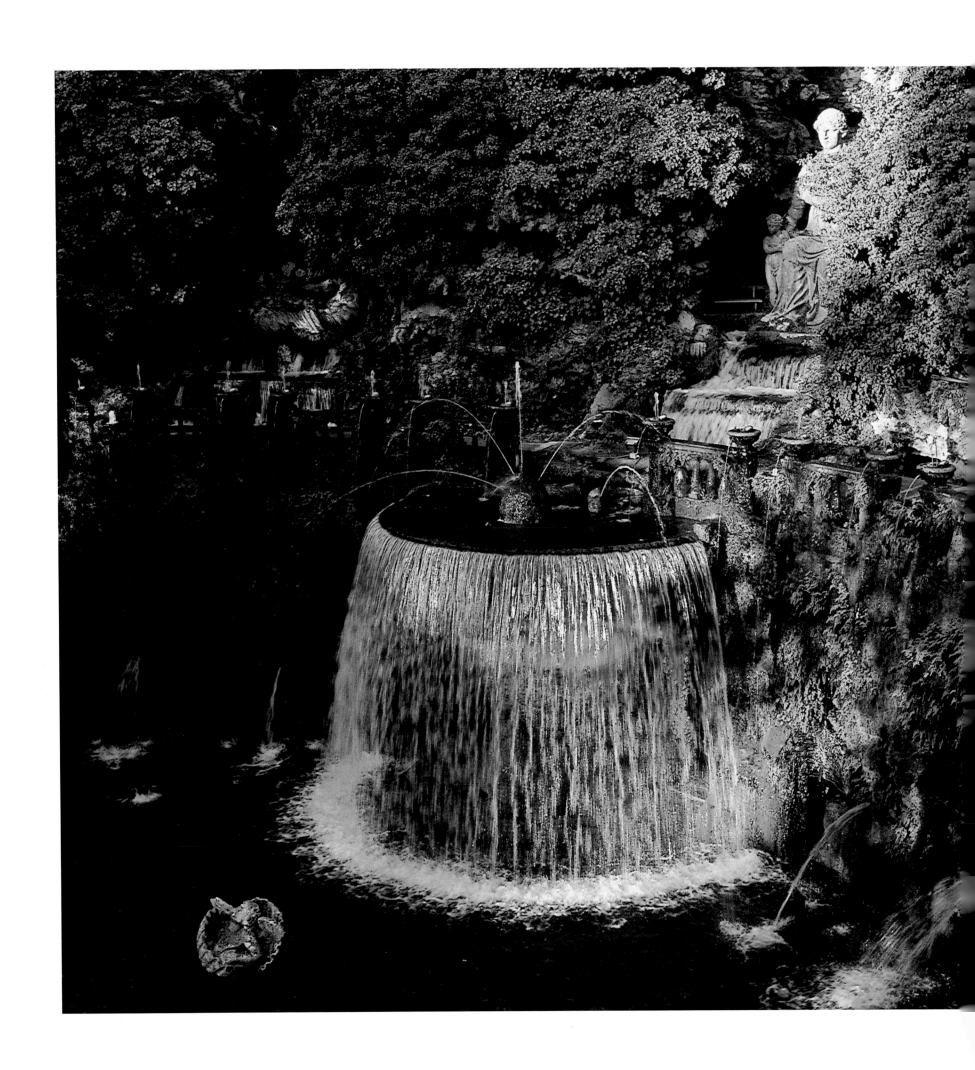

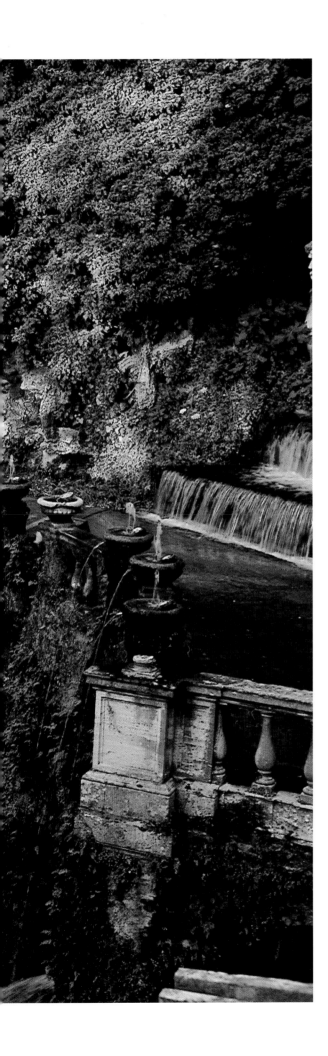

at the cost of some ponderousness and infantile symbolism. We cannot fail to be transported by the fountains, the avenue of a hundred water jets, the theater of gushing waters, the Dragon Fountain, the cascade of fish ponds, and even by the slightly oppressive atmosphere produced by the giant cypresses, the invasive ivy, the moss that smothers basins and fountains, and the wind that sweeps along the dusty paths.

The Este gardens clearly illustrate symbolic themes in late Renaissance thought. Ligorio was probably responsible for this humanist iconography, which is based on ancient themes (for example, the reconstruction of Olympus) on religious themes (there are depictions of the stories of Noah and Moses) and on the great theme of the family mingled with an agreeable paganism in which Hercules, whom the cardinal regarded as a distant ancestor, appears many times.

The Villa d'Este is the perfect example of those great mythical creations whose fascination has not lost its power with the passage of time. A famous engraving by Étienne Dupérac dating from 1573 shows the garden just after its creation. Everything is ordered, luminous, clear, and the paths are distinct. With the relative neglect that the estate suffered during the eighteenth and nineteenth centuries, nature has gradually reasserted itself. Gardens that were once so neatly drawn have acquired a romantic, gloomy quality, as if the gods of the cardinal's proud Olympus have taken their revenge. ⚜

Opposite: The Oval Fountain, over which towers a statue of the sibyl of Tibur, the main element in a theatrical water display.

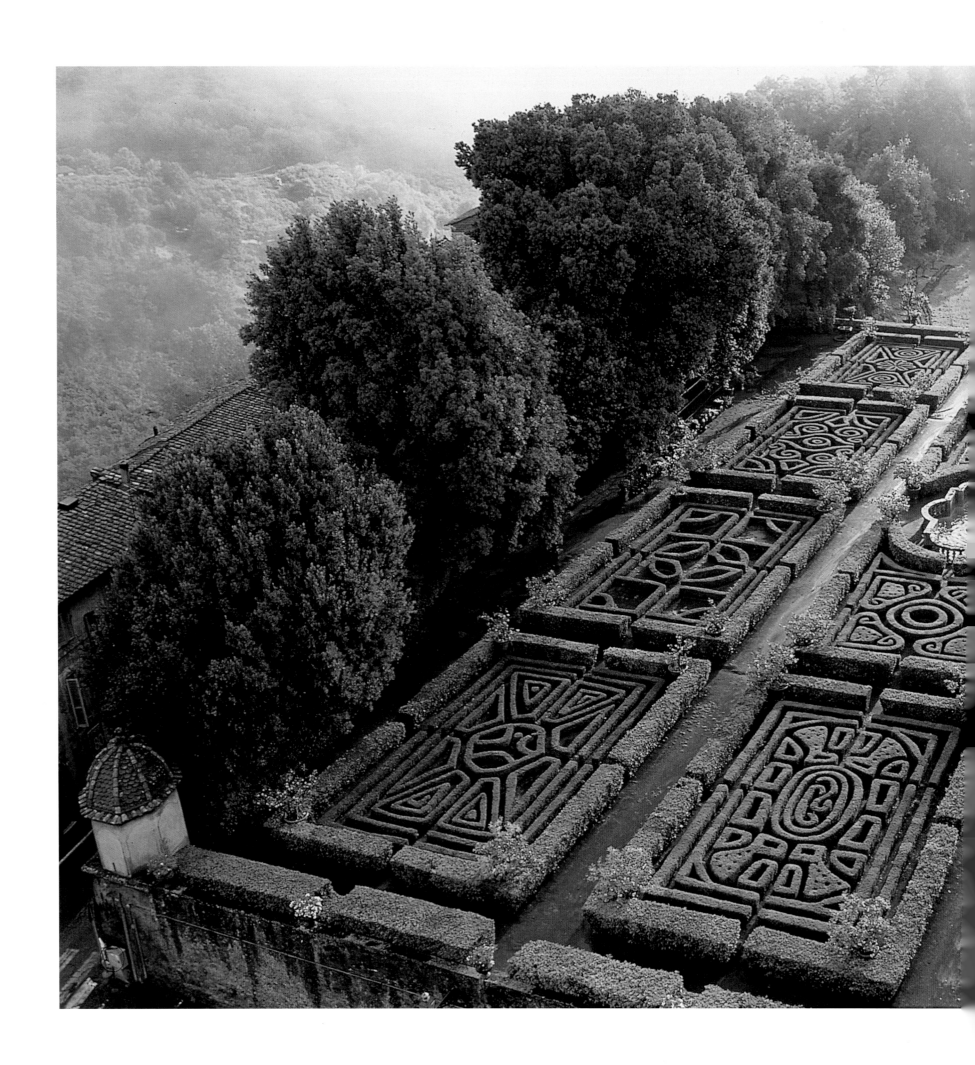

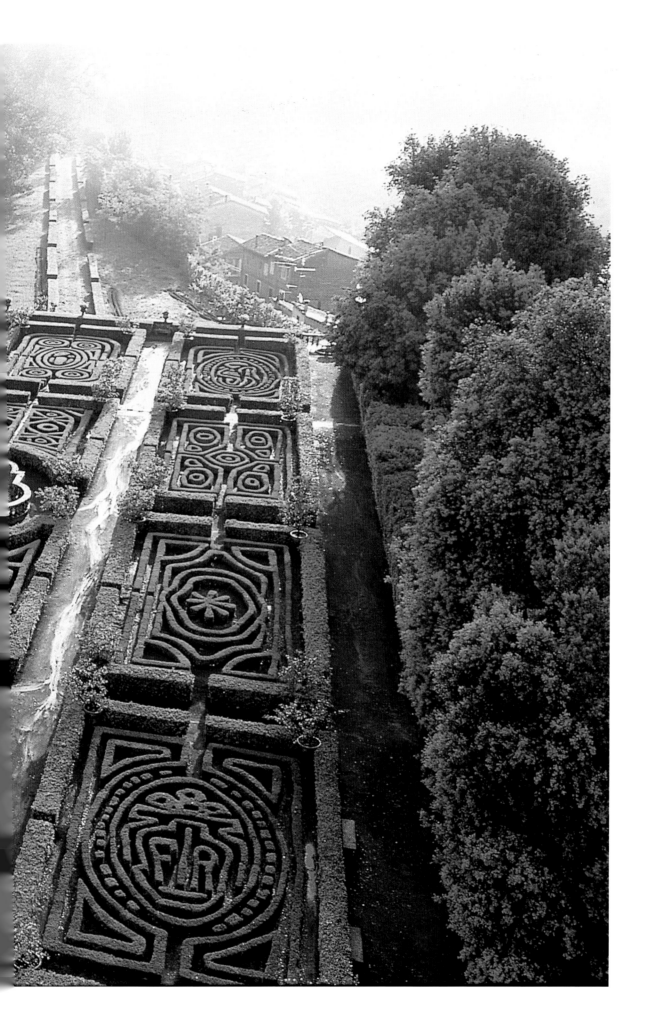

Castello Ruspoli

A FAMILY TRADITION

VIGNANELLO, ITALY
End of the sixteenth century
Designer: Ottavia Orsini

This former Benedictine monastery, converted into a fortress in the eleventh century and then into a castle in the sixteenth century, has retained its gardens almost intact. An inventory dating from 1656 lists a garden of greenery, a small secret garden, the *barchetto* (small park) and *barco* (park) reserved for hunting, a wood, and an orchard.

The *giardino di verdura* (garden of greenery) is one of the best-preserved gardens of the Italian Renaissance. It is the work of Countess Ottavia Orsini (daughter of Vicino Orsini, of Sacro Bosco, Bomarzo), who modernized the fortress starting in 1582 and undertook large-scale works, banking and shoring up the ground in order to create terraces on a spur of fragile tufa.

The garden is divided into twelve compartments, demarcated by trimmed hedges of laurel, myrtle, and box, within which are fine patterns of trimmed box hedges. Their design is decorative, emblematic, or incorporates the initials of Countess Olivia and her two sons, Vicino and Galeazzo. At the center, an elegantly scalloped fish pond enlivens the whole with a murmuring fountain. In its perfection, this garden is the culmination of the Italian Renaissance style that for two centuries was to inspire the sumptuous flowerbeds of palaces in France, England, and Germany. ✥

On the borderline between the Renaissance and the early Baroque, this green garden on a spur of tufa has been preserved exactly as it had been by the Ruspoli family for more than four centuries.

Sacro Bosco

THE AESTHETIC OF THE MONSTROUS

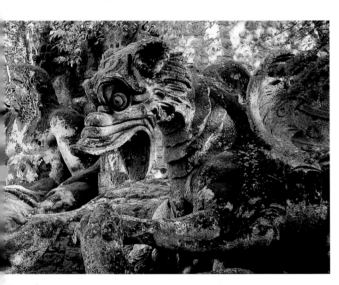

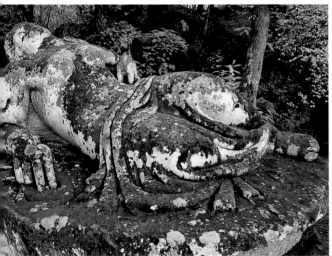

BOMARZO, ITALY
1548–80
Designer: Vicino Orsini

So much effort, so much money, and so much imagination were invested in this garden, which soon fell into oblivion! It was not until the 1950s that the art historian Mario Praz brought about its rediscovery and rescued it from the vegetation that had swallowed it up.

Who, then, was this Vicino Orsini who engineered the transformation of a ravine below his palace at Bomarzo into a garden to which Salvador Dalí would one day pay tribute? The none-too-wealthy heir of a minor branch of the Roman Orsini family, he was involved in a few military adventures, which cost him two years' jail in Flanders. A great traveler, he also read widely, especially metaphysical poetic works such as *Hypnerotomachia Poliphili* (Poliphilo's dream about the strife of love), attributed to Francesco Colonna, or *L'Amadigi* by Bernardo Tasso, which are full of descriptions of peregrinations in strange lands populated by monsters, which clearly inspired him. After retiring to his estate he decided to modernize his ponderous palace at Bomarzo. Unable to rival Alessandro Farnese, who was building the fabulous villa of Caprarola not far away, perhaps he chose to distinguish himself by creating an incomparable

garden. To this he devoted the rest of his life, from 1548 to 1580, periodically adding a new sculpture, fountain, grotto, or temple. However, these were enormous, strange, wobbly, or deformed. Many visitors were shocked by the rustic realism of certain sculptures placed at the entrance, such as that of a giant dismembering a young woman. Many interpretations of the garden have been put forward. The plan is confused, or has been blotted out altogether: all that remains are a few constructions and some sculptures of "monsters" that are very similar to the grotesques that appear in so much decorative painting of the time. But here they are greatly magnified, and in stone.

Bomarzo is one of the most extravagant fantasy gardens of the late Renaissance. ❧

*Left, top: The dragon probably evokes a
passage from the work of Bernardo Tasso.*

*Left, bottom: This sleeping nymph
is of monumental proportions.*

*Opposite: A screaming mask is placed
at the end of a path to frighten visitors.*

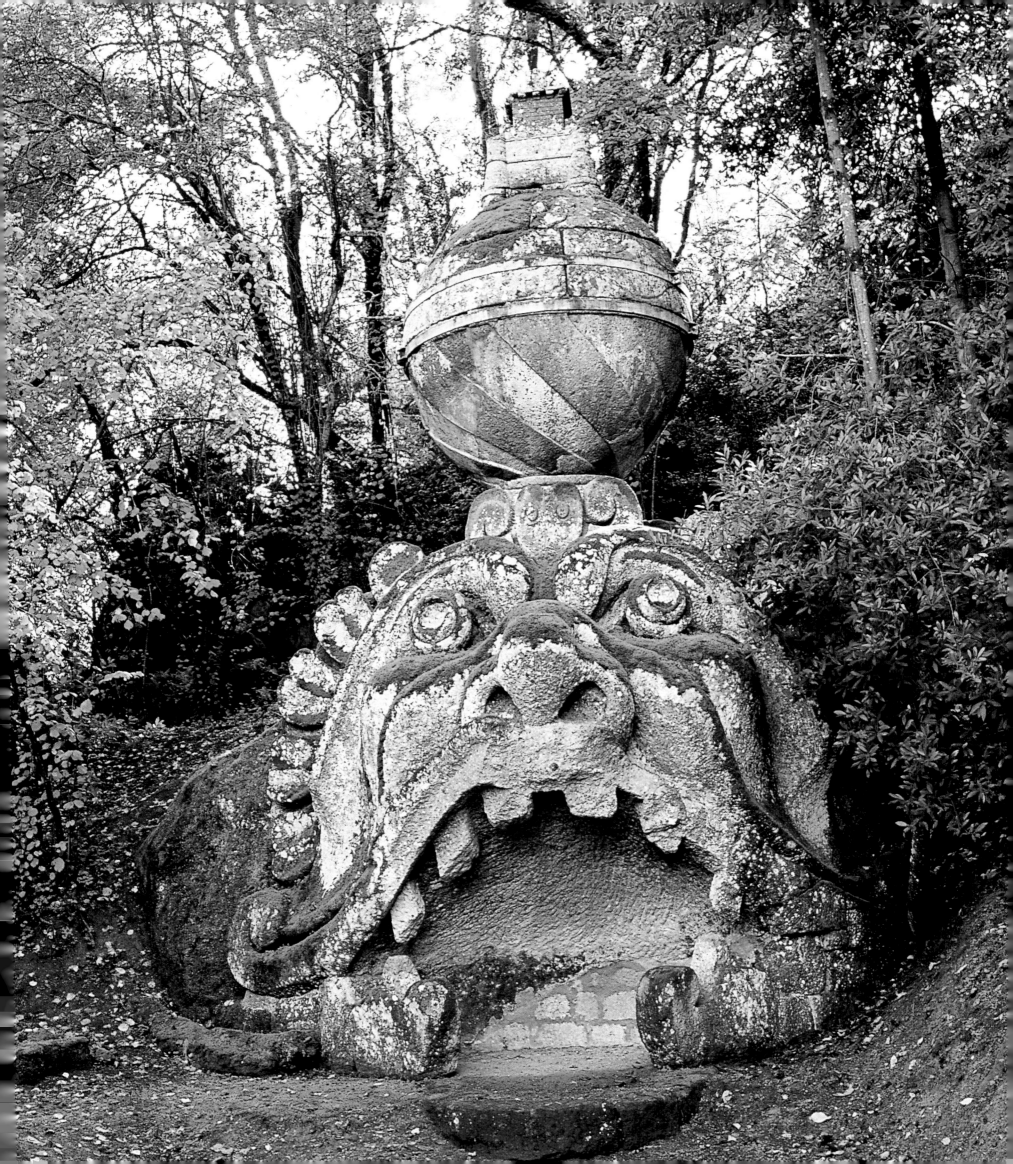

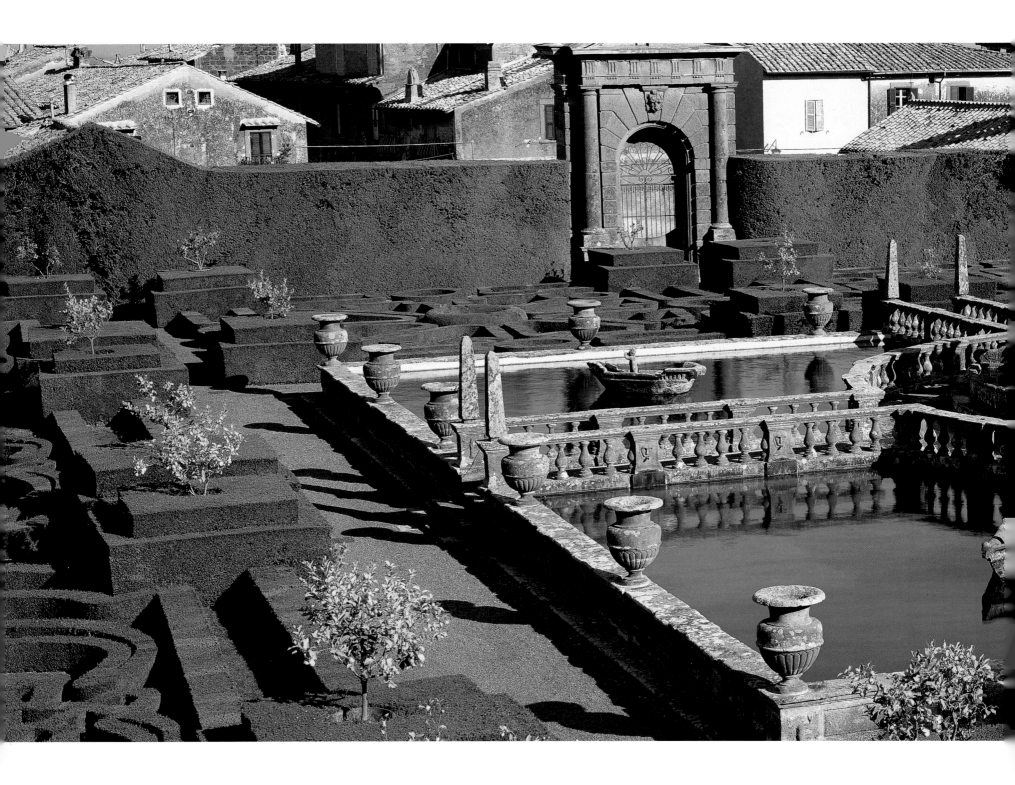

Villa Lante

The Expression of the Renaissance Style

BAGNAIA, ITALY
1566
Designer (presumed): Vignola

The gardens of the Villa Lante, at Bagnaia, near Viterbo, are the only gardens in Latium to have lasted the centuries without undergoing significant change, and in historical terms they can teach us more than can the villa, which consists of two small independent pavilions. In 1566 Cardinal Gambara was assigned ownership of the *barco* of Bagnaia, a vast hunting reserve surrounded by walls on the heights of the small town. Immediately he began

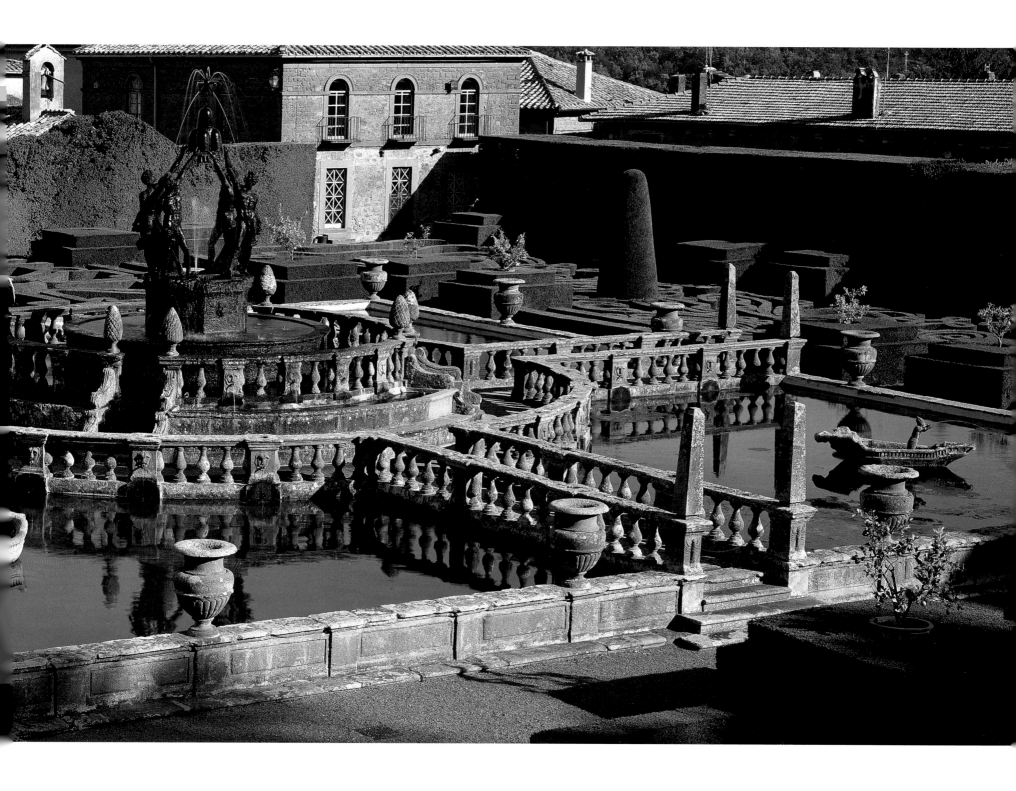

to build a villa, connected to this park by a series of tiered terraces. Working on difficult terrain, and neither able nor willing to resort to producing a piece of palatial architecture, he created a pleasure garden so masterfully executed that it was preserved by all his successors. The great Vignola—sculptor, architect, and landscape gardener—is thought to have been responsible for the plans, but no document has yet confirmed this.

As at Tivoli, water flows down from the heights of the park to the village via a variety of original devices. The visitor set out from the Fountain of the Deluge, continued to the Fountain of the Dolphins, reached the Fountain of the Giants, then that of Pegasus, and passed through the grottoes of Neptune and Venus to arrive, finally, at the imposing Fountain of the Moors at the gates of the village. Perhaps they took refreshment at the cardinal's vast

"table" of floating dishes and relaxed by the music of the *catena d'acqua,* a small, sloping aqueduct down which water poured at breakneck speed, in a splashing of moss, light, and sound of rushing waters. ⌖

The gardens of the Villa Lante are the most perfect expression of the Renaissance garden, dedicated to the delights of life.

La Gamberaia

Florentine Elegance

SETTIGNANO, ITALY
Seventeenth to twentieth century

Described by Bernard Berenson, Edith Wharton, and Harold Acton, La Gamberaia is an elegant villa at Settignano, on the hills above Florence. It was built in 1610 and both the villa and its gardens retain the style of the end of the previous century. After being lovingly tended by successive owners, it was destroyed at the end of World War II, but was restored so that it is almost identical to the original building. Its idyllic gardens were rearranged and preserved at the beginning of the nineteenth century by Martino Porcinai and Luigi Messeri, two distinguished landscape gardeners.

The photogenic charm of this long and narrow garden, suspended like a balcony above the Arno valley, lies in the connection it creates between the villa, the adjacent woods, and the outlook over a vast panorama. It is not so much an outside room as an open-air apartment with several "rooms"—a lawn, a garden of lemon trees, a "chamber" of rocks, a water garden—separated by hedges, differences in level, and even by a geological fault. It is demarcated by a famous exedra of pruned cypresses. Some of these "rooms" look out on to the villa, others on to the surrounding natural landscape. The secret of this place lies no doubt in this concentration of ideas, which make it a Renaissance garden that is emblematic of Italy. ⌖

Restored at the beginning of the twentieth century, the gardens of La Gamberaia, which look out over Florence, remain emblematic of the art of living in the Tuscan countryside in the sixteenth century. The famous exedra is in the background.

Park of Courances

THE GRANDEUR OF THE FRENCH FORMAL STYLE

FRANCE

Sixteenth to twentieth century

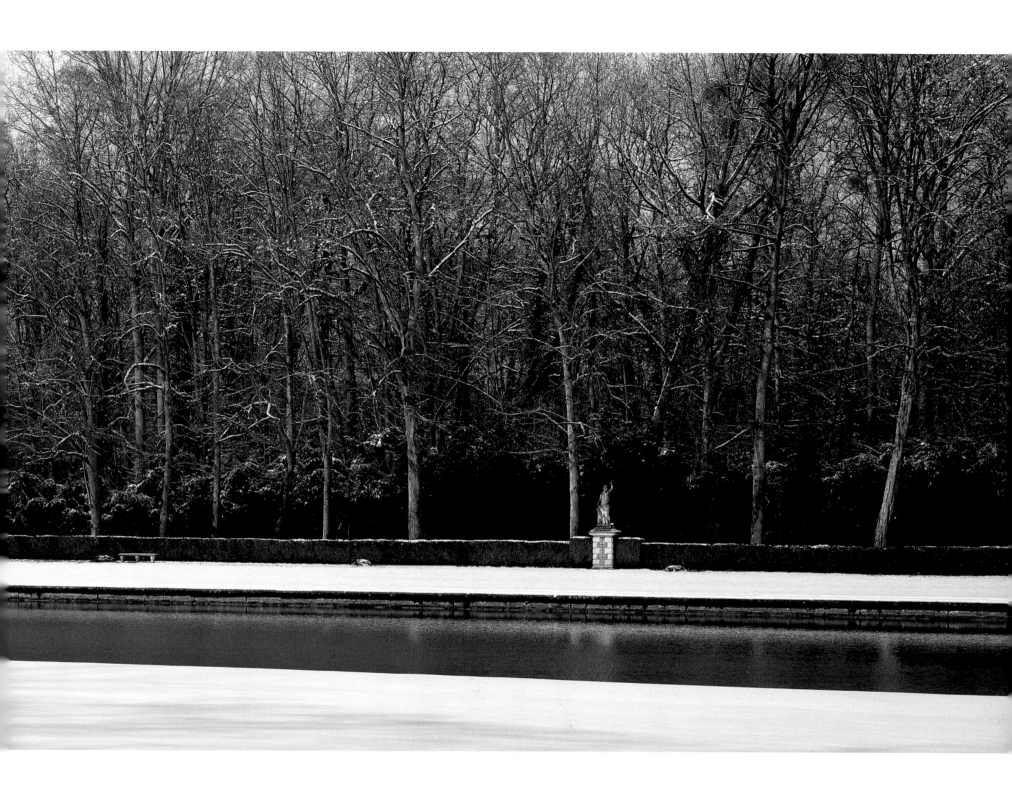

For two hundred years it was fondly believed that the park of Courances, near Fontainebleau, was the work of André Le Nôtre. This notion was not based upon any particular document, but it was sufficiently flattering and plausible that the park's former owners, as well as visitors, liked to think so. Recent research, especially by the historians Sylvie de Gaspéri and Françoise Boudon, have shown this to be false. The main features of Courances existed before André Le Nôtre emerged, and if there was any connection at all, it would have been with his father, Jean. The essentials of the park were already laid out by 1622. Archival research, followed by the study of maps and aerial photographs, later revealed that an initial project for a park had been begun in 1558.

This discovery—of which one had a presentiment when walking along the paths by the enormous pools, the immense canal, and other bodies of water—also demonstrated that Courances was a water garden. This type of arrangement was very widespread during the sixteenth century in northern Europe in marshy areas or regions that were abundantly watered by rivers whose banks were still not

The Mirror, in front of the palace. The hedges are punctuated by ten statues inspired by antiquity.

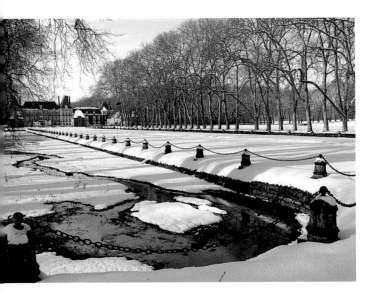

Above: The lake of the double plane trees.

Right: The lake of the single plane trees.

firmly defined. Water was a defense (in the form of a moat) as well as a source of energy (for watermills) and pleasure, for it allowed parks and gardens to be laid out. In 1530 Francis I (r. 1515–47) had the Great Garden laid out at Fontainebleau, which was divided into islets by a network of canals. Androuet du Cerceau, too, in his third *Livre d'Architecture* (Book on architecture) of 1559, illustrated the use of canals in the gardener's art. And Chenonceaux pushed the fashion for water to extremes by placing the palace on the river itself, with its gardens, surrounded by moats, on the bank.

The reconstruction of the original plan of Courances has shown that at the end of the sixteenth century the great canal was already in place, as were the palace's moats, the water room and its fourteen

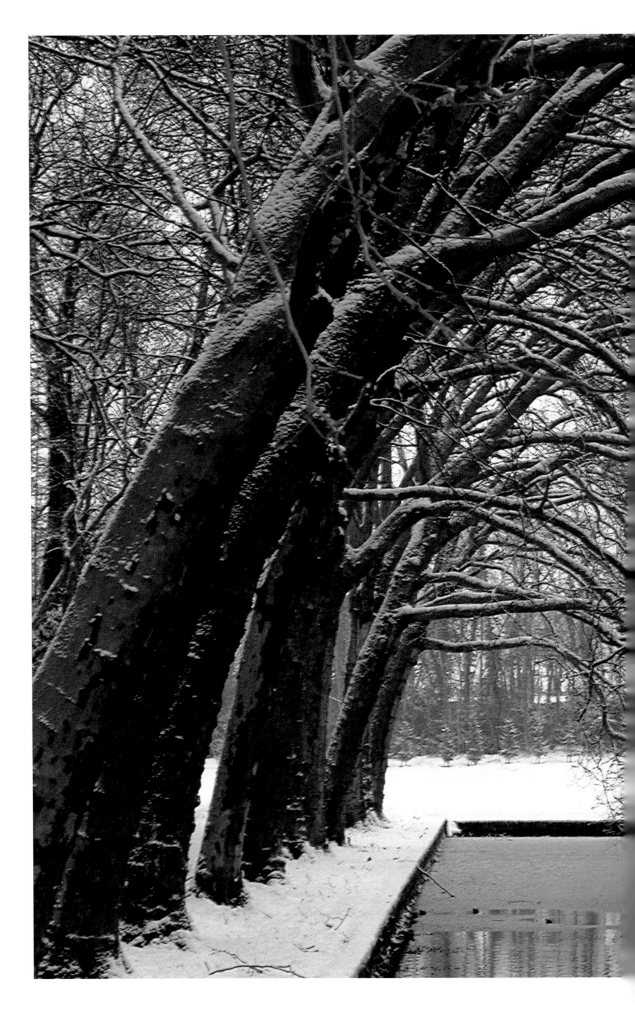

spouts from which gushed an ample flow, the canals at the entrance, an "island meadow" surrounded by canals, and two pools near where the Japanese garden is now. During the seventeenth century this watery scene was enhanced with lateral canals, in line with the castle, and the Gerbe pool and canal, where the little river was channeled.

What is also interesting about this research is the continuity that it has revealed. Many famous gardens have been transformed over the centuries, often for the better, but not always, as can be seen at Het Loo and at Villandry. In its unquestionable beauty, born of its rigor and timeless modernity, Courances embodies a great gardening tradition of the Île-de-France region that dates back to the Renaissance. The Ganay family has thus for a century safeguarded a living testimony to the history of gardens. ❧

Opposite: The snow picks out the
patterns of trimmed hedges added
by the landscape gardeners Henri
and Achille Duchêne in 1904.

Above: The two marble recumbent
lions—this one has its eyes
open—were inspired by the work
of Canova and sculpted in Italy
during the nineteenth century.

Baroque and Rococo Gardens

During the seventeenth century, the European garden was French. Renewed prosperity and the end of the wars of religion allowed the luxurious art of royal and princely parks and gardens to blossom. Richelieu was a great facilitator: by taming the belligerent nobility, he left them the choice between pulling down their fortresses and transforming them into "country seats." Halfway through the century, the Italian model imported by Catherine and Maria de' Medici was still in fashion, but the enthronement of Louis XIV opened the door to a new style, favored by the young king.

At the same time gardeners, as they were still known, sought, developed, and found new solutions. Issac de Caus published his *Nouvelles Inventions de lever l'eau plus haut que sa source avec quelques machines mouvantes* (New Inventions for Carrying Water Higher than its Source Using Various Moving Machines), which enabled the thorny problem of water supply to be solved. Père Nicéron's research on perspective and optics, in 1638, led to some optical tricks that André Le Nôtre was to use to marvelous effect, with his views tilting toward infinity and his "slowed perspectives" of which Baltrusaïtis wrote. Le Nôtre (1613–1700) studied painting with Simon Vouet, then architecture with François Mansart. For Vaux-le-Vicomte and Versailles, Le Nôtre surrounded himself with specialist collaborators—fountain makers, hydraulic engineers, gardeners, florists, and so forth—and worked with the painter Charles Lebrun. The garden became one with the park; it became an essential artistic form that every important figure needed to embrace. It had a regular plan, and water was used copiously for its reflective qualities, its movement, and its verticality. Surprises were put in place to delight the visitor, and statues erected to enhance the structure and draw the eye. Everything was planned and calculated with eternity in mind. The garden was a three-dimensional painting into which the visitor was invited to step. Louis XIV was so enthusiastic about this new art form that in 1689 he wrote *Manière de montrer les jardins de Versailles* (How to Enjoy the Gardens of Versailles), a small guide aimed at his distinguished guests, who came from all over Europe and who, astonished, were to disseminate this new style.

The fountain in the pool of Latona. The sculptures by the brothers Balthazar and Gaspard Marsy depict a subject drawn from Ovid's Metamorphoses. *Through her prayers, Latona, mother of Diana and Apollo, turned some peasants who had insulted her into lizards and toads.*

Versailles

THE FRENCH MODEL FOR GARDENS

FRANCE
Seventeenth to eighteenth century
Designer: André Le Nôtre

Versailles! Since the seventeenth century, thousands of books have been published that described this palace and its park. It has been seen as the triumph of monarchy, as the culmination of the Baroque style, as conveying a solar, pagan theme, as the glory of French architects and engineers, and also as one of the reasons why the people became disaffected with their rulers. This vast complex of thousands of acres is unquestionably one of the few large historic gardens to have been conceived as a model. The young Louis XIV, in assuming absolute power, had given this old hunting lodge an important symbolic

role: it was to become the place from where his power would radiate. Aimed at inspiring respect for the French monarchy and nobility, the project was soon imitated by other European courts.

The gardens were as important as the palace, and it is fascinating to read contemporary commentators such as André Félibien, Madeleine de Scudéry, Deslauriers, and many others, as well as the criticisms of the marquis de La Fage, prudently published in 1717. What is most striking is the new way water was used. Although people at the time knew water only as a scarce commodity in cities,

or as something that brought the ravages of floods or pestilence from marshes, here they discovered domesticated water—abundant, always ready to refresh, surprise, amuse, hold the viewer's gaze. People were amazed at the vast works undertaken to divert the Eure River (a costly failure), by the enormous "machine de Marly" that pumped water out of the Seine, by the great canal that could be navigated by boat, and by the millions of flowers,

miles of patterns made by close-cut box hedges, acres of lawn, and thousands of fruit trees in the orchard, which could thrive thanks to the hydraulic exploits of Le Nôtre and his teams of collaborators.

Louis had thus tamed nature in one of its most elusive and formidable aspects. This imposition of his will on water, trees, plants, and the whole of nature would be extended at the same time over the arts and over the people: always, he had to subjugate, organize, and control everything.

This enormous park, whose theme was power, was to become wearisome in the end. The water would run dry, the scented flowers would no longer be carried in their clay vases in front of the king as he walked, the groves would be neglected, and soon the Trianons would have their own garden—designed, at last, for pleasure alone. ⟡

The flower bed of the Orangerie (1678) and the source from the Lake of the Swiss, which was extended from 1683.

Het Loo

THE GARDEN REDISCOVERED

APELDOORN, THE NETHERLANDS
Seventeenth to twentieth century
Designers: Jacob Roman and Daniel Marot

The reconstruction of the royal palace gardens at Het Loo began in 1974 and revealed one of the most interesting late-seventeenth-century creations in northern Europe.

William III of Orange, stadholder of the Netherlands, had built this agreeable palace inspired by Versailles in 1685, despite the poor relations between the Netherlands and France. The building, made of brick, was adequate, but its pleasure gardens were designed with great elegance by the Dutch sculptor and architect Jacob Roman and the Frenchman Daniel Marot, who was famous for his patterns of close-cut hedges. The palace became neglected after William became king of England, but it was then transformed by Louis Bonaparte, who became king of the Netherlands in 1806. By a curious repetition of history, he surrendered to the English fashion—that of the sworn enemy of France under Napoleon—and had the classic plan covered with a layer of earth four feet (1.5 m) thick,

and planted a park and lawns. In 1911 the palace was totally disfigured by the addition of an extra floor; only in the last few years has Het Loo once again shown its original style.

The gardens have been restored to their French design. This is symmetrical, with a sunken section in front of the palace that is enhanced by eight parterres of patterns, all bordered by terraces and an avenue of oak trees. Farther away, the upper garden, arclike in shape, contains several fountains. The originality lies in the refined, closely trimmed hedges by Marot, which contrast with lawns, strips of turf, and narrow flower beds between low box hedges. Het Loo is once again one of the most visited monuments in the Netherlands. ❧

At the beginning of the nineteenth century, the French-style gardens had been transformed into an English-style park. Recently, however, they have been restored, including the globe, a faithful reproduction of the original.

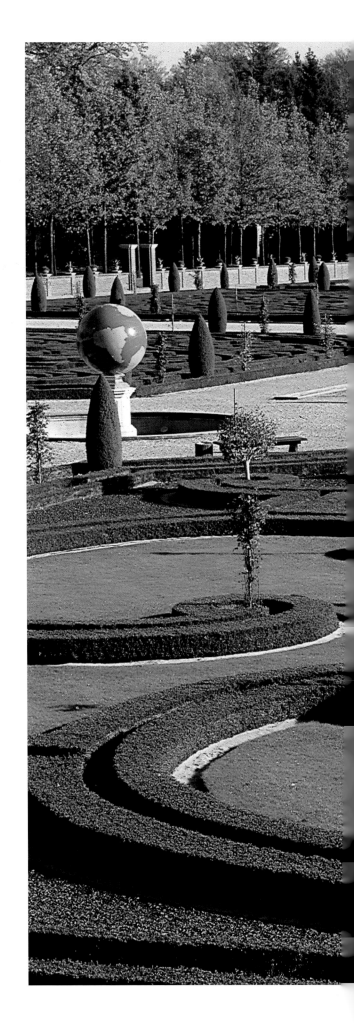

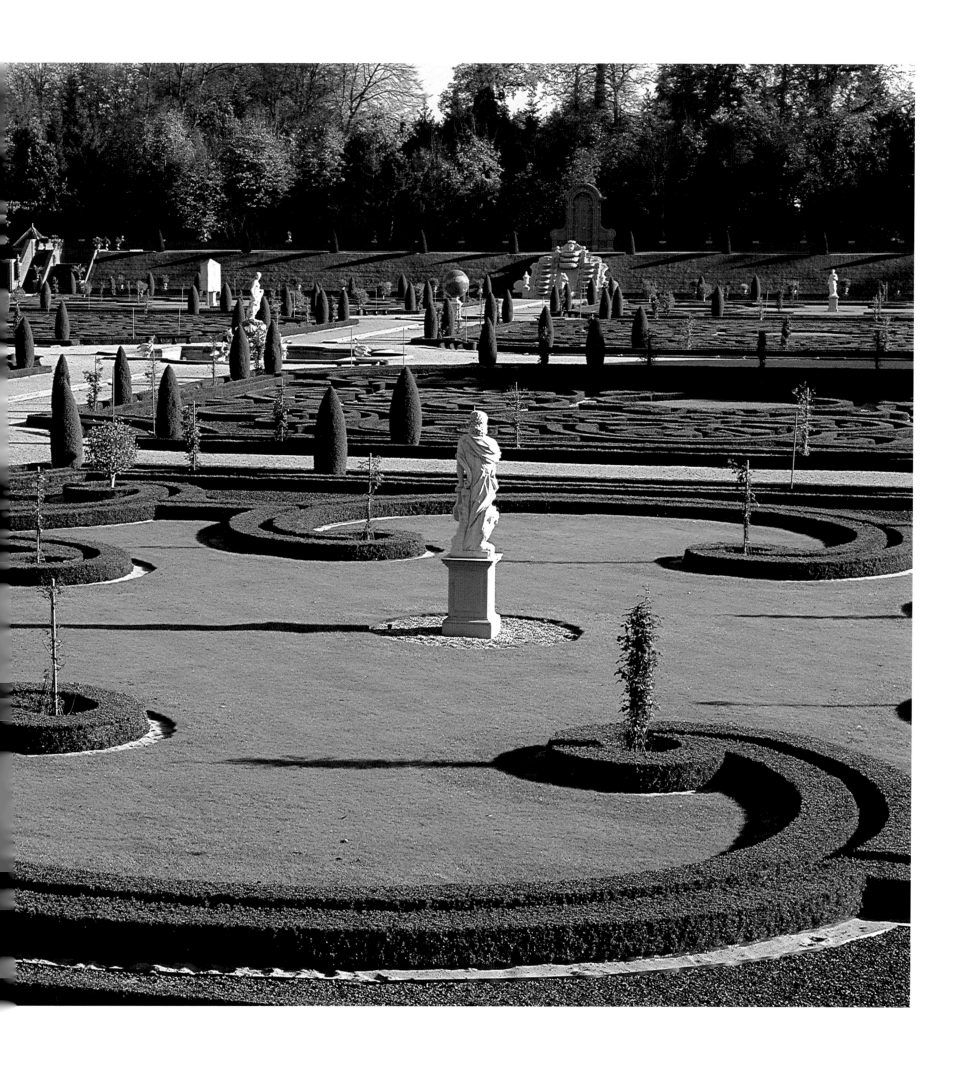

Levens Hall

A TASTE FOR FORMS

KENDAL, GREAT BRITAIN
1694–1810
Designer: Guillaume Beaumont

The gardens of Levens Hall, in the Lake District in northern England, are a concrete example of how artistic influences spread. Colonel James Grahme settled in this large Elizabethan house in 1688. He modernized it discreetly and called on Guillaume Beaumont, a French pupil of Le Nôtre, who had worked wonders with the gardens of the royal palace of Hampton Court. In a smaller area Beaumont laid out a formal park around an avenue of beech trees that has now disappeared, but most importantly he designed a fabulous topiary garden closer to the house. This art, which originated in Italy, had been extensively developed during the seventeenth century in the Netherlands; it is known that Beaumont had spent time in the Netherlands before settling in England. He made use of his newly acquired knowledge to create a ballet of abstract, human, and animal shapes: chessmen, spirals, crowns, a figure of Queen Elizabeth with her ladies-in-waiting, hemispheres, and sculpted parterre borders. Green and gold box are marvelously suited to the twice-yearly trimmings that have been carried out from the beginning. The four gardeners who look after the grounds still work largely by hand, and the garden of Levens Hall, revived at the start of the nineteenth century, is a stunning testimony to a meticulous, almost ferocious will to subordinate nature to an idea. ⌖

Since it was created at the end of the seventeenth century, Levens Hall has been visited by lovers of topiary from all over the world. Several restorations have not compromised this garden's eccentric charm.

Peterhof

THE WINDOW OF POWER

**PETRODVORETS (PETERHOF),
NEAR ST. PETERSBURG, RUSSIA**
1717
Designers: Jean-Baptiste Le Blond,
Niccolò Michetti, and Johann Braunstein

Work on Peterhof began in 1714, but it was not until after Peter the Great had traveled to France and visited Versailles that the tsar decided to create what was to become one of the most sumptuous gardens of the eighteenth century. He called on the services of a Frenchman, Jean-Baptiste Le Blond, who on arrival in Russia in 1717 produced extensive plans and set the first works in motion. After his death in 1719, the architects Niccolò Michetti and Johann Braunstein, who were responsible for the palace's architecture, continued his work.

Peterhof is one of the last great Baroque water gardens. In 1720 abundant springs were discovered that allowed full development of the water theme—complete with 176 fountains—appropriate for its place near the Gulf of Finland.

Preceding pages: This is the view Peter the Great would have had of his palace when arriving by sea from St. Petersburg.

Above: The pools of the upper garden feed the countless fountains in the lower one, especially the great cascade.

Opposite: The gardens are sheltered from the Gulf of Finland by a dike.

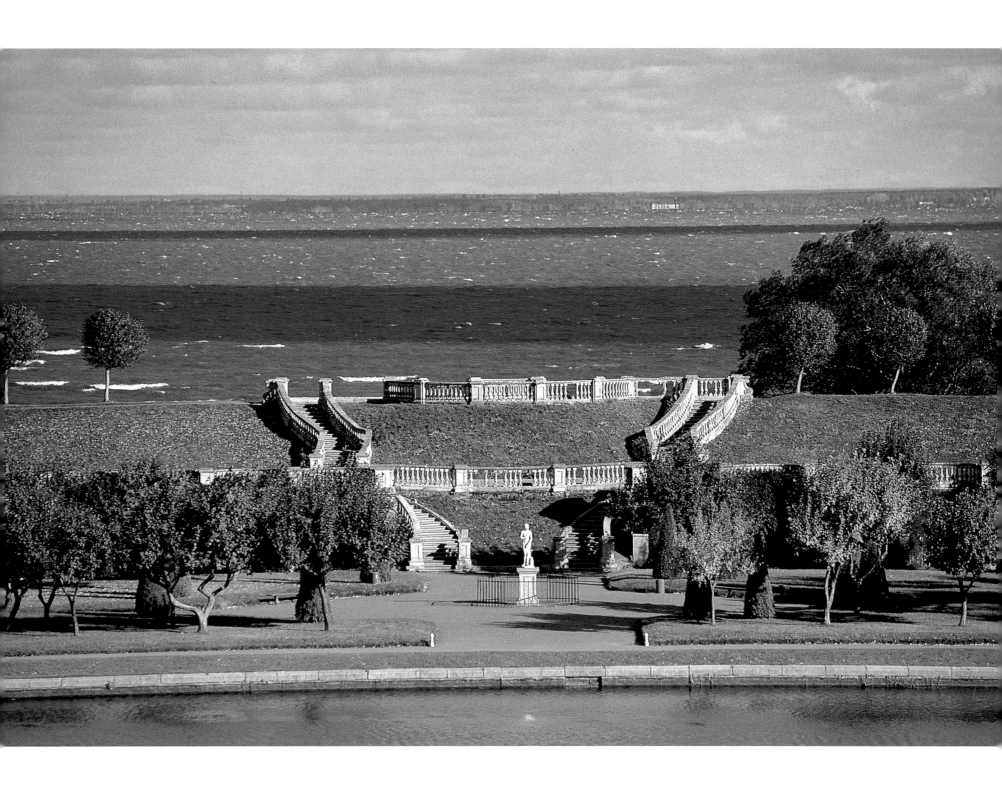

Indeed, the tsar usually arrived from St. Petersburg by boat, via a small canal that ended opposite the gigantic waterfall, which seems to gush from the palace's very foundations. The effect is as spectacular today as ever.

Each fountain had a particular theme: fountains depicting Adam and Eve, Italian and French fountains, the Golden Mountain waterfall, a fountain with a chessboard guarded by dragons, the Fountain of Shells in the Chinese garden, and many small fountains that surprise the visitor, such as a splashing tulip-shaped fountain or treelike fountains.

This riot of water, machines, gilded statues, pavilions, and themed gardens had a precise purpose: to show everyone that the Russia that had defeated Sweden was now a major European power. Like Versailles, the gardens at Peterhof were a superb political device. ⚓

Park of the Château de Bizy

FOUNTAINS

BIZY, EURE, FRANCE
1723–1817
Designer: Constant d'Ivry

Bizy is one of those neglected palaces that were once appreciated by many prominent people. These included the duke of Belle-Isle, grandson of Fouquet, Louis XV, the duke of Penthièvre, grandson of Louis XIV, and king Louis-Philippe, who often stayed there, and said of it: "It is only five quarter-hours away from Paris by train." Work on the gardens began in 1723, before construction of the palace and the waterfalls (1728–39), and continued after 1759, thus covering a period when English influence was making itself felt but when the Italian Baroque charm of water works was still seen as essential to gardens. Louis-Philippe had the park redesigned in the English style, planting the vast trees that can still be admired today. The palace was later demolished, in 1858, by its new owner, the Protestant banker Ferdinand von Schickler, and was rebuilt in an Italianate style not without a certain nobility. Twenty years later it became the property of the Suchet d'Albuféra family, who still own it.

All traces of the Baroque garden have vanished under the English-style reworking, but the Rococo watercourse has remained as it was, and is exceptional in its position and shape. It starts on a hillside overlooking the palace, where a Gribouille fountain brings together several springs, plunges down a series of steps, watched over by two winged fish, empties into a pool of sea horses, crosses the majestic porch of the stables (modeled on those at Versailles), feeds the Dolphin Fountain, fills a pool shaped like a violin in the center of the stable courtyard, vanishes under the palace, and then resurfaces in front of it in a curved pool, from which a vigorous spout rises.

Virtually all over Europe, neglect, the high cost of maintenance, dried-up springs, and changing tastes have caused most of these rocky, or Rococo, water features to disappear. Bizy is a rare surviving example of these luxurious delights.

Opposite: The majestic cascade, which begins on the side of a hill. The water re-emerges in the palace courtyard.

Left, top: View of the English-style park.

Left, bottom: The Château de Bizy was rebuilt twice during the nineteenth century; its Italian façade now presides.

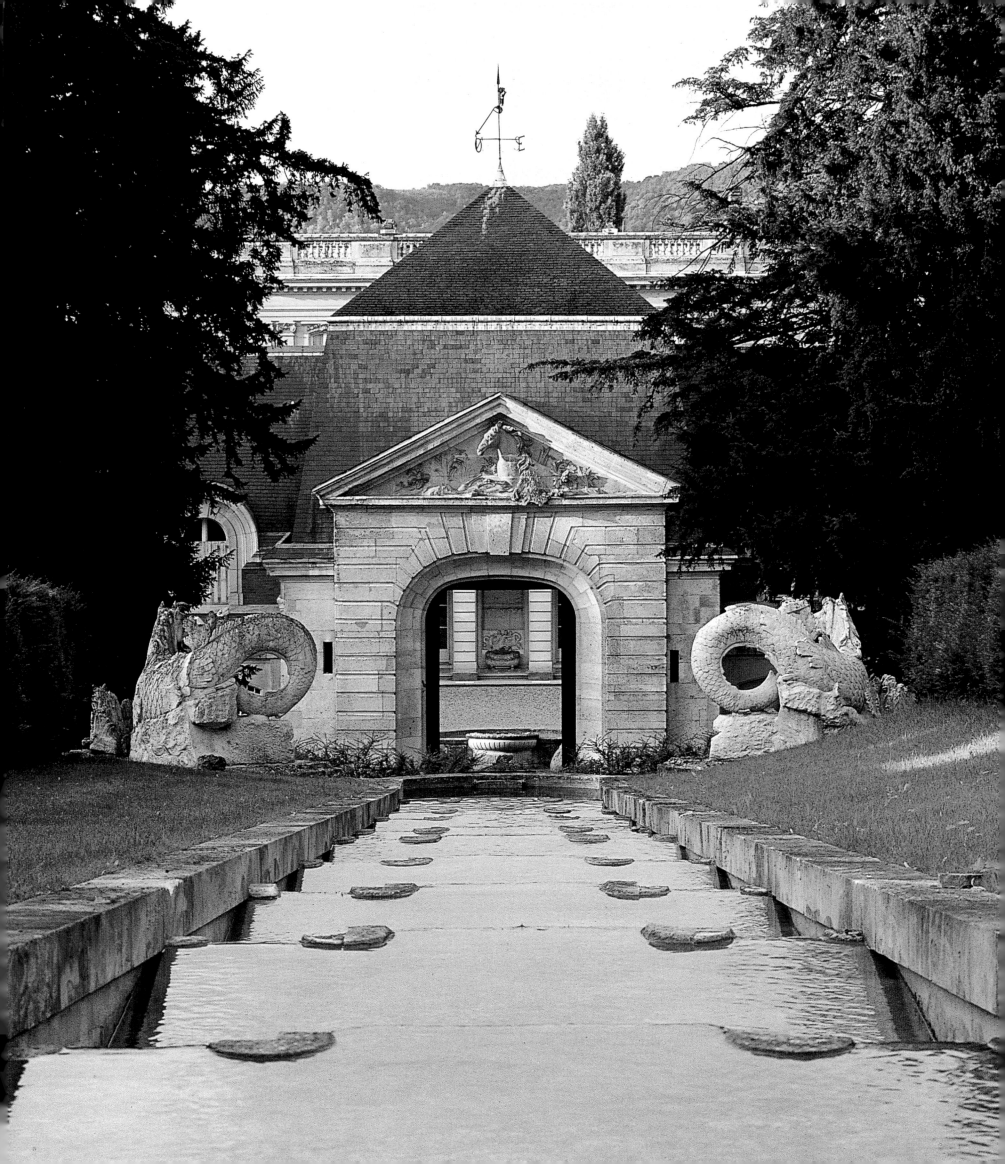

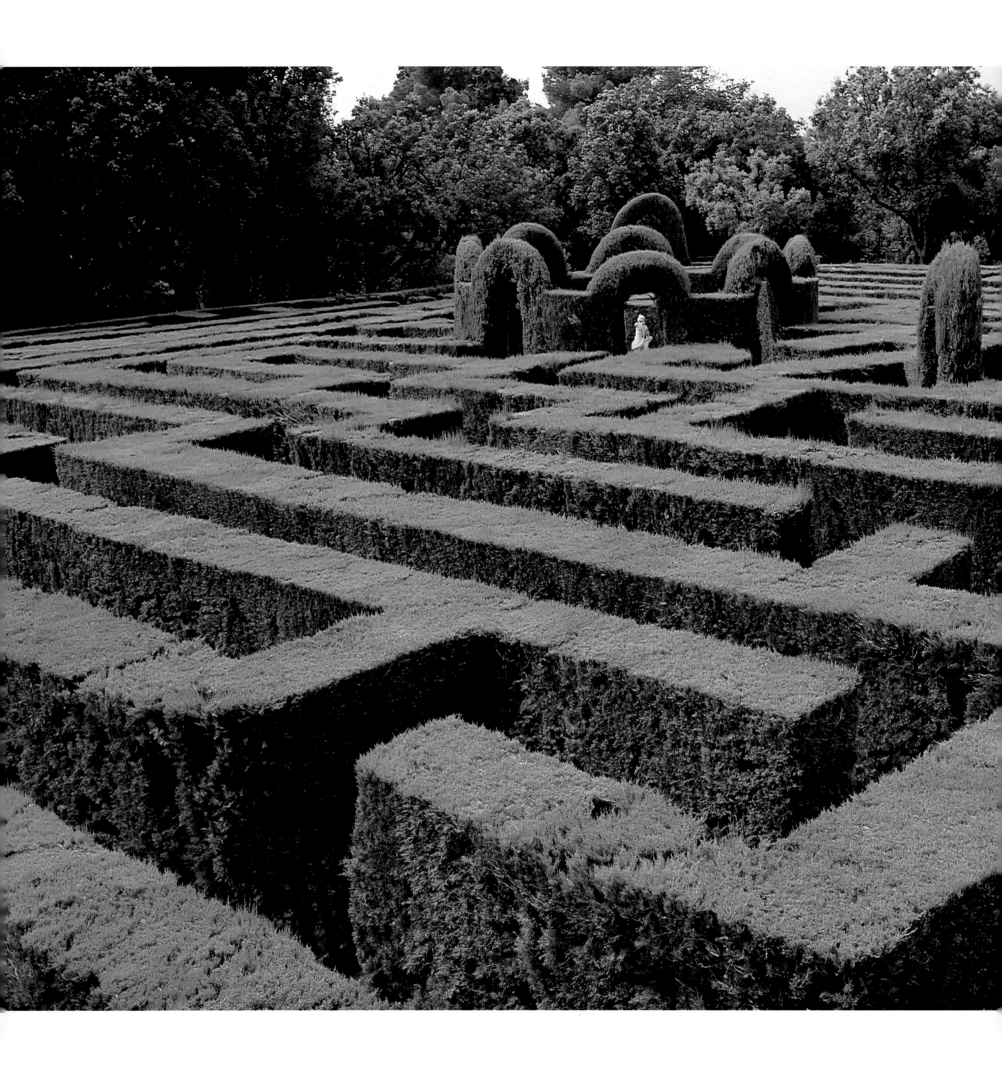

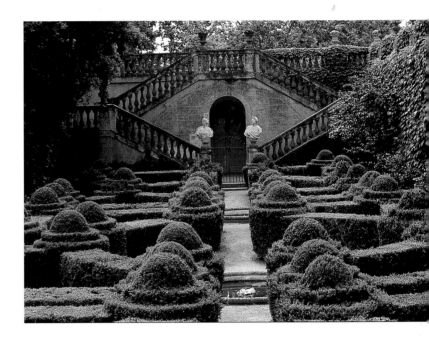

The Labyrinth of Horta

A MINOTAUR TRANSFORMED INTO EROS

BARCELONA, SPAIN
1794–1850
Designer: Domenico Bagutti

Left: The labyrinth of pruned cypress trees forms a maze through which it is impossible to see.

Above: The Italianate box garden.

The adventures of Theseus, Ariadne, and the Minotaur could not fail to fascinate the well-read European public who, ever since the Renaissance, had had a lively interest in myths and symbols. As a result, countless labyrinths were created in Italy, as well as in France and England. Many of these vanished, victims of the fall from favor of the art of topiary, and especially through lack of maintenance. However, Antoni Desvalls, marquis of Llupià i Alfarràs and a highly cultured man, decided in 1791 to create a large garden on one of his estates near Barcelona. He called on the Italian architect Domenico Bagutti (1760–1836), who began works that were still not complete when the marquis died

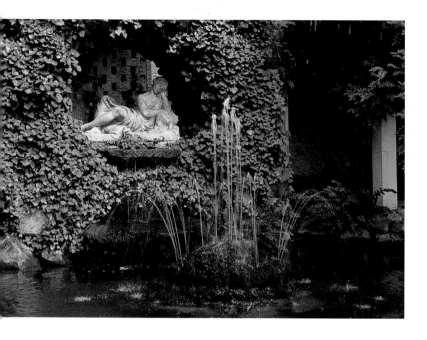

around 1850. The plan was to create a neoclassical garden, that is, one that was composite in character. It was no longer a matter of controlling nature, but rather of surprising, amusing, disconcerting, and bewitching the senses and the mind.

Bagutti created four levels: the first was in the Italian style, for the pleasure of guests who came to the palace, the second was planted with groves of trees, the third was occupied by the labyrinth, and finally there was a vast area devoted to a small lake and various picturesque buildings. The labyrinth, which measures about 150 by 164 feet (45 by 50 m), is formed from incredibly hardy, closely packed cypresses. The way through—which is relatively easy to find—leads to a small central space where there stands a statue, not of the Minotaur but of Eros, around which is a semicircular bench.

The Desvalls family retained ownership of this extraordinary splendor until the 1970s, and then sold the estate to the city of Barcelona. The place was popular with the public, and the labyrinth suffered as a result. Today, restored exactly as it once was and carefully protected, the Labyrinth of Horta is certainly one of the most beautiful historical examples of the art of the garden in Catalonia. ⚜

Park of the Reggia
A Royal Gesture

CASERTA, ITALY
Eighteenth century
Designer: Ludovico Vanvitelli (Ludwig Van Wittel)

One of the last great feats in the Baroque style: water gushes from the mountainside and tumbles toward a pool.

The monumental scale of Caserta has disturbed visitors ever since it was created. The palace is supposedly too massive and causes claustrophobia, while its gardens are said to be out of proportion. These criticisms are unfair, for the palace was never completed, it has some of the most fluid circulation of the eighteenth century, and the landscape gardener's prowess displayed here is perhaps the most grandiose since the Grand Canal at Versailles.

The similarity to Louis XIV's palace is no accident, for Caserta was built by his great-grandson Charles III—king of Naples, and later of Spain—who had the French model in mind. In Naples, he had had the unpleasant experience of finding himself within range of the cannons of the English fleet, which is why he decided to move his capital inland, at the foot of the Tifatini mountains.

The plans were entrusted to the Dutchman Ludwig Van Wittel—whose name was Italianized to Ludovico Vanvitelli—a brilliant architect, engineer, painter, and landscape gardener who devoted the last twenty-two years of his life to the project, supported first by Charles and then by his son, Ferdinand IV.

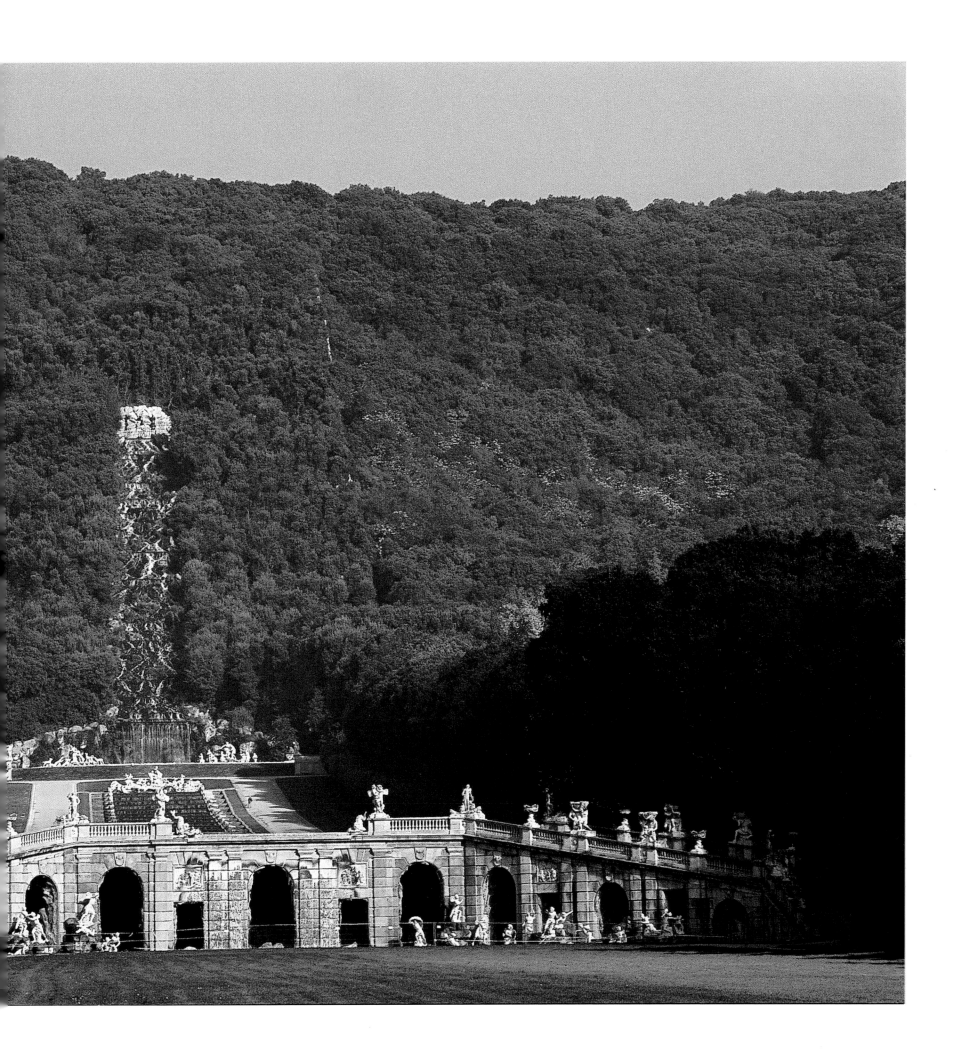

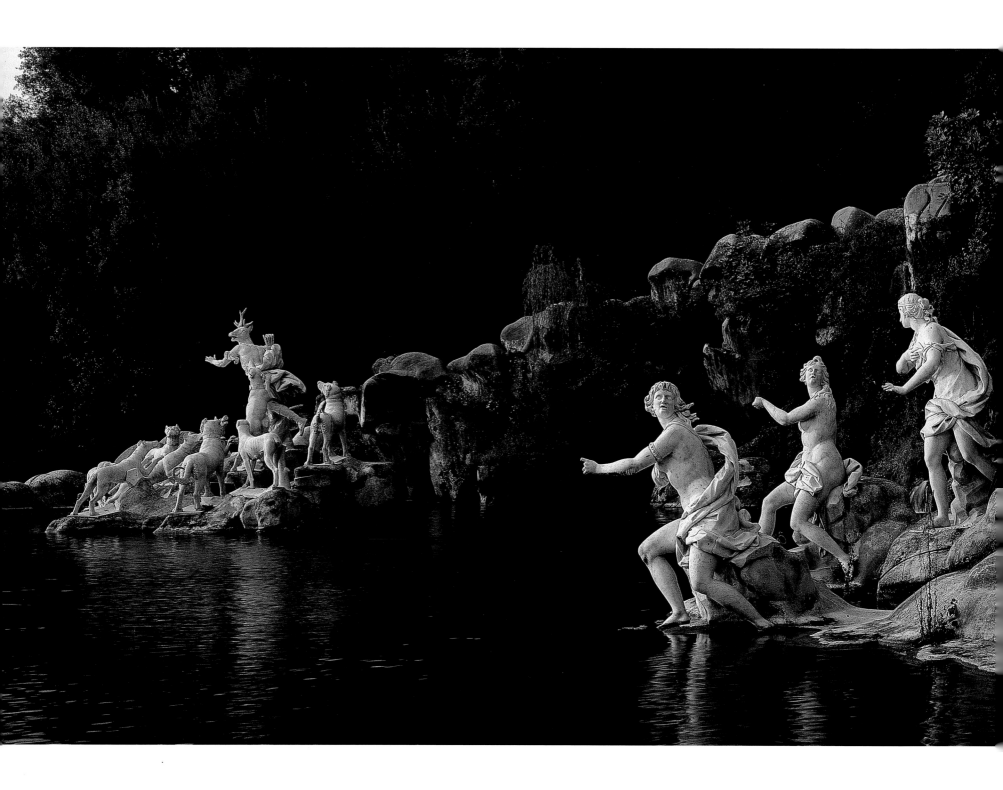

The plans were for a grandiose palace, but also for a city, a spectacular aqueduct nineteen miles (30 km) long, a factory producing silk goods—a model for industrial development—experimental farms, hunting reserves, and finally, gardens. The first stone was laid in 1762 and the palace, containing twelve hundred rooms, was completed ten years later.

The grand "gesture" of the park of the Reggia of Caserta is none other than the longest Baroque waterfall in the world. The water flows from a hillside, plunging five hundred feet (150 m) down to the fountain of Venus and Adonis, under the sign of love, from where it flows to the fountain of Diana and Actaeon—the latter being attacked by a pack of dogs in marble. It then flows down a gentle slope for two miles (3 km) and is then covered before reaching the palace. Along the way it forms a series of pools, home to a whole population of tritons, fantastic animals, deer, and naiads, before arriving at the enormous fountain of Aeolus, close to the palace. From the top of this monumental watercourse, that fountain looks almost tiny, but on a clear day the original plan is evident: a grand avenue was to start from the other side of the Reggia, leading straight to Naples and the sea. This would have formed a link between land and sea—a great axis asserting the royal power that was taking charge of this kingdom's

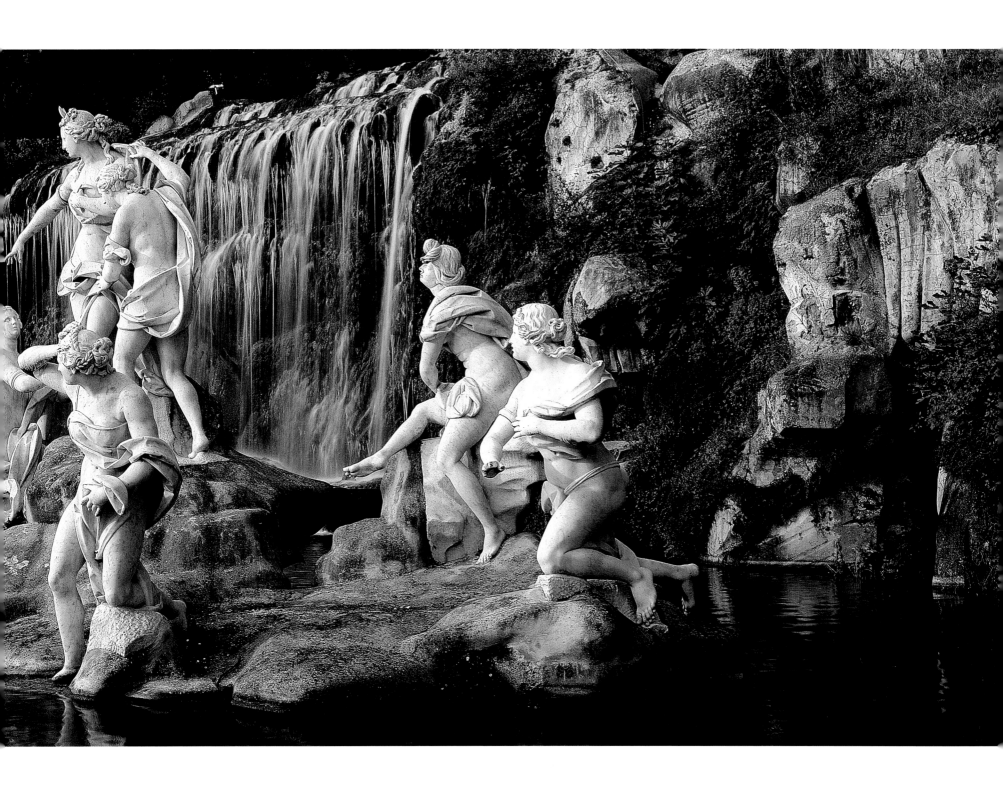

development. Certainly the present park could be rendered more pleasant by restoring the patterns of close-trimmed low hedges and the basins of flowers, as well as by keeping at bay the pressure from housing development. Nevertheless, this staggering irruption into a space that opens out into infinity is a true act of grandeur.

To the right of Actaeon's pool are the iron gates leading to an English garden that Queen Maria Carolina had laid out in 1782. The new ideas coming from England were therefore reaching the furthermost point of Europe. Then came Napoleon, followed by a French king, and into the nineteenth century came the triumph of English landscape gardening, for which such a long waterfall was anathema to their aesthetic of the picturesque. ❧

Diana and her nymphs face Actaeon, turned into a deer and attacked by dogs.

Following pages: The longest series of cascades in Europe— almost two miles (3 km) in the background is the Reggia.

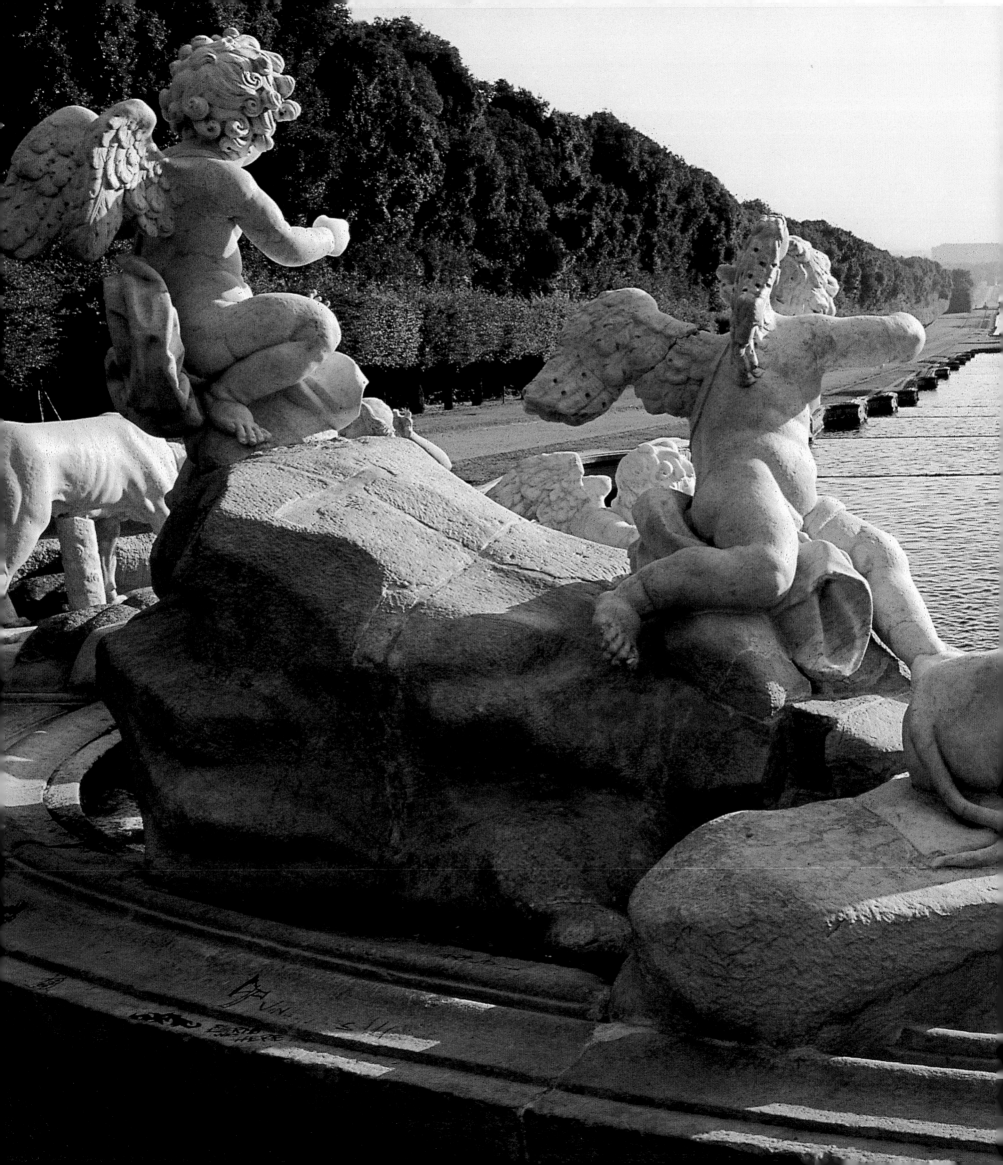

Schwetzingen

The Great Circle

GERMANY
Seventeenth to nineteenth century
Designers: Johann Ludwig Petri, Nicolas de Pigage, and Ludwig von Skell

Schwetzingen, one of Germany's most famous gardens, has miraculously been preserved despite changing tastes and the ravages of war. It enthralled Europe's aristocrats and intellectuals from its creation in 1748, to the point that one of Voltaire's last wishes was to see it again before his death. The Elector Palatine Charles Theodore (1724–99), a powerful, cultivated prince who resided in Manheim, had developed a passion for this former

hunting lodge. He enlarged it considerably, added two low wings that formed a semicircle, and asked Johann Ludwig Petri to design a garden worthy of this summer residence. Petri produced a formal plan, but of a new type; the first part was contained within a vast circle—a shape never before seen in a garden and rarely imitated subsequently—which formed the basis of a clever arrangement of rectangular beds subdivided into geometric shapes and opening up a view toward a small lake and distant mountains.

The middle of the eighteenth century was a turning point. From England came the fashion for a freer way of treating nature, a contrast to the formal, Versailles-style garden that until then had been enthusiastically embraced by German princes. In a sense, Schwetzingen was to be the life-size test for the successive fashions of the time:

The great arbor that leads to the lake, and the fountains with animal figures in white marble, which sunlight renders almost translucent.

English, picturesque, and neoclassical. Sensitive to new ideas, Charles Theodore called upon one of the great French architects of the time, Nicolas de Pigage, who had just been working for Stanislas Leszczyński in Lorraine. Pigage retained the circular plan, and extended the beds as far as a huge pool surrounded by dells, and added to the whole a generous sprinkling of the picturesque: grottoes, a temple of Apollo, a fountain with birds, a ruined temple of Mercury, a theater, a mosque, and an arbor with a painted background in perspective. From 1776, the landscape gardener Ludwig von Skell was entrusted with a new plan to extend the garden, this time radically altered to the English style. He transformed the pool into an informal lake and dug a canal, which was soon spanned by a charming white-lacquered Chinese bridge, a symbol of the triumph of new ideas in garden design. Schwetzingen continued to evolve during the nineteenth century, but Charles Theodore's original vision was not essentially altered.

Huntington Botanical Gardens

A COLLECTION OF GARDENS

SAN MARINO, CALIFORNIA, UNITED STATES
Twentieth century
Designer: Henry Edwards Huntington

The Huntington Library, Art Collections, and Botanical Gardens, in the heart of California, were mostly put together between 1903 and 1927 by Henry Edwards Huntington, who bequeathed them to the state of California after his death. This collection of gardens can be admired much as a collection of paintings or sculptures: from this intertwining of styles, centuries, geographical origins, and species a sudden dazzling perspective

emerges: the North Vista, a tribute to the art of the Baroque garden.

In a straight line, softened by the feathery effervescence of the huge, splendid palm trees that Le Nôtre could never even have dreamed of, stands an army of stone and marble statues dating from the first half of the eighteenth century. They are supposedly from a villa in Padua, and were removed at the time when major American collectors bought shiploads of European antiquities. This great avenue of greenery ends rather suddenly with a stone basin. A strange place, which foreshadows the neo-Baroque houses that were built soon afterward in Florida, the North Vista imposes the rigor of reason in the polymorphous creation that is the Huntington Gardens. ❧

This splendid North Vista showcases a row of eighteenth-century Italian statues.

The English Garden

At the end of the seventeenth century, England was still cultivating the relics of the medieval and Renaissance garden. Versailles was little appreciated, and English gardeners looked inward, with a return to the art of topiary. They cut, shaped, and sculpted hedges to produce figures and animals, sometimes lapsing into the ridiculous. Literature came to the rescue: Alexander Pope mocked these restricted gardens; John Milton wrote *Paradise Lost*; and James Thomson sang the praises of infinite vistas. Charles Bridgeman (1690–1738) and William Kent (1685–1748) were to revolutionize the scale of gardens, inventing the art of using clumps of trees, opening up vistas into "wild" Arcadian surroundings, and creating parks as if they were composing paintings. This landscape movement and new aesthetic in landscape design culminated in the work of Lancelot "Capability" Brown (1715–1783), and was greatly helped by the country's remarkable economic development. The Americas and trade enriched the big aristocratic families, and the political system allowed them to spend much of the year on their country estates, thus justifying the building of sumptuous country houses with huge parks. Perhaps, too, the very nature of the English landscape—gently undulating, open, divided by hedges into fields, and with relatively little woodland—favored such plans. The aim was to improve nature rather than to transform it, in order to attain an ideal beauty, refined by the addition of fake ruins, temples, and grottoes. This wholly artificial, theoretical approach, which required vast earth-moving operations, took decades to take root. But by the end of the eighteenth century, lawns had covered over the flowerbeds, exotic trees had ousted topiary, and "natural" rivers and lakes had taken the place of formal pools and canals. These new ideas soon crossed the Channel to Germany and, finally, to the France of Louis XV and XVI.

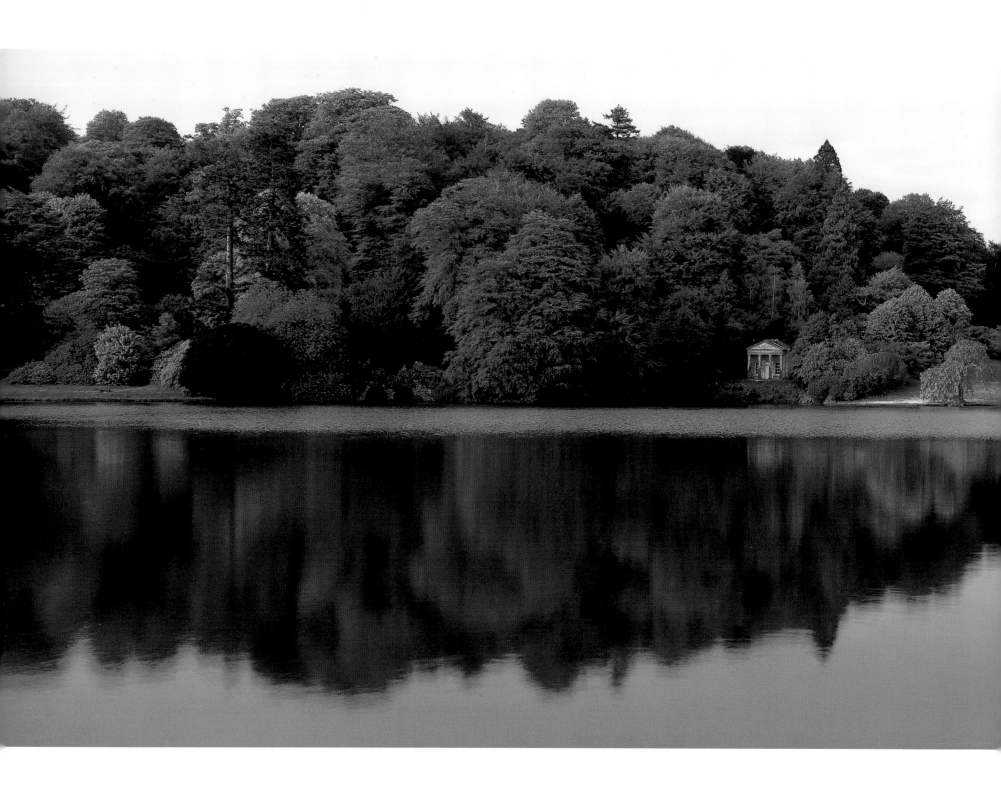

Stourhead

LIKE A PAINTING BY CLAUDE LORRAIN

STOURTON, GREAT BRITAIN
1745
Designers: Henry Hoare II, Henry Flitcroft, and Richard Colt Hoare

In space as well as in time, Stourhead is a masterly lesson in landscape gardening. In 1745 the banker Henry Hoare II returned from a long journey in Italy, where he had been enchanted by the Arcadian landscapes of Claude Lorrain and Gaspard Dughet (Gaspard Poussin). His mind full of historical references and mythological visions, he decided to create a new landscape around his Palladian mansion in Wiltshire, with the help of Henry Flitcroft, a well-

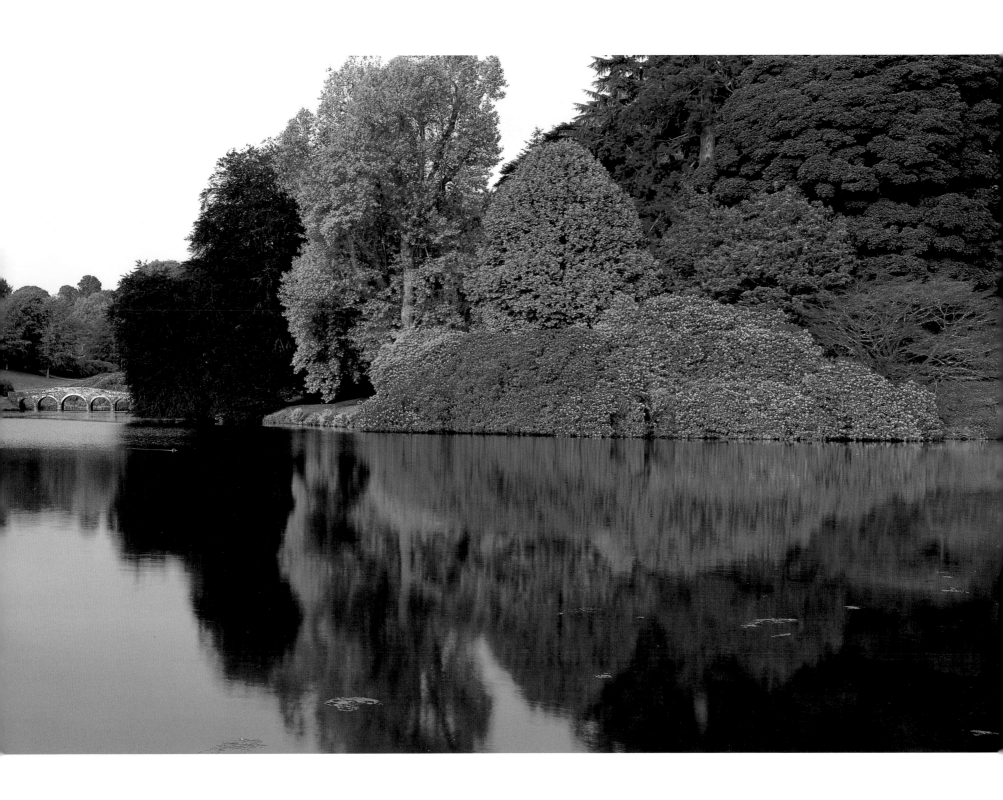

known architect. In a few years, the two men were to create a landscaped park that is one of the most emblematic of the English style.

A dam across the River Stour produced a lake that radically changed the landscape, which until then had consisted purely of vegetation. A path goes around the lake, so as to offer multiple viewpoints, as in a Chinese water garden. A temple of Flora and Aeneas's grotto bear witness to Hoare's literary preoccupations, for he was a great admirer of Virgil's *Aeneid*. Then, in 1755, a mysterious Pantheon, inspired by Claude's *Landscape with Aeneas at Delos,* sprang up at the end of the lake. Between 1760 and 1785 a bridge—which created the impression that a river flowed toward the small village of Stourton—and a temple of Apollo were added. Small structures, in the picturesque garden style that was then all the rage, proliferated: a Turkish

This Arcadian landscape in the English countryside has a Palladian bridge in the middle distance.

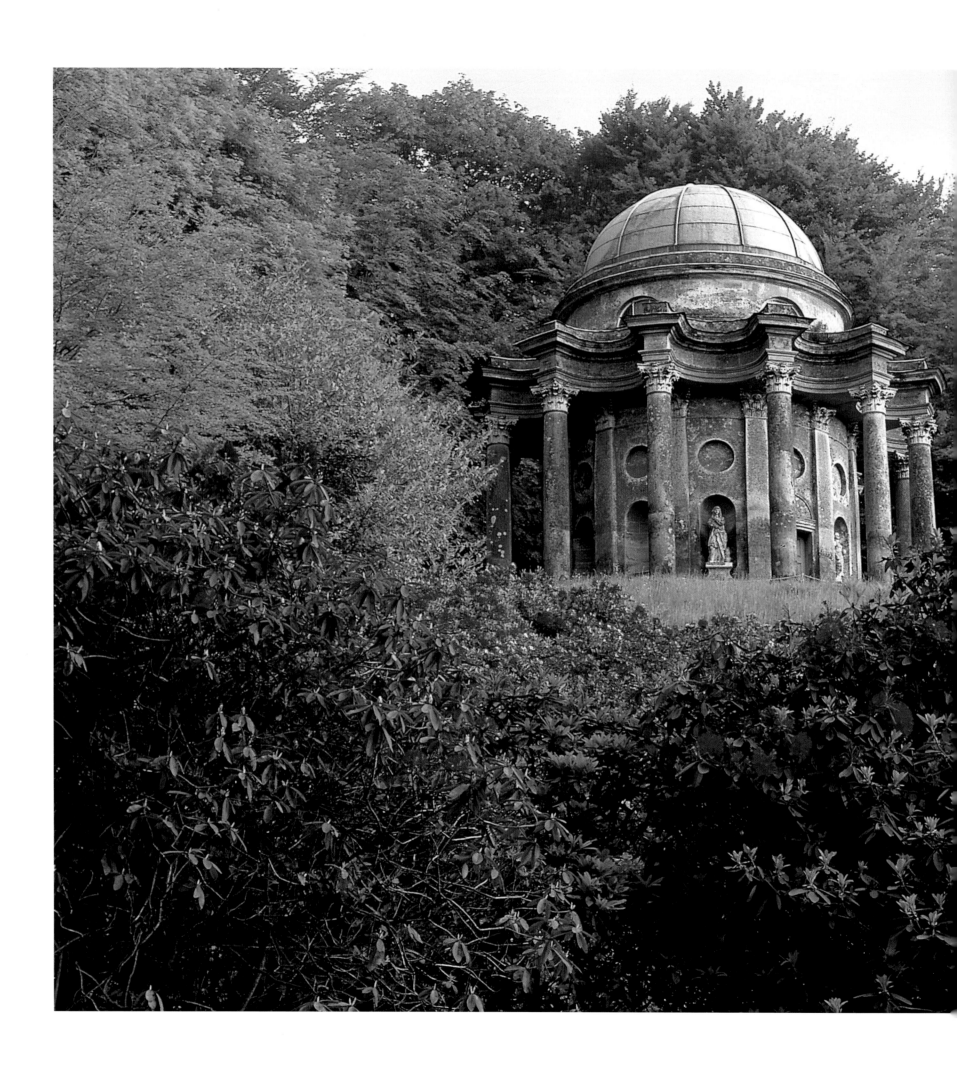

The temple of Apollo,
designed by Henry
Flitcroft, was directly
inspired by Claude
Lorrain's Landscape
with Aeneas at
Delos. *It houses a*
collection of statues.

tent, a Venetian bench, a Bristol cross. Between 1785 and 1820 Hoare's heir, Richard Colt Hoare, revised the gardens and opened up a new vista toward the village, which was now part of the picture. Crenels were added to the church and to some of the buildings to create the desired effect and plantings were modified by the arrival of exotic trees and laurels, so as to make the temple of Apollo look as if it was rising out of a sea of greenery. At the end of the nineteenth century, magnolias were planted, which were destined to grow to a gigantic size.

Thus it took more than eighty years to create this park, which has attracted many visitors ever since it was first laid out. Today Stourhead is still magnificent, but its splendor is no longer the same as that which drew such admiration at the time it was laid out. The mature trees and magnolias now restrict views over the lake, which was once the mirror from which the eye rebounded in all directions, seeking new surprises; now it is the center of attention. The years of growth have transformed the gardens from a luminous, Arcadian clarity to an almost Gothic romanticism. Yet this feeling that everything is constantly changing, that a work is in motion, is one of the fascinating aspects of the art of the garden. ⚜

Sanspareil

THE ADVENTURES OF TELEMACHUS

WONSEES, GERMANY
1744
Designer: Wilhelmina, margravine of Bayreuth

In 1744 the margravine of Bayreuth, Wilhelmina (1709–58), keen to distance herself from her fickle husband, decided to refurbish a ruined castle that her family owned at Zwernitz, in the rugged landscape of Franconian Switzerland. There, in the middle of a nearby beech wood, she discovered strange limestone formations consisting of caves, faults, and escarpments. Even though she wrote to her brother, Frederick II of Prussia, that "nature was its sole architect," we are indebted to her for the first landscaped garden in continental Europe. A cultured woman, she had been thrilled by reading Fénelon's *Les aventures de Télémaque,* (The adventures of Telemachus), and decided to stage it. She took advantage of the natural relief to produce a Calypso's grotto, a temple of Aeolus, a Vulcan's cave, a rock theater reminiscent of Piranesi, and several small stone and wood structures that have long since disappeared. It must have been most entertaining to walk through this forest and stumble upon the surprises, picnics, little concerts, and the plays that the margravine organized.

Today Sanspareil has lost all its gaiety. The sun has difficulty penetrating the canopy of trees, the buildings are eaten away by moss, and it is more reminiscent of the monsters of Bomarzo and the engravings of William Blake than of the formative adventures of the young Telemachus. However, in the process Wilhelmina's plaything of a garden has acquired an authentic poetic power. ⬦

This moody and evocative scene is the entrance to the enchanted estate of Sanspareil.

Canon

THE PASSION OF A LIFETIME

FRANCE
1770–85
Designer: Élie de Beaumont

In writing *La Nouvelle Héloïse* (Julie: Or, The New Eloise) and *Les Rêveries du promeneur solitaire* (Reveries of the Solitary Walker), Rousseau had made fashionable a return to nature that seemed an incarnation of the new style of the English landscape gardeners. In 1770 Élie de Beaumont, a friend of Voltaire's, became the owner of Canon, a recently built country house that boasted gardens in the grand French style. For the park, he retained

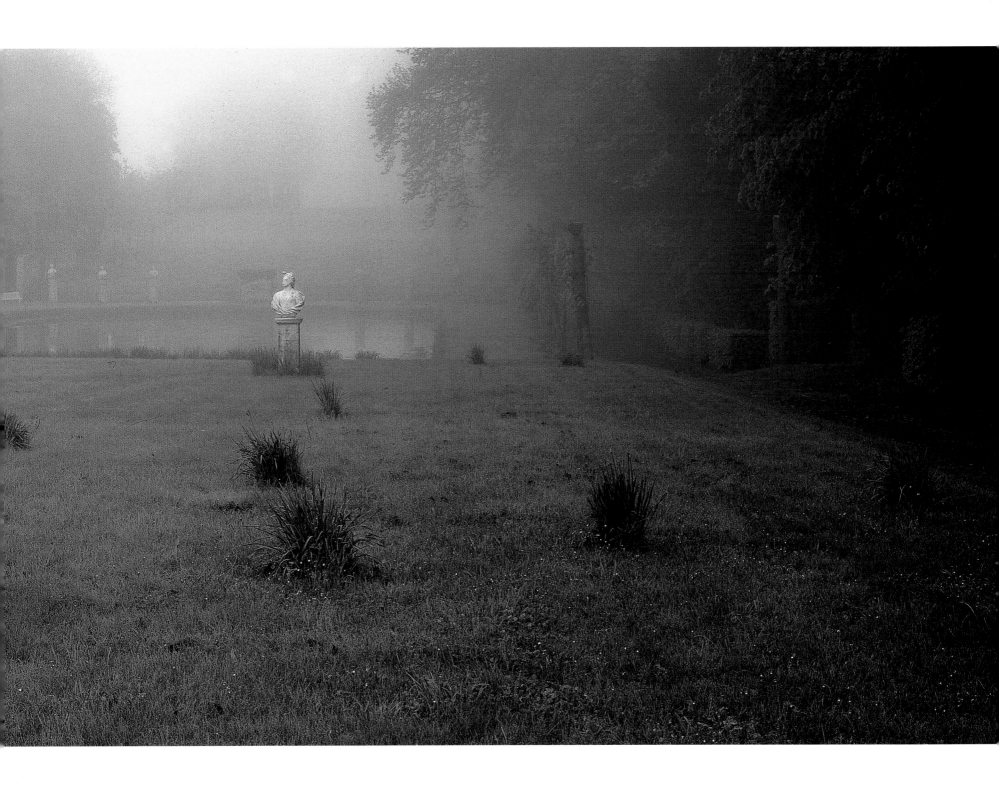

the overall orthogonal plan and channeled pools, waterfalls, and planted thickets of plane trees, elms, limes, yews, and hornbeams. Being of limited means, Élie de Beaumont could erect only a small number of buildings, but these were practical: between the two ruined towers of an old castle he built a chamber perched on Doric columns and, a short distance away, a bathhouse in which the bath was level with the river that flowed past the walls. One

of his most astonishing creations was the group of "Carthusians" made in 1775, which consisted of thirteen pieces of masonry open to the sky and forming as many fenced orchards; access to these is via a series of semicircular arches ending, in a fine effect of perspective, with a statue of Pomona by Dupaty.

"I have all manner of things in my gardens . . . both the well-trimmed and the wild," wrote Voltaire

of his estate at Ferney. Canon fits this description: it combines successive, even opposite, styles, in a harmonious organized whole marked by the elegiac spirit of the works its creator had read. ❧

At the end of the eighteenth century,
Canon represented a subtle marriage
of the French and English styles.

Wörlitzer Park

A GARDEN OF THE ENLIGHTENMENT

GERMANY
Eighteenth century
Designers: Friedrich Wilhelm von Erdmannsdorff, Johann Leopold Schoch, and Johann Georg Schoch

Goethe once said that *Elective Affinities,* his brilliant novel that describes the creation of a landscaped park, had been inspired by Hirschfeld, author of the memorable five-volume *Theory of Garden Art,* published in 1779, and by Wörlitzer Park. For twenty years all Europe had been talking about Wörlitz, the park created by Prince Leopold Friedrich von Anhalt-Dessau, who wanted to make his principality into a "republic of scholars."

The estate lies a couple miles from the Elbe River, around one of its backwaters that has been turned into a lake. The prince had traveled widely in England, accompanied by his architect, baron Friedrich Wilhelm von Erdsmannsdorf (1736–1800), and his gardener, Eyserbeck, and had brought back the new ideas of William Chambers and "Capability" Brown, which had seemed revolutionary in a country that was used to miniaturized copies of Versailles.

The estate that is now Wörlitzer Park comprises a village, a neoclassical palace, and a large number of buildings, including a pantheon (right).

Left: The Gothic house is Tudor style on one side, Venetian on the other (1793–1813).

Right: This rocaille *bridge is one of nine on the estate.*

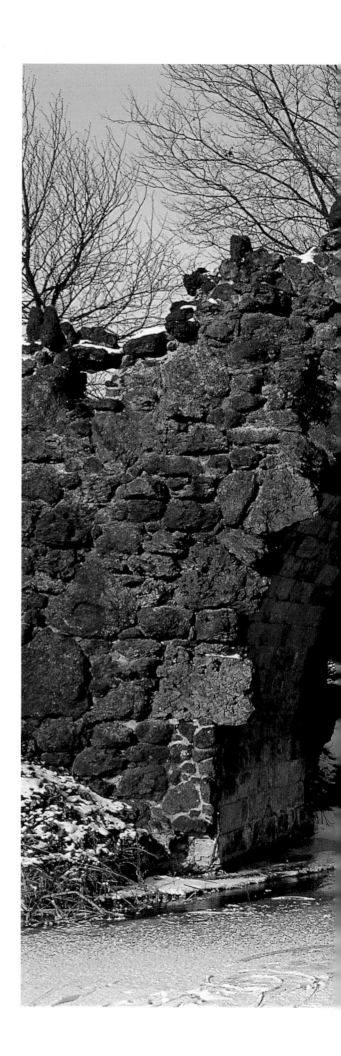

Starting in 1770, and for the following twenty years, the prince undertook enormous improvement works over about a thousand acres of land to create an "English" park whose size, variety, and intelligence of conception were unique. Wörlitz has the gamut of English-style garden elements: changing vistas, viewpoints, surprises, dramatic scenes, carefully organized pockets of peaceful nature, picturesque buildings, and perspectives looking out to wild nature. Added to this is the dimension of the spirit of the Enlightenment, in a cultural vision of what a princely residence should be in the context of an economic approach to the estate.

The prince of Ligne, who was responsible for the gardens at Beloeil and a great connoisseur of gardens, described Wörlitz as a play in five acts and seven scenes, citing the forty or so new buildings erected around the lake: the residence, naturally, but also a library, a Gothic house, temples to Venus and Flora, a nymphaeum, bridges and, in the lake's center, the island dedicated to Jean-Jacques Rousseau, whom the prince had met in Paris. Despite their sometimes picturesque appearance, these structures all had real architectural quality and each had its own function. The most frivolous and astonishing was a volcano that could belch flames and into whose side was set a temple of the night, lit by stained-glass windows.

Wörlitzer Park marks Germany's entry into the history of gardens, and foreshadows the neoclassicism—*Klassizismus*—that would be seen in the work of Peter Joseph Lenne and Karl Friedrich Schinkel at Potsdam, once the Napoleonic tornado had passed. ✣

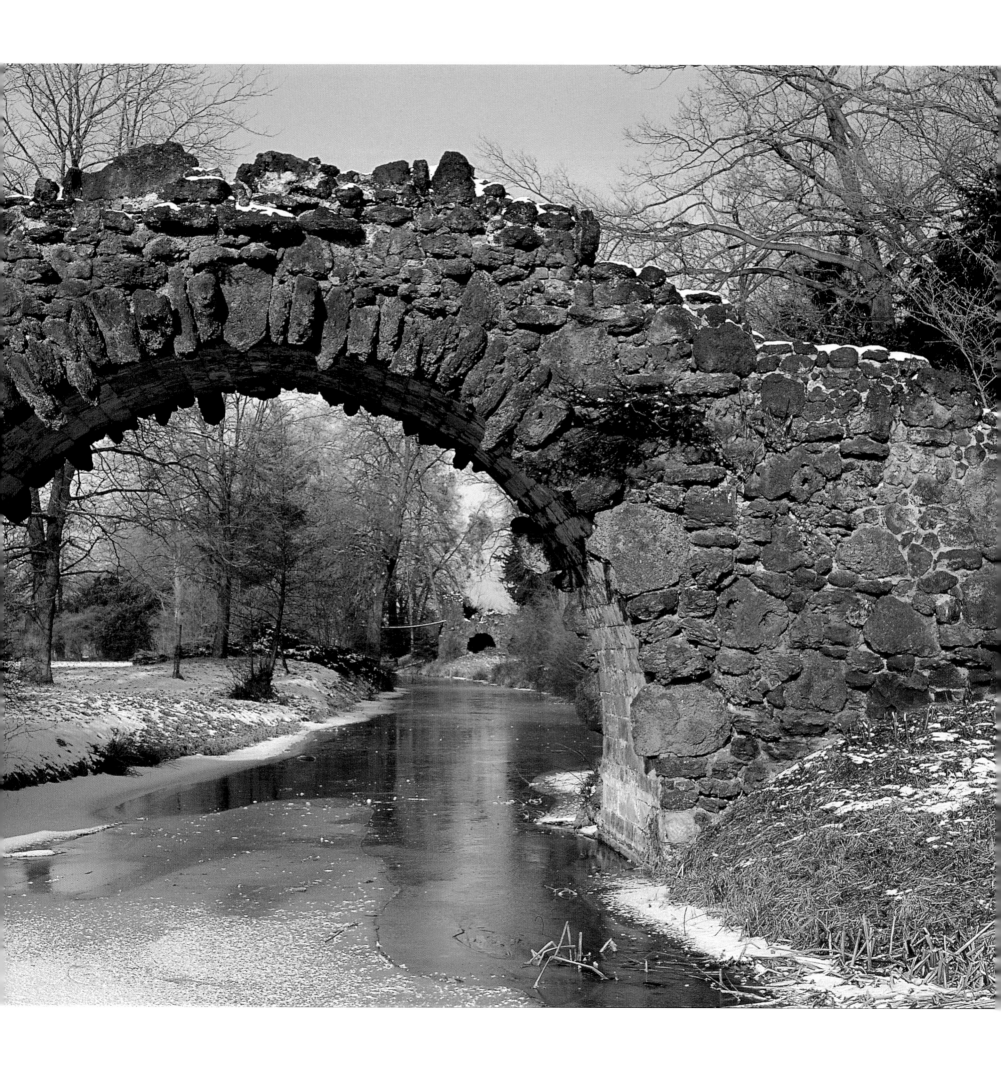

Château de Groussay

A PARK OF ILLUSIONS

MONTFORT-L'AMAURY, FRANCE
1950–70
Designers: Emilio Terry and Alexandre Serebriakoff

"To play the card of illusion in the midst of nature." This was the aim of Charles de Besteigui, an extremely wealthy art lover of South American origin, whose family had made its fortune in silver mining. The interior of his Parisian apartment had been furnished by Le Corbusier, and he owned the Palazzo Labbia in Venice, where he had held the famous "party of the century" in 1951. In 1939 he had also bought Château de Groussay, not far from

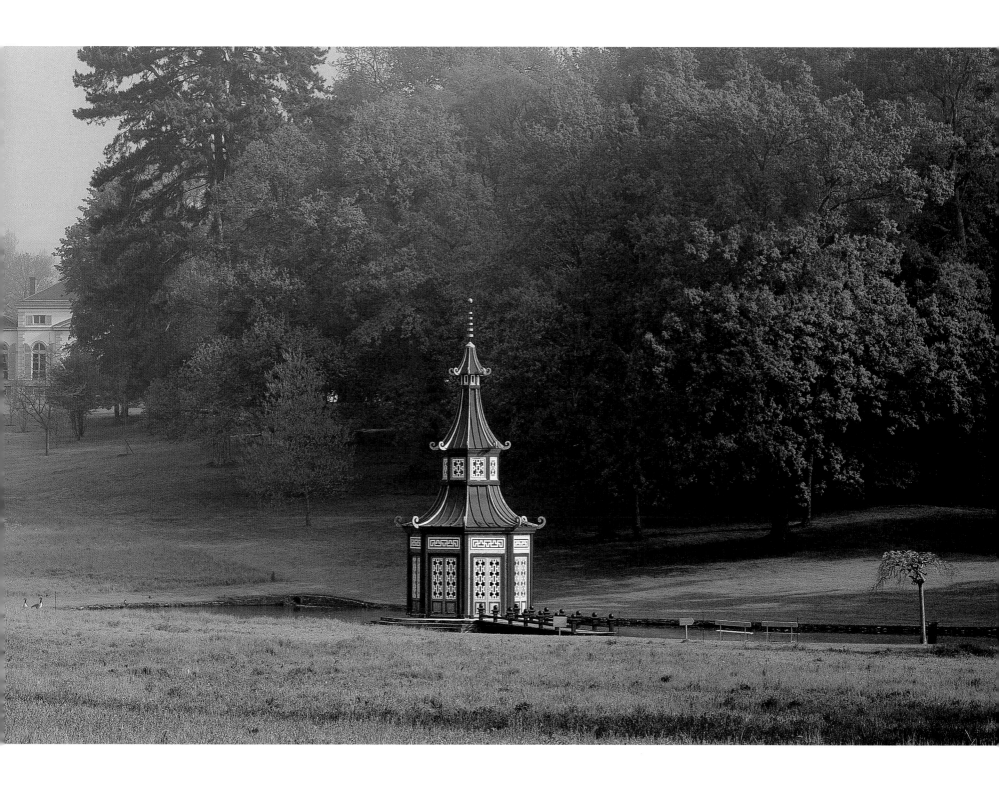

Paris, which was "free of any conservation or planning constraints." His plan, which he implemented from 1950 until his death in 1970, was to create something that contained and evoked the splendors of the best of seventeenth- and eighteenth-century European style. Groussay is a work of stylistic fantasy based on models gleaned from England, France, Italy, Spain, and even Sweden. To create this "folly," regarding which he had precise, fixed ideas, Charles de Besteigui enlisted the help of Emilio Terry, an architect and designer unflatteringly nicknamed "the father of Louis XVIII style," and Alexandre Serebriakoff, a painter and designer who was acquainted with all the great houses of Europe.

The place still astonishes, both for the brilliant, intelligent luxury of the palace and for the size of the park and the originality of its fourteen structures.

Groussay was never completed, but it was classed as a historic monument in 1993. This was a tribute to one of the last great private French gardens and to a resolutely antimodern goal, whose successful achievement has been its best justification. ⚜

*The pagoda in the foreground
is one of the structures by
Alexandre Serebriakoff.*

Contemporary Gardens

BOTANICAL GARDENS

In the fourth century B.C., the philosopher Aristotle assembled the first recorded collection of plants, the original ancestor of today's botanical garden. In a world at the mercy of agriculture's uncertainties, plant gardens, herb gardens, and gardens of medicinal herbs and simples carried out the important functions of preserving and exhibiting plants that were rare and exotic or that otherwise possessed special properties. These gardens were mostly to be found in monasteries and universities, the sole repositories of any kind of scientific knowledge prior to the Renaissance. The sixteenth and seventeenth centuries saw new interest in collecting, buying, and even speculating in plants—most notably the tulip, which brought about the collapse of the Amsterdam stock exchange in 1635. In the eighteenth century, scientists and economists seeking to develop agricultural production began to take a passionate interest in growing plants. Finally, specialized gardens were created in every city of Europe, the United States, and Japan following the work of Linnaeus (1707–78) in Sweden, which opened the way to a methodological classification of plants. Today botany is not so much a science of discovery as one of the preservation of species and their diversity. It is the close companion of man in a relationship with nature that is becoming progressively more fraught. Recently established botanical gardens such as the Eden Project in Cornwall offer an overview of thousands of years of plant history through the study, defense, and consideration of everything mankind owes to plants—including their beauty.

Eden Project's immense 150-foot-tall "biomes," or greenhouses, designed by Nicholas Grimshaw, are among the largest of their kind in the world.

Eden Project

UTOPIA AND ECOLOGY

SAINT AUSTELL, CORNWALL, GREAT BRITAIN
1998–2001
Designers: Tim Smit and Nicholas Grimshaw

The Eden Project is probably the most exciting botanical garden created in the entire twentieth century, and will doubtless retain that title for a good part of the twenty-first. Indeed, "botanical garden" is a modest and largely inaccurate way to describe it, given the extraordinarily ambitious educational, touristic, and civic scale of this endeavor.

The idea for it came to Tim Smit in 1994, when he imagined a garden that would bring together all the plants in the world that were used by mankind since prehistoric times, and a place that would also serve as a laboratory to demonstrate both the lives of plants in their natural environments and the ways humanity has gradually domesticated them.

Smit envisioned this historical-ecological panorama as divided into three zones: temperate, humid tropical, and warm temperate. The first would be in the open air, the second and third would be in immensely tall greenhouses, allowing for the growth of forest. Where would it be? With whom would Smit create it? And at what cost?

Smit and his friends succeeded in convincing Nicholas Grimshaw (architect of the new Waterloo Station), the engineering company Ove Arup, and many other specialists to join their initiative. Most important of all, they managed to sway the Millennium Council, which was in charge of distributing British National Lottery money to major projects for the celebration of the millennium. The council awarded 55 million euros to the Eden Project. Enthusiasm, faith in the idea, and a determination to overcome all difficulties did the rest. A site was found—an abandoned kaolin quarry lost in the countryside—and work began on reconstituting the soil, assembling plants, and perfecting the marvelous plan for biomorphic greenhouses. Visitors soon came. By the year 2000, half a million had appeared just to look at the worksite, and by 2005 the figure had swelled to 1.26 million a year. Eden Project is another proof, if any were needed, that nature is popular. ✤

The English Garden at Caserta

A Nostalgic Beauty

CASERTA, ITALY
1782
Designers: John Andrew Graefer, Carlo Vanvitello, and Joseph Banks

In 1782, Queen Maria Carolina of Austria, wife of Ferdinand IV and sister of Marie-Antoinette, laid out a delightful English garden over sixty-two acres (25 ha) at the top of Caserta's glorious waterfall. Thankfully neglected by tourists who would be exhausted by the climb to the fountain of Venus, it offers shade, the coolness of its springs, and viewpoints that are multiplied by a clever arrangement of curved paths. This remarkably well-maintained Regium Viridarium Casertanum is also one of the richest and oldest botanical gardens in Europe, while lacking the ponderously didactic, impoverished appearance this type of garden too often has. It has a complex, informal plan by the British gardener John Andrew Graefer—helped by Carlo Vanvitelli, son of the architect of the Reggia di Caserta, and advised by the botanist Joseph Banks. Graefer laid out paths, created contoured features, and added ruins, pools, secret passages, statues (some of them from Pompeii or the Farnese collection), and fountains. He succeeded in importing plants from China and Japan, including one of the first camellias, and traveled all over Campania, Sicily, Capri, and Ischia to gather plants that he brought back and cultivated in four handsome greenhouses. This garden, which the queen herself apparently financed, was considered so modern in its day that it exerted a powerful influence in southern Europe for a long time. Through the years it was treated with greater respect than some other gardens, so it retains its original plan. It even contains many of its original plantings, and these increase the nostalgia of this well-preserved place. ⚜

Opposite: This tranquil setting is one of the many pools in the Caserta Botanical Gardens.

Above: Statues half-concealed by the luxuriant vegetation add to the general atmosphere of discovery and surprise.

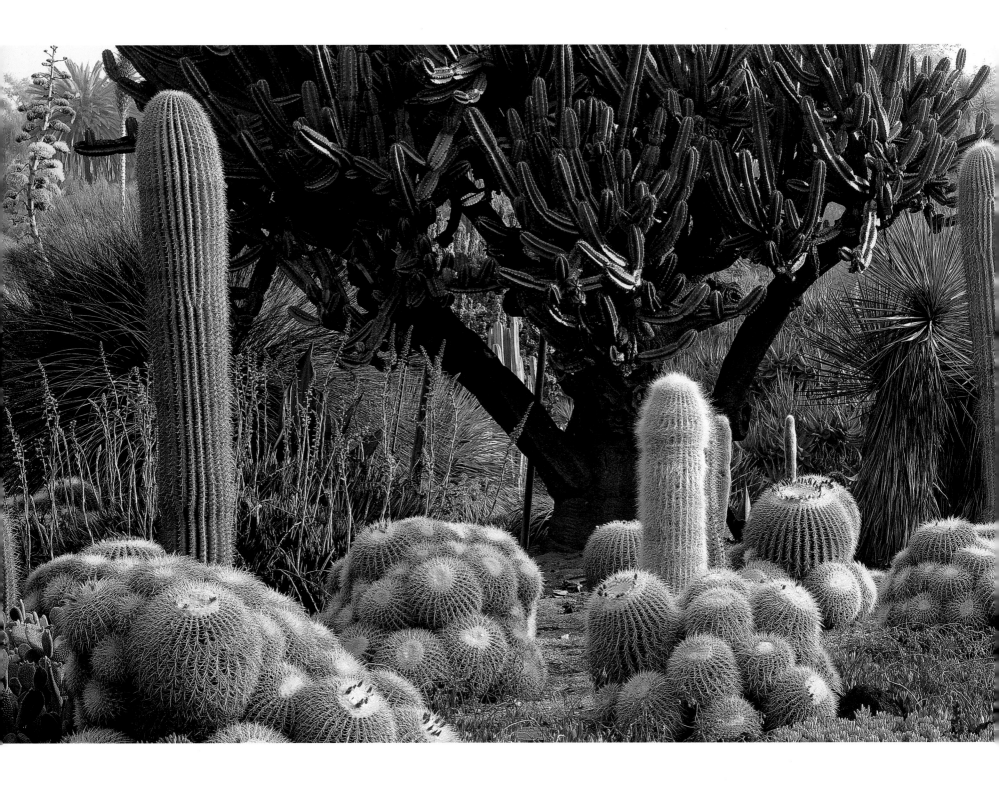

North Vista, Huntington Botanical Gardens

A COLLECTION OF GARDENS

SAN MARINO, CALIFORNIA, UNITED STATES
1903–68
Designer: Henry Edwards Huntington

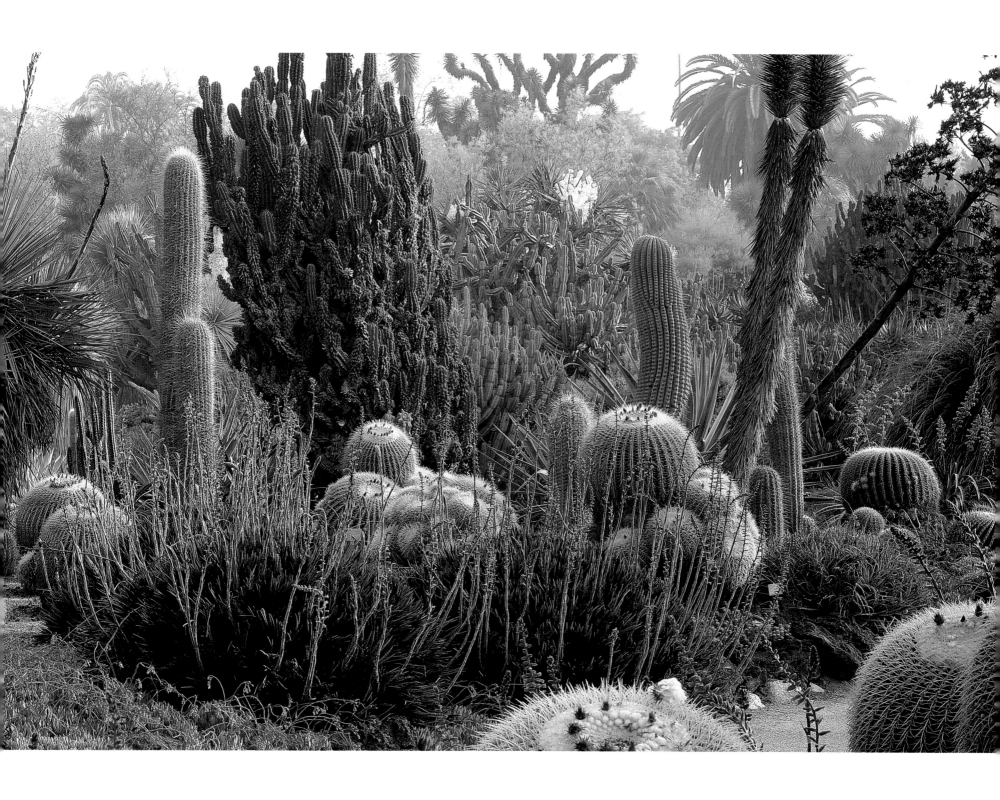

Henry Edwards Huntington (1850–1927) was a man of gargantuan enterprise. He made a fortune from the Pacific Electric Tramways Company of Los Angeles, inherited millions on the death of his uncle, and subsequently married his aunt; but he had no children and resolved to dedicate his life to a work that he could leave to his fellow citizens. Recognizing the extraordinary natural beauty of the San Gabriel Valley east of Los Angeles, he acquired a very large property there. His plan was to turn this estate into a park, overlooked by a house filled with his extensive collection of rare books. The idea of creating a collection of gardens, not merely of plants, came to Huntington while he was wondering what to do with the land surrounding his colonial-style mansion. Enlisting the help of William Hertrich, who began at the Huntington Botanical Gardens as a young man and directed them for fifty years

The Desert Garden is a collection of more than 4,000 desert plants, among them golden "mother-in-law's cushions," which retain quantities of water.

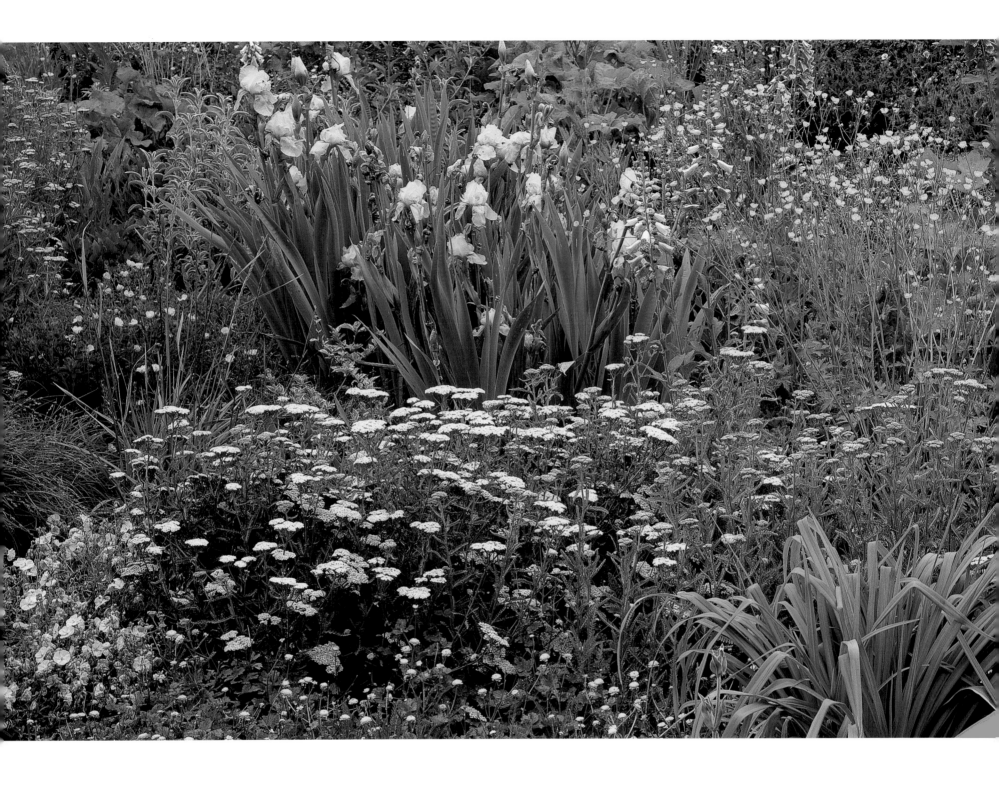

thereafter, Huntington began pouring vast quantities of energy and money into the garden project.

The work continued without a break from 1908 until the millionaire's death in 1927. Terraces, canals, irrigation, soil enrichment, construction, mature tree planting, attempts at acclimatization, failures, renewed effort and finally success (California's first avocados were raised here) went on relentlessly year after year, according to a strict plan. By 1920

Huntington was the owner of one of the most beautiful botanical gardens in the entire United States. Since that time, the property has progressed steadily and has remained in magnificent condition thanks to the enormous fund bequeathed to it by its creator.

After looking at Huntington's collection of books, paintings, and furniture, the visitor passes into the open, wandering successively through a rose garden, a Shakespeare garden planted exclusively

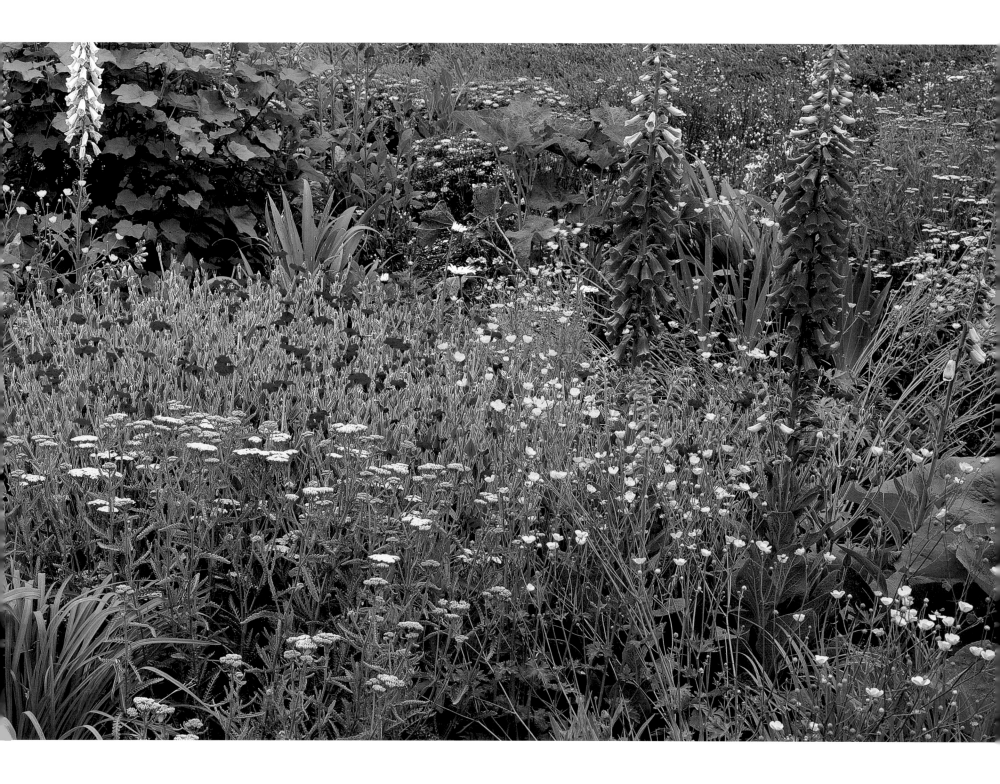

with species mentioned in Shakespeare's works, an herb garden, a desert garden with no fewer than four thousand species and one of the finest cactus collections in the world, a Japanese garden (see page 54), a collection of prehistoric palms, an Australian garden, a subtropical garden, a palm grove, a camellia collection, and several pleasure and sculpture gardens.

The passing years and the slow development of the planted vegetation has softened the originally hermetic planted areas. Today the Huntington Botanical Gardens are a fitting celebration of nature's essential oneness. ⚜

The Shakespeare Garden, laid out in 1983, includes all the plants mentioned by Shakespeare in his plays. It is one of ten thematic areas of the Huntington Botanical Gardens.

Marimurtra

THE WINDOW TO THE BOTANICAL MEDITERRANEAN

BLANES, SPAIN
1920
Designer: Karl Faust

The softness of the Blanes microclimate is much touted today as a tourist attraction. It is nonetheless a historical reality, having been described as early as A.D. 73 by Pliny the Elder in his *Natural History*. Toward the end of the eighteenth century, Antonio Palau Verdera, a celebrated Catalan botanist and a translator of Linnaeus, planted his first botanical garden in this spot. But it was not until 1920 that the present garden was laid out by a wealthy German, Karl Faust, a keen plant enthusiast who had fallen in love with Blanes, then a small fishing village. Faust chose a terraced site between two bays, and began to assemble an inventory of plants according to the advice of the greatest experts of his time. Soon after, he founded the International Mediterranean Biology Station, which survived the Spanish Civil War and World War II. After Karl Faust's death in 1952, his gardens were turned into one of Europe's most extensive botanical gardens, with some four thousand plant species. Marvelously sited on a natural balcony overlooking the sea, they somehow contrive to accomplish a scientific mission to promote the knowledge and preservation of Mediterranean species, while admitting more than half a million visitors each year. The plantations are grouped in what are known as "phytoepisodes," in other words, reconstitutions of specific vegetable landscapes (Catalan bush, South African bush, etc.), which make it possible to study plants and take action to preserve them as effectively at Blanes as in their original habitat.

This scientific and ecological dimension does not prevent Marimurtra from being a most pleasant garden, rich in fountains and beautiful views of the sea and coastline. Plant and garden lovers—the two are not necessarily synonymous—are united in their admiration of it. ❧

The Marimurtra Garden is laid out between two inlets, on terraces overlooking the sea.

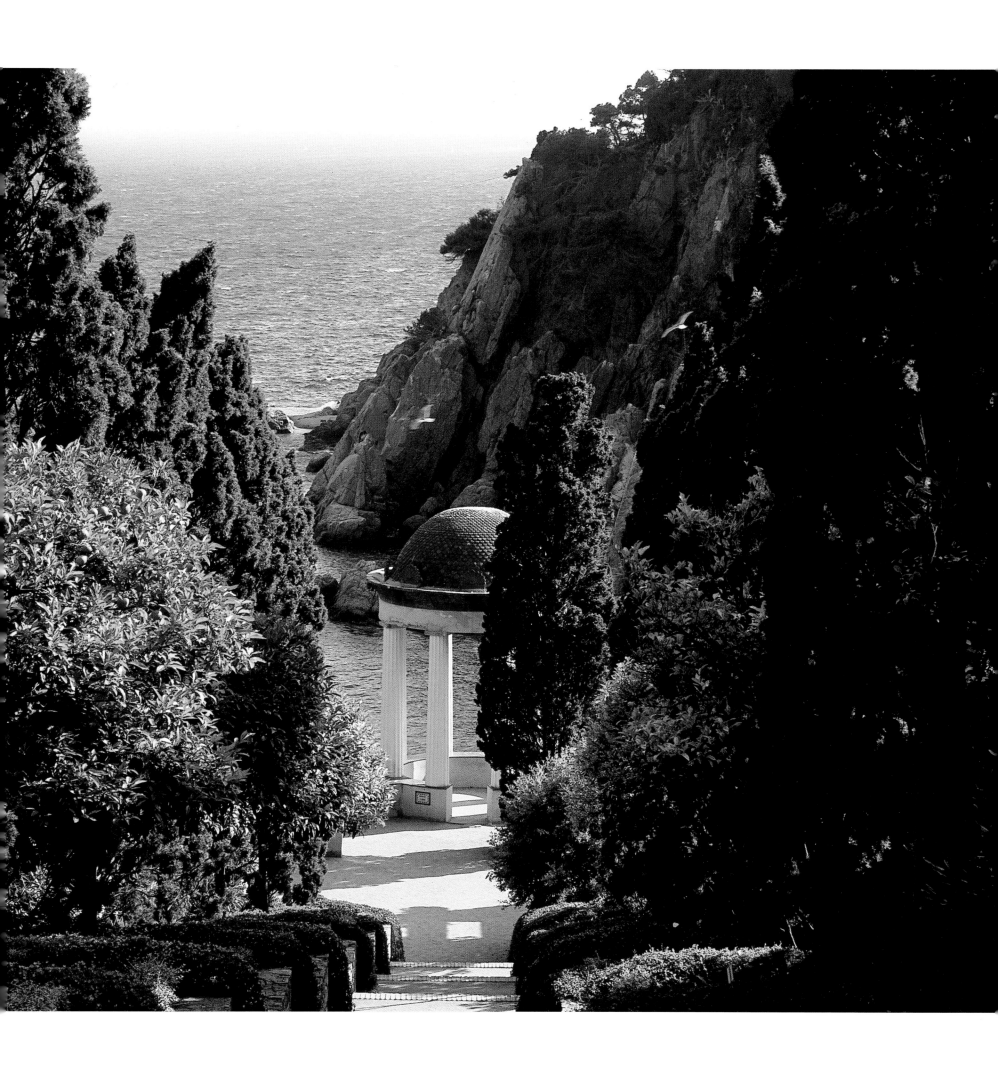

Guatiza

Cactus Garden

LANZAROTE, SPAIN
1987–92
Designer: César Manrique

César Manrique, the creator of this astonishing garden, was a colorful character. It took plenty of courage and energy just to live on his native Lanzarote, a tiny Atlantic island 500 miles (800 km) from the African coast and ravaged by a six-year volcanic eruption beginning in 1730, and whose only resource for a while was the raising of cochineal beetles for dye.

Manrique, born in 1919, was a painter, sculptor,

designer, and architect who for many years lived the fashionable life in Europe and America before finally returning to the island of his birth. He saw Lanzarote as an "unmounted, unframed work of art." In the late 1960s he resolved to fight the real-estate promoters who were threatening to do to Lanzarote what they had already done to the coast of mainland Spain, the Balearic Islands, and the other Canary Islands. With the backing of local people and allies in Madrid, he

managed to turn back the tide of development. He then created roads, viewpoints, and restaurants that were integrated into the natural surroundings, as well as a foundation for the protection of Lanzarote and a villa for himself, built into a natural cave system.

One of Manrique's last projects was the Cactus Garden, now the symbol of Lanzarote, which was declared a World Biosphere Reserve by UNESCO

Over 14,000 plants of 1,400 species were assembled by César Manrique in an abandoned quarry amphitheater of 54,000 square feet (5,000 sq. m).

in 1993. The garden is laid out in an old quarry from which lava was once extracted to protect crops from the effects of wind and evaporation. It is shaped like an amphitheater, against a distant, spectacular background of red mountains—"the mountains of blood." Within a few years, and with the help of the botanist Estanislao González Ferrer, Manrique's garden had accumulated more than 14,000 cacti of 1,400 different species from Madagascar, South

America, and the Canary Islands. Their sensual, serpentine, stumpy, or precise outlines blend with those of lava blocks eroded by the winds, amid a surrealistic and theatrical mise-en-scène.

The choice of the cactus theme for this garden was anything but a random one. The Lanzarote cochineal caterpillar feeds on cactus, and the island's interior is full of the tunera prickly pears, which form the cochineal larva's preferred diet. This strange

botanical garden belongs to no particular category, true to César Manrique's dictum that "classification is negative. It weakens art." ✥

Cacti from all over the
Americas—from Canada
to Patagonia—grow here in
conditions that suit them. The
soil is covered with lava shale,
which limits the evaporation
caused by wind and heat.

A series of terraces, some retained by sculptural walls of Cor-Ten steel, offer a comprehensive overview of Mediterranean vegetation.

Barcelona Botanical Garden

CONTEMPORARY BOTANY

BARCELONA, SPAIN
1997
Designer: Bet Figueras

The hill of Montjuic, a discreet eminence that blocks the southward expansion of Barcelona, is not only the home of that ultimate icon of modernism, Mies van der Rohe's pavilion; it is also the site of José Luis Sert's Fundatión Miró, a stadium designed by Arata Isozaki, and a television tower built by Santiago Calatrava. As if this weren't enough, it now has Bert Figueras's brand new botanical garden.

Bet Figueras is a Catalan landscape designer and botanist. His project is at once a study of the architecture of nature and a discourse on the evolution of Mediterranean plants and landscapes. Instead of a standard conservatory, he visualized a public thoroughfare through a chronological sequence of vegetable species, from bushes to trees by way of grasses, aquatic plants, and flowers. The direction is south to north, spares visitors the summer heat,

and meanders through a redistributed or "fractal" landscape. Put more simply, the idea was to put together a contemporary version of the terrace cultivation that has been practiced around the fringes of the Mediterranean for time out of mind. The earth is retained by walls of low concrete or by Cor-Ten steel, a material that assumes a superb patina and is much favored by Spanish landscape architects. The pathways are covered by steel, cement plaques, and wooden planking; the reception and maintenance buildings, which are low and discreet, use the aesthetic of sharp angles and stretched volumes. This botanical garden, the most modern in Europe, contrives to blend didacticism with the emotion of discovering a mineral and vegetable world that is entirely contemporary—to the delight of a broad public. ⌖

Modern Inspirations

The end of the nineteenth century and the twentieth century were golden years for gardens and landscape design. For one thing, a wholesale privatization took place: no longer was the gardener's art restricted to the great domains of princes and aristocrats. It was within reach of everyone—or almost everyone. The Arts and Crafts movement in England had a huge influence in this regard. In its celebration of doing things with one's own hands and its promotion of the aesthetic of everyday existence, Arts and Crafts was bound to focus on the surroundings of the home. We owe to it many sensitive creations that were more open than ever before to the sheer wealth of the botanical world—creations inspired by a body of literature devoted to the exploration of the self and by a generation of painters who were discovering the physical sensations of light and color. This shrinking of the garden rejected the great baroque perspectives of Caserta and Stowe, preferring to enrich the individual's experience. Gardens were no longer dramatized by grand gestures, archaic symbolism, or the picturesque—all of which had demonstrated their limitations. Instead the owner of the garden became the gardener, with the help and advice of skilled practitioners of the art. The new generation had a profound knowledge of botany, shared that knowledge with others of like mind, and perpetuated the tradition of Gertrude Jekyll in both Europe and the United States. Christopher Lloyd, Alan Jellicoe, and Russell Page were in the vanguard. As far as they were concerned, there were still rules to be obeyed, but they were not straitjackets; instead they were elements in a more interiorized game of artistic creation.

Left: The garden surrounds a fifteenth-century manor house, restored by Lutyens.

Right: Great Dixter was the research and acclimatization laboratory of the botanist Christopher Lloyd.

Great Dixter

THE GARDEN OF CHRISTOPHER LLOYD

NORTHIAM, SUSSEX, GREAT BRITAIN
1910
Designers: Edwin Lutyens, Nathaniel and Christopher Lloyd

"It is upon the right relation of the garden to the house that its value and the enjoyment that is to be derived from it will largely depend. The connection must be intimate, and the access not only convenient but inviting." This is the first sentence in Gertrude Jekyll's famous book *The Arts and Crafts Garden*. The greatest gardener of the Edwardian era had no part in the creation of Great Dixter, but she appreciated the plant work of its owner, Nathaniel Lloyd, and even invited his young son Christopher to her house; he would become one of the greatest gardeners of the twentieth century.

Great Dixter is a charming fifteenth-century manor, entirely restored in 1911 by the architect and garden designer Edwin Lutyens, friend of Gertrude Jekyll's. He intervened with discretion and customary intelligence, creating gardens that retained their shape well over the decades.

Lloyd allowed his plants an unusual measure of freedom, opening the way to an environmentalist view of the gardener's art.

He comfortably surrounded the house with a combination of garden forms (cross garden, topiary garden, meadow, rose garden, terraced garden, an immense tall border) and multiplied the points of view, intimate spaces, architectural details (stone walls, round staircases). The ensemble is a masterpiece of an epoch that saw England's upper class take up a lasting passion for the art of the garden and, above all, for gardening itself.

Christopher Lloyd, who died in January 2006, was one of the great gardeners of the twentieth century. He lived at Great Dixter all his life and made a critical contribution as an artist and botanist to the plantings we admire there today. With his books, articles and columns, and his daring use of grasses in flowering meadows, he was the link between the Arts and Crafts style and modern landscape gardening with its emphasis on the natural—indeed on nature itself. ⚜

Mughal Garden

A Garden for Butterflies

DELHI, INDIA
1912–36
Designer: Edwin Lutyens

In the extension to the New Delhi Viceregal Garden, after making his way past a strange red granite pergola with elephant's trunk pendants, the visitor carrying the necessary authorizations will come upon something more intimate than the vast Persian carpet laid out by Edwin Lutyens under the windows of the viceroy's apartments. It is organized around a circular pool, itself surrounded by a bed of mignon-ettes, dahlias, and climbing roses. The atmosphere is

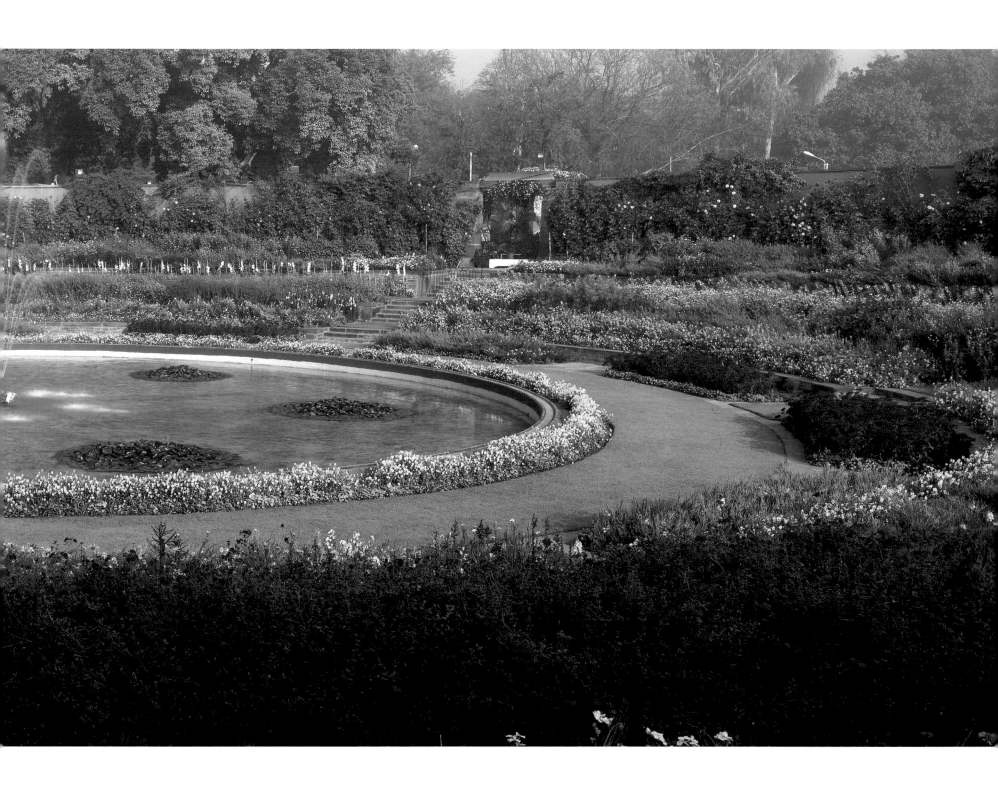

no longer Indian, but resolutely Arts and Crafts; very similar to that of Heywood, an Irish garden designed by Lutyens a few years earlier.

The most charming aspect of this little corner of England in India is that Lutyens chose its plants with the help of W. R. Mustoe, its horticulture director, in such a way that at a certain time of year they would attract innumerable butterflies, so many that the color of the garden itself would be more that of the butterflies than that of the flowers themselves. In a small building adjoining the office of the horticulturist in charge of the gardens there is a remarkable bonsai collection. Several different civilizations of garden lovers—Mughals, British, and Japanese—seem to have come together in this butterfly garden. ❖

The pool is surrounded by flowers specially selected to attract butterflies at a certain time of year.

Sissinghurst

A LITERARY CREATION

CRANBROOK, KENT, GREAT BRITAIN
1930
Designers: Vita Sackville-West and Harold Nicolson

Sissinghurst, in the classic Edwardian or late Arts and Crafts style, is a garden made up of different "rooms." This is one of the doors to the upper courtyard.

The English are a nation of gardeners. There are many reasons for this, but chief among them are the soft, damp climate of England and its people's love of their homes and the gardens that surround them. In earlier times, the English garden may have offered a way to forget galloping industrialization, or a means of demonstrating an attachment to the traditional countryside by imitating and perpetuating the aristocratic ideal of country houses and parks. Whatever the reason, the English love of horticulture persists: in no other country today are there so many magazines, TV programs, radio broadcasts, internet sites, markets, fairs, and exhibitions devoted to the creation and maintenance of gardens.

Vita Sackville-West, who with her husband, Harold Nicolson, was the creative force behind the gardens of Sissinghurst Castle, was the quintessential garden-loving aristocrat. She dedicated much of her considerable energy to giving conferences, making radio broadcasts, and writing books and brochures about plants, while maintaining a prolific literary output and an active social life.

The Nicolsons bought the ruins of Sissinghurst in Kent in 1930 precisely because the property seemed to offer a chance to create the kind of garden they wanted. Little remained of the original Elizabethan

pile; there were only a strange old tower, some wrecked outbuildings, and a few crumbling walls. But Sissinghurst had magnificent views of the surrounding countryside and a powerful atmosphere of romance, and within ten years, the new garden had found its balance. Harold Nicolson designed it from the top of the tower, shouting orders to his two sons, who scurried about below him hammering pegs into the grass to mark out the avenues and delineate the various zones. The Nicolsons knew and admired Gertrude Jekyll; they were also friends with Edwin Lutyens, who had helped them with their previous house. Their personal taste was inclined to marking off patches of green and enlivening them with long lines north, south, east, and west. Their project was fully in the spirit of Arts and Crafts; William Morris's principle that "a garden must be protected from the outside" exactly suited their ideal. The Nicolsons put into practice the modernity of their youth, but afterward Sissinghurst remained for many decades an emblematic place, capable of launching fashions such as the all-white garden, or flowering plants trained into trees. Today it has a special dimension of its own, at once intellectual and nostalgic; for it remains above all a monument to the eccentric couple who dedicated so many years of their lives to its creation. ⚜

Charming mixed borders in the
cottage garden were inspired
by the art of Gertrude Jekyll.

Following pages: Sissinghurst
owes much of its poetry to the
remains of the old castle, with
its moss-covered walls, moats
transformed into pools, and
outbuildings overwhelmed
by climbing roses.

La Mortella

THE GARDEN OF MUSIC

FORIO, ISLAND OF ISCHIA, ITALY
1956
Designers: Russell Page and Susana Walton

Nowadays, to create a garden from scratch is a real adventure. "I must have been totally, totally mad," says Lady Walton, when she tries to explain how she and her husband came to create their tropical gardens overlooking the Bay of Naples, on the island of Ischia.

William Walton was one of Britain's greatest twentieth-century composers. He and his young Argentinean wife, Susanna, arrived on Ischia in 1949, shortly after their marriage, and decided to settle there for the duration. They wanted a house, but while they were waiting for it to be built they acquired a disused lava quarry that looked like a good place for growing things. Their dream was a tropical garden—on an island that had no local water and depended on supplies brought across the bay by boat and truck.

Their friend Russell Page (1906–85), the legend-

La Mortella, created from an old lava quarry, explores links between gardens and music.

On an island bereft of water, the Waltons succeeded in creating a near-tropical garden by skillful use of the land available.

ary English landscape gardener and botanist and one of the most refined gardening aesthetes of the day, devised an L-shaped plan that was perfectly adapted to the narrow site with its scattered lumps of black volcanic lava. He visualized a stream, waterfalls, and pools, but the Waltons had to wait until the arrival of a water main from the continent before their astonishing project could take shape.

The Mediterranean is anything but a tropical zone, but this valley garden on Ischia has somehow created its own microclimate; one is not surprised to see tree ferns, Chilean cycas and African flowers blooming there at their ease.

La Mortella (which means "myrtle" in the local dialect) is full of musical associations. William Walton died in 1983, but the Walton Foundation continues to invite young composers and musicians for master classes and concerts every summer. The garden is kept generously open to the public, a rarity for Italy, where private gardens tend to be extremely private. With little money at the outset and the kind of constraints that would have discouraged most people, La Mortella has gradually composed its own wonderfully original and poetic score. There has always been a special link between gardens and music. ⚜

There is no hint that this garden is on the island of Ischia, in the middle of the Bay of Naples: even certain varieties of fern have become acclimatized.

Ayrlies

NATURAL STYLE OF THE SOUTHERN HEMISPHERE

AUCKLAND, NEW ZEALAND
1967–present
Designers: Beverley and Malcolm McConnell

Back in 1967, there was nothing here but a farm of cultivated fields and pastureland. In forty years, Malcolm and Beverley McConnell have succeeded in making Ayrlies one of the most exuberant gardens in the southern hemisphere. As with many contemporary private gardens that have become famous, the original ambition was modest enough; but gradually this wealthy Auckland couple became wedded to their task—and the little garden they had envisaged around the house "to keep Beverly busy" was transformed into a landscaped park that exceeded seventy-four acres (30 ha) once it was extended into neighboring marshland.

The natural site was fabulous, as is often the case in New Zealand, but the plan did not begin to blossom until the McConnells went to England and discovered what water could do. Immediately on their return, they dug three pools at different levels, around which they assembled an informal, incredibly vigorous, tufted plantation. The sheer freedom of Ayrlies is perhaps its most striking characteristic. The plants seem to have gathered

Visitors are free to wander anywhere they like among the paths and clearings of Ayrlies.

there at their pleasure, whereas in fact they are the result of long acclimatization—to begin with, many of the imported varieties were allergic not only to the clay soil, but also to the droughts, strong winds, and heavy rains that are frequent in this region. With time, local species like giant ferns gained the ascendancy as they always do, along with a few happy surprises from Japan or North America such as bougainvilleas, rhododendrons, magnolias, and American maples. In recent years, a garden of aloes and agaves has grown up in a protected corner, inspired by the one at the Huntington Botanical Gardens in San Marino, California.

Freedom of another kind is permitted to visitors. There are no majestic avenues at Ayrlies, no assigned itineraries and no calculated, foreseeable effects. People wander where they will along the few pathways or through the grass and undergrowth, exploring the gardens at their leisure, From time to time they encounter a stunning scarlet aloe ferox or glimpse the ocean through the trees.

Ayrlies is a synthesis of the McConnells' wonderful gift for horticulture and their relaxed ideal of a natural landscape. ⚜

URBAN GARDENS

The turn of the twenty-first century saw a return of the gardener's art. Neither the general public nor those who loved gardening had ever rejected this ancient skill, yet the juggernaut of modernism had largely lost interest in the architectural aftermath of World War II. The handling—or rather ignoring—of the natural environments surrounding postwar state housing projects partly explains their state of crisis. All too often, parking lots took the place of lawns, pools, and shrubberies, reinforcing the repetitive and relentless effects of functionalism in our great anxiety-inducing urban sprawls. But in recent years this has begun to change. Urban planners, architects, landscape designers, and artists are fighting hard to reintroduce parks and gardens into cities, in forms that genuinely suit the new ways of living. The Parc de la Villette in Paris, laid out by Bernard Tschumi, is a good example of a major project whose popularity with the public has proved its value. Nature is regaining territory in every city—beside the Thames in London, on the banks of the Rhône in Lyon, along the Spree in Berlin; also in more unexpected places like the Atocha railway station in Madrid, or among the ruins of an old Ruhr steelworks. Gardens are appearing in privately owned places, on roofs and terraces, and even on walls, thanks to Patrick Blanc. Their creators are annexing new areas, using new materials, adopting new plants, and exploring new artistic and conceptual approaches. They are discovering democracy.

Above: One of Patrick Berger's two greenhouses in the upper zone of the garden.

Right: This modernist topiary border creates an effect of cut velvet.

Parc André-Citroën

THE FIRST CONTEMPORARY PARISIAN PARK

PARIS, FRANCE
1985–92
Designer: Gilles Clément

Freshly laid out on land released by the demolition of a giant automobile factory beside the Seine, the Parc André-Citroën is the most ambitious new green park in Paris since the Buttes Chaumont of 1867. It is above all one of the most brilliant pieces of urban garden design undertaken in Europe in the latter part of the twentieth century, in terms of its intelligence, its concern for the people who use it, and its aesthetic, which is modern but not provocative. You have to go there on a Sunday morning in spring to see exactly how much Parisians appreciate these green spaces, and to what point this park, with a complexity carefully masked by the fullness of its masterly perspectives, answers to their taste. It is a taste that is not, as one might have feared, wholly nostalgic.

Gilles Clément laid out the park, which has a broad lawn running down to the Seine from two tall greenhouses designed by Patrick Berger, and a succession of serial gardens, each with a distinct

This alcove garden at the edge of the park is a plant staircase.

personality of its own. These intimate roomlike spaces, with their contrasting colors and plants (white garden, black garden) are structured by walls and partitions of stone, wood, or metal. A terrace offers an overview of them, from the top of a shaded promenade: this is anything but the conventional presentation of a botanical collection.

Clément has successfully opened the entire broad space at his disposal to the restless, ever-shifting sky of the Île-de-France. At no time does one feel boxed in, as one does in some of the nineteenth-century parks. Here, the city has receded to allow a corner of contemporary nature to take root—and spread. ⌖

Atocha Station

A RAILWAY STATION GARDEN

MADRID, SPAIN
1992
Designers: Arturo Fernández, Ernesto Fernández, Joaquin Fernández,
Alfonso Ramirez, and Mariano Sánchez, in collaboration with Rafael Moneo

The restructuring of an old railway station can produce pleasant surprises. Paris turned the Gare d'Orsay into a museum; Madrid has created a botanical garden in the middle of the Atocha station.

A modern facility was needed for the Madrid-Seville high-speed train link (AVE), one of the major projects spawned by the 1992 Universal Exposition. Already existent in the middle of the city was a huge terminus built in 1892 by Alberto de Palacio with the assistance of Gustave Eiffel, but it was decrepit and unsuitable. Rafael Moneo, one of the most brilliant contemporary architects in Spain, was chosen to restructure it. Moneo designed a new, lively square, a station for the AVE, another for suburban trains, and another for buses—and then transformed the old building into a reception area for passengers. Above all, he reorganized the cavernous glass-roofed station hall into a greenhouse containing a tropical garden: seven thousand plants belonging to more than four hundred species were acclimatized

for the space, but today it appears that the plantings are being refocused to create a palmarium—since of all things palm trees are happiest in the Castilian sunshine, on condition that they are protected from the harsh winter cold.

The Atocha station now resembles a gigantic crystal palace of the nineteenth century, not unlike the one at the Retiro Park near the Prado museum. It epitomizes a fast-evolving architectural trend: that of placing gardens in shopping centers, creating covered spaces between buildings, and devising courtyards and atriums on a majestic scale. Atocha's tropical winter garden, which looks both to the past and the future, has been quickly absorbed into the expanding network available to pedestrians in Spain's capital city. ⊶

The platforms of the old Atocha station have been supplanted by a tropical garden, with the original glass overhead doing service as a greenhouse.

Camille Muller's Garden

A ROOFTOP IN PARIS

PARIS, FRANCE
2000
Designer: Camille Muller

The rooftops of Paris conceal many an enchanted green corner. Many roof gardens in the French capital have been famous in their time—notably that of the Comtesse de Pange, on the seventh floor of a modern building on the rue de Grenelle; Charles de Bestegui's terrace, designed by Le Corbusier, overlooking the Champs Élysées; and Helena Rubinstein's garden-salon on the Île Saint-Louis. But since these were installed, many other terrace gardens have appeared on the roofs of buildings both old and new—small verdant havens far removed from Mimi Pinson's show of geraniums.

Camille Muller, a respected garden designer who has worked with Gilles Clément and helped with the Bois des Moutiers at Varangeville-sur-mer, has made a specialty of hidden urban gardens. Her own, which is in the eleventh arrondissement of Paris, is wedged between blank walls and metal panels; yet its poetic riot of vegetation is so completely at ease with itself that it has invaded not only Muller's apartment but also the neighbors' walls. "I create gardens that I can feel, not concepts," says Muller, and indeed her creations are places for dreaming and giving free rein to the imagination. Nevertheless, a hanging garden is by its very nature a technical feat of great and delicate prowess. The weight of the soil that must be imported, the shrubs that rapidly become trees, the water supply which is constantly in danger of leaking through to the apartments below, are all problems that must be resolved before planting even begins. Yet the poetry of an alcove of green nature high in the sky is a fitting reward—and also a fitting reversal of fortune, insofar as nature is reconquering, in her own way, some of the space that has been taken from her. ❧

Camille Muller has created a secret, romantic hanging garden in one of the most densely populated quarters of the French capital.

Grupo Planeta Balconies

The Curtain Garden

BARCELONA, SPAIN
1970
Designers: Enric Tous, Josep Maria Fargas,
and Jordi Aguilá

On a corner of the Avenida Diagonal in Barcelona stands the former Banca Catalana building, now the headquarters of the giant publishing company Grupo Planeta. In this relentlessly mineral quarter of the Eixample, built in the years following 1869, nature's sole representatives for many decades were a few lines of sooty trees fighting valiantly against the ambient pollution, a reminder if ever there was one that green areas in this part of town were few and far between.

The architects Joseph Maria Fargas and Enric Tous, when they were drawing up the plans for this huge office building, had the idea of vegetalizing the façade. The techniques perfected by Patrick Blanc in Paris were not available twenty-five years ago, so they imagined a system of balcony window boxes, for which the landscape architect Jordi Aguila selected the necessary resilient, cascading plants. The faceted façade, well designed but a little hard and dry in its effect, has now acquired a voluptuous skin that seems to have prevented it from aging. Its slightly dated style is forgotten behind the green curtains of ivy and wisteria that ripple down it and furnish an elegant supporting structure. This remarkable idea, so difficult to accomplish on account of structural problems, orientation, climate, the aging of the plants and their maintenance, has unfortunately found few imitators. ❖

In the resolutely stone-and-concrete environment of the Avenida Diagonal, the former Banca Catalana building boasts one of the first plant façades in Europe.

Renaudie Gardens
The New Hanging Gardens

IVRY-SUR-SEINE, FRANCE
1970–83
Designer: Jean Renaudie

At Ivry-sur-Seine in the Paris suburbs, the Centre Jean-Hachette is an emblematic piece of French state housing, and one that has yet to be repeated. The star-shaped buildings designed by the architect Jean Renaudie (1925–81) illustrate a generous vision of the city environment, which in its time was heavily resisted by the administration. For Renaudie, urban planning and architecture were one and the same, and architecture's function was to facilitate people's lives, development, and encounters with others. With this in mind he devised a series of astonishing constructions in which homes, offices, workplaces, and shops were all combined under one roof. The star shape made it possible for human functions and traffic to overlap, and above all for unusual, stimulating spaces to be included in each apartment. Real gardens were slipped in between the living spaces and the balconies, and these formed the blueprint for a new brand of urban landscape. For the first time,

rented, cheap accommodation became available with the unheard-of luxury of a small private garden in the middle of the city.

Renaudie's experiment had its critics, but they were almost never to be found among the generations of tenants who succeeded one another at Ivry over the years, and for whom a living room with an extension of a few square meters of green garden was worth spending years on a waiting list. Today the terrace gardens are no longer available as state housing, but a new generation of architects is taking every opportunity to introduce green areas into urban blocks and thoroughfares, and to strew façades with plants. A new chapter in the history of gardens has begun. ❧

Skillfully combined balconies and terraces bring the pleasures of the garden into the heart of the city.

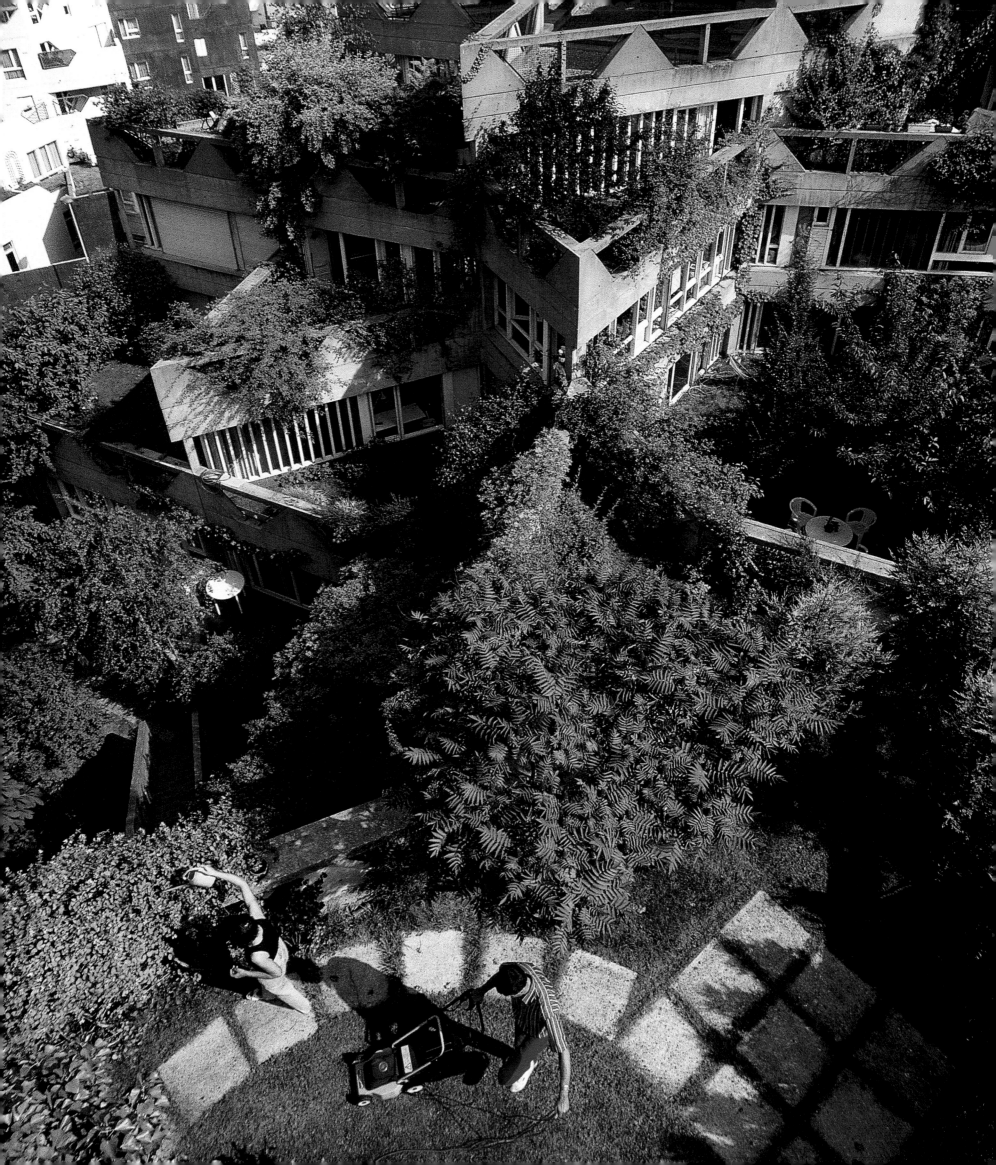

Left: Saturday in the garden.

Right: The gardeners of Bagnolet took advantage of major earth-moving operations during the construction of a new highway.

Family Gardens
A GARDEN FOR EVERYONE

BAGNOLET, FRANCE
1998

"Let us give back to the French their roots in the land, which is the source of such well-being for our human family; let us preserve our workers from the proletariat, which lies in ambush for them and rots their lives." This call to arms was uttered in 1894 by Abbé Lemire, a representative of the Pas-de-Calais in the French parliament, when he founded the Ligue Française du Coin de Terre et du Foyer (The French league for a home and a plot of land) and started a movement on behalf of what were known as *jardins ouvriers* (workers' gardens), and, after 1952, *jardins familiaux* (family gardens).

The league saw the garden as a social panacea that would not only provide extra food for the family, but also guard against idleness. The gardens were hugely successful at first, went into decline in the 1960s, and are now making a strong comeback. There are more than 200,000 *jardins familiaux* in France today.

At Bagnolet, a great center for gardens of this sort between the wars, an association, the municipal authorities, and Daniel Girard recently took advantage of the construction of the new A3 autoroute to create a brand new gardening zone that has been a huge success with local people.

The allotments fulfill their function well. In general they are beautifully maintained vegetable patches, usually with a corner set aside for flowers. The gardeners go to them after work, or visit with their families on weekends, meeting friends and chatting in an atmosphere reminiscent of Robert Doisneau's photographs. Their small workers' allotments resemble those of the Middle Ages, which like them were not only productive but also served as an escape from the daily grind. And it goes without saying that their owners are true garden lovers. ✤

ECLECTIC GARDENS

In modern gardening, eclecticism is very much the order of the day. It is both a chronological and a stylistic eclecticism, offering the freedom to reconstruct a medieval garden, restore a classic French garden, build a Japanese garden, or install an Andalusian garden in a riad in Marrakech. Likewise, one may call on the services of a sculptor, painter, architect, engineer, botanist—or even a gardener. But above and beyond all this activity, the sheer volume of which no other art can match, a few great creators stand out as the true progenitors of the twentieth- and twenty-first-century gardening style. The authentic contemporary garden is usually the consequence of an act of will—if we except Gilles Clément with his "garden in motion," and the work of a few other environmentalist landscape designers. The contemporary garden is not Arcadia, nor does it copy the patterns of carpets and embroideries, nor does it depend on literary or pictorial symbolism. On the contrary, its essence resides in an abstract approach to nature. Careful earth-moving, sophisticated plantsmanship, accumulated motifs, experiments with textures, concern for monochrome effects, and rare plant species are part and parcel of this approach; likewise the care taken over the maintenance of plants and the way they develop over time. All these elements are very much present, and in turn are subject to prevailing economic conditions. The garden, according to the leading designers and gardeners of today, is raw material for art and architecture. The natural environment it exhibits can now attain a level of beauty and energy fully capable of moving anyone who loves the paintings of Mark Rothko, the sculpture of Eduardo Chillida, or the music of John Adams. Nature redesigned by man today is seen as a triumph of man's culture—no more, no less.

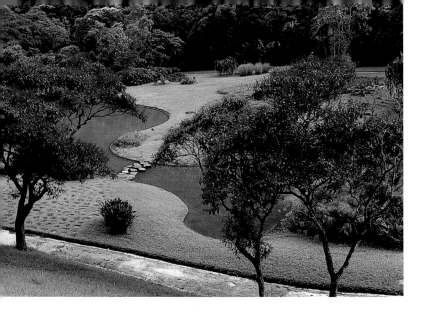

Fazenda Marambaia

AN ICON OF BRAZILIAN MODERNISM

PETROPOLIS, BRAZIL
1948 and 1988
Designer: Roberto Burle Marx

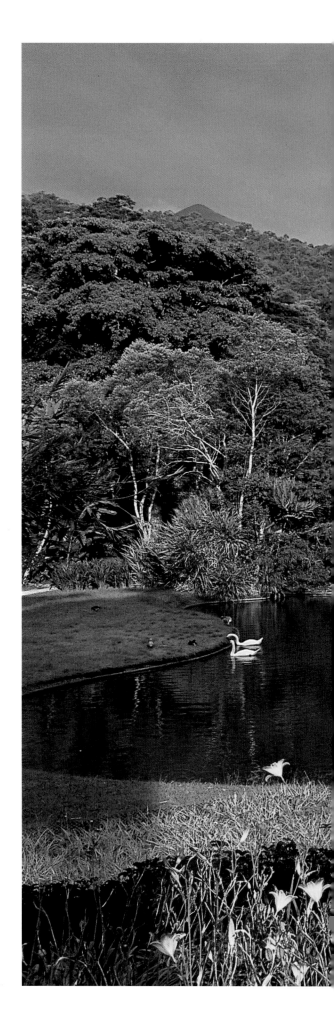

Roberto Burle Marx (1909–94) was one of the most gifted landscape architects of the twentieth century. He made people look at gardens in a new way. The key to his work lies in his native Brazil—not in Europe, as many champions of the modern movement would have it. Roberto may have gone to Germany in 1928 for a year's cultural sabbatical—where, oddly enough, he discovered South American botany for the first time in the greenhouses of Dahlem—but it was not until his return that he began his studies at the Rio de Janeiro art college. There, helped by a network of friendships and his own insatiable curiosity, he fell in with young architects such as Lucio Costa and Oscar Niemeyer. He received his first garden design commission in 1932 and was appointed director of parks at Recife in 1934. Meanwhile, he painted copiously, fell in love with his country's flora, and went on expeditions to the mountains to find rare specimens. In 1936 he joined the Rio project of the Ministry of Health and Education—to which Le Corbusier also contributed—and was commissioned to lay out gardens both at ground level and on the roofs of buildings. This launched his career, allowing him to divide his time among landscape design, the painting of wall frescoes, pottery, music, and botany.

In 1948 Burle Marx designed the garden of the Fazenda Marambaia for his close friend Odette Monteiro. As with all his projects, this one should be viewed just as it was originally conceived, as an abstract painting that could be hung from a dado. The composition indicates the house, the human traffic around it, and the lake to be built, as well as the color relationships between lawns, water, planted or preserved woodlands and flowerbeds.

Right: The garden stands against a spectacular backdrop of mountains on the outskirts of Petropolis, the city created by the last emperor of Brazil.

Above: View of the pool.

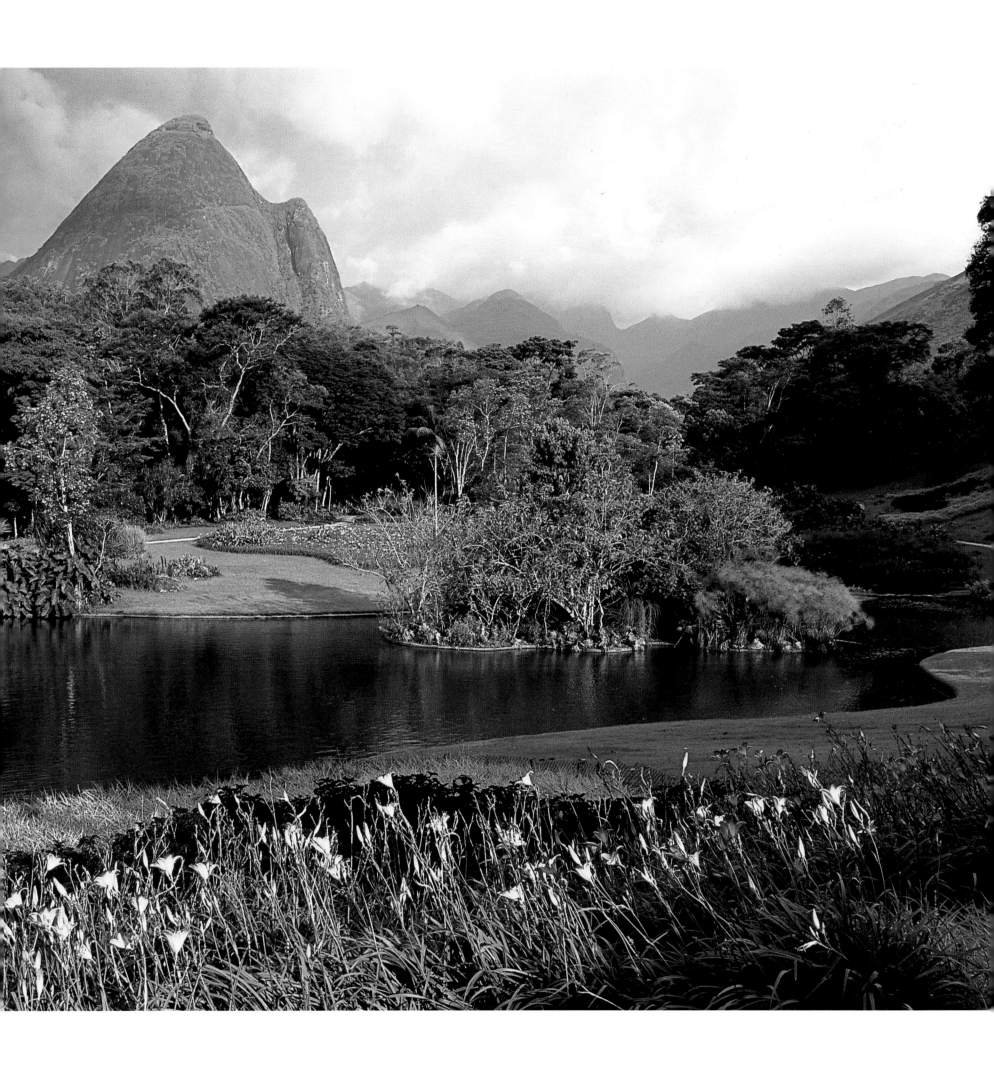

The vegetation is composed with a view to creating a texture of colors, different heights, shiny or matte surfaces, and trimmed effects. The randomly shaped borders are completely integrated with the lawns.

Astonishingly, the real-life garden that eventually emerged is a faithful rendering of the atmosphere of this painting-cum-design. The specificity of Burle Marx's work resides in the lyrical, organic movement of shapes and in a chromatic range that chimes with the Brazilian landscape. Semiwild nature is only a few feet away, stubby mountaintops stretch away into the distance, and it is obvious that if this garden were not constantly maintained it would soon be swallowed by the tropical forest. The central idea was to create a randomly contoured lake as the center of a garden clearing in the forest. The flickering water surface concentrates the light, is the focus of viewpoints from the avenue that circles it, and serves as a frame for groupings of local trees and plants, often of a single color and chosen for their harmony with the surrounding natural environment, or with the pink ocher façades of the house. In spite of its sophistication, this garden is in no way an imposed geometrical feature, being in total communion with the landscape that contains it. It is precisely this deep, authentic sensitivity to the environment that lies at the heart of Roberto Burle Marx's concept of the modern garden. ⚜

Tacaruna

THE MASTERPIECE SALVAGED

PETROPOLIS, BRAZIL
1954 and 1994
Designer: Roberto Burle Marx

While Burle Marx is chiefly famous for his urban landscape architecture at Brasilia and along the Copacabana seafront with its famous waves of flagstones, he also designed a large number of private gardens. His gardens at Tacaruna, for example, surround a discreet and emblematic villa with a concrete skin, devised by Oscar Niemeyer for Edmundo Canavelas in 1954. Both house and gardens were bought twelve years ago by a Rio designer, who now

says they own him much more than he owns them. They were well on the way to oblivion and a search had to be made for the original plans and the lists of local plants selected by Burle Marx before these exemplary gardens could be restored to their former glory. The modernists did not excel as gardeners, for the most part opting for a relentless geometry within which the vegetable was overwhelmed by the mineral. Burle Marx saw things otherwise.

For him, a garden was an aligning of ecological surroundings with the requirements of civilization; in other words, for him the planning and creation of each new garden or landscape was a specific adventure whose outcome depended entirely on the natural environment and the human beings involved. Here the house was set between two wings of the garden; a "masculine" one, in which the plantations constituted broad checkerboards of color—with

plants and varieties of grass framing a crystalline blue swimming pool—and a "feminine" wing, with ample, sensual embroideries descending to a large pond. This yin and yang concept is not as artificial as it seems, given that in its own way each zone is a

The "feminine" garden in front of the house was designed as an organic reinterpretation of European embroidery.

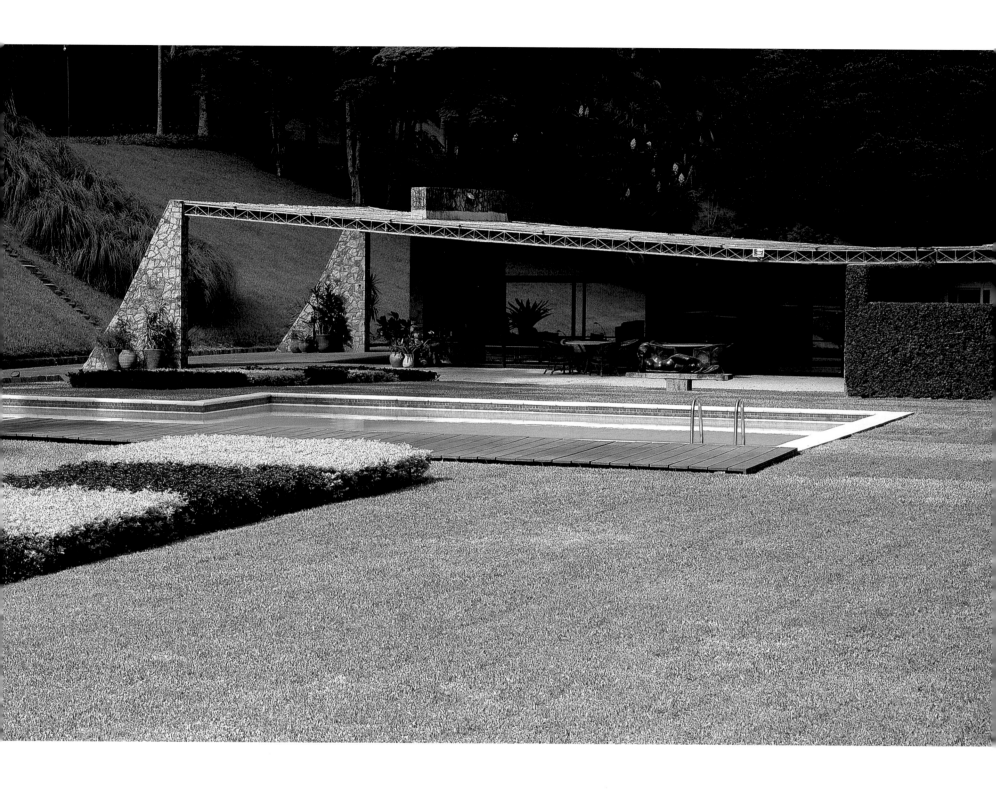

response to the surrounding landscape. On the one hand the checkers create a platform that leads to the sky and the dark, triangular mountain outlines in the distance. On the other, the modern embroidery flows smoothly down to the pond with its organic shape, and thence into tropical forest. This garden forms a rational yet lyrical enclave of its own, which affirms a state of civilized refinement in the face of wild nature, but in no way ignores its presence.

The colors change with the seasons, but Burle Marx chose his plants—all of which are local—taking into consideration their future development, in such a way that his composition retains its freshness and contrast even in the depths of winter. The new owner has saved from extinction a twentieth-century masterpiece, one that bears witness to the creativity of a continent that has hitherto been absent from the mainstream history of gardening. ⚜

Above: Behind the house is the "masculine" checkerboard garden, with a swimming pool on the edge of the lawn.

Opposite, left: The lawn is composed of two different types of grass, which create a checkerboard effect.

Opposite, right: Niemeyer's villa, one of the most secret retreats in Petropolis.

A Topiary Garden

CONTEMPORARY CLASSICISM

SCHOTEN, NEAR ANTWERP, BELGIUM
1970s
Designer: Jacques Wirtz

Some gardens sing; others dance, flutter, talk, and tell stories. Jacques Wirtz's gardens are musical, but in the manner of a partita by Bach, his favorite composer. They offer harmony, rhythm, progression, composition, repetition, chords—and silence. In them nature is contained, designed, shaped, sometimes constrained; they express a modern sensitivity to the plant world of a kind that is integral to the great creations of past centuries. Here there are

no small fountains to circumvent, no complicated effects, and no dry masonry; only broad clipped avenues, open perspectives, and carefully organized masses of hedges and borders that are lessons in the art of topiary.

Jacques Wirtz and his two sons Martin and Peter are creators of very discreet gardens. Even though they have won a number of hotly contested competitions for designs such as the Jardins du Carrousel in Paris, Alnwick Castle in Northumberland, and the gardens of the Bank of Luxembourg, their work is primarily done for private residences, like this one amid pine and beech woodland near Antwerp, Belgium. The composition consists of a series of enclosed areas, each protecting its own functional ensemble—for example, a swimming pool, a flower garden, and a vegetable plot. None of these can be seen from the house. Stepped hedges surround

A musical composition of topiary, tinged with winter reds and golds.

the moats of a raised grass sward; elsewhere, grass fringes redden in the winter in harmony with the beech leaves. Jacques Wirtz has designed a garden that offers a different renewal of beauty for every season, from summer's emerald green to the gray-green and silvery ocher of frost in winter.

Wirtz is a plantsman as well as a creator of gardens. He knows exactly what he can put in the ground, and his firm takes care of his gardens afterward. The risks he takes are carefully calculated and are based on long experience with soils and growing things. In this, too, he belongs to a long tradition in the art of gardening, though he has fully assimilated the aesthetics and practices of our times. ⚜

Wirtz sees grass as an important plant that can play a role of its own if allowed the freedom to do so.

The Getty Center

A PLANT INSTALLATION

SANTA MONICA, CALIFORNIA
1992–97
Designers: Robert Irwin and Laurie Olin, in association with Richard Meier

The Getty Center on its hill in Santa Monica is museum, research center, library, and educational institution all rolled into one. The modernist architecture of Richard Meier divides all these different functions among a group of buildings faced in limestone that strongly resembles a mountain town of Umbria or Tuscany. Here, though, everything is dedicated to the cause of culture and blessed with abundant funds.

The task of creating the Getty's gardens was assigned to the installation artist Robert Irwin in 1992. The choice led to a bitter controversy that delighted the American press. Meier, a famously refined and rigorous figure, was appalled by the proposals of the Californian artist, and said so. He did not question the value of Irwin's work, but saw no point in placing it right beside his own near-perfect architectural composition. This kind of conflict is rare in the history of gardens, given that the architect is usually preeminent and has a strong say in

*Above: The central garden by
Robert Irwin, a plant installation.*

*Right: Laurie Olin's cactus garden,
overlooking Santa Monica.*

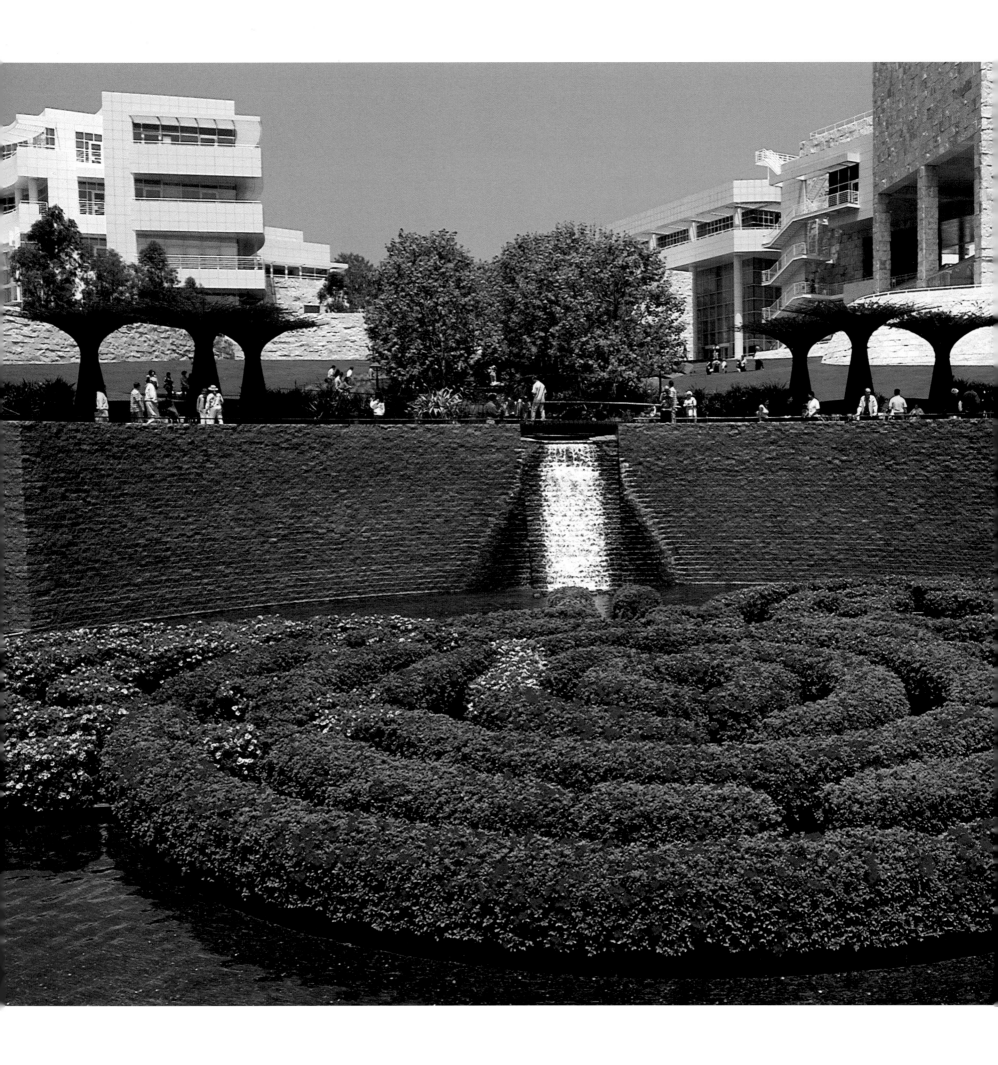

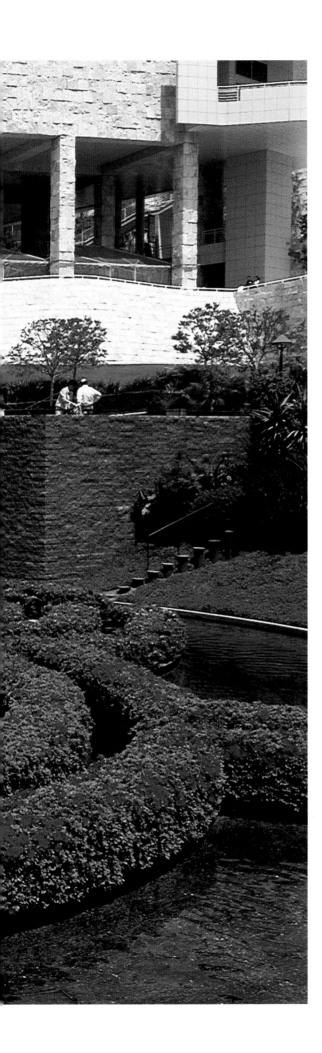

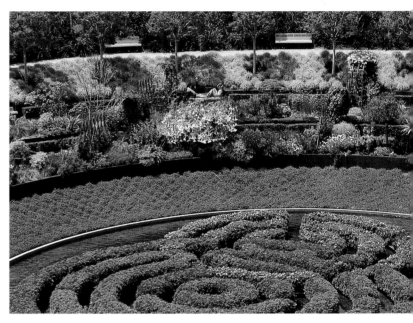

the choice of the gardener even when he does not work with him directly. In this case, at the end of the twentieth century, it was deliberately decided that an architect and a garden designer should work side by side, the garden being viewed as a work of art just like the ones inside Meier's austere buildings.

Robert Irwin, who had never designed a garden before in his life, grappled with his task and announced that he planned to make "a sculpture in the form of a garden aspiring to be art." It was an original departure. Neither Le Nôtre, nor Duchêne, nor Caruncho, nor Wirtz ever claimed to be creating art works; if they said anything at all, they merely stated they were working with nature to create a landscape. The difference was an important one.

Irwin appropriated a ravine separating the

Left: The central labyrinth and waterfall occupy a ravine between the museum and the research center.

Above: Two views of Robert Irwin's installation suggest how the choice of the plants, their height, and their texture play an important role. The number of colors is severely restricted.

museum and the research center, and organized his composition around the idea of a stream tumbling down to a broad circular pool. This installation, even though it sometimes has a very formal character that echoes the architecture beside it, offers above all a sensory ramble through a thematized, instrumental- ized environment. Thus the heights of the plants increase as one descends from terrace to terrace, the sound of the water creates a stereophonic effect, the

changing seasons have been taken into account, and the colors, apart from a dash of green, are reduced to white, magenta, orange, and red. Local ecologists are appalled by the quantities of water consumed by all this. The effect of a walk in this faceted garden is upsetting if one is accustomed to balanced, progres- sive compositions, but it cannot be denied that Irwin has achieved his objective—which was to give an artistic perception of what a contemporary garden

juxtaposed with a major architectural work might look like, when the architectural work did not at first appear to need anything of the sort. Nevertheless, the museum called in the landscape designer Laurie Olin, who collaborated closely with the architect to create several other sensitive gardens, among them a cactus grove on a kind of bastion, which is to some extent reminiscent of Le Nôtre's garden for the Château de Gourdon in Provence. ⚜

*Opposite: Marble amphitheater
composed of jardinières of white
blossoms, by Laurie Olin.*

*Above: "Tree" jardinières
designed by Robert Irwin.*

Mas de les Voltes

CONTEMPORARY BEAUTY

NEAR GERONA, SPAIN
1995
Designer: Fernando Caruncho

Baked by the summer sun, the Mas de les Voltes is a Catalan country enclave where nature suddenly seems to draw herself up and appear in the best possible light. As soon as you arrive you are intrigued by an immense grassy avenue of olive trees and cypresses—the dry flame of the latter matched by the venerable contortions of the former—and by broad pools reflecting the sky, dense foliage, and the omnipresent gold of ripe wheat. The wheat is sown

in giant parterres of a classic Virgilian landscape, an all-pervasive element that punctuates the passage of time. Each year sees the bare earth of autumn, the green wheat of spring, the ripening golden crop that darkens just before the harvest—whereupon the straw stacks and bales are laid out according to a precise plan that totally alters our perception of the countryside.

The cylinders and pyramids of straw at Mas de les Voltes are part of a three-dimensional geometrical composition that transforms them into conceptual sculpture. A landscape architect has clearly focused here on productive, cultivated nature, instead of redesigning it purely for visual pleasure—even though that is achieved as well.

Fernando Caruncho is among the most extraordinary landscape creators in Spain, indeed in all Europe. Discreetly—because he mostly works for private clients whose properties are not open to the public—he has put together a corpus of work that includes over a hundred gardens. Having originally studied philosophy, he turned to landscape design

One approaches the Mas de les Voltes along a grass avenue shaded by alternating olive trees and cypresses.

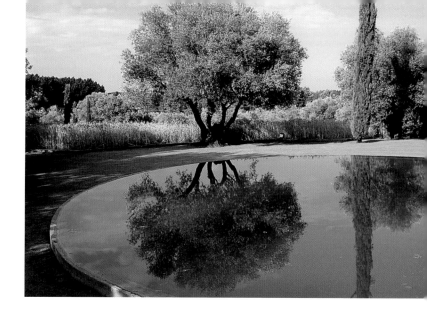

at a later stage; so his training was steeped in the works of Epicurus and Virgil, in addition to the study of Moorish gardens in Andalusia, Zen gardens in Japan, Italian gardens of the Renaissance, and the work of Le Nôtre in France.

The Caruncho garden is formal, but in its own way. Geometry plays an important role, structuring, dividing, and supporting the space, as at the Mas de les Voltes; or else it takes control, as in the composition of the pools at Camp Sarch in the Balearic Islands. Nevertheless, this is the geometry of an artist, not a mathematician. Caruncho's emphatic lines are a way of thinking nature through and not a way of forcing her to behave in a certain manner. They are a projection of our visual perception. At the same time, the designer adopts a rigorous, textured approach to plantings, which are often used in large, monochrome masses. In the garden of Caruncho's house in Madrid, for example, massive rounded box

trees produce a kind of ground movement, with no reference whatsoever to traditional topiary.

Caruncho is an organized man who expresses himself with great clarity. He spurns gratuitous effects and provocation, even though his work is an unambiguous challenge to the kind of landscape designers whose gardens all too often lose contact with nature. He also perpetuates, in his own way, a brand of austere, determined elegance that is uniquely Spanish. ⚜

Preceding pages: The garden is fully integrated with the farm. The pools of water among the vines also serve as reservoirs.

Left: The Mas de les Voltes is a perfectly orchestrated Mediterranean landscape.

Above: The mirror pool reflects the perfect organization of its surroundings.

Casa del Laberinto

CATALAN VITALITY

NEAR BARCELONA, SPAIN
1999
Designers: Bet Figueras in collaboration with Oscar Tusquets Blanca

Architect, designer, figurative painter, author of books on art, conference organizer, cultural agitator, enfant terrible, warm-hearted friend, Oscar Tusquets Blanca first appeared on the European scene in the early 1980s. Since then he has taken a highly personal, distinctly Catalan course in life, never yielding an inch to fashion—and certainly not to minimalism, either. In the multiplicity of his talents and interests he is something of a Renaissance figure, and his suc-

cess shows that the contemporary world has room for creators of every stamp. "I don't want roots," says Blanca. "I want wings." The image is a perfect one to describe his project for the gardens of the Casa del Laberinto, a fifteenth-century listed villa overlooking Gerona.

The layout of the Casa del Laberinto echoes the gardens of the Italian Renaissance. It begins with a highly architectural organization, punctuated by

Above and following pages:
This contemporary labyrinth is
a free, even surreal, interpreta-
tion of the Minotaur myth.

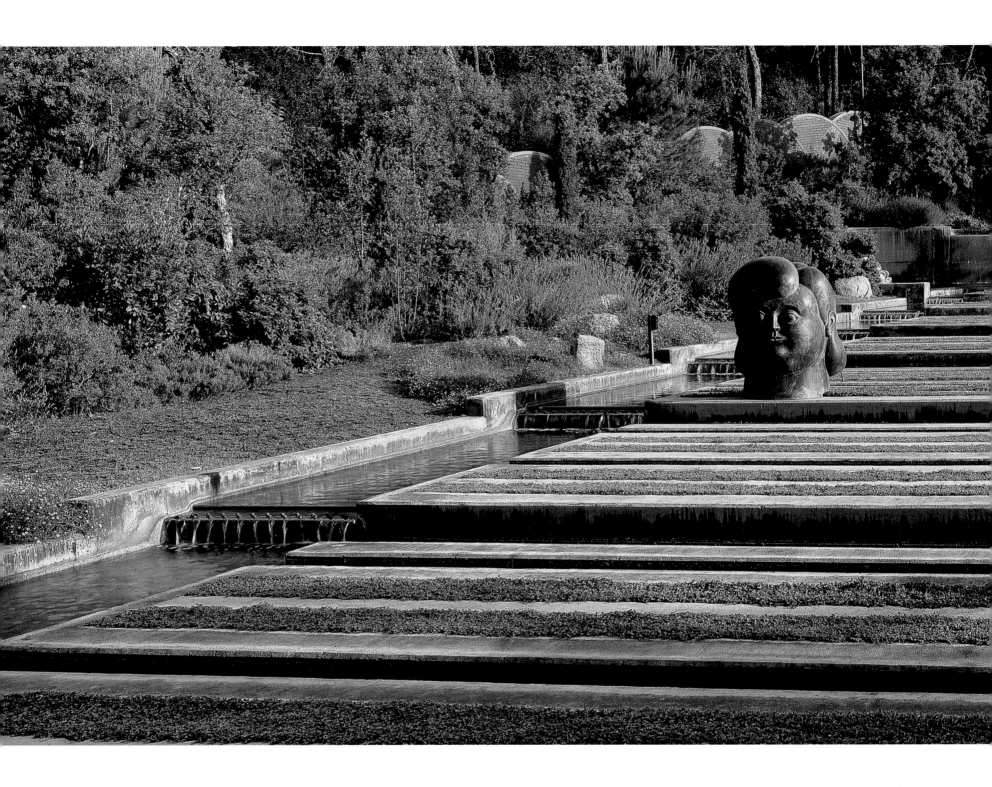

columns, pools, a belvedere, a labyrinth, and a wall enclosure in the arcs of a circle. After these come a sequence of terraces that blend eventually with the fields around. The Tusquets style is present in the handling of the surfaces and colorings of the materials; in the tense and complex shapes, many of them drawn from typologies of the past; in the importance of light throughout; and in the occasional surprise, such as a grotto pool. The landscape designer and botanist Bet Figueras contributed much to the Casa del Laberinto project, giving it an original botanical dimension by varying the heights of the plants, by envisioning flowering terrace meadows, and by preserving venerable trees such as its two magnificent date palms from the Canary Islands.

The gardens of the Casa del Laberinto are proof of a rediscovered freedom in the art of garden design, a freedom well suited to creative artists. ⚜

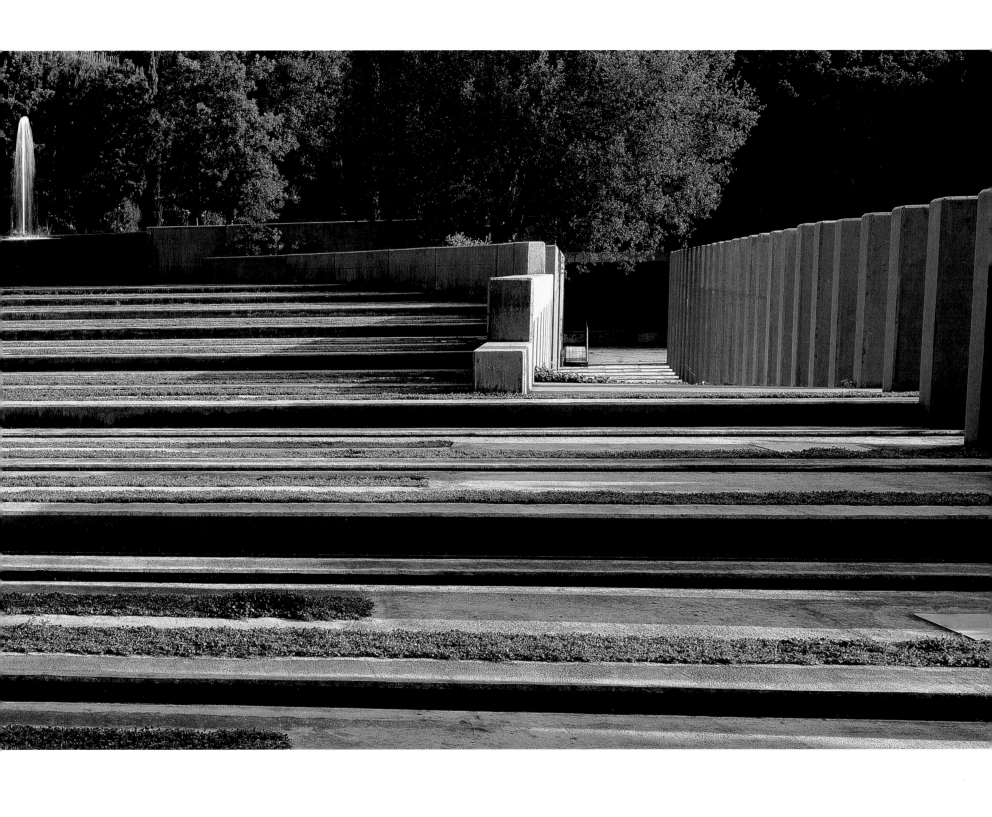

Gardens by Artists

The art of gardening has always fascinated writers and painters. The greatest poets have described the pleasure of hours spent in quiet gardens, and painters did not wait for the triumph of the Impressionists to discover that flowers and plants were within range of their skills. After the frescoes of Pompeii, medieval illuminated manuscripts were filled with scenes from cloister gardens, romantic trysts on mossy banks, and serenades in shady arbors. Later, eighteenth-century English aristocrats liked to pose for their portraits standing before open perspectives of their magnificently landscaped parks. But it was not until the nineteenth and, above all, the twentieth century that the painters themselves became original gardeners, like Monet in France, Majorelle in Morocco, and Dalí in Spain.

The art of the garden is special in that it does not reach full plenitude until it goes beyond the organization, structure, and realities of botany to open itself to art proper. Great artists may become gardeners, but a great gardener is always an artist because his work finds echoes in other people; intellectual echoes perforce, but mostly in the realms of the body and senses, because they have to do with our belonging to the world of nature. Through this infinitely complex and subtle art, nature herself is sublimated, ordered, and revealed in beauty. The relationship of artist-gardeners to nature evolves with the times, with their vision of the world and mankind, and with mankind's visions, too—but at all times it is a relationship that reflects ourselves.

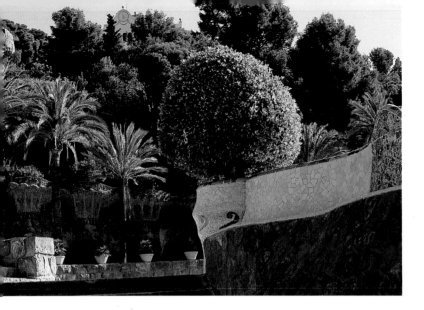

Park Guell

GAUDÍ AND NATURE

BARCELONA, SPAIN
1900–14
Designer: Antoni Gaudí

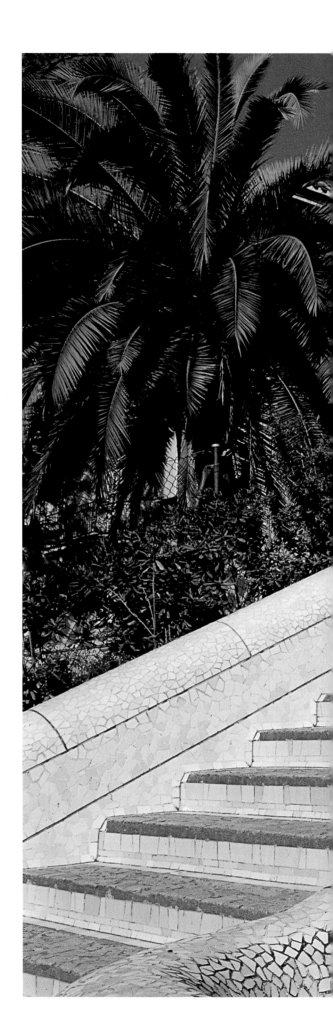

Park Guell, overlooking the city of Barcelona, is now a public garden; nevertheless, it was originally conceived by Antoni Gaudí for an entirely different purpose. Count Eusebi Güell, a rich admirer and client of the artist, wanted to build forty villas on a piece of private property he had just bought in the Salud quarter, where wealthy Catalan families once came to escape the summer pestilence of the barrios and enjoy the panoramic views across the Mediterranean. The objective was to create a luxury enclave for a rich elite who would appreciate the work of Gaudí, already famous for the town mansions and buildings he had designed in the city

below. As usual, Gaudí's plans were grandiose and shocking. After a long investigation of the site, he decided to take advantage of its complex topography instead of ripping it to shreds. His plan was basically idiosyncratic, though not without reference to the organization of Islamic gardens and their use of water: for example a vast underground reservoir was incorporated into the plans, to collect all the available water. Gaudí's technical skill was concealed behind

Gaudí installed an array of fabulous creatures in his extraordinary garden, which obeys none of the previously respected rules of the gardener's art.

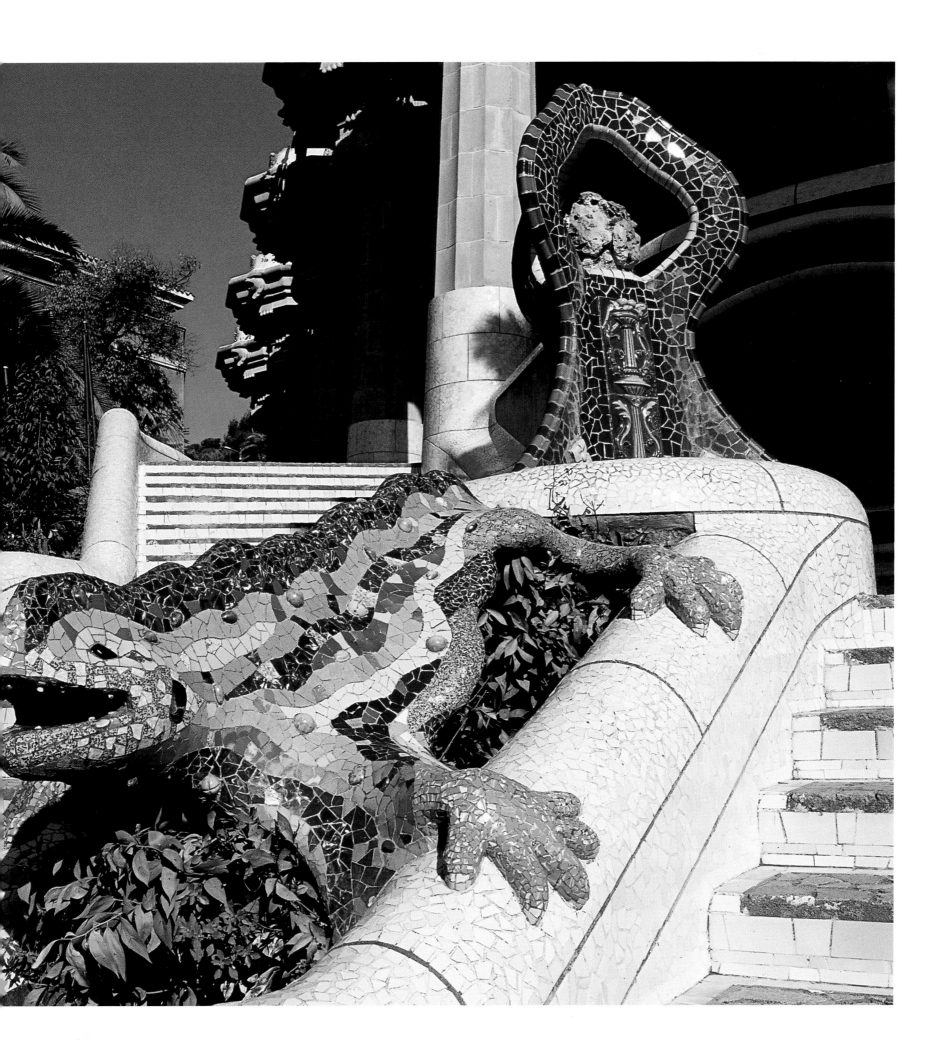

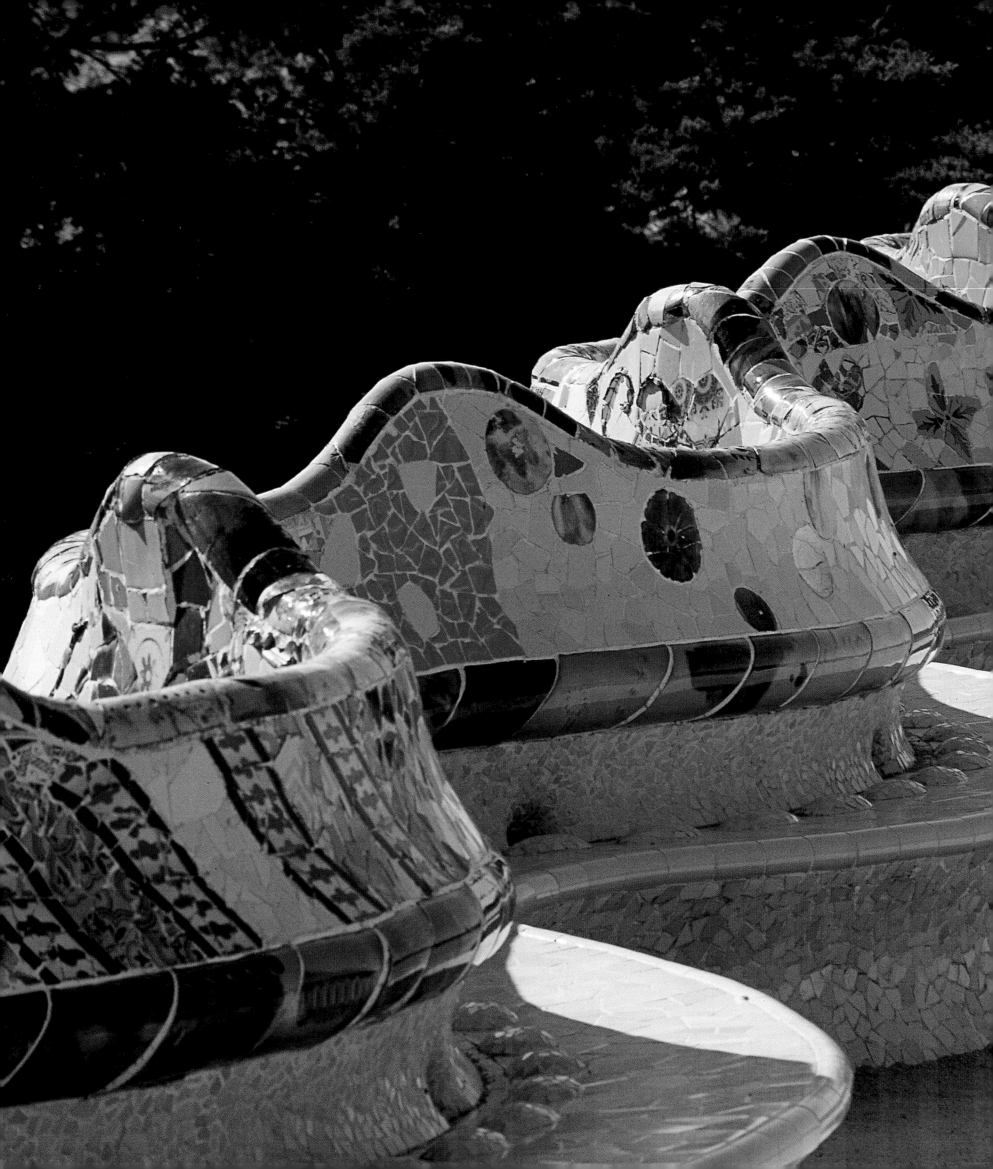

The famous benches, recently restored, were encrusted with ceramics by Josep Maria Jujol (1879–1949).

an astonishing overload of decorative elements. These spilled over the meandering brick-pillared, palm-encrusted viaducts, into a colonnade whose columns pierced its capitals and supported the architect's famous ceramic benches, and followed around walls that were crenellated purely for the sculptural effect. All this is brightened by the poly-chrome omnipresence of *trencadis,* shards of broken tiles and plates mounted in glittering abstract and animal compositions. Nature, so often requisitioned for other purposes by Gaudí, here seems a trifle puzzled by his architectural bestiary.

World War I put an end to the count's real-estate venture, and the Park Guell and its initial construc-tions were eventually handed over to the city of Barcelona in 1922. Thus, the one-time elite enclave became one of the most popular public gardens in a city that sorely lacked green areas. Gaudí acquired an entirely unexpected popularity, to the point where the citizens of Barcelona actually believed that the park's disturbing efflorescence of shapes and colors had been designed with them in mind. But children loved the Park Guell, and continue to love it; and the city has made it one of its symbols. ⌖

The Gardens of Claude Monet

A Painter's Inspiration

GIVERNY, FRANCE
1883–93
Designer: Claude Monet

Oddly enough, the garden of Giverny—created by the greatest of the Impressionist painters—is seldom mentioned in reference works on gardeners and landscape designers (with the notable exception of the one written by Michel Baridon). And yet Claude Monet spent more than half his life amid these flower-filled acres, and they became the subject matter for many of his best-known paintings, such as his many treatments of water lilies.

In 1883, after years of poverty, the success of his work at last made it possible for Monet to buy the property at Giverny he had rented for so many years. He immediately redesigned the garden in front of the house. His new layout divided the plot into long rectilinear beds, a rigor that was immediately annihilated by an explosion of flowers, from the most ordinary to the most exotic. Monet skillfully composed flower mixtures that allowed him to obtain rich and refined chromatic effects for most of the year. His central pathway was covered by graceful arches, on which were trained the roses that quickly spread to the façade of the house.

"All my money goes into my garden," wrote Monet. He extended his passion for gardening into his paintings, sketching in the open and completing the canvases in the studio he had built beside the house. In 1893 he was able to acquire another plot on the other side of the road and railway line, where he excavated a pond for water lilies, reeds, irises, bamboo, and wisteria. The wisteria was trained across first one, then two Japanese bridges that recall the painter's deep interest in Japanese prints.

The garden at Giverny was abandoned for many years after Monet's death. It was restored in the years after 1974. Today, it is among the principal tourist attractions of the valley of the river Oise, perhaps because so many of those who visit it identify a garden that could easily be their own. With his example, Claude Monet proved that the creation of a garden doesn't have to be a rich man's enterprise, or some kind of ambitious transformation of an entire landscape. It is no more than the simple pleasure of bringing together the colors and shapes of nature. ❦

In front of the house where Claude Monet spent the greater part of his life is his flower garden, a play of forms and color combinations.

Following pages: In the background of Monet's famous water lily pond stands one of the two Japanese bridges.

Jacques Majorelle's Garden

PLAY OF COLORS

MARRAKECH, MOROCCO
1923–81
Designer: Jacques Majorelle

The garden possesses a collection of aquatic plants, a great rarity in a Muslim-inspired garden.

In 1917, Jacques Majorelle, the painter son of a famous cabinetmaker from Nancy, arrived in Tangier hoping to be cured of tuberculosis. Shortly afterward he moved to Marrakech, where he built a large villa in the European quarter of Guelig, near the Palmeraie. All around it he laid out a wonderful walled garden, famous in its time but virtually abandoned after Majorelle's death in 1962. In 1981 Yves Saint Laurent and Pierre Bergé visited this neglected kingdom and were duly enchanted. They bought the property and restored it to the original glory it should never have lost. Today the garden is the property of the Majorelle Trust and is open to the public; it is also viewed as the central work of a painter who was able to catch the essence of Morocco on the brink of modernity in his vibrant, beautifully constructed paintings.

This garden is an artistic creation of great purity. It does not obey any classical rule of organization, even though it is partly inspired by Andalusian art. The eleven raised pools do not exist to supply coolness, reflections of the sky and irrigation alone; they also contain a rare collection of aquatic plants that have adapted to the Moroccan climate. Bamboos whose green leaves are striped with white, rustling eucalyptus trees, tall magnolias, and blossom-laden bougainvilleas form a shady jungle where hundreds

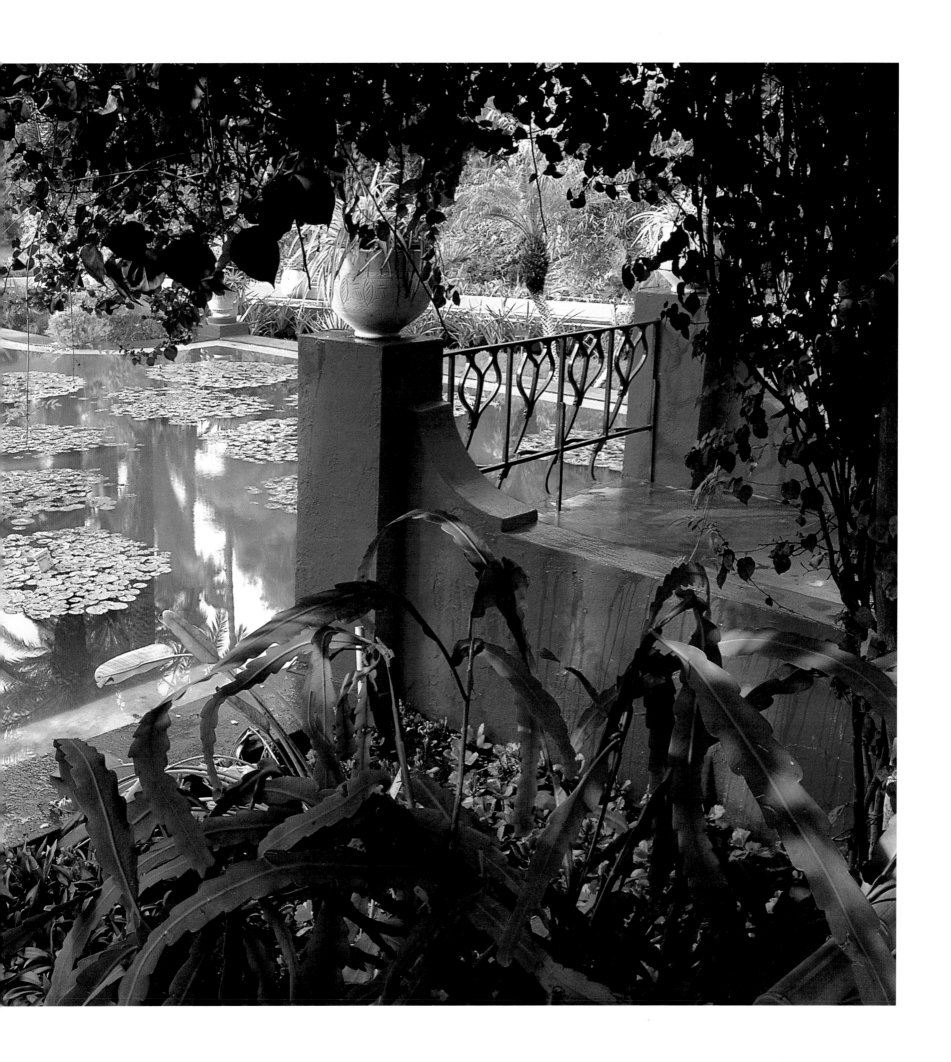

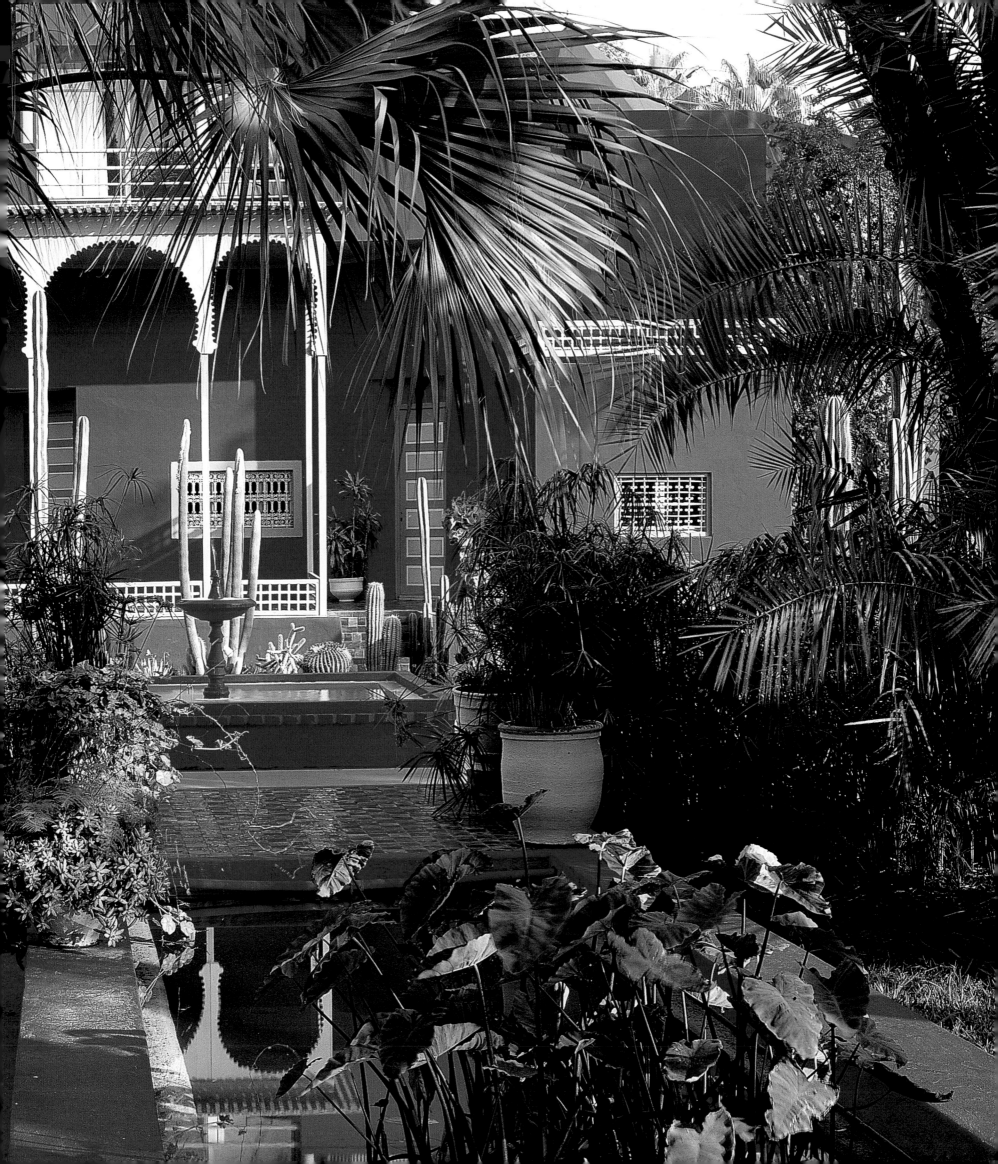

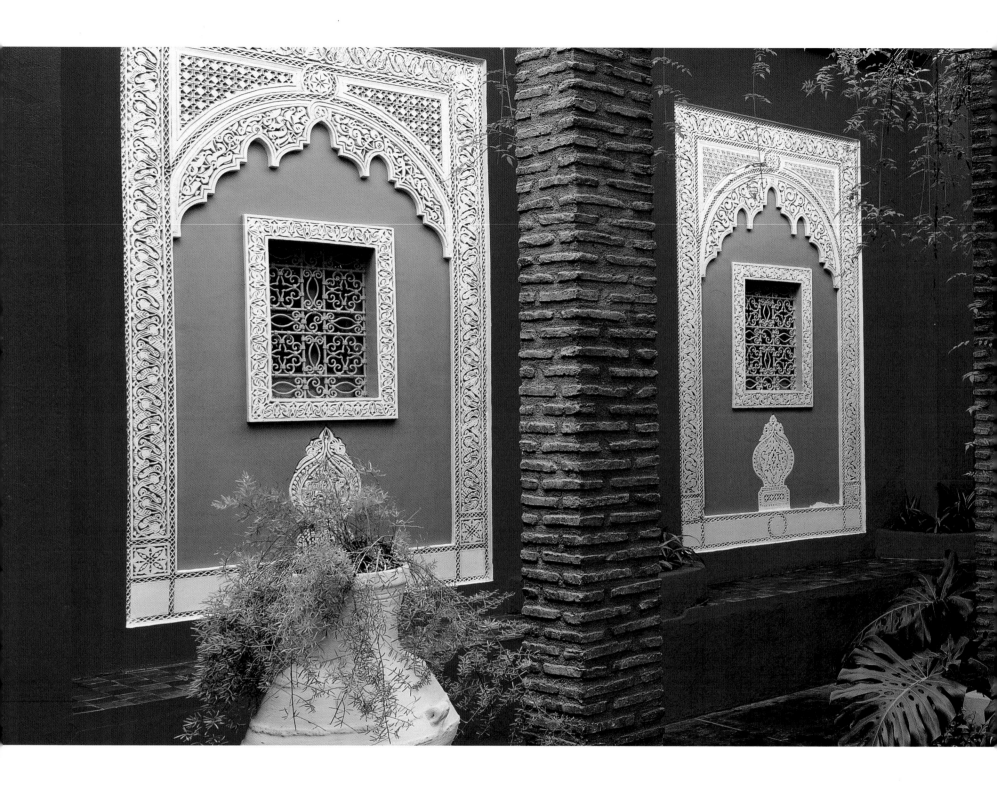

of birds come to nest and roost, adding their songs to the tinkle of water and whisper of foliage. Majorelle assembled more than 1800 varieties of plants and 400 palm trees, many of which survived the period of abandon. The originality of his vegetal composition lies above all in a kind of chromatic counterpoint, based on the artist's choice of an intense cobalt blue. This blue (whose composition was patented by Majorelle) runs everywhere in the garden—along walls, curbs, pillars, vases, and fountains. It is the luminous vibration against which the sky is measured, as well as the dark water in the pools, the ocher and yellow ceramics, the red terracotta floors, and the hundreds of different shades of green among the plants. Yves Saint Laurent worked on many of his collections amid this explosion of color, which is constantly altered and modified by the shifting sunbeams that filter through the branches.

Majorelle's is one of the greatest gardens of modern times, in which stone and even artifice play an important role. Contemporary designers, especially Americans, have copied and developed this idea, but the Majorelle gardens of Marrakech are perhaps the only ones to have succeeded so spectacularly in blending the colors of nature with those of an artist's palette. ❧

Preceding pages: Majorelle blue is the a hard cobalt color that contrasts so vividly here with nature's hues.

Above: Majorelle took a great interest in Moroccan handicrafts and funded several workshops to preserve and teach the best local traditions.

Castle of Púbol

A Surrealist Garden

NEAR GERONA, SPAIN
Fourteenth, fifteenth, and twentieth centuries
Designer: Salvador Dalí

Above: A Surrealist encounter in Dalí's garden.

Right: The fountain is a collage of different styles and elements, dedicated to Richard Wagner.

In 1968 Dalí and his muse, Gala, wishing to acquire a more discreet residence than the one they already had at Port Lligat, which was too surrounded by tourists and gallery owners, came upon a small fifteenth-century castle overlooking the plain of Ampurdan, not far from Figueras and La Bispal. The painter bought this place for his wife in fulfillment of a promise he had once made to her. The building was in very poor condition—but Dalí redecorated it with great enthusiasm. Today it retains something of his early Surrealist exuberance, bordering on kitsch in some of the frescoes, in the hole in the floor, in the strange shapes of the fireplaces and in the trompe l'oeil doors and radiators.

The castle's walled garden had practically vanished beneath a jungle of brambles when Dalí arrived. It was redesigned on a right-angled grid of narrow box-hedged paths like the garden of a vicarage—except that its occupants were not vicars but bronze elephant-giraffes, suddenly encountered. At the end of the main pathway is a large pool fed by a huge fountainhead in the form of a fantasy animal, flanked by a dozen busts of Wagner. The plantings are a trifle monotonous, and the box and yew deserve a little more fertilizing and a surer hand in the clipping, but this small, shady garden peopled by uncertain creatures in the middle of a sun-baked plain beckons us for a few moments into a fascinating vegetable side-alley in the unconscious mind of a great artist. ❧

Portrack

THE CREATION OF THE WORLD

SCOTLAND, GREAT BRITAIN
1990–2000
Designer: Charles Jencks

During the Renaissance and in the seventeenth century, gardens were designed with the ostensible purpose of illustrating a story from mythology or a literary work. Thus Vicino Orsini's Bomarzo garden was inspired by the *Dream of Polyphilus,* and the Sanspareil Park of the margravine of Bayreuth was based on the *Adventures of Telemachus.* The practice went out of fashion with the close of the nineteenth century, but it has recently re-emerged in the north

of Britain, in Little Sparta, a strange moorland landscaped by the sculptor Ian Hamilton Finlay, and at Portrack, in a work by the postmodern architect Charles Jencks. Jencks is a theoretician of the relationship between culture and architecture and the husband of Maggie Keswick, a recognized specialist in the history of the Chinese garden. At Portrack, Maggie Keswick's Scottish estate, Jencks found the natural space he needed to express an original

conceptual approach. In his thought he associates chaos theory with ancient Chinese geomancy. For him, "Art must engage with contemporary science and cosmology, if it wishes to rediscover the depth and energy it possessed in earlier centuries." The

The Garden of Cosmic Speculation offers a postmodern, scientific presentation of nature's beauty.

universe is perpetually evolving and changing in a cosmogony of which we are both the witnesses and agents, without always being aware of the fact. The garden at Portrack sets out to illustrate this vision of the world.

Portrack is not to be understood at a single glance. Its complexity was originally determined both by the presence of the house and by the topography of the land, which involved protracted earth-moving operations. The visitor is guided along a course that is well nigh initiatory, punctuated by landscape features and sculptures—for example, a pool representing the "quark soup" of earth's origins, a DNA garden dominated by a helix sculpture, a tumulus-mastaba containing a kind of op-art chapel, a galactic bench, a black hole represented by a dynamic checkerboard of lawn and concrete, a jumping bridge, the last-known avatar of the Japanese bridge, and so on. The composition is more one of collage than of continuity, but all the same it arouses our interest

and admiration—among other things for its "snake mound," which stands between two spiral-shaped pools. Seldom in the West has landscape been manipulated to such sculptural effect.

You can't not like Portrack. It may well be that this place offers a new way forward for the gardeners' art, which after several centuries of more or less refined aestheticism, needs to rediscover some kind of valid philosophical content whereby it can use provocative formalism like this to explain the world. ✥

Left: This path leads to the jumping (or fractal) bridge, inspired by the theory of catastrophes whereby a minor event can provoke a major one.

Above: One of the metal gates by John Gibson, and wooden pillars bearing inscriptions with multiple meanings or which read the same upside down.

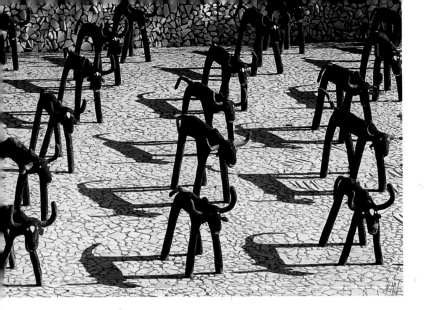

Rock Garden

The Fabulous Kingdom of Nek Chand

CHANDIGARH, INDIA
Begun in 1958
Designer: Nek Chand

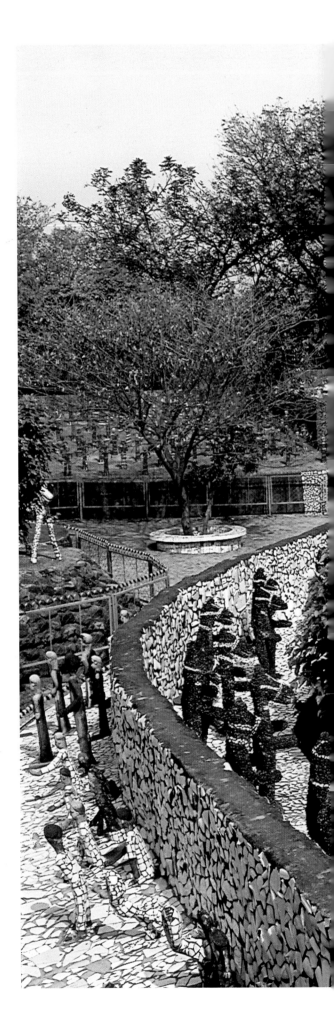

Right: Over a period of thirty years, Nek Chand created an enchanted garden in the jungle, peopled by thousands of fantasy creatures.

Above: One of the herds of Nek Chand's fantasy kingdom a few kilometers from Chandigarh, the capital of the state of Punjab built by Le Corbusier.

Anybody can create a garden. But Nek Chand, creator of India's world famous Rock Garden, initially ran into more difficulties than most. As a minor civil servant in Chandigarh, he possessed neither a plot of ground, nor plants, nor building materials, nor money. But he dreamed of an idyllic garden and longed to escape a daily life of irksome constraint and poverty.

Nek Chand began by collecting eroded stones along roadsides. Then he built a tiny shelter in the depths of a state forest infested by snakes and mosquitoes—and one night, by the light of a burning tire, he began to lay out his own private kingdom. Time went by, the work progressed, and eventually the forest rangers discovered his domain. It was enchanting, but he had not asked anyone's permission to put it there. At this point, a miracle occurred: Nek Chand was acclaimed, freed of his government job, and presented with a secure salary and the help of forty workmen to carry on with his project. From

that moment he had no more need for concealment. He launched himself body and soul into a transformation of the forest landscape, digging gorges, designing immense waterfalls, and modifying the site to receive hundreds and eventually thousands of figurines, which he made himself.

Nek Chand is an entirely self-taught artist. He is a man driven by an obsessive idea. His work, raw as it is, has a dimension that over the years has become steadily more topical in the modern world: that of salvaging and recycling things that others have thrown out. The materials he uses are

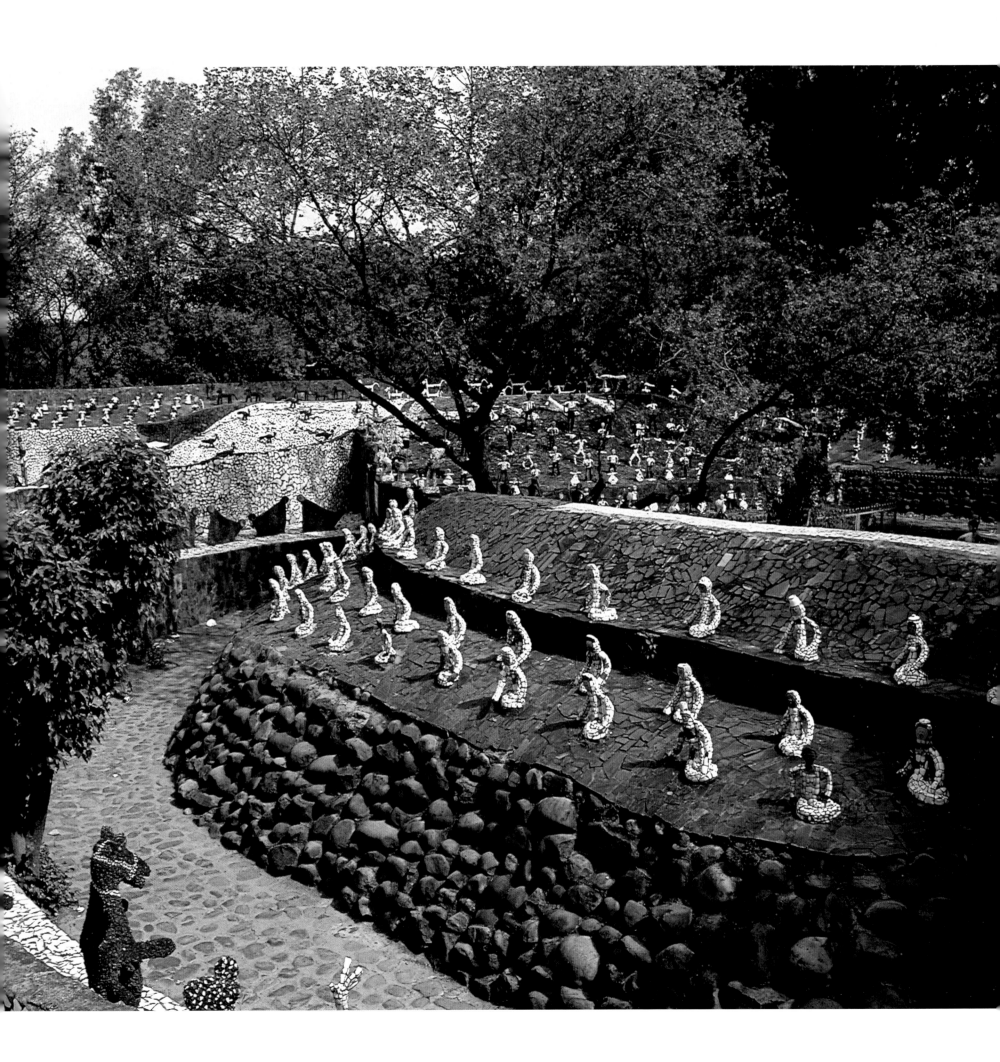

Above: Nek Chand's garden art has acquired an enthusiastic following as "outsider" art that takes recycling to a richly creative level.

Left: This mosaic was made using a technique similar to that of Jujol in the Park Guell, Barcelona.

all recycled. He transmutes into art all the flotsam of mass consumption—crockery, chunks of concrete, old clothes, bicycle frames, beer bottles, silver wrappers. His marvelous animals, birds, kings, princesses and warriors are made of terracotta, cement, stone, and mosaic made up of broken plates, basins, and lavatories. His aim is to "offer a different relationship to things, whereby the creator and his creations can arouse the onlooker's awareness of the environment, his sense of wonder and his own creative spirit." Nek Chand's brand of art escapes all classification, being fundamentally individualistic and of the people; yet his idea of the garden is rooted in the ancient Indian tradition of an earthly Paradise. His Eden is that of a kindly, well-ordered, peaceful society, in harmony with nature. And only a few miles from it stands Chandigarh, the capital of the Punjab and the masterwork of Le Corbusier. ⚜

Chaumont-sur-Loire Garden Festival

A Celebration of the Garden

CHAUMONT, FRANCE
1992
Designer: Jean-Paul Pigeat

*Left: A concept by
Liliana Motta and
Jean-Christophe Denise
on the theme of eroticism
in the garden, 1992.*

*Above: On the same
theme* The Fuzzy
Garden *by Luís
Bisbe, Sara Dauge,
Alex Aguilar, Pernilla
Magnusson, Arola
Tous, and Silvia
Vespasiani; a Catalan
contribution for 2002.*

The modern love of gardens has brought about a proliferation of temporary (and often highly commercial) shows and fairs. They may take the form of flower shows and gardeners' conventions as at Courson, or exhibition parks as at Keukenhof in the Netherlands, which is the invention of professional tulip growers. But the most significant event in the calendar is probably the International Garden Festival held in the park of Catherine de' Medici's former château by the Conservatoire international des jardins et du paysage de Chaumont-sur-Loire.

Every spring, twenty-five temporary gardens are installed in twenty-five enclosures surrounded by hedgerows planted by Jacques Wirtz, on an area of seven and a half acres (3 ha). Gardeners, landscape designers, students, and artists from all over the world come here to exhibit their work,

which sometimes takes a long time to set up. The themes are as rich as they are provocative: crises, curiosities, water, mosaic gardening, chaos, weeds, and memory have been a few of them. The many and various features on offer are equally diverse, with spectacular successes, short-lived provocations, ideas that will take their course, clumsy ventures, and memorable creations. This blend of beauty, knowledge, skill, concept, intelligence, and botany shows that gardening, far from being a thing of the past, has become a new focus of reflection for contemporary artists. The enduring success of Chaumont is also due to the innumerable encounters that occur at the festival, not only among designers themselves, but also among the throngs who come to see nature in an unaccustomed guise.

The Chaumont Festival, the brainchild of Jean-Paul Pigeat, is directed today by Christian Mary. It represents the new history of gardening, which is being written before our eyes. ⚜

Above: Do You Support Me? *(2002) by Véronique Airiau and Marie-Yvonne Gimmerthal, of the École des Beaux-Arts, Angers, was a contribution on the theme of eroticism in the garden.*

Right: The Nest of the Mappa Goddesses *(2002) by Hémisphère, a landscape design workshop, Rémi Duthoit and Éric Barbier.*

This giant puppy contains 25 tons of irrigated earth in which thousands of flowers are regularly planted and replanted.

The Guggenheim Puppy

THE GARDEN DOG

GUGGENHEIM BILBAO
BILBAO, SPAIN
1997
Designer: Jeff Koons

Puppy is a botanical sculpture by the American artist Jeff Koons that since 1997 has stood in front of Frank Gehry's building for the Guggenheim Bilbao. This giant canine made of flowers was such a huge success with the public at the museum's inauguration that the city fathers decided to make it a permanent feature, and *Puppy* is now well on its way to becoming Bilbao's mascot. Koons is no garden specialist, but a post-pop artist who gleefully cultivates kitsch, bad taste, pornography, and sentimentalism. His thirty-six-foot-high *Puppy* stands in front of the museum as a provocative vegetal reproduction of a piece of fairground pottery, and it works very well indeed. The animal is covered in thousands of flowers that are regularly renewed, so it always has an attractive pelt. The effect is fascinating: the texture and brightness of the blossoms make people forget the ridiculousness of a giant floral Scotch terrier—and take it to their hearts. *Puppy* is the heir to a long tradition of topiary sculpture stretching back to antiquity, and it seems to be coming back into fashion in the United States and Japan, where huge geometrical compositions of living box and coniferous trees have appeared, along with monstrous faces and spheres covered in ivy and whole texts cut into fields growing wheat. *Puppy,* for the moment, is a very fashionable dog indeed. ⊰⊱

Indexes

BIBLIOGRAPHY

ACIDINI LUCHINAT, Cristina. *Jardins des Médicis, jardins des palais et des villas dans la Toscane du Quattrocento* (The Medici gardens, palace and villa gardens in Tuscany of Quattrocento). Arles: Actes Sud, 1997.

ACTON, HAROLD. *The Villas of Tuscany.* New York: Thames and Hudson, 1987.

ASLET, Clive. *The Last Country Houses.* New Haven and London: Yale University Press, 1982.

BARIDON, Michel. *Les Jardins: Paysagistes, jardiniers, poètes* (Gardens: Landscapists, gardeners, poets). Paris: Robert Laffont, 1998.

BAYREUTH, Margrave of. *Mémoires* (Recollections). Paris: Mercure de France, 1967.

BAZIN, Germain. *Paradeisos: The Art of the Garden.* Boston: Cassell, 1990.

BÉNETIÈRE, Marie-Hélène, Monique Chatenet, and Monique Mosser. *Jardin, vocabulaire typologique et technique* (The Garden: Typological and technical vocabulary). Paris: Monum, Éditions du Patrimoine, 2002.

BRENOT, Anne-Marie and Bernard Cottret (texts compiled together). *Le Jardin: Figures et métamorphoses* (The Garden: Representations and Metamorphoses). Dijon: Éditions universitaires de Dijon, 2005.

BROWN, Jane. *Vita's Other World, a Gardening Biography of V. Sackville-West.* New York: Viking Penguin, 1987.

CARANDELL, Joseph Maria and Pere Vivas. *Park Güell: Gaudi's Utopia.* Barcelona: Triangle Postals, 1998.

CAUQUELIN, Anne. *Petit Traité du jardin ordinaire* (A Brief Look at the Ordinary Garden). Paris: Payot & Rivages, 2003.

CHAMBERS, William. *A Dissertation on Oriental Gardening.* London: W. Griffin, 1772.

CHARAGEAT, Marguerite. *L'Art des jardins* (The Art of Garden Design). Paris: PUF, 1962.

CLIFFORD, Derek. *A History of Garden Design.* New York: Praeger, 1967.

COOPER, Guy and Gordon Taylor. *Gardens for the Future: Guestures against the Wild.* New York: Monacelli Press, 2000.

COOPER, Paul. *Living Sculpture.* London: Mitchell Beazley, 2001.

COOPER, Paul. *The New Tech Garden.* London: Mitchell Beazley, 2001.

CORPECHOT, Lucien. *Parcs et jardins de France* (Parks and Gardens of France). Paris: Librairie Plon, 1937.

DE BAY, Philip and James Bolton. *Gardenmania.* Arles: Actes Sud/Motta, 2000.

DE MEDICI, Lorenza. *The Renaissance of Italian Gardens.* New York: Fawcett Books, 1990.

FESTING, Sally. *Gertrude Jekyll.* London: Penguin Books, 1993.

GANAY, Ernest de. *Beaux Jardins de France* (France's Beautiful Gardens). Paris: Librairie Plon, 1950.

GANAY, Valentine de and Laurent Le Bon (eds.). *Courances.* Paris: Flammarion, 2003.

GARRIGUES, Dominique. *Jardins et jardiniers de Versailles au Grand Siècle* (Versailles' Great Century Gardens and Gardeners). Paris: Champ Vallon, 2001.

GARRIGUES, Dominique. *De la composition des paysages* (On the Composition of Landscapes). Seyssel, France: Champ Vallon, 1999.

GOTHEIN, Marie Luise. *A History of Garden Art.* New York: Hacker Art Books (reprint), 1966.

GRÜNING, Uwe and Jürgen M. Pietsch. *Goethes Gartenhaus* (Goethe's Summer-house). Spröda, Germany: Edition Schvarz Weiss, 1999.

HADFIELD, Miles, Robert Harding, and Leonie Highton. *British Gardeners.* London: Zwemmer, Condé Nast, 1980.

HOBHOUSE, Penelope. "Gardens of Persia," in *Cassel Illustrated.* London: 2003.

HUNT, John Dixon. *L'Art du jardin et son histoire* (The Art of the Garden and its History). Paris: Odile Jacob, 1996.

HYAM, Edward. *A History of Garden and Gardening.* New York: Praeger, 1971.

Jardins contre nature (Gardens against Nature). Paris: Éditions de Minuit, 1976.

JEKYLL, Gertrude, and Lawrence Weaver. *Arts and Crafts Gardens.* London: Garden Art Press, 2005.

JENCKS, Charles. *The Garden of Cosmic Speculation.* London: Frances Lincoln, 2003.

KLUCKERT, Ehrenfried. *European Garden Design: From Classical Antiquity to the Present Day.* Cologne: Könemann, 2000.

LAIRD, Mark. *Jardins à la française, l'art de la nature* (French Gardens, the Art of Nature). Paris: Chêne, 1993.

LANDSBERG, Sylvia. *The Medieval Garden.* London: British Museum Press, 2002.

LE DANTEC, Jean-Pierre. *Jardins et paysages: Une anthologie* (Gardens and Landscapes: An Anthology). Paris: Éditions de la Villette, 2003.

LE TOQUIN, Alain and Jacques Bosser. *The Most Beautiful Gardens in the World.* New York: Harry N. Abrams, 2004.

LIMIDO, Luisa. *L'Art des jardins sous le second Empire* (The Art of Gardens under the Second Empire). Seyssel, France: Champ Vallon, 2002.

LOUIS XIV. *Manière de montrer les jardins de Versailles* (The Manner of Presenting the Gardens of Versailles). Paris: RMN, 2002.

MONTERO, Marta Iris. *Roberto Burle Marx, The Lyrical Landscape.* Berkeley: University of California Press, 2001.

MONUMENTAL, annuel 2001, *Dossier Jardins* (Garden Files). Paris: Éditions du Patrimoine, 2001.

MOSSER, Monique and Georges Teyssot. *The History of Garden Design: The Western Tradition from the Renaissance to the Present Day.* London: Thames and Hudson, 2000.

NICOLI, Pierluigi and Francesco Repishti. *Dictionary of Today's Landscape Designers.* Milan: Skira, 2003.

Nitschke, Günter. Japanese Gardens. Los Angeles: Taschen, 2003.

NOURRY, Louis-Michel. *Les Jardins de Villandry* (The Villandry Gardens). Paris: Herscher Belin, 2002.

ORSENNA, Érik. *Portrait of a Happy Man, André Le Nôtre 1613–1700.* New York: George Braziller, 2001.

OTTEWILL, David. *The Edwardian Garden.* New Haven and London: Yale University Press, 1989.

PEREIRE, Anita. *Gardens for the 21st Century.* North Pomfret, VT: Trafalgar Square, 2001.

PEREIRE, Anita, Gabrielle Van Zuylen, and Robert César. *Private Gardens of France.* London: Weidenfeld and Nicolson, 1983.

RIDLEY, Jane. *The Architect and His Wife.* London: Chatto & Windus, 2002.

RUSSELL, Vivian. *Edith Wharton's Italian Gardens.* Boston: Bulfinch, 1998.

SALMON, Xavier and Gianni Guadalupi. *Versailles,* Villanova di Castenaso. Paris: FMR, 2005.

SCHINZ, Marina and Gabrielle Van Zuylen. *Gardens of Russell Page.* New York: Stewart, Tabori & Chang, 1995.

SMITHERS, Peter. *Adventures of a Gardener.* London: Harvill Press, 1996.

STEENBERGEN, Clemens and Reh Wouter. *Architecture and Landscape.* Boston: Birkhäuser, 2004.

STRONG, Roy. *The Renaissance Garden in England.* London: Thames and Hudson, 1979.

TURNER, Tom. *Garden History, Philosophy and Design 2000 BC–2000 AD.* London and New York: Spon Press, 2005.

VALENCIENNES, Pierre Henri de. *Perspectives des jardins* (Perspectives of Gardens). La Rochelle: Rumeur des anges, 2005.

WALPOLE, Horace. *On Modern Gardening.* London: Pallas Editions, 2004.

WATELET, Claude-Henri. *Essay on Gardens: A Chapter in the French Picturesque.* Philadelphia: University of Pennsylvania Press, 2003.

WEISS, Thomas (ed.). *Das Gartenreich Dessau-Wörlitz* (The Garden Realm of Dessau-Wörlitz). Hamburg: L & H Verlag, 2004.

WILSON, Andrew. *Influential Gardeners: The Designers Who Shaped 20th-Century Garden Style.* London: Mitchell Beazley, 2005.

The Wirtz Gardens. Exhibitions International, 2004.

GARDEN INFORMATION

Only gardens that are open to the public are listed.

BRAZIL

Fazenda Marambaia
Correas – Petropolis
Rio de Janeiro – RJ
Tel.: +55 (24) 2233 5000
www.fazendamarambaia.com.br

Tacaruna
Pedro de Rio – Petropolis
Rio de Janeiro – RJ
strunck@diacm.com.br

CHINA

Suzhou
Suzhou Municipal Administrative
Bureau of Gardens
Gongyuan Road, 12
Suzhou (Jiangsu)
Tel.: +86 (512) 65224929
www.ylj.suzhou.gov.cn/en/yl.htm

FRANCE

Abbey of Mont-Saint-Michel
BP 22
50170 Mont Saint Michel
Tel.: +33 (0) 2 33 89 80 00
www.monum.fr

Canon
14270 Mézidon–Canon
Tel.: +33 (0) 2 31 20 71 50
www.chateaudecanon.com

Château de Groussay
Rue de Versailles
78490 Montfort-l'Amaury
Tel.: +33 (0) 1 34 86 94 79

Chaumont-sur-Loire Garden Festival
Conservatoire international des parcs
et jardins et du paysage
Ferme du château
41150 Chaumont sur Loire
Tel.: +33 (0) 2 54 20 99 22
www.chaumont-jardin.com

Family Gardens
Rue du Général Leclerc
93170 Bagnolet

Monet's Gardens
Fondation Claude Monet
84, rue Claude Monet
27620 Giverny
Tel.: +33 (0) 2 32 51 28 21
www.fondation-monet.com

Parc André-Citroën
Quai André-Citroën
75015 Paris
www.paris.fr

Park of the Château de Bizy
Avenue des Capucins
27200 Vernon
Tel.: +33 (0) 2 32 51 00 82

Park of Courances
91490 Courances
Tel.: +33 (0) 1 40 62 07 71 / 64 98 41 18
www.courances.net

Versailles
Établissement public du musée et du
domaine national de Versailles
Pavillon Dufour
RP834
78008 Versailles cedex
Tel.: +33 (0) 1 30 83 78 00
www.chateauversailles.fr

Apremont
Société hôtelière d'Apremont
18150 Apremont-sur-Allier
Tel.: +33 (0) 2 48 77 55 00
www.apremont-sur-allier.com

Priory of Notre-Dame d'Orsan
Sonia Lesot, Patrice Taravella
18170 Maisonnais
Tel.: +33 (0) 2 48 56 27 50
www.prieuredorsan.com

Villa Île-de-France
1, avenue Ephrussi de Rothschild
06230 Saint-Jean-Cap-Ferrat
Tel.: +33 (0) 4 93 01 45 90
www.academie-des-beaux-arts.fr/
fondations/index.html
www.villa-ephrussi.com

GERMANY

Sanspareil
Haus Nr. 29
96197 Wonsees

Tel.: +49 (0 92 74) 9 09 89 06 /
9 09 89 12
www.schloesser.bayern.de/englisch/
garden/objects/bay_morg.htm

Sanssouci Park
Besucherzentrum
Postfach 60 14 62
14414 Potsdam
Tel.: +49 (03 31) 96 94 202
www.spsg.de

Schwetzingen
Schloss Mittelbau
68723 Schwetzingen
Tel.: +49 (06202) 81482
www.schloesser-magazin.de/eng/
objekte/schw/schwthe.php

Wörlitzer Park
Schloss Großkühnau
06846 Dessau
Tel.: +49 (03 40) 6 46 15-0
www.gartenreich.com

GREAT BRITAIN

Bayleaf
Weald and Downland Open Air
Museum
Singleton
Chichester
West Sussex PO18 0EU
Tel.: +44 (0) 1 243 811363
www.wealddown.co.uk

Eden Project
Bodelva
St. Austell
Cornwall PL24 2SG
Tel.: +44 (0) 1 726 811911
www.edenproject.com

Great Dixter
Northiam
Rye
East Sussex TN31 6PH
Tel.: +44 (0) 1 797 252878
www.greatdixter.co.uk

Levens Hall
Kendal
Cumbria LA8 0PD
Tel.: +44 (0) 1 5395 60321
www.levenshall.co.uk

Portrack
Garden of Cosmic Speculation
Scotland
www.charlesjencks.com

Queen Eleanor's Garden
The Great Hall
The Castle
Winchester
Hampshire S023 8UI
Tel.: +44 (0) 1 962 846476
www.hants.gov.uk/discover/places/
eleanor.html

Sissinghurst
Nr Cranbrook
Kent TN17 2AB
Tel.: +44 (0) 1 580 710 700
www.nationaltrust.org.uk

Stourhead
Stourhead Estate Office
Stourton
Warminster
Wiltshire BA12 6QD
Tel.: +44 (0) 1 747 84 1152
www.nationaltrust.org.uk

INDIA

Fatehpur Sikri
Agra
http://asi.nic.in

Mughal Garden
Rashtrapati Bhavan
India Gate
New Delhi, DL
http://presidentofindia.nic.in/
mughalGarden.html

Rock Garden
Sector n°4
Chandigarh, 160 019
Tel.: +91 172 740 645

The Taj Mahal
Agra
http://asi.nic.in

IRAN

Bagh-e-Fin
Amirkabir Avenue
Kashan

Bagh-e-Shazdeh

Mahan

ITALY

Castello Ruspoli

Piazza della Repubblica, 9

01039 Vignanello (VT)

Tel.: +39 (0761) 754 707 / 755 338

castelloruspoli@libero.it

La Gamberaia

Via del Rossellino, 72

50135 Settignano (Florence)

Tel.: +39 (055) 697205 / 697090

www.villagamberaia.com

Hadrian's Villa

Via Villa Adriana

00019 Tivoli

Tel.: +39 (0774) 53 02 03

The Majolica Cloister

Complesso Museale di Santa Chiara

Via Santa Chiara, 49c

80134 Naples

Tel.: +39 (081) 195 759 15

www.santachiara.info

La Mortella

Fondazione William Walton

Via Francesco Calise, 39

80075 Forio

Isola d'Ischia (Naples)

Tel.: +39 (081) 986 220

www.ischia.it/mortella

www.mediterraneangardensociety.
org/gardens/La.Mortella.cfm

Park of the Reggia

Viale Douhet, 22

81100 Caserta

Tel.: +39 (0823) 448084 / 277380

www.reggiadicaserta.org

Pompeii

Soprintendenza per i Beni
Archeologici di Pompei

Via Villa dei Misteri, 2

80045 Pompei (Naples)

Tel.: +39 (081) 8575111

www.pompeiisites.org

Sacro Bosco

Loc. Giardino SNC

Bomarzo (Viterbo)

Tel.: +39 (0761) 924029

Villa d'Este

Piazza Trento, 1

00019 Tivoli

Tel.: +39 (0424) 600460 /
when local: 199766166

www.villadestetivoli.info

Villa Lante

Via Jacopi Barozzi, 71

01031 Bagnaia

Tel.: +39 (0761) 288 008

JAPAN

www.jnto.go.jp/fra

MOROCCO

El Bahia Palace

Rue de la Bahia

Zitoun el–Jedid

Medina

40000 Marrakech

Jacques Majorelle's Garden

Avenue Yacoub el-Mansour

40000 Marrakech

Tel.: +212 (04) 4301852

www.jardinmajorelle.com

THE NETHERLANDS

**Cloister of Saint-Martin's
Cathedral**

Achter de Dom, 1

3512 JN Utrecht

Tel.: +31 (0) 30 231 04 03

Het Loo

Paleis Het Loo Nationaal Museum

Koninklijk Park, 1

7315 JA Apeldoorn

Tel.: +31 (0) 55 577 24 00

www.paleishetloo.nl

NEW ZEALAND

Ayrlies

125 Potts Road

Whitford

Auckland

Tel.: +64 (09) 530 8706

ayrliesgardens@xtra.co.nz

RUSSIA

Peterhof

ul.Razvodnaya, 2

198516 Saint Petersburg

Tel.: +7 (812) 427 7425

www.peterhof.org

SPAIN

Alhambra and Generalife

La Alhambra

Colina de La Alhambra

18009 Grenada

Tel.: +34 (958) 02 79 00

www.alhambra.org

Atocha Station

Avenida de la Ciudad de Barcelona

Madrid

Barcelona Botanical Garden

Passeig del Migdia

Sants Montjuïc (Dt 3)

08038 Barcelona

Tel.: +34 (93) 426 49 35

www.jardibotanic.bcn.es

www.bcn.es/parcsijardins/
pa_botanic.htm

Castle of Púbol

Púbol

17120 La Pera

Tel.: +34 (972) 488 655

www.salvador-dali.org

Convent of Pedralbes

Baixada del Monestir, 9

08034 Barcelona

Tel.: +34 (93) 203 92 82

www.museuhistoria.bcn.es/eng/
centres/pedralbes/index.htm

The Galiana Palace

Paseo de la Rosa, s/n

45003 Toledo

Tel.: +34 (925) 220 852

Grupo Planeta Balconies

Edificio Planeta

Diagonal 662-664

08034 Barcelona

Guatiza

Carretera General del Norte, 35544

Guatiza (Lanzarote)

Tel.: +34 (928) 52 93 97

The Labyrinth of Horta

Carretera Germans Desvalls

08035 Barcelona

Tel.: +34 (93) 428 25 00 / 428 39 34

www.bcn.es/english/ihome.htm

Marimurtra

Passeig Carles Faust 9

Apartat Correus 112

17300 Blanes (Girona)

Tel.: +34 (972) 330 826

www.jbotanicmarimurtra.org

Monastery of Santes Creus

Office du Comarcal de Tourisme de
l'Alt Camp

Pl. Sant Bernat, 1 (Santes Creus)

43815 Aiguamúrcia

Tel.: +34 (977) 638 329 / 638 328

Museo Guggenheim Bilbao

Abandoibarra, 2

48001 Bilbao

Tel.: +34 (94) 435 90 80

www.guggenheim-bilbao.es

Park Guell

Carretera del Carmel

08024 Barcelona

Tel.: +34 (93) 424 38 09

www.bcn.es/parcsijardins/
pa_guell.htm

UNITED STATES

The Getty Center

1200 Getty Center Drive

Los Angeles, CA 90049

Tel.: +1 (310) 440 7300

www.getty.edu

Huntington Botanical Gardens

1151 Oxford Road

San Marino, CA 91108

Tel.: +1 (626) 405 2100

www.huntington.org

Index of Names

ACKNOWLEDGMENTS

First and foremost, I would like to give my greatest thanks to the numerous individuals from around the world who opened the gates to these beautiful gardens and allowed me to realize, little by little, this ambitious project:

Embassy of Spain, Paris (Mari Mar Rey); Embassy of India, Paris (Hemalata C. Bhagirath); The United States Embassy in Paris (Valérie Ferrière); Apremont (Elvire de Brissac, Tony Poupin); Ayrlies (Beverley McConnell); Bagnolet (Daniel Girard, Raymond Demurget); Barcelona (Bet Figueras); Bayleaf (Gael Kettel); Bilbao (Jeff Koons); Bizy (Denis Vergé); Bruges (Danielle and François Van der Elst); Canon (Hervé de Mezerac); Caserta (Francesco Canestrini, Antonio Raiano); Castello Ruspoli (Claudia Ruspoli, Santino); Cité Jeanne d'Arc (Sylvie and Gilles Pison); Courances (Jean-Louis and Philippine de Ganay); Eden Project (David Meneer); Fazenda Marambaia (Luiz César Fernandes); Galiana (Alejandro Fernández de Araoz Marañón); Getty Center (John Giurini, Melissa Pauna, Melissa Rodriguez); Giverny (Claudette Lindsey); Great Dixter (Christopher Lloyd, Perry Rodriguez); Groussay (Jean-Louis Remilleux, Hubert de la Cotardière); Huntington Botanical Gardens (Lisa Blackburn); Iran (Azadeh, Davoud Deghghan); Kyoto (Kunio Kadowaki); La Mortella (Susanna Gil Walton); Levens Hall (Hal Bagot, Lydia and Chris Crowder); Madrid (César Jiménez Callaba, Mariano Sánchez); Majorelle (Pierre Bergé, Abderrazzak Benchâabane, Danièle Leclercq); Mas de les Voltes (Fernando Caruncho, Oliver Preuss); Mont-Saint-Michel (Jean-Pierre Hochet, Martine Meron); Versailles (Nadine Pluvieux, Jeanne Hollande-Latrobe); Paris (Camille Muller, Jun Fujiwara); Pedralbes (Ana Castellanos); Peterhof (Vadim Znamenov, Tatiana Verbitskaïa, Igor Guerassimov); Petrópolis (Luciana Bassous Pinheiro); Portrack (Charles Jencks); President of India (S.M. Khan); Priory of Orsan (Sonia Lesot, Patrice Taravella); Púbol (Imma Barada); Rock Garden (Nek Chand); Sacro Bosco (Giovanni Bettini); Sanspareil (M. Schwarzott, Renate Gerspitzer); Sanssouci (Sybille Michel); Schoten (Jacques Martin and Peter Wirtz); Schwetzingen (Harry Filsinger); Sissinghurst (The National Trust, Nigel Nicolson, Sarah Cook); Stourhead (The National Trust, Katharine Boyd); Tacaruna (Martha and Gilberto Strunck); Taj Mahal (Dr. D. Dayalan, Dr. R. K. Dixit, R. R. Rathore); Utrecht (Marie-Antoinette Kroone); Villa Gamberaia (Luigi Zalum); Villa Île-de-France (James de Lestang); Villa Lante (Rafaella Stratti); Winchester (Sylvia Landsberg, Ann Murphy); Wörlitz-Dessau (Uwe Quilitzsch)

I am also pleased to thank the small team that formed around the book—five talents that worked with passion and ingeniousness in order to bring the book together: Carole Daprey (editor), Jacques Bosser (design), Brigitte Govignon (editorial director), Francis M. (art director), and Cécile Vandenbroucque (production manager).

www.letoquin.com

Translated from the French by Simon Jones and Anthony Roberts

Project Manager, English-language edition: Magali Veillon
Editor, English-language edition: Mary Christian
Designer, English-language edition: Shawn Dahl
Jacket design, English-language edition: Jonathan Sainsbury
Production Manager, English-language edition: Colin Hough Trapp

Library of Congress Cataloging-in-Publication Data
Le Toquin, Alain.
Gardens in time / photographs by Alain Le Toquin ; [text by] Jacques Bosser.
p. cm.
ISBN 0-8109-3092-7 (hardcover with jacket)
ISBN 13: 9-780-8109-3092-6
1. Gardens—Pictorial works. 2. Gardens—History. I. Bosser, Jacques. II. Title.
SB465.L417 2006
712.09—dc22
2006018847

Printed and bound in Spain
10 9 8 7 6 5 4 3 2 1

HNA
harry n. abrams, inc.
a subsidiary of La Martinière Groupe

115 West 18th Street
New York, NY 10011
www.hnabooks.com